The Robert Lehman Collection

I

The Robert Lehman Collection

I

Italian Paintings

JOHN POPE-HENNESSY

Assisted by Laurence B. Kanter

The Metropolitan Museum of Art, New York
in association with
Princeton University Press, Princeton

Egbert Haverkamp-Begemann, Coordinator

Published by The Metropolitan Museum of Art, New York

John P. O'Neill, Editor in Chief
John Daley, Nora Beeson, Editors
Bruce Campbell, Designer

Type set by Columbia Publishing Company, Inc., Frenchtown, New Jersey
Printed and bound in Italy by Amilcare Pizzi, S.p.a., Milan

LIBRARY OF CONGRESS CATALOGING-IN-PUBLICATION DATA
Metropolitan Museum of Art (New York, N.Y.)
The Robert Lehman Collection.
Bibliography: p. xv
Includes index.
Contents: v. 1. Italian paintings
/ John Pope-Hennessy—
1. Lehman, Robert, 1892–1969—Art collections—
Catalogs. 2. Art—Private collections—
New York (N.Y.)—Catalogs. 3. Metropolitan Museum
of Art (New York, N.Y.)—Catalogs.
I. Pope-Hennessy, John Wyndham, Sir, 1913– . II. Title.
N611.L43N48 1986 708.147′1 86-12519
ISBN 0-87099-479-4 (v. 1)
ISBN 0-691-04045-1 (Princeton: v. 1)

Contents

Preface

This is the first volume of the comprehensive catalogue of the Robert Lehman Collection at The Metropolitan Museum of Art. It is fitting that this initial installment be devoted to Italian paintings of the thirteenth to eighteenth centuries, a school of painting particularly close to Mr. Lehman's heart and central to his interests as a collector. In forming the collection, Robert Lehman was advised by the leading scholars of the day, in particular Bernard Berenson; so it is singularly appropriate that this volume should reflect the graceful scholarship and incomparable knowledge of Sir John Pope-Hennessy, former Consultative Chairman of the Department of European Paintings at The Metropolitan Museum of Art and *primus inter pares* among present-day scholars and connoisseurs of early Italian paintings.

At the time the collection came to The Metropolitan Museum, it was recognized by the Museum and by the Robert Lehman Foundation that a collection of such scope, quality, and diversity should be recorded in a comprehensive catalogue incorporating both the thinking of acknowledged experts and the latest techniques of classification, conservation, documentation, and reproduction. Accordingly, a joint venture was formed by the Museum, the Foundation, and the Institute of Fine Arts at New York University, the leading repository of art-historical scholarship in the United States, with a view to producing such a catalogue.

The contributions of many parties should be acknowledged. Principal responsibility throughout has been vested—in the area of scholarly coordination—in the Institute of Fine Arts and—in the area of production and publication—in the Publications Department of the Metropolitan Museum. In this regard, particular thanks are due to Professor Egbert Haverkamp-Begemann, who has functioned as de facto chief executive of the catalogue project and has been responsible for liaison between the three institutional partners. To a very large extent, this catalogue is a product of his wide knowledge of art and art history, his familiarity with the experts in various fields, his executive ability, and, not least, his patience.

Thanks, too, are due to three successive Directors of the Institute of Fine Arts, without whose cooperation and vision the project might not have moved forward: Dr. James McCredie and his predecessors, Professors A. Richard Turner and Jonathan Brown.

At the Metropolitan Museum, Bradford J. Kelleher, Vice President and Publisher, and John Daley, Editor, have been responsible for the editorial and production stages of the project. In addition, Sir John Pope-Hennessy has represented the Museum on scholarly matters, and Ashton Hawkins, Vice President, Secretary, and General Counsel, was most helpful in setting the project in motion.

Special thanks must also go to Sydney J. Freedberg, recently Professor of Fine Arts at Harvard and currently Chief Curator of the National Gallery of Art, Washington, who has acted throughout the entire project as independent scholarly advisor to the Robert Lehman Foundation. Acting on behalf of the Foundation have been Paul C. Guth, Michael M. Thomas, and the undersigned.

Publication of Volume One is an occasion for celebration and regret. Thanks to the efforts of those named above and of many others, the Robert Lehman Collection will be documented at a level of scholarship commensurate with its singularly high quality as an assemblage of works of art. To be regretted, however, is that Robert Lehman, the moving spirit behind the monumental 1928 catalogue of the collection, should not be alive to celebrate with us the publication of this altogether worthy successor.

Alvin W. Pearson
Late President of the
Robert Lehman Foundation, Inc.

Foreword

Precisely one month after the death of Robert Lehman on August 9, 1969, the Board of Trustees of The Metropolitan Museum of Art registered its collective regret at his passing and its appreciation for his many years of service by eulogizing him as "one of the finest Trustees in the history of the Museum" and as "a wise, just, and humane man."

This was not hyperbole or a fatuous demonstration of the dictum, "de mortuis nihil nisi bonum." For Robert Lehman did possess to an astonishing degree wisdom, justice, and humanity. From the time of his election to the Board in 1941 until his death in 1969, he advised the Museum well in all its financial and artistic affairs. He was a Vice President of the Museum from 1948 to 1967 and thereafter its first Chairman of the Board. During this exceptionally long period, he collaborated closely with Francis Henry Taylor, James J. Rorimer, and Thomas P. F. Hoving, all directors of strong will and varying temperament.

Profound as his acumen was for Museum affairs, it was prodigious where collecting was concerned. Robert Lehman's connoisseurship and shrewdness permitted him repeatedly to make the most enlightened purchases. Throughout his lifetime Robert Lehman contributed his wealth, scholarly knowledge, and—most important—his sense of quality to the enhancement of his collection, started by his father, Philip Lehman, around 1910. It grew to be one of the largest private collections of its day, unmatched certainly in the field of early Italian paintings and Venetian eighteenth-century drawings. For many decades the collection was made available to the public in the house built by Philip Lehman on West 54th Street in New York City in accordance with Robert Lehman's belief that "important works of art, privately owned, should be beyond one's own private enjoyment and [that] the public at large should be afforded some means of seeing them."

In accordance with Robert Lehman's wishes, his Foundation, which had received the collection under his will, transferred it to The Metropolitan Museum of Art under arrangements providing for its exhibition in the Robert Lehman Wing. Lehman's gift of the collection and the Museum's commitment to provide specially for its display were reciprocal accommodations made by "two strong wills who discovered they both wanted the same thing," in the words of Joseph A. Thomas, Robert Lehman's long-time partner and late President of the Lehman Foundation. In 1975 the Museum opened the Lehman Wing, a pyramidal, skylit exhibition hall lying to the west, on the axis of the Museum's principal entrance at 82nd Street. Sheathed in a veneer of Indian limestone chosen to harmonize with the old facade of Victorian red brick and granite, the Wing and its galleries ideally serve for the display of this collection and at the same time carry out Robert Lehman's belief that some works of art should be exhibited in the setting of a private home for which they were selected; therefore seven interiors from the Lehman mansion are replicated in the Wing.

In unsystematic fashion the Robert Lehman Collection has been the focus of scholarly attention, and many of the works in it have been featured in learned monographs ever since the elder Lehman began collecting. That it has not received a comprehensive treatment is hardly surprising for two reasons: its assembly was not completed until Mr. Leh-

man's death, and the collection is so wide-ranging that no single expert could hope to write convincingly on all its varied aspects. Indeed, the present catalogue demanded the coordination of Professor Egbert Haverkamp-Begemann and the combined expertise of many scholars to produce the thirteen volumes required to treat adequately this most variegated of collections. In breadth alone it has no rival, including Italian paintings from the thirteenth to the eighteenth centuries, Italian drawings from the fifteenth, sixteenth, and eighteenth centuries, Northern Renaissance paintings, French and Spanish nineteenth- and twentieth-century paintings, and an outstanding collection of decorative arts encompassing Italian and Northern European bronzes, furniture, textiles, glass, majolica, and objets de virtú. Volumes I and VI in the series, which are being published simultaneously, embody the fruits of the very latest scholarship by some of the most illustrious art historians of our day. The appearance of these volumes represents the tangible result of many years of planning and effort by countless individuals. To all these the Museum extends its gratitude, but particularly to the Robert Lehman Foundation and to its late Presidents, Edwin L. Weisl, Sr., Joseph A. Thomas, and Alvin W. Pearson, for their consistent and unfailing support of the Wing and the catalogue project.

Philippe de Montebello
Director

Acknowledgments

Over the past sixty years the Italian paintings in the Robert Lehman Collection have been extensively discussed. An elaborate catalogue by Robert Lehman was published in 1928, and a guide by the curator of the collection, Dr. George Szabo, appeared in 1975. My prime debt in the preparation of this catalogue has been to the work of scholars of an earlier generation than my own, but I must acknowledge a deep obligation to Everett P. Fahy and Keith Christiansen, who have repeatedly read and criticized the entries. A substantial debt is also due to Federico Zeri and Miklós Boskovits, with whom many of the problems presented by the catalogue have been discussed. For assistance on specific points I am also indebted to Andrea Emiliani (who has provided information on the Gozzadini portraits), to Erich Schleier (in connection with the panels from the altarpiece by Ugolino di Nerio), to Terisio Pignatti, and to Alan Chong (by whom the painting by Cimaroli was first identified).

In any modern catalogue of paintings special importance must attach to accurate description of physical condition. Technical examination of the pictures has been undertaken by Laurence B. Kanter under the supervision of John Brealey and members of the staff of the Paintings Conservation Department and with the assistance, in the field of infrared reflectography, of Maryan Ainsworth. As is indicated on the title page, Kanter's contribution through the whole period of work on the catalogue has been very great. Without it, and without the tireless assistance of Rolf Bagemihl, this would have been a less adequate and a more superficial book.

John Pope-Hennessy

List of Plates

Bibliographical Abbreviations

Berenson, 1894	B. Berenson, *The Venetian Painters of the Renaissance, with an Index to Their Works*, New York and London, 1894.
Berenson, 1896	B. Berenson, *The Florentine Painters of the Renaissance, with an Index to Their Works*, New York and London, 1896.
Berenson, 1897	B. Berenson, *The Central Italian Painters of the Renaissance*, New York, 1897.
Berenson, 1897	B. Berenson, *The Venetian Painters of the Renaissance, with an Index to Their Works*, New York and London, 1897 (third ed.).
Berenson, 1900	B. Berenson, *The Florentine Painters of the Renaissance, with an Index to Their Works*, New York and London, 1900 (second ed.).
Berenson, 1907	B. Berenson, *The North Italian Painters of the Renaissance*, New York, 1907.
Berenson, 1909	B. Berenson, *The Central Italian Painters of the Renaissance*, New York, 1909 (second ed.).
Berenson, 1909	B. Berenson, *The Florentine Painters of the Renaissance, with an Index to Their Works*, New York and London, 1909 (third ed.).
Berenson, 1927	B. Berenson, *North Italian Painters of the Renaissance*, New York and London, 1927 (reprint of 1907 ed.).
Berenson, 1932	B. Berenson, *Italian Pictures of the Renaissance: a List of the Principal Artists and Their Works, with an Index of Places*, Oxford, 1932.
Berenson, 1936	B. Berenson, *Pitture italiane del Rinascimento: Catalogo dei principali artisti e delle loro opere con un indice dei luoghi*, Milan, 1936.
Berenson, 1957	B. Berenson, *Italian Pictures of the Renaissance: a List of the Principal Artists and Their Works, with an Index of Places: Venetian School*, 2 vols., London, 1957.
Berenson, 1963	B. Berenson, *Italian Pictures of the Renaissance: a List of the Principal Artists and Their Works, with an Index of Places: Florentine School*, 2 vols., London, 1963.
Berenson, 1968	B. Berenson, *Italian Pictures of the Renaissance: a List of the Principal Artists and Their Works, with an Index of Places: Central Italian and North Italian Schools*, 3 vols., London, 1968.
Crowe and Cavalcaselle, 1864–66	J. A. Crowe and G. B. Cavalcaselle, *A New History of Painting in Italy*, 3 vols., London, 1864–66.

Crowe and Cavalcaselle, eds. Douglas and Borenius	J. A. Crowe and G. B. Cavalcaselle, eds. R. Langton Douglas (vols. 1–4) and T. Borenius (vols. 5–6), *A History of Painting in Italy: Umbria, Florence, and Siena, from the Second to the Sixteenth Century*, 6 vols., London, 1903–14.
Crowe and Cavalcaselle, ed. Hutton	J. A. Crowe and G. B. Cavalcaselle, ed. E. Hutton, *A New History of Painting in Italy*, 3 vols., London, 1908–9.
Crowe and Cavalcaselle, *A History of Painting in North Italy* 1871	J. A. Crowe and G. B. Cavalcaselle, *A History of Painting in North Italy: Venice, Padua, Vicenza, Verona, Ferrara, Milan, Friuli, Brescia, from the Fourteenth to the Sixteenth Century*, 2 vols., London, 1871.
Crowe and Cavalcaselle, *A History of Painting in North Italy*, ed. Borenius	J. A. Crowe and G. B. Cavalcaselle, *A History of Painting in North Italy: Venice, Padua, Vicenza, Verona, Ferrara, Milan, Friuli, Brescia, from the Fourteenth to the Sixteenth Century*, 3 vols., New York, 1912.
Laclotte, 1957	Paris, Musée de l'Orangerie, *La Collection Lehman*, 1957.
R. Lehman, 1928	R. Lehman, *The Philip Lehman Collection, New York: Paintings*, Paris, 1928.
Szabo, 1975	G. Szabo, *The Robert Lehman Collection, a Guide*, New York, 1975.
Thieme-Becker, *Künstler Lexikon*	U. Thieme and F. Becker, eds., *Allgemeines Lexikon der bildenden Künstler von der Antike bis zur Gegenwart*, 37 vols., Leipzig, 1907–50.
Van Marle, *Development*	R. van Marle, *The Development of the Italian Schools of Painting*, 19 vols., The Hague, 1923–38.
Vasari, ed. Milanesi, *Vite*	G. Vasari, ed. G. Milanesi, *Le vite de' più eccellenti pittori, scultori ed architettori scritte da Giorgio Vasari, pittore aretino, con nuovo annotazione e commento di Gaetano Milanesi*, 9 vols., Florence, 1878–85.
Vasari, ed. Ricci, *Le vite . . .* , 1927	G. Vasari, ed. C. Ricci, *Le vite del Vasari nell'edizione del 1550*, 4 vols., Milan and Rome, 1927.
Venturi, *Storia*	A. Venturi, *Storia dell'arte italiana*, Milan, 1909–40.

SIENA

Fourteenth Century

The Master of Monte Oliveto

The Master of Monte Oliveto derives his name from a panel at Monte Oliveto Maggiore. His early paintings, two of the finest of which are catalogued here, seemingly date between about 1310 and 1325. A close follower of Duccio, he also reflects the influence of Segna di Bonaventura. His works show unmistakable idiosyncrasies of palette and design as well as remarkable vigor of execution.

1. Madonna and Child with Nine Angels

1975.1.1

Tempera on panel. 38.4 × 26.9 cm. (15⅛ × 10⅝ in.), with engaged frame. The panel has been thinned and cradled. There is no longer any trace of the figure of a saint said by R. Lehman (1928, pl. 14) to have been painted on the back of the panel.

The Virgin is seated on a crimson cushion on a marble throne decorated with glass inlay and draped with a pink and green cloth. She wears a blue cloak over a red dress and holds the Child in her left arm. The Child is dressed in a white lawn tunic covered with a deep mauve veil; his right hand is raised toward the Virgin's face. At each side of the throne are three standing angels. Those in the foreground wear (*left*) a blue cloak over a light green tunic and (*right*) a greenish blue cloak over a red tunic; those in the central plane wear (*left*) a red cloak over a green tunic and (*right*) a red cloak over a blue tunic; and those at the back (*left*) a green cloak over a gold-patterned red tunic and (*right*) a light brown cloak over a green tunic. All of the angels have red wings striated in gold. Behind the throne three angels in half-length hold up a cloth of honor of deep pink brocade with a white pattern turned over at the top to reveal a reverse side with a fringe and white surface decorated in gold, red, and blue. The upper angels wear (*center*) a blue cloak over a bright red tunic, (*left*) a pale green cloak over a mauve tunic, and (*right*) a dark green cloak over a crimson tunic.

This panel and No. 2, which originally formed a diptych, were formerly ascribed to Duccio di Buoninsegna (R. Lehman, 1928, pls. 14, 15) and were exhibited as by Duccio at the New York World's Fair in 1939 (G. H. McCall, *Catalogue of European Paintings and Sculpture from 1300–1800*, p. 42, nos. 86, 86A). The attribution to Duccio had, however, already been rejected by L. Venturi (*Pitture italiane in America*, 1931, pls. 19, 20) with the perceptive comment: "Non meraviglia quindi che quest'opera sia stata attribuito a Duccio stesso.

Sembra tuttavia di notare che lo spirito è differente, meno eroico e grandioso e solenne di quello di Duccio, più vivace e gentile, più limitato alle possibilità umane, così che da tutti quegli angeli scaturisce una fiaba ideale. Per qualità d'ispirazione e finezza cromatica l'autore di questo quadro è fratello a Ugolino da Siena." The diptych was relegated to the following of Duccio by Van Marle (*Le scuole della pittura italiana*, vol. 2, 1934, p. 106, where the panels are mistakenly stated to have come from the cathedral at Cracow), and was tentatively and wrongly attributed by Berenson (1932, p. 295; 1936, p. 253) to an early phase in the career of Ugolino Lorenzetti. It has since been associated with, or attributed to, the follower of Duccio known as the Master of Monte Oliveto from a panel that originally formed the center of a triptych, now preserved in the abbey of Monte Oliveto Maggiore. The integration of the work of this artist was begun by De Nicola ("Duccio di Buoninsegna and His School in the Mostra di Duccio at Siena," *Burlington Magazine*, 22, 1912–13, p. 147), who connected the Monte Oliveto panel with a diptych in the Yale University Art Gallery, and was continued by Brandi (*Duccio*, 1951, p. 152), E. R. Mendelsohn (*The Master of Monte Oliveto*, M.A. thesis, directed by Richard Offner, New York University, Institute of Fine Arts, 1950), Coor ("A New Attribution to the Monte Oliveto Master and Some Observations Concerning the Chronology of His Works," *Burlington Magazine*, 97, 1955, pp. 203–7), Vertova ("A New Work by the Monte Oliveto Master," *Burlington Magazine*, 112, 1970, pp. 688–91; "Un frammento duccesco," *Arte illustrata*, 2, 1969, pp. 38–47), and Stubblebine ("Duccio's *Maestà* of 1302 for the Chapel of the Nove," *Art Quarterly*, 35, 1972, pp. 239–68; *Duccio di Buoninsegna and His School*, 1979, pp. 92–102).

Despite this lengthy bibliography there is substantial disagreement on the catalogue of works attributable to the artist and on their chronology. The attribution of the present diptych is questioned on qualitative grounds by Brandi, who regards it as the work of a "Maestro di Monte Oliveto divenuto più raffinato," and by Coor, who notes the "greater refinement and certain stylistic differences" that distinguish these panels and the related wings of a triptych in the Metropolitan Museum of Art (acc. no. 41.190.31) from the eponymous panel at Monte Oliveto. Vertova likewise gives the present diptych to a follower of Duccio distinct from the Master of Monte Oliveto. The attribution is, however, accepted by Mendelsohn (and therefore, by implication, by Offner) and by Stubblebine.

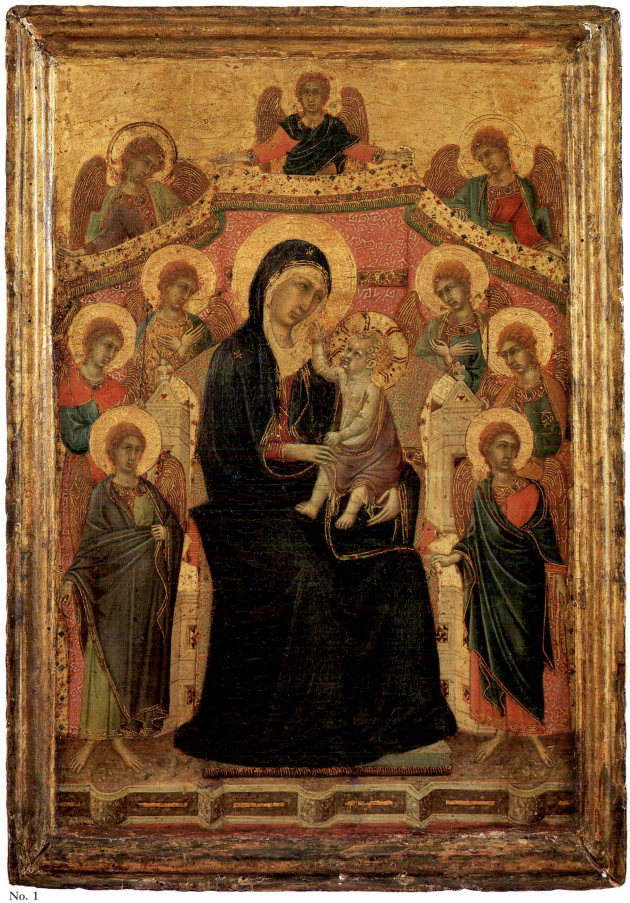

No. 1

The heterogeneous group of panels given to the Master of Monte Oliveto by Stubblebine is of widely divergent quality, but includes a small number of works closely comparable to the present diptych, which are in turn associable with the Monte Oliveto panel. These comprise a *Crucifixion* (Stubblebine, *Duccio*, pp. 93–94, fig. 210; whereabouts unknown), a second *Crucifixion* in the Grassi collection, New York (ibid., p. 94, figs. 211, 470), a triptych in the Metropolitan Museum of Art (acc. no. 18.117.1; ibid., pp. 97–98, fig. 219), and the triptych wings in the Metropolitan Museum mentioned above (ibid., pp. 100–101, fig. 228).

The form of the cloth of honor behind the Virgin and Child in the present diptych is related to that in a coarse *Virgin and Child with Six Angels* in the Yale University Art Gallery, which also forms part of a diptych with a *Crucifixion* and is generally ascribed (De Nicola, loc. cit.; Stubblebine, *Duccio*, pp. 94–95, figs. 212, 213) to the Monte Oliveto Master. The *Madonna* at Monte Oliveto is regarded by Stubblebine as based on the lost *Maestà* of Duccio painted in 1302 for the Chapel of the Nove in the Palazzo Pubblico in Siena, and as the artist's earliest work. An early dating soon after 1310 is also accepted by Coor. For Mendelsohn (op. cit., p. 30), on the other hand, the present diptych is "without any doubt . . . the earliest extant work by the Monte Oliveto Master."

The cartoons used for the individual figures are not employed in precisely the same form in any other paintings. It may be noted, however, that two of the three male figures at the extreme right of the *Crucifixion* are closely related to the corresponding figures in a Ducciesque *Crucifixion* in the Museum of Fine Arts, Boston, and that the frontal figure of the Virgin on the left side of the panel recurs, not in the Boston *Crucifixion* or in the *Crucifixion* on Duccio's *Maestà* (where the Virgin is shown in profile), but in a panel of the *Crucifixion* incorrectly ascribed to Duccio and Ugolino da Siena, formerly in the Crawford collection, now in the Manchester City Art Gallery (Stubblebine, *Duccio*, pp. 174–75, fig. 430). The open composition of the *Madonna and Child*, with angels arranged in a semicircle around the throne, is a conscious reminiscence of the central section of the front of Duccio's *Maestà*, and the pose of the Child with right arm raised toward the Virgin's veil finds a parallel in a *Madonna* by the Badia a Isola Master in the Fondazione Giorgio Cini, Venice (for which see F. Zeri, M. Natale, and A. Mottola Molfino, *Dipinti toscani e oggetti d'arte dalla collezione Vittorio Cini*, 1984, no. 7). Though they are in no sense conclusive, these points taken together suggest that the Lehman diptych is likely to date from about 1315.

CONDITION: The paint surface is well preserved, with only minor paint losses, notably at the back of the Child's head and on his raised right hand. The gold of the haloes and of the ground is intact. The panel is wrongly described by Stubblebine (*Duccio*, p. 96) as in mediocre condition.

PROVENANCE: Cardinal Franchi, Rome; Commandante Rossi, Rome; Pol Popiel, Warsaw (not Lvov as stated by R. Lehman, pl. 15), by whom presented to the cathedral in Warsaw; Count Horodetzki, Paris; F. Kleinberger Galleries, New York. Acquired by Philip Lehman in 1923.

EXHIBITED: World's Fair, New York, *Masterpieces of Art*, 1939, no. 86 (as Duccio di Buoninsegna); Metropolitan Museum of Art, New York, 1944 (as Duccio di Buoninsegna); Colorado Springs Fine Arts Center, *Paintings and Bronzes from the Collection of Mr. Robert Lehman*, 1951–52 (as Duccio di Buoninsegna); Metropolitan Museum of Art, New York, 1954–61 (as Duccio di Buoninsegna); Musée de l'Orangerie, Paris, *La collection Lehman*, 1957, no. 16 (as Entourage de Duccio di Buoninsegna); Cincinnati Art Museum, *The Lehman Collection*, 1959, no. 2 (as Duccio di Buoninsegna); Metropolitan Museum of Art, New York, *Masterpieces of Fifty Centuries*, 1970, no. 178a.

2. The Crucifixion

1975.1.2

Tempera on panel. 38.2 × 27 cm. (15 × 10⅝ in.), with engaged frame. The panel has been thinned and cradled. There is no longer any trace of a damaged figure of Saint Francis said by R. Lehman (1928, pl. 15) to have been painted on the back of the panel.

In the center is Christ on the cross, his eyes closed in death. He wears a transparent loincloth decorated in gold, and blood pours from his hands, side, arms, and feet. On the level of the arms of the cross are two red angels flying outward, and below the arms are four more flying angels, two in dull blue and two in red, three of whom carry receptacles for Christ's blood. In the left foreground is the fainting Virgin, supported between a Holy Woman in a deep mauve robe to the left and the red-clad figure of the Magdalene at the right. Behind them, immediately beside the cross, is the standing figure of Saint John the Evangelist in a crimson, gold-edged cloak. The heads of three further Holy Women are visible at the left. On the opposite side is a group of eleven male figures. Two of them, in the foreground, one in a mauve cloak crouching on the ground with left hand raised and the other standing in a greenish blue cloak, recoil from the cross; behind these, two others gesture toward the body

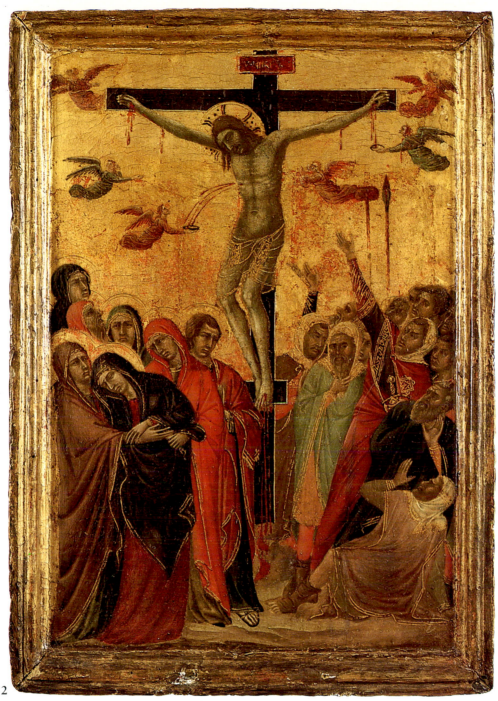

No. 2

of Christ. Raised above the crowd are the spear and the sponge of vinegar.

For the diptych to which this panel belonged, see No. 1.

CONDITION: The paint surface is slightly less well preserved than that in the companion panel. The gold is somewhat abraded, and small scratches across the figures on the right have been inpainted. The shaft of the spear, the sponge, and the stream of blood from Christ's wound have been reinforced. The six angels around the cross survive only in fragments of original paint and have been extensively restored.

PROVENANCE: See No. 1.

EXHIBITED: World's Fair, New York, *Masterpieces of Art*, 1939, no. 86 A (as Duccio di Buoninsegna); Metropolitan Museum of Art, New York, 1944 (as Duccio di Buoninsegna); Colorado Springs Fine Arts Center, *Paintings and Bronzes from the Collection of Mr. Robert Lehman*, 1951–52 (as Duccio di Buoninsegna); Metropolitan Museum of Art, New York, 1954–61 (as Duccio di Buoninsegna); Musée de l'Orangerie, Paris, *La collection Lehman*, 1957, no. 17 (as Entourage de Duccio di Buoninsegna); Cincinnati Art Museum, *The Lehman Collection*, 1959, no. 1 (as Duccio di Buoninsegna); Metropolitan Museum of Art, New York, *Masterpieces of Fifty Centuries*, 1970, no. 178b.

The Goodhart Ducciesque Master

The works of this rare master were first isolated and identified by Offner, who named him for the panel now in the Lehman Collection. The few pictures certainly by his hand show him to have been heavily influenced by Duccio's pupil Segna di Bonaventura and to have been active in the period roughly 1315–30. Debatable additions to his oeuvre have been proposed by Coor, who believed him to be a follower of Ugolino da Siena, and Stubblebine, who regarded him as a direct follower of Duccio.

3. Madonna and Child Enthroned with Two Donors

1975.1.24

Tempera on panel. 52.6 × 29.9 cm. (20¹¹⁄₁₆ × 11¾ in.). The engaged moldings are original. The panel has been unevenly thinned but not cradled, and the center of the back shows the original surface of the wood.

Beneath a triangular gable, on a throne of white marble with Cosmatesque inlay, the Virgin sits on a cushion before a cloth of honor. She wears a blue cloak over a red tunic and is turned slightly to the right, with the Child Christ, in an orange tunic and violet robe, cradled in her left arm. The Child holds a fruit in his left hand, and with his right blesses a youth kneeling beside the throne on the left. On the right, with hands clasped in prayer and head upturned, kneels a male donor wearing a blue robe and *cappuccio*. The arms and canopy of the throne terminate in marble finials; beneath the platform under the throne is a projecting marble step. Stubblebine (*Duccio di Buoninsegna and His School*, 1979, p. 109) regards the donors as a father and son.

The artist derives his name from the present panel, which was associated by Offner, when it was in the collection of Mr. and Mrs. A. E. Goodhart, with a diptych valve with the Madonna and Child, Annunciation, and Nativity in the Metropolitan Museum of Art (acc. no. 20.160) and a polyptych in the Samuel H. Kress collection, now in Birmingham, Alabama (for which see F. R. Shapley, *Paintings from the Samuel H. Kress Collection, Italian Schools XIII–XV Century*, 1966, p. 18, fig. 40). Offner's attribution was not published, but is recorded by Wehle (*The Metropolitan Museum of Art: A Catalogue of Italian, Spanish and Byzantine Paintings*, 1940, p. 72) and by Shorr (*The Christ Child in Devotional Images in Italy during the XIV Century*, 1954, pp. 154–57). To these

three works Coor ("Contributions to the Study of Ugolino di Nerio's Art," *Art Bulletin*, 37, 1955, pp. 163–64, n. 57) added a polyptych at Monterongriffoli and a *Saint Anne and the Virgin*, then with Knoedler & Co. and now in the National Gallery of Canada, Ottawa (for which see No. 5), characterizing the painter as a follower of Ugolino da Siena active in the second and third decades of the fourteenth century. Offner's initial group of three paintings was accepted by Berenson (1968, vol. 1, pp. 118–19), who added to them a *Madonna and Child with Saints and Angels* formerly in the Reinach collection, Paris (for which see Stubblebine, op. cit., pp. 108–9, fig. 259). Four further works—one in the Volterra collection, Florence, another in the Athenaeum in Helsinki, and the remainder of uncertain location—were added to this list by Stubblebine (ibid., pp. 106–10), who regards the artist as an independent follower of Duccio active between 1310 and 1325. The validity of these extended lists is questionable; only the three works ascribed to the artist by Offner and the Volterra *Madonna* reveal a true identity of authorship.

CONDITION: The paint surface is well preserved, but the gold ground has been scratched and abraded, impairing the silhouette of the throne. The head of the donor at the right is damaged and has been restored.

PROVENANCE: Mr. and Mrs. A. E. Goodhart, New York. Bequeathed by Mrs. Goodhart to Robert Lehman in 1952.

EXHIBITED: Metropolitan Museum of Art, New York, 1954–61 (as Sienese, fourteenth century); Musée de l'Orangerie, Paris, *La collection Lehman*, 1957; Cincinnati Art Museum, *The Lehman Collection*, 1959, no. 29 (as Sienese Master, fourteenth century).

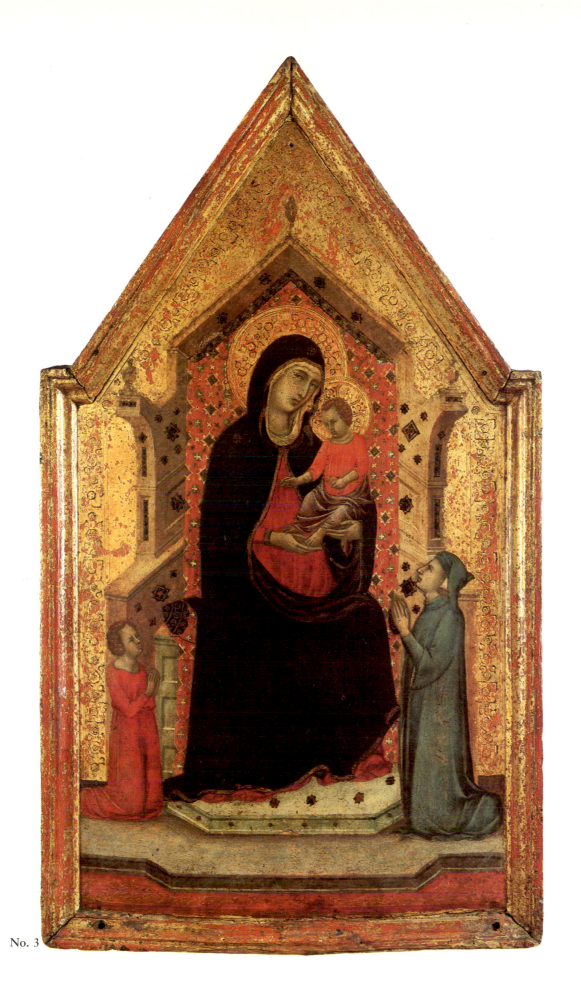

No. 3

Ugolino da Siena

The most original and accomplished of Duccio's close followers, Ugolino di Nerio, generally known as Ugolino da Siena, is recorded in documents of 1317, 1324–25, and 1327, none of which, however, relates to an extant work of art. His signature is recorded beneath the missing central panel of the high altarpiece from Santa Croce in Florence, the dispersed fragments of which form the basis for a reconstruction of his style. None of the pictures attributed to Ugolino is dated. Though his career is generally assumed to have begun ca. 1305, it is unlikely that his earliest paintings predate 1315, while it is probable that he remained active well into the 1330s. His later works show the increasingly pronounced influence of Ugolino's near contemporary, Pietro Lorenzetti.

4. The Last Supper

1975.1.7

Tempera on panel. Overall: 38.1 × 56.5 cm. (15 × 22¼ in.); picture surface: 34.3 × 52.7 cm. (13½ × 20¾ in.). The panel, which has not been thinned down, is 3 cm. deep. There is a trapezoidal insert (7.6 × 3.5 cm.; 3 × 1⅜ in.) in the lower left corner to complete an area cut out for the attachment of the base of a framing element. The frame is modern.

Christ sits at the left at the head of a long table running horizontally across the panel. With his right hand extended on the tablecloth, he informs his disciples that one of them will betray him. To his left, behind the table, is Saint John, with his head pressed against Christ's arm; next to Saint John is Saint Peter, with raised hand, asking of whom Christ has spoken. Behind Saint Peter is a towel hanging from a pole. The other apostles—four seated behind the table, one at its foot, and five on a wooden bench in front—have stopped eating, and look "one on another, doubting of whom He spoke" (John 13:22). Judas, without a halo, sits in front of the table at Christ's right reaching toward a plate in front of Christ. The table is set with dishes of meat and fruit, small bowls, cups, and knives on a white cloth. The room has a coffered ceiling and three walls, gray at the back and white at the right. There is a small window in the right-hand wall.

This panel formed part of the predella of the high altarpiece of the church of Santa Croce in Florence. The lost central panel of the altarpiece was signed by Ugolino da Siena. The polyptych is mentioned as a work of Ugolino's in 1550 in the first edition of Vasari's *Lives* (*Le vite . . .*, ed. C. Ricci, 1927, vol. 1, p. 155). In 1566 it was moved from the high altar to be replaced three years later by a ciborium designed by Vasari. In 1785 it was described by Guglielmo Della Valle (*Lettere sanesi*, vol. 2, p. 202) in the upper dormitory of the convent premises. After this date and before 1810, when the friary was suppressed and an inventory of its contents omits all reference to the altarpiece, those pieces judged to be worth saving were bought by an Englishman, probably William Young Ottley, in whose house they were described by Waagen (*Kunstwerke und Künstler in England*, vol. 1, 1837, pp. 393–95) in 1835. The panels owned by Ottley comprised the central Virgin and Child (lost); three lateral figures of Saints John the Baptist, Paul, and Peter from the main register, now in the Staatliche Museen, Berlin-Dahlem; ten paired figures of saints from the intermediate upper register (three panels with Saints James the Greater and Philip, Matthew and James the Less, and Matthias and Clare, in the Staatliche Museen, Berlin-Dahlem, and two with Saints Simon and Thaddeus, and Saints Bartholomew and Andrew, in the National Gallery, London); four pinnacles with prophets; some spandrel panels with angels; and the seven panels of the predella.

J. S. Sartain (*The Reminiscences of a Very Old Man*, 1899, p. 98), who worked in Ottley's house from 1823 till 1825, describes some rooms there, "the walls of which were covered from floor to ceiling with pictures by the old Pre-Raphaelite artists, which Mr. Ottley had collected in Italy during the latter part of the last century. Most of them were taken from churches during the occupation by the French soldiery, and but for Mr. Ottley's intervention might have been destroyed."

A drawing of the altarpiece as it appeared in the dormitory at Santa Croce was made, probably between 1785 and 1789, for Séroux d'Agincourt and is preserved in the Biblioteca Vaticana (Vat. Lat. 9847, fol. 92r.), where it was discovered in 1978 by Henri Loyrette ("Une source pour la reconstruction du polyptyque d'Ugolino da Siena à Santa Croce," *Paragone*, vol. 29, no. 343, 1978, pp. 15–23). Though it is demonstrated by Gardner von Teuffel ("The Buttressed Altarpiece," *Jahrbuch der Berliner Museen*, 21, 1979, pp. 21–65) that the form of the altarpiece must already have been modified when the Vatican drawing was made, this, in conjunction with three engravings by Giovanni Antonio Baccanelli (published in N. Catalano, *Fiume del Terrestre Paradiso, diviso in quattro capi, o discorsi*, 1652, pp. 424–25), is the prime source for its reconstruction, superseding the conjectural reconstructions proposed by Hutton (*The Sienese School in the National Gallery*, 1925, pp. 16–21), Coor

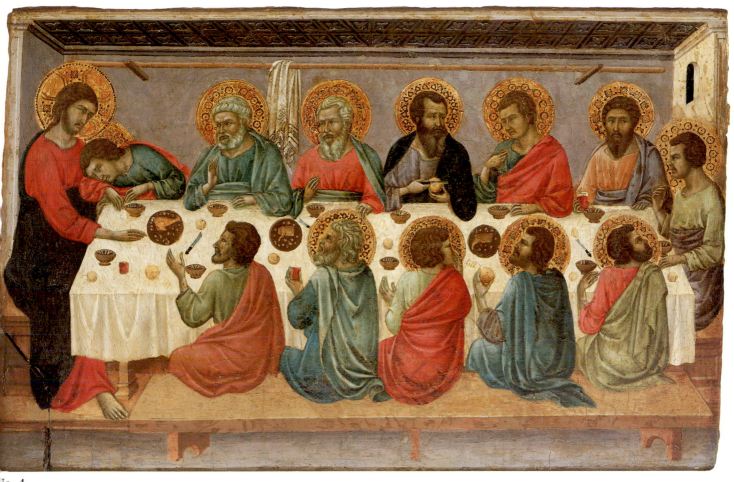

No. 4

("Contributions to the Study of Ugolino di Nerio's Art," *Art Bulletin*, 37, 1955, pp. 153–67), and Stubblebine (*Duccio di Buoninsegna and His School*, 1979, pp. 164–68). A conclusive reconstruction, based on physical examination of the panels in London and elsewhere, is presented by Gordon ("Three Newly Acquired Panels from the Altarpiece for Santa Croce by Ugolino di Nerio," *National Gallery Technical Bulletin*, London, 8, 1984, pp. 36–52). It can be inferred that the seven main panels of the altarpiece represented (*left to right*) Saint Anthony of Padua, Saint John the Baptist, Saint Paul, the Virgin and Child, Saint Peter, Saint Francis, and Saint Louis of Toulouse. In the drawing the seven predella panels are spaced evenly across the base of the altarpiece and, except for the one in the center, are not aligned with the upper panels. At the time the drawing was made the lateral framing of the altarpiece, which seems to have had columns or pilasters whose bases intruded on the predella at the lower left corner of the left-hand panel (the Lehman *Last Supper*) and the lower right corner of the right-hand panel (the London *Resurrection*, which is completed by an insert similar to that in the Lehman panel), had disappeared. The seven predella panels were arranged in their normal narrative sequence: *The Last Supper* (No. 4), *The Arrest of Christ* (National Gallery, London, no. 1188; Fig. 2), *The Flagellation* (Staatliche Museen, Berlin-Dahlem, no. 1635A; Fig. 3), *The Way to Calvary* (National Gallery, London, no. 1189; Fig. 4), *The Deposition* (National Gallery, London, no. 3375; Fig. 5), *The Entombment* (Staatliche Museen, Berlin-Dahlem, no. 1635B; Fig. 6), and *The Resurrection* (National Gallery, London, no. 4191; Fig. 7). A *Crucifixion* (lost) filled the space above the Virgin and Child in the central pinnacle.

Though the style of the predella panels is generically Ducciesque, the iconography of the individual scenes is not closely dependent on that of the corresponding scenes on the back of Duccio's *Maestà*. In *The Arrest of Christ*, the Christ and Judas and the Saint Peter and Malchas derive directly from this prototype, but *The Flagellation* and *The Way to Calvary* diverge widely from the relevant depictions on the *Maestà*. In *The Deposition*, the disposition of Christ, the Virgin, Nicodemus, and Joseph of Arimathaea recalls that devised by Duccio. The seventh scene, *The Resurrection*, is not depicted on the *Maestà*. The most striking divergence occurs in the present panel: whereas in Duccio's *Last Supper* Christ is seated centrally, with Saint John and six other apostles beside him on the far side of the table and five apostles seated in front, in the present panel Christ is seated on the left facing down the table. This disposition of the figures is Giottesque,

and has a precedent in the Arena Chapel frescoes at Padua and a close parallel in a panel by Giotto or from his workshop in the Alte Pinakothek in Munich. It is widely assumed that the Munich *Last Supper* and five other surviving panels from the same predella formed part of one of Giotto's altarpieces in Santa Croce. A more highly developed version of the scheme occurs in *The Last Supper* by Taddeo Gaddi in the Accademia, Florence, from a cycle of scenes from the lives of Christ and of Saint Francis that decorated a cupboard in the sacristy of Santa Croce.

The father of Ugolino di Nerio was active as a painter, and two of his brothers were also painters. Allowance must therefore be made for the fact that the Santa Croce high altarpiece was the work not only of the painter who signed the central panel, but of a family workshop. This is reflected in inequalities of execution in the individual panels and notably in the predella. Thus, while the tomb and rocky setting are the same in the two concluding scenes, the Berlin *Entombment* and the London *Resurrection*, *The Resurrection* is much inferior in execution to *The Entombment*. The studio hand responsible for *The Resurrection* may also have intervened in the relatively weak *Flagellation* in Berlin. In *The Last Supper*, the faulty depiction of the cups and dishes on the table (which is notably less sophisticated than in Duccio's *Last Supper* on the *Maestà*) could be adduced as evidence that the panel, though designed by Ugolino, was executed by another member of his shop.

There is no agreement on the date of the Santa Croce altarpiece. The church was opened for services in 1321, and it is suggested by Coor (op. cit., p. 161) that the high altarpiece was commissioned at this time. A high altarpiece for Santa Maria Novella is thought to have been commissioned from Ugolino before 1324. The dominant artist in Santa Croce in the years before and after 1320 was Giotto, who was engaged successively on the frescoes in the Bardi and Peruzzi Chapels as well as on the four altarpieces recorded by Ghiberti in the church. The intervention of other artists in the decorative campaign opens at about the time of Giotto's departure for Naples (1328) with Bernardo Daddi's frescoes in the Pulci-Beraldi Chapel and with Taddeo Gaddi's frescoes in the Baroncelli Chapel (after 1328–ca. 1334). If, as is likely from its style, Ugolino's altarpiece dates from the half decade 1325–30 (C. Weigelt, *Sienese Painting of the Trecento*, 1930, p. 18; M. Boskovits, *Gemäldegalerie in Berlin: Katalog der Gemälde*, 1986; and others), it may well have been commissioned in 1327, when one of Ugolino's brothers, Guido di Nerio, was inscribed in the Arte dei Medici e Speziali in Florence (for this see P. Bacci, *Dipinti*

inediti e sconosciuti di Pietro Lorenzetti, Bernardo Daddi, etc. . . . , 1939, p. 137).

CONDITION: The panel is covered with an uneven layer of oxidized varnish, and is disfigured by crude, discolored repaints along minor scratches and flakes. The white tablecloth and the gray wall have been reinforced. There is some retouching in the faces and robes of the apostles in front of the table, and the face of Judas is heavily damaged and repainted. The central leg of the bench in the foreground has been scraped away and repainted with no indication of a receding side.

PROVENANCE: Cappella Maggiore, Santa Croce, Florence (till 1566); upper dormitory, friary of Santa Croce, Florence; William Young Ottley, London; Warner Ottley, London; Warner Ottley sale, Foster and Son, London, June 30, 1847 (bought in); Warner Ottley sale, Foster and Son, London, June 24, 1850, lot 55; Rev. John Fuller Russell, Eagle House, near Enfield (see G. F. Waagen, *Treasures of Art in Great Britain,* 1854, vol. 2, p. 462); Russell sale, Christie's, London, April 18, 1885, lot 116; Canon L. Myers, Swanmore Park; F. Sabin, London. Acquired by Robert Lehman in 1934 (see R. Tatlock, "Ugolino da Siena's Predella Completed," *Apollo,* 21, 1935, p. 66).

EXHIBITED: Manchester, *Art Treasures Exhibition,* 1857, no. 25; Royal Academy, London, *Exhibition of the Works of Old Masters,* 1878, no. 177; Colorado Springs Fine Arts Center, *Paintings and Bronzes from the Collection of Mr. Robert Lehman,* 1951–52; Metropolitan Museum of Art, New York, 1954–61; Musée de l'Orangerie, Paris, *La collection Lehman,* 1957, no. 56; Cincinnati Art Museum, *The Lehman Collection,* 1959, no. 8.

5. Saint Matthew

1975.1.6

Tempera on panel. 38.2 × 32.4 cm. (15 1/16 × 12 3/4 in.). The panel has been thinned and cradled and has been cut on all four sides.

The apostle is represented in bust-length, looking outward at the spectator, with his body turned three-quarters to the left. He wears a red cloak over a blue tunic with a gold collar. His brow is creased, and he is represented with white hair and eyebrows and a curling white beard.

The panel was first published by Perkins ("Alcuni appunti sulla Galleria delle Belle Arti di Siena," *Rassegna d'arte senese,* 4, 1908, p. 51, n. 1; "Appunti sulla Mostra Ducciana a Siena," *Rassegna d'arte,* 13, 1913, p. 8; "On Some Sienese Paintings in American Collections," *Art in America,* 8, 1920, p. 205, n.; "Ugolino da Siena," in Thieme-Becker, *Künstler-Lexikon,* vol. 33, 1939, p. 543)

as a work of Ugolino da Siena. Ugolino's authorship of the painting has since been accepted by Hutton (in his edition of Crowe and Cavalcaselle, vol. 2, 1909, p. 20, n. 3), Weigelt (*Duccio di Buoninsegna,* 1911, pp. 186, 262; *Sienese Painting of the Trecento,* 1930, p. 73, n. 33), De Nicola (*Mostra di opere di Duccio di Buoninsegna e della sua scuola: Catalogo,* 1912, p. 25, n. 45), Lusini ("Di Duccio di Buoninsegna," *Rassegna d'arte senese,* 8, 1912, pp. 60–98), Berenson ("Ugolino Lorenzetti," in *Essays in the Study of Sienese Painting,* 1918, p. 20; 1932, p. 583; 1936, p. 501; 1968, vol. 1, p. 438), Van Marle (*Development,* vol. 2, 1924, p. 104), R. Lehman (1928, pl. 17), Edgell (*A History of Sienese Painting,* 1932, p. 61), Coor ("Contributions to the Study of Ugolino di Nerio's Art," *Art Bulletin,* 37, 1955, p. 164, n. 57), Carli (*La pittura senese,* 1955, p. 52), Frinta ("Note on the Punched Decoration of Two Early Painted Panels at the Fogg Art Museum," *Art Bulletin,* 53, 1971, p. 306, n. 5), Stubblebine (*Duccio di Buoninsegna and His School,* 1979, p. 173), and Kanter ("Ugolino di Nerio: *Saint Anne and the Virgin,*" *National Gallery of Canada, Annual Bulletin,* 5, 1981–82, pp. 22–24).

Throughout almost the whole of this extensive literature the painting is regarded as a cut-down lateral panel from a polyptych of which no other part survives. In 1982, however, it was conclusively established (Kanter, loc. cit.) that it originates from the same polyptych as the *Saint Anne with the Infant Virgin* (Fig. 1) in the National Gallery of Canada, Ottawa. This case rests (i) on the fragment of original molding visible in the upper left corner of the present panel and faintly visible beneath regilding at the upper right, the low curvature of which implies the presence of a trilobe arch like that of the panel in Ottawa; (ii) on the punching within the molding at the upper left corner, which recurs along the edges of the Ottawa panel; and (iii) on the stamped halo, which is closely related in pattern to the haloes of the central panel though some different punches are employed. The original dimensions of the Ottawa panel, which has been cut down, would have been on the order of 88 cm. in height and 52–54 cm. in width, and those of the present panel can be estimated at about 66 cm. in height and 40–42 cm. in width. The proportions of the two panels would thus have corresponded with those found in other Ugolinesque altarpieces. Stylistically, moreover, the two panels are interrelated. Both represent a later phase in Ugolino's development than the Tadini-Buoninsegni *Madonna* in the Contini-Bonacossi Bequest in the Palazzo Pitti, Florence, or the heptaptych in the Clark Art Institute at Williamstown, and it is inferred by Kanter that they fall midway between the polyp-

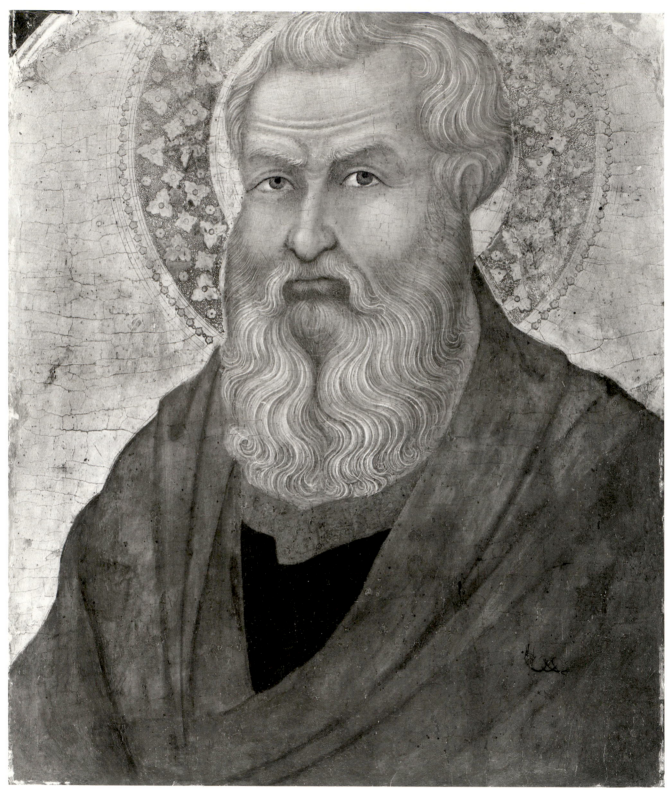

No. 5

tych by Ugolino and an assistant at Brolio and the *Saint Peter* in the Chiesa della Misericordia at San Casciano, and were thus probably painted between 1330 and 1335.

From the time of the first publication of the panel, the apostle depicted was identified as Saint John the Evangelist until, in 1955, Coor (op. cit., p. 162, n. 42) demonstrated its affinities with representations of Saint Matthew by Duccio and Pietro Lorenzetti. This identification appears to be correct. In paintings by or from the circle of Ugolino, Saint John is invariably represented bald with a long white beard, and in Ducciesque painting generally, though he is sometimes depicted with a tuft of hair above his forehead, he is also bald. Saint Matthew, surviving representations of whom are rare, has a full white beard and a full head of hair, with a fan-shaped lock falling over his forehead.

CONDITION: The face and hair of the apostle are well preserved, apart from small scratches and a small area of inpainting at the top of the panel. The red robe has suffered extensive losses and is heavily inpainted, especially along the bottom and sides of the panel. Losses in the gold ground at the top edge of the panel, in the halo to the right of the apostle's ear, and beside his left shoulder have been repaired.

PROVENANCE: F. Mason Perkins, Lastra a Signa (before 1908). Acquired by Philip Lehman in 1913.

EXHIBITED: Siena, *Mostra di opere di Duccio di Buoninsegna e della sua scuola*, 1912, no. 45; Cincinnati Art Museum, *The Lehman Collection*, 1959, no. 7.

6. Madonna and Child

1975.1.5
Tempera on panel. 89.8 × 58.4 cm. (35⅜ × 23 in.). The panel has been thinned and cradled.

The Virgin is shown in half-length, turned slightly to the right and holding the Child on her left arm, her right hand extended across his right thigh. Though she is depicted in three-quarter face, her eyes are turned to the spectator. The curly haired Child is wrapped in a transparent veil and a mauve cloth which he clutches to his chest with his right hand. Over her red dress the Virgin wears a white veil and a dark blue, gold-bordered cloak with gold stars over the forehead and on the right shoulder.

This majestic painting was initially attributed by Douglas, Borenius, and Sirén (verbally) to Duccio (R. Lehman, 1928, pl. 16). It was first discussed in detail by Perkins ("Some Sienese Paintings in American Collections, Part II," *Art in America*, 8, 1920, pp. 205–6), who ascribed it to a follower of Duccio. The relevant sentences of his analysis read:

> The painting comes . . . surprisingly close to certain of the master's works, both in its forms and in its general design. . . . Nevertheless, we cannot bring ourselves to agree with those who would see in this picture a genuine work of Duccio's hand. In our opinion, the resemblances which it reveals to the master's manner are more superficial than real. . . . To us, the picture lacks, in spite of all that may be urged in its favour, that peculiar and indescribable vitality of execution and expression which is never missing in Duccio's authentic work.

Wrongly ascribed by Van Marle (*Development*, vol. 2, 1924, pp. 147–53) and L. Venturi (*Italian Pictures in America*, 1933, pl. 18) to Segna di Bonaventura, it was attributed to Ugolino by R. Lehman (loc. cit.) and Berenson (1932, p. 295; 1936, p. 501; 1968, vol. 1, p. 438). Concurrently it was proposed by Weigelt ("Berichte über die Sitzung des Institutes: 23. Sitzung—15. Februar 1930: Kleine Beiträge zur frühsienesischen Malerei," *Mitteilungen des Kunsthistorischen Institutes in Florenz*, 3, 1919–32, p. 357; *Sienese Painting of the Trecento*, 1930, p. 74, n. 34) that the panel was the work of an anonymous painter influenced by Duccio, Ugolino, and the Master of Città di Castello, who would also have been responsible for a cut-down *Madonna* in the Chiesa dei Servi at Montepulciano, a *Madonna* (formerly in the Platt collection) in the Princeton University Art Museum, and a pentaptych in the Ricasoli collection at Brolio. Brandi (*Duccio*, 1951, p. 155, n. 34) also gave the picture to an anonymous painter between Duccio and Ugolino, to whom he attributed a *Madonna* from the Tadini-Buoninsegni collection and a *Crucifix* from San Paolo in Rosso. The panel was restored to Ugolino by Coor ("Contributions to the Study of Ugolino di Nerio's Art," *Art Bulletin*, 37, 1955, pp. 153–65) as an early work. For Stubblebine (*Duccio di Buoninsegna and His School*, 1979, p. 170) the "stylized statement of forms" in the present panel is "alien to Duccio and even to Ugolino's earliest work," and he regards it for that reason as a late work by Ugolino.

While the Tadini *Madonna*, the Princeton *Madonna*, and the Brolio polyptych (for which see L. Bellosi in *Mostra di opere d'arte restaurate nelle provincie di Siena e Grosseto*, III, exh. cat., Pinacoteca Nazionale, Siena, 1983, pp. 30–31, no. 6) are substantially autograph works by Ugolino, the present panel and the Monte-

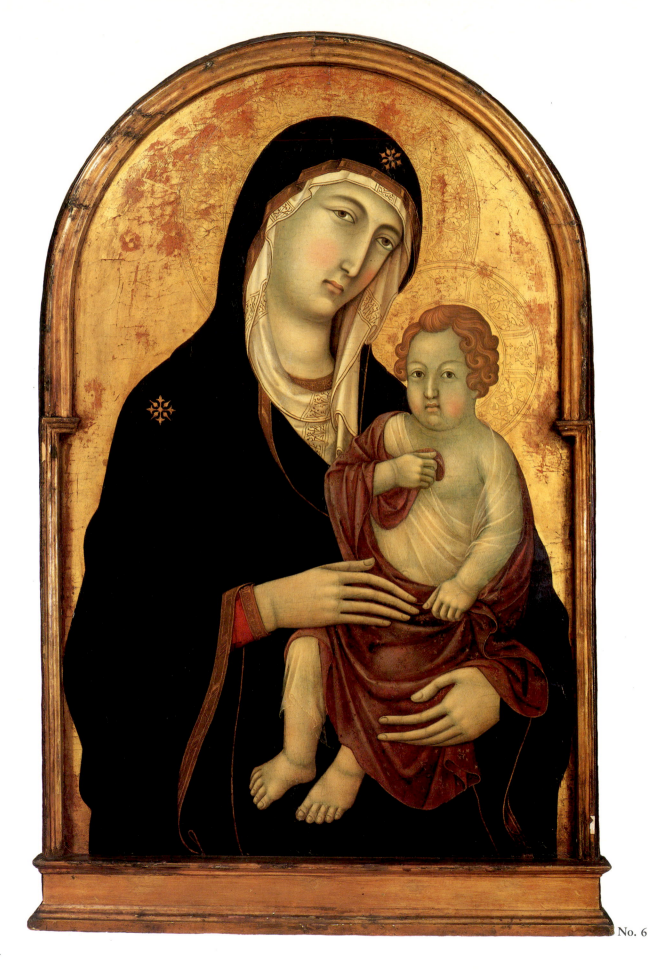

pulciano *Madonna* appear to be, as Weigelt claimed, works by a member of Ugolino's shop. The same hand may be traced in a panel showing Saint Catherine in the Krannert Art Museum, Champaign, Illinois (Stubblebine, op. cit., p. 171, fig. 421), a pentaptych in the Cleveland Museum of Art (H. S. Francis, "An Altarpiece by Ugolino da Siena," *The Connoisseur*, 151, 1962, pp. 128–34; Stubblebine, op. cit., pp. 160–61, figs. 385–88), two panels with Saints Mary Magdalene and Louis of Toulouse in the California Palace of the Legion of Honor, San Francisco (ibid., p. 161, figs. 388–89), a *Saint Thomas* from the Berenson collection in the Harvard Center for Renaissance Studies at Villa I Tatti, Florence (ibid., pp. 157–58, fig. 371), and a *Saint Michael* in the Czartoryski Collection of the Muzeum Narodowe, Cracow (ibid., pp. 157–58, fig. 372; M. Boskovits, "Una scheda e qualche suggerimento per un catalogo dei dipinti ai Tatti," *Antichità viva*, vol. 14, 1975, no. 2, pp. 13–14). That this painter worked primarily as an assistant to Ugolino rather than as an independent master is indicated (i) by the underdrawing in No. 6, visible under infrared reflectography, which is fully consonant with the quality of that of Ugolino's autograph works, and (ii) by the presence of this artist's hand in a minor capacity among the lateral panels of the Ugolino polyptych in the Clark Art Institute, Williamstown, and Polyptych 39 in the Pinacoteca Nazionale, Siena.

It was suggested by Stubblebine that the Champaign *Saint Catherine* and the present panel originally formed parts of a single altarpiece. The disparity in scale between the two makes such a grouping unlikely. The height of No. 6 to the spring of the arch is between 46.5 and 50 cm., whereas the corresponding height of the Champaign panel is only 40 cm. The Champaign panel is exactly the same size as the Cracow *Saint Michael* and is inscribed in the same way. There can be little doubt that these two panels originated from a single complex. The only panels attributed to Ugolino that might have been joined to the Lehman *Madonna* are the San Francisco *Saint Mary Magdalene* and *Saint Louis of Toulouse*, where the height to the spring of the arches is about 47 cm., but there is no more positive evidence than this for a reconstruction. The Lehman *Madonna* and the San Francisco *Saints* appear to date from ca. 1325 and to be approximately contemporary with Ugolino's Polyptych 39 in Siena (see L. Kanter, "Ugolino di Nerio: *Saint Anne and the Virgin*," *National Gallery of Canada, Annual Bulletin*, 5, 1981–82, pp. 13–14, 25, 26, n. 15, for the dating of this altarpiece).

The type and pose of the Child in the present panel (for which see D. Shorr, *The Christ Child in Devotional Im-*

ages in Italy during the XIV Century, 1954, p. 153) closely correspond with those in the Montepulciano *Madonna* and in the Princeton *Madonna* (where the head is turned further to the right and the legs are differently disposed). As Coor notes (op. cit., p. 164), the source of the motif is the *Madonna* on the front of Duccio's *Maestà*, from which the cartoon of the left hand of the Virgin and of the Child clutching his own rather than his mother's draperies also derives.

CONDITION: The gold ground is well preserved except for rubbing along the edges and across the upper left part of the panel. The paint surface is intact save for small crackle repairs on the Virgin's throat, her right eye, and her veil, but is covered with thick, discolored varnish.

PROVENANCE: Earl of Haddington, East Linton, Scotland (said to have been purchased in Siena about 1860); R. Langton Douglas, London; Philip Lehman, New York, 1920; Pauline Ickelheimer, New York. Acquired by Robert Lehman in 1946.

EXHIBITED: Colorado Springs Fine Arts Center, *Paintings and Bronzes from the Collection of Mr. Robert Lehman*, 1951–52; Metropolitan Museum of Art, New York, 1954–61; Musée de l'Orangerie, Paris, *La collection Lehman*, 1957, no. 55; Cincinnati Art Museum, *The Lehman Collection*, 1959, no. 6.

Bartolomeo Bulgarini
(Ugolino Lorenzetti)

Bartolomeo Bulgarini is mentioned by Vasari as a follower of Pietro Lorenzetti and is recorded in numerous documents from 1337 to 1378. From these he appears to have been one of the most important artists active in Siena in the middle and in the third quarter of the fourteenth century. He was first identified by Meiss as the previously anonymous painter who had been christened Ugolino Lorenzetti by Berenson on the basis of the evident dependence of his early works on Ugolino di Nerio (q.v.) and of his mature works on Pietro Lorenzetti. Ugolino Lorenzetti was subsequently renamed the Ovile Master by scholars who rejected Berenson's list of early works, but this distinction of two separate hands appears to be factitious. The identification of Ugolino Lorenzetti with Bartolomeo Bulgarini rests on the supposition that a *biccherna* cover of 1353 certainly by Ugolino Lorenzetti is the same as one for which payment was made to Bartolomeo di M. Bolgarino.

7. Saints Matthias and Thomas

1975.1.8

Tempera on panel. Overall: 53 × 46 cm. (20⅞ × 18⅛ in.); picture surface: 44.2 × 42.7 cm. (17½ × 16¾ in.). The original panel has been truncated at the top and built into a modern frame. The beginnings of the gable at either side, up to the line of truncation, show traces of original gilding and crockets sawn off horizontally. The spandrels and arches have been regessoed and regilt to appear integral with the frame, but patches of original bole and of gold and blue paint are visible through holes in the gesso.

Saint Matthias (*left*) has white hair and a white beard and is shown turned three-quarters to the right. He wears a light blue cloak over a pale red tunic of which the right cuff is visible, and holds a red book. Saint Thomas, depicted almost in full face, is clean shaven and wears a violet-red cloak over an orange-yellow tunic. The edge of his cloak is caught up over a book held in his left hand. Each saint is set inside a quinquefoil ogival arch, the points of whose lobes cut both haloes on the left. Beneath is a blue titulus band with the names of the two saints in the form S. MAT TIAS and S. TOMMAS.

The panel was unknown to Berenson when he reconstructed the oeuvre of the so-called Ugolino Lorenzetti ("Ugolino Lorenzetti," in *Essays in the Study of Sienese Painting*, 1918, pp. 1–36) and it was first published under the master's name by R. Lehman (1928, pl. 31, where the left-hand saint is incorrectly identified as Matthew). The attribution is accepted by Hendy ("'Ugolino Lorenzetti': Some Further Attributions," *Burlington Magazine*, 55,

1929, pp. 232–38), who regarded the painting as an early work, Berenson (1932, p. 295; 1936, p. 253; 1968, vol. 1, p. 436), and Van Marle (*Le scuole della pittura italiana*, vol. 2, 1934, p. 164).

The panel comes from the upper register of a polyptych, where it would—on the analogy of Ugolino da Siena's high altarpiece from Santa Croce, Florence, and Simone Martini's Pisa polyptych—have been set over a single panel with a saint in three-quarter length and surmounted by a gable with a bust-length prophet. Only two other apostles are known which can be associated with No. 7 as parts of the same altarpiece. Now in the Wallraf-Richartz-Museum in Cologne (nos. 610, 611; Fig. 8), they have been cut out of their frame and regilt. They correspond, however, to the Saints Matthias and Thomas in size, in style, and in what can be discerned of their original punched decoration beneath modern gilding. The Cologne panels lack their tituli and have been provided with false inscriptions over the modern ground, but they appear to represent Saints Peter and Matthew (see G. Coor, "Trecento-Gemälde aus der Sammlung Ramboux," *Wallraf-Richartz Jahrbuch*, 18, 1956, p. 116). If, as is likely, all twelve apostles were represented on six panels, the altarpiece would have been a heptaptych. Its central panel has been identified by Steinweg and Coor (in Coor, loc. cit., n. 17) with a fragmentary *Madonna* in the Wallraf-Richartz-Museum (no. 494), also from the Ramboux collection, which was associated by Meiss ("Ugolino Lorenzetti," *Art Bulletin*, 13, 1931, pp. 376–97) with two full-length panels of Saints Peter and Paul in San Pellegrino, Siena. The identification is stylistically plausible, but cannot be supported by any physical evidence from the panels themselves. Two further panels from the Ramboux collection, however, with the prophets Moses and Daniel (Keresztény Múzeum, Esztergom; see M. Boskovits, M. Mojzer, and A. Mucsi, *Das Christliche Museum von Esztergom*, 1965, pp. 32–35), may have been among the pinnacles that stood above the panels with paired apostles. All these panels are generally dated around 1350.

CONDITION: The ground is much abraded and has been partially regilt. The figures have suffered extensive abrasion and have been liberally retouched, especially the Saint Thomas. All four hands and the folds in both cloaks have been reinforced. The best-preserved section is the head of Saint Matthias. The tituli are much restored but have not been altered.

PROVENANCE: Kleinberger, Paris. Acquired by Philip Lehman before 1928.

No. 7

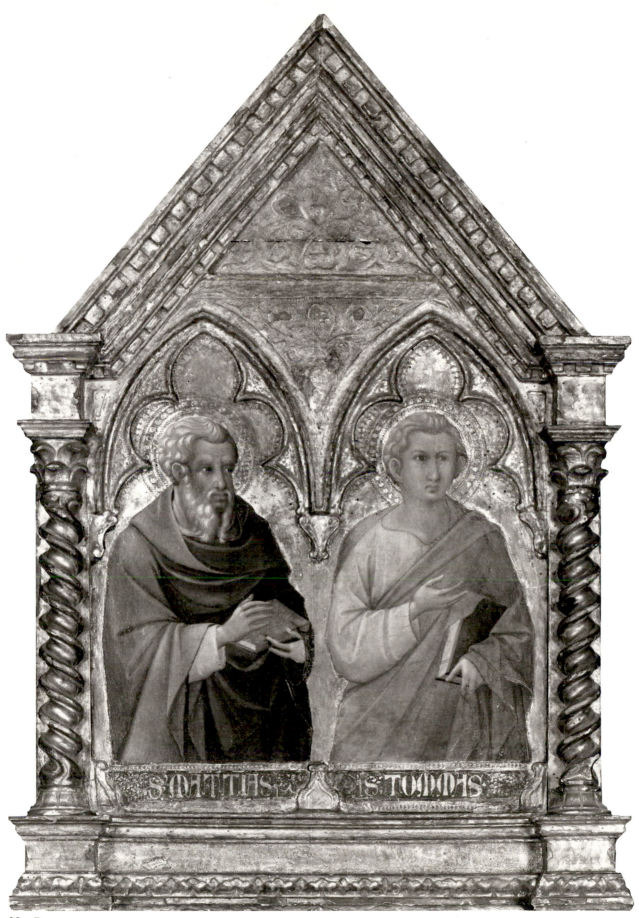

Born about 1284, Simone Martini seems to have been trained in the shop of Duccio, on whose *Maestà* (completed in 1311) he may have worked. In 1315 he executed the fresco of the Maestà in the Sala del Mappamondo in the Palazzo Pubblico in Siena, and in 1317 was active in Naples where he completed for Robert of Anjou a painting of the king crowned by Saint Louis of Toulouse (Pinacoteca Nazionale di Capodimonte, Naples). The fresco of the Maestà was restored or reworked by the artist in 1321. In 1319 he executed a polyptych for Santa Caterina at Pisa (Museo Nazionale di San Matteo, Pisa) and following this, in or about 1321, three polyptychs for Orvieto. He was married in 1324 to the daughter of the painter Memmo di Filipuccio, and an altarpiece of the Annunciation (Uffizi, Florence), painted jointly with his brother-in-law Lippo Memmi for the chapel of Sant'Ansano in the Duomo in Siena, is dated 1333. At the end of his life, probably after 1340 when he is last documented in Siena, Simone Martini worked at Avignon, where he died in 1344. Earlier chronologies of the artist's work include a fresco of Guidoriccio da Fogliano in the Sala del Mappamondo of the Palazzo Pubblico, Siena, the date (1328) and attribution of which have since been questioned. Simone Martini's most important works, the frescoes in the chapel of Saint Martin in the lower church at Assisi, are undated. They have been assigned (F. Bologna, *I pittori alla corte angioina di Napoli, 1266–1414*, 1969, p. 154; G. Previtali in *Simone Martini e "chompagni,"* exh. cat., Pinacoteca Nazionale, Siena, 1985, p. 18) to the years 1316–18, but their style and space construction are incompatible with those of the predella of the altarpiece of 1317, and they are likely to have been painted in the middle of the 1320s. Also undated is an important votive painting, *The Beato Agostino Novello and Four of His Miracles*, which seems to have been painted for the tomb of the *beato* in Sant'Agostino in Siena. The lack of securely datable works from the mid-1320s and from the years between 1333 and 1340 is reflected in the literature of two undated polyptychs, one of which is discussed below.

8. Madonna and Child

1975.1.12

Tempera on panel. Overall: 58.8 × 39.6 cm. (23⅛ × 15½ in.); picture surface: 57.2 × 38.4 cm. (22½ × 15⅛ in.). The panel has been thinned and cradled, and strips approximately 1.6 cm. wide have been added on all four sides between it and its frame. The lip of the original paint surface is apparent at the bottom, but has been lost at the top and sides.

The Virgin is shown in half-length holding the Child in her left arm. She wears a dark blue cloak, with an imitation Cufic border in gold and a star on the shoulder and cowl, over a red dress with gold-embroidered cuffs. Her white veil has a light brown edge and strips of patterning in the same color over the forehead and at the throat. The Child has curly orange-yellow hair and is dressed in a red surcoat with a triple gold edge over a pink robe. He pulls at the Virgin's cloak with his left hand, and his right hand rests on its upper edge.

The present panel and No. 9 (*Saint Ansanus*) formed part of a five-panel polyptych that also included *Saint Peter* (Fig. 9), formerly in the Lehman Collection and now in a private collection, *Saint Andrew* (Fig. 10), formerly in the Blumenthal collection, New York, and now in the Metropolitan Museum of Art, and *Saint Luke* (Fig. 11), formerly in the Lederer collection, Geneva, and now in the J. Paul Getty Museum, Malibu. The coherence of this group of panels, which was first established by Perkins ("Some Sienese Paintings in American Collections, Part II," *Art in America*, 8, 1920, pp. 281–83), is attested by size, shape, and the uniform punching of the gold grounds along the tops and sides. The panel in the Getty Museum is inscribed with the name of Saint Luke (s̄: LUC[A]S EVLˢTA) on the gold ground beside the halo, and traces of a similar inscription appear on the *Saint Andrew* in the Metropolitan Museum. The gold grounds of the two panels from the left side of the pentaptych, the *Saint Ansanus* and the *Saint Peter*, are seriously abraded and bear no trace of an inscription.

It is wrongly stated by Zeri (*Italian Paintings: A Catalogue of the Collection of the Metropolitan Museum of Art: Sienese and Central Italian Schools*, 1980, p. 94) that the frames on the *Saint Andrew* in the Metropolitan Museum and the others in the series "are modern reproductions, not, as has usually been assumed, the original ones." The Getty *Saint Luke* retains its original frame, still engaged along the right-hand side, with the punching of the saint's halo continuing on the innermost molding at the top. Early photographs of the *Madonna and Child*, the *Saint Peter*, and the *Saint Andrew* show their frames still engaged. At some undetermined time after their arrival in New York, these panels were excised from their frames, thinned, and cradled. The frames were then reduced slightly in size by shaving and rejoining at the corners, and replaced on the panels from which they had been removed but inverted in each case. The inner molding of the frame on No. 8 was repaired and regilt, while

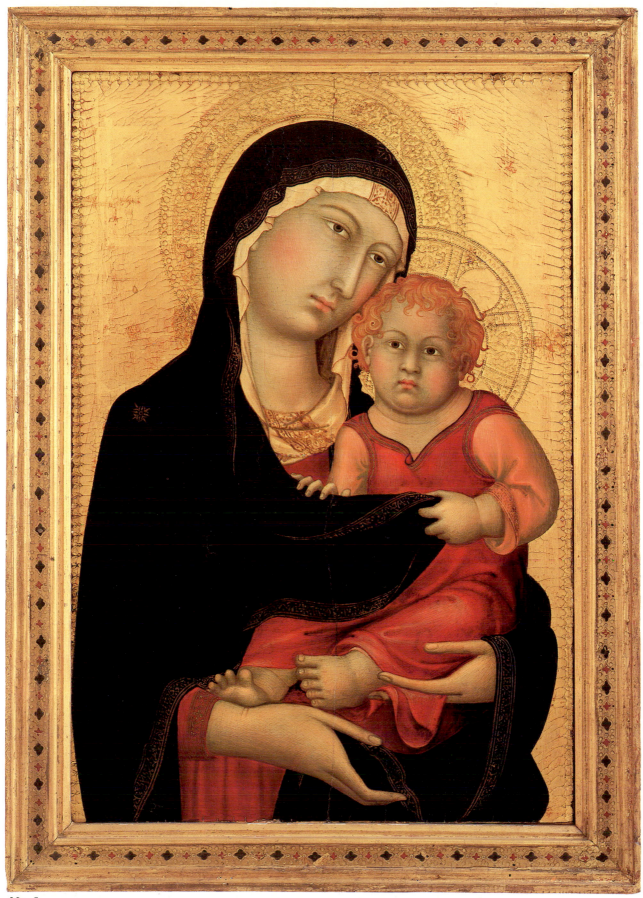

No. 8

the frame on the *Saint Andrew* is entirely original save for a modern backing (the arc of the saint's halo, trimmed at the top of the panel, can still be seen continued on the innermost molding of the frame, though in the present reconstruction at the bottom rather than at the top). The frame on No. 9 is likewise original, though its inner moldings have been heavily regessoed and regilt; the drastic restorations undergone by this panel before its arrival in New York (see the following entry) included cutting away and repairing the frame, which, though it has not been reduced in size, has, like the others, been inverted.

The form of the altarpiece is unorthodox. Perkins (loc. cit.) observes that the "unusual rectangular shape and peculiar framing [of the panels] render it questionable if they were ever incorporated in an altarpiece of the elaborate model generally in vogue at the period of their execution," and suggests that they were probably "united in such a way as to form a simple dossale, without pinnacles or predella." Boskovits ("A Dismembered Polyptych, Lippo Vanni and Simone Martini," *Burlington Magazine*, 116, 1974, pp. 367–76), though postulating the presence of triangular gables above the present panels, likewise notes that "the rectangular shape of the single panels is also quite unusual among fourteenth-century Italian altarpieces and resembles rather that of little portable tabernacles." The fact that the central panel is exactly the same size as the four lateral panels (*pace* Zeri, loc. cit.), and that the edges of the frame of the *Saint Luke* show traces of hole plugs, possibly from hinges (also visible beneath the regilding on the right edge of the frame on No. 9), tends to support the conclusion that the complex of which the five panels once formed a part was a portable altarpiece. The back, sides, and bottom of the Getty *Saint Luke*, the only panel that has not been thinned or cradled, show traces of porphyry paint and no sign of fixed wooden or metal braces. The absence of such painting at the top of the Getty panel, and the presence there of two holes for dowel battens, provide indirect evidence that the panels were once surmounted by further wooden structures, possibly pinnacles. Horizontal worm channels at the tops (bottoms in the present reconstruction) of the frames of the other panels also imply the presence of pinnacles, though no panels are known today that might have served this function.

The five panels have been variously ascribed to Simone Martini, to the workshop of Simone Martini, and to Lippo Vanni in a hypothetical Simonesque phase. The attribution to Lippo Vanni was proposed by Perkins ("Alcuni dipinti di Lippo Vanni," *Rassegna d'arte senese*, 6, 1910, pp. 39–41) at a time when the *Madonna* alone was

known, on the strength of resemblances to a signed triptych of 1358 by Lippo Vanni in Santi Domenico e Sisto, Rome, and to the central section of a frescoed polyptych in San Francesco in Siena. In a later article by Perkins ("Some Sienese Paintings," loc. cit.), this attribution was extended to the lateral panels. Espoused by Berenson ("Un antiphonaire avec miniatures par Lippo Vanni," *Gazette des Beaux-Arts*, 66, 1924, pp. 257–85; *Studies in Medieval Painting*, 1930, p. 53; 1932, p. 588, and subsequent editions of his lists) and De Nicola ("Studi sull'arte senese, III: I saggi senesi del Berenson," *Rassegna d'arte*, 1919, pp. 98–99), it gained widespread currency. It is accepted by Rubinstein-Block (*Catalogue of the Collection of George and Florence Blumenthal*, vol. 1, 1926, pl. 19), R. Lehman (1928, pls. 33, 34), L. Venturi (*Italian Paintings in America*, 1933, vol. 1, pl. 96), Bologna (*I pittori alla corte angioina di Napoli*, 1969, p. 288), and Vertova ("Lippo Vanni versus Lippo Memmi," *Burlington Magazine*, 112, 1970, p. 441). The first documentary reference to the activity of Lippo Vanni occurs in 1344, and his earliest dated work is an illuminated Gradual of 1345 in the Museo dell'Opera del Duomo in Siena. The present panels were regarded by Perkins as dating from before this time, and were believed by Berenson to have been executed under the influence of Simone Martini about 1335. Bologna dates them before 1343, the presumed date of a triptych at Coral Gables supposedly painted by Lippo Vanni for the Angevin court at Naples, and Vertova unpersuasively assigns them to a moment in the 1350s when Lippo "sought to refine his manner on the models of Simone Martini." As Weigelt recognized (in Thieme-Becker, *Künstler-Lexikon*, vol. 23, 1929, pp. 277–78), the analogies between the five panels and authenticated works by Lippo Vanni are too slight to sustain this attribution.

A valid context for the panels is supplied only by the work of Simone Martini. The *Saint Ansanus* was exhibited in 1915 as the work of Simone Martini (*Arundel Club Portfolio*, 12, 1915, no. 1), and in 1916 the *Saint Andrew* was ascribed to Simone Martini by Sirén (in a manuscript letter). This panel, the *Saint Peter*, and the *Saint Ansanus* were later ascribed to Simone Martini by Van Marle (*Simone Martini et les peintres de son école*, 1920, pp. 30, 199), who subsequently (*Development*, vol. 2, 1924, pp. 275–77, 465, n. 1) gave them to Simone's workshop. A direct ascription to Simone Martini for the entire complex has since been advanced by Boskovits (op. cit.) and Zeri (loc. cit.), and an ascription to a member of Simone's workshop is supported by Bellosi ("Jacopo di Mino del Pellicciaio," *Bollettino d'arte*, 57, 1972, p. 75) and Volpe ("Su Lippo Vanni da miniatore a pittore," *Paragone*, vol.

27, no. 321, 1976, p. 56). The polyptych is tentatively identified by Boskovits with a lost altarpiece of 1326 executed by Simone Martini for the Cappella de' Signori in the Palazzo Pubblico, Siena. This case is accepted by Caleca ("Tre polittici di Lippo Memmi," *Critica d'arte*, 42, 1977, pp. 70–71) and De Benedictis (*La pittura senese 1330–1370*, 1979, pp. 17, 60), but is disproved by Eisenberg ("The First Altarpiece of the Cappella de' Signori of the Palazzo Pubblico in Siena," *Burlington Magazine*, 123, 1981, pp. 134–48), who rejects the attribution of the present panels to Simone Martini.

The Lehman *Saint Ansanus*, as Perkins observed, depends from the full-length figure of this saint in Simone Martini's *Annunciation* altarpiece of 1333 in the Uffizi (though it is not "a straightforward copy" as claimed by Vertova). On this ground alone it might be argued that the present panels were painted after 1333. The view that the altarpiece was executed between this date and Simone Martini's departure for Avignon is supported by analogies with a polyptych from Sant'Agostino at San Gimignano (rightly dated in the 1330s by Boskovits [op. cit., p. 376], but assigned by De Benedictis, [in *Simone Martini e "chompagni,"* exh. cat., Pinacoteca Nazionale, Siena, 1985, p. 50] to ca. 1317), of which the central panel is in the Wallraf-Richartz-Museum, Cologne, three of the lateral panels are in the Fitzwilliam Museum, Cambridge, and a fourth lateral panel is in an Italian private collection. Two of the lateral panels of this polyptych are autograph works by Simone Martini, and two, the Cambridge *Saint Michael* and the *Saint Catherine of Alexandria*, are by a member of the artist's shop who was also responsible for the pinnacles. The finials of a painted cross in the Chiesa della Misericordia at San Casciano, also datable to the mid-1330s, are perhaps by the same hand. The *Madonna and Child* in the present polyptych is closely comparable to the *Madonna* in Cologne and was certainly designed by Simone Martini, though the rather awkward rendering of the Child's feet may testify to some measure of studio intervention in its execution. The *Saint Ansanus*, on the other hand, while less well preserved, is related to the autograph panel of *Saint Geminianus* in the Cambridge polyptych. The *Saint Peter* appears to have been executed from Simone's cartoon by the same hand as the Cambridge *Saint Michael*. The *Saint Luke* and the *Saint Andrew* are fully autograph.

The panel is first recorded in the collection of Alessandro Toti, bishop of Colle Val d'Elsa till 1903, who owned a number of paintings now in the Pinacoteca Nazionale at Siena, seemingly acquired in and around Colle. There is thus a presumption that the present panels came from Colle or its vicinity. Boskovits (op. cit., p. 368) contests the possibility of an origin from Colle Val d'Elsa on the ground that the town was under Florentine control from an early date. Two Simonesque panels with Saints Louis of Toulouse and Francis in the Pinacoteca Nazionale, Siena, were, however, painted for San Francesco at Colle Val d'Elsa.

CONDITION: The paint surface, which is in a nearly perfect state of preservation, has suffered only minimal loss along a vertical crack running slightly to the right of the center of the panel. A small hole in the Madonna's right hand and two smaller holes beneath her right eye have been inpainted. The gold decoration on the border of the cloak and dress are worn down to the mordant. It has been suggested (Szabo, 1975, p. 12) that the gold ground is modern. The gold is in fact original and well preserved.

PROVENANCE: Bishop Alessandro Toti, Colle Val d'Elsa (according to F. M. Perkins, "Il cosidetto originale della 'Madonna del Popolo,'" *Rassegna d'arte senese*, 1, 1905, p. 129); Achille Cavagnini, Siena; C. Fairfax Murray, 1904; A. Imbert, Rome, 1906; Richard Norton, Boston; Norton sale, Christie's, London, May 26, 1919, lot 150 (as Memmi; bought Stover); R. Langton Douglas, London. Acquired by Philip Lehman in or shortly before 1920.

EXHIBITED: William Rockhill Nelson Gallery of Art, Kansas City (Mo.), 1942–44 (as Lippo Vanni); Colorado Springs Fine Arts Center, *Paintings and Bronzes from the Collection of Mr. Robert Lehman*, 1951–52 (as Lippo Vanni); Metropolitan Museum of Art, New York, 1956–61 (as Lippo Vanni); Musée de l'Orangerie, Paris, *La collection Lehman*, 1957, no. 57 (as Lippo Vanni); Cincinnati Art Museum, *The Lehman Collection*, 1959, no. 15 (as Lippo Vanni).

9. Saint Ansanus

1975.1.13

Tempera on panel. Overall: 57.5×38.1 cm. ($22\frac{5}{8} \times 15$ in.); picture surface: 57.2×37 cm. ($22\frac{1}{2} \times 14\frac{1}{2}$ in.). The panel has been thinned and cradled.

The saint is represented in full face, with reddish blond hair. He wears a blue-green tunic with gold-embroidered collar and cuffs, and a purple cloak also edged with gold embroidery, tied on the shoulder and folded back on the right to reveal a lining of the same color. In his left hand he holds a black-and-white banner affixed to a light wooden staff, and in his right hand a palm branch. The pink cuff of his underdress is visible.

The panel originates from the same complex as No. 8 (q.v.).

A photograph of this picture in the archives of the Harvard Center for Renaissance Studies at Villa I Tatti, Florence, sent to Berenson by A. S. F. Gow (see provenance, below), shows Saint Ansanus holding a sword instead of his martyr's palm. The wavy profile of his hair was at that time painted out to a circular outline, and the shaft and banner in his left hand were continued to the top of the panel. A second photograph at I Tatti, annotated on the reverse as having been sent by J. D. Beazley, shows the picture in the state in which it was exhibited in 1915 (*Arundel Club Portfolio*, 12, 1915, no. 1). At this time the false sword was removed, exposing the palm branch in Ansanus's right hand and the knot of his cloak on his right shoulder. His hair was returned to its original profile, and the gold ground of the panel was heavily overpainted. A subsequent cleaning removed this overpaint, revealing the present much-damaged state of the gold ground (see below), but also exposing the punched gold cross at the top of the saint's staff.

CONDITION: The gold ground has been scraped away save for an area round the banner, where the gold is original. The halo has been rubbed down and regilt, obscuring the original profile, but a thin ring of original gold survives along the silhouette of the saint's hair, and some of the original punchwork is faintly visible in the bole beneath. The faint outlines of a cross originally punched into the gold at the top of the banner are visible in the upper right corner. The borders of the panel have been regilt, but fragments of the original punching survive at the upper left and along the right margin. The paint surface, save for small local losses, is extremely well preserved though obscured by a dark varnish, and the gold on the cuffs survives intact.

PROVENANCE: The panel was bought in Paris prior to 1915 by J. D. Beazley of Oxford University and A. S. F. Gow of Eton College (the purchase is said to have been made at a bookstore [R. Lehman, 1928, pl. 34]; the companion panels [see No. 8] of *Saint Peter* [private collection; Fig. 9] and *Saint Luke* [Getty Museum; Fig. 11] likewise had a Parisian provenance, the dealer E. Bonesi); R. Langton Douglas, London. Acquired by Philip Lehman in 1916.

EXHIBITED: Arundel Club, London, 1915, no. 1; F. Kleinberger Galleries, New York, 1917, no. 46; Metropolitan Museum of Art, New York, 1954–61; Musée de l'Orangerie, Paris, *La collection Lehman*, 1957, no. 58 (as Lippo Vanni); Cincinnati Art Museum, *The Lehman Collection*, 1959, no. 16 (as Lippo Vanni).

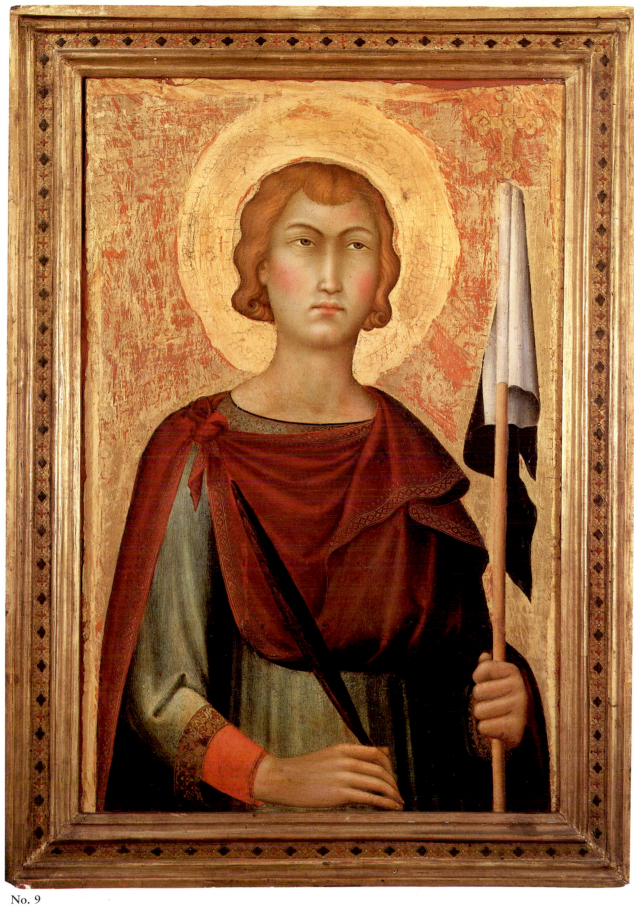

No. 9

Virtually nothing is known of this painter outside of the existence of two signed works: a *Madonna and Child* in the Cook collection, Richmond, dated 1347, and a *Man of Sorrows* in the Liechtenstein collection, Vaduz. A small number of panels may be attributed to the same hand: all of exquisite and painstaking craftsmanship, they reveal an artist trained in the orbit of Simone Martini and Lippo Memmi but strongly influenced by Ambrogio Lorenzetti. Naddo's pictures have sometimes been confused with those of his contemporaries Andrea Vanni and Jacopo di Mino Pelliciaio.

10. Madonna and Child

1975.1.10

Tempera on panel. With frame: 62.7 × 27.3 cm. (24¹¹⁄₁₆ × 10¾ in.); picture surface: 50.5 × 21.9 cm. (19⅞ × 8⅝ in.). The engaged frame is original, but has been entirely regilt.

The Virgin, shown in half-length with her head turned slightly to the right, wears a dark blue cloak over a gold-brocaded dress. The Child, whom she holds against her left shoulder, is draped in a cloth of gold brocade, which leaves his chest and shoulders exposed. His right hand is raised in a gesture of benediction.

Early attempts to establish the authorship of this panel were confused by misunderstanding of its condition. While the face and hands of the Child and the hands of the Virgin are built up with a fine layer of pigment with white crosshatched highlights over a thin verdaccio ground, the face of the Virgin is a later addition painted thickly in a relatively coarse technique over a heavy ground of green mixed with white. Beneath this ground are traces of thinner verdaccio underpainting like that beneath the figure of the Child. At the time that the Virgin's head was repainted, her cloak seems also to have been scraped down and made good. Traces of the original green lining are visible in the area of the sleeve below the Virgin's right wrist, which was then covered with a denser green (now discolored to brown). There is no means of determining whether the repainted surfaces date from the late fourteenth or the first half of the fifteenth century. It is suggested by Berenson (1932, p. 360; 1968, vol. 1, p. 269) that the Virgin's head was possibly repainted by Spinello Aretino.

Given by Langton Douglas (in Crowe and Cavalcaselle, vol. 3, 1908, p. 70) to "some good follower of Simone Martini," by Perkins (verbally) to an anonymous contem-

porary of Naddo Ceccarelli, by De Nicola (verbally) to an eclectic artist close to Andrea Vanni, by Berenson (see above) to Lippo Memmi, by Offner (verbally) to a follower of Lippo Memmi, and by R. Lehman (1928, pl. 26) to the circle of Lippo Memmi, the painting is rightly attributed by De Benedictis ("Naddo Ceccarelli," *Commentari*, 25, 1974, pp. 146, 150, 153, n. 24; *La pittura senese, 1330–1370*, 1979, p. 82) to Naddo Ceccarelli. Those parts of the painting that are not overpainted (the face, hands, and feet of the Child, the Virgin's hands, the gold brocade of her tunic and of the Child's swaddling cloth, and the elaborately tooled haloes and gold ground) unmistakably reveal the hand of Ceccarelli. Characteristic of Ceccarelli are the type of the Child—which is comparable to that in the signed *Madonna* in the Cook collection, Richmond, in the *Madonna* in the Fondazione Horne, Florence, and in the central panel of a polyptych in the Pinacoteca Nazionale in Siena (no. 115)—and the rendering of the thin, elegant hands, which have a clearly defined bone structure and are positioned at an angle to the picture plane.

There are no known panels that might originally have been joined with No. 10 to form a diptych or small tabernacle. Throughout its recorded history the panel was framed as a triptych with two fifteenth-century panels of Saints Michael and Nicholas of Bari (Nos. 46, 47).

CONDITION: The Virgin's robe survives only in small islands of darkened blue paint, while the rest of the panel, save for some rubbing round the Child's right hand and foot, is very well preserved. The back of the panel has been overpainted in yellow, beneath which appear red bole and oxidized silver leaf. A vertical crack, reaching slightly more than halfway up the panel, has not resulted in any visible paint loss.

PROVENANCE: C. Fairfax Murray, Florence, till 1885; Charles Butler, Warren Wood, Hatfield, Herts. (a label on the back reads: "By Agnolo Gaddi. Florentine School. Bt. at Florence from Mr. Fairfax Murray"); Captain H. L. Butler, Warren Wood, Hatfield, Herts.; R. Langton Douglas, London. Acquired by Philip Lehman in 1918.

EXHIBITED: New Gallery, London, *Exhibition of Early Italian Art*, 1893–94, no. 62 (as Florentine School, fourteenth century); Smith College Museum of Art, Northampton (Mass.), 1942; Cincinnati Art Museum, *The Lehman Collection*, 1959, no. 11 (as Follower of Lippo Memmi).

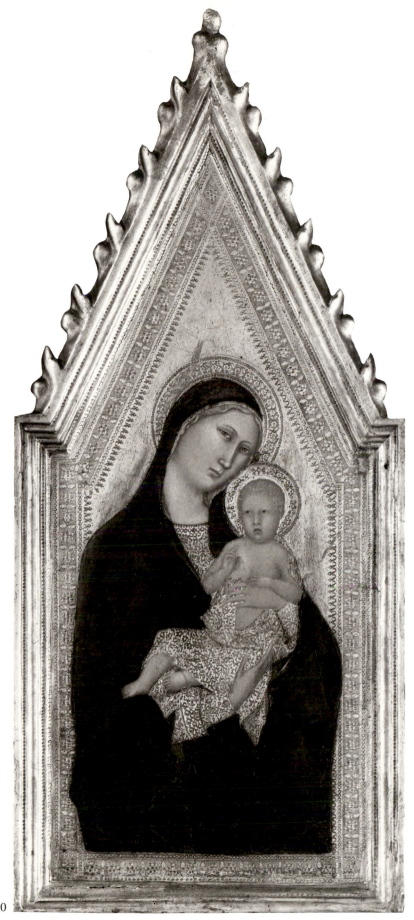

No. 10

Barna da Siena is the name conventionally assigned to the author of a cycle of frescoes of scenes from the New Testament on the right wall of the Collegiata at San Gimignano. It has been shown that the name originates in a misreading by Vasari of a reference to the frescoes in Ghiberti's *Commentari* (see G. Moran, "Is the Name Barna an Incorrect Transcription of the Name Bartolo?" *Paragone*, vol. 27, no. 311, 1976, pp. 76–80), and the frescoes have since been ascribed to Lippo Memmi and assigned to a period following Simone Martini's departure for Avignon (A. Caleca, "Tre polittici di Lippo Memmi, un ipotesi sul Barna e la bottega di Simone e Lippo," *Critica d'arte*, 41, 1976, pp. 49–59, and 42, 1977, pp. 55–80) or to an independent member of his workshop (L. Bellosi, "Moda e cronologia. B) Per la pittura del primo Trecento," *Prospettiva*, 11, 1977, pp. 12–27; Bellosi, *Simone Martini e "chompagni,"* exh. cat., Pinacoteca Nazionale, Siena, 1985, p. 100). The dramatic character of the San Gimignano frescoes is incompatible with that of any paintings directly associable with Lippo Memmi. If, as is likely, the frescoes were painted in the fifth decade of the fourteenth century, their author may well have been trained in Memmi's studio.

Follower of Barna da Siena

11. Saint Mary Magdalene

1975.1.14

Tempera on panel. With original bottom and side moldings: 43.3 × 27.4 cm. (17¹/₁₆ × 10¾ in.); picture surface: 39.7 × 21.1 cm. (15⅝ × 8⅜ in.). The molded frame from the spring of the arch upward is modern. The sides and bottom are original, but have been regessoed and regilt, obscuring the original profiles of the moldings.

The saint is represented in half-length on a panel terminating at the top in a pointed arch divided into seven lobes by punched gesso moldings. Her body is turned slightly to the left; she wears a gold-embroidered blue dress and a red cloak and holds an ointment jar seen slightly from below. In the spandrels are two tondi, each with a half-length angel. The back of the panel is painted to represent porphyry and shows in the center a trilobe medallion of fictive marble. Along the outer edge at the back is a fictive wood or marble frame which has been overpainted black.

The panel comes from the same complex and is by the same hand as No. 12. Both panels were published by Perkins ("Nuovi appunti sulla Galleria delle Belle Arti di

Siena," *La balzana*, 2, 1928, p. 148) as parts of a polyptych of which four panels (Figs. 12 and 13) with Saints Catherine of Alexandria, John the Evangelist, John the Baptist, and Paul, in the Pinacoteca Nazionale in Siena (nos. 94, 85, 86, 93), also formed parts. This identification is corroborated by the dimensions, style, and iconography of the paintings and by the conformity of their framing elements, and is universally accepted. In the case of the four panels in Siena, however, the upper parts of the frames, with triangular gables containing medallions of prophets (and, in one case, of an angel), are preserved. The Siena *Baptist* and the present panels come from the right side and the three other panels in Siena from the left side of the altarpiece. The sequence of subjects is plausibly reconstructed by D'Argenio (in *Simone Martini e "chompagni,"* exh. cat., Pinacoteca Nazionale, Siena, 1985, pp. 112–14, nos. 22–25) as (*left side*) Saint Catherine of Alexandria, Saint John the Evangelist, Saint Paul, (*right side*) Saint Peter, Saint John the Baptist, Saint Mary Magdalene. Since the *Saint Paul* is surmounted by a gable with an angel (or the Angel of the Annunciation), the corresponding panel, the *Saint Peter*, would have shown in the gable an angel or the Virgin Annunciate. The four panels in Siena are recorded in 1842 as coming from the suppressed convent of Santa Marta (C. Pini, *Catalogo delle tavole dell'antica scuola senese riordinate nel corrente anno 1842 ed esistenti nell'I. e R. Istituto di Belle Arti di Siena*, 1842, p. 8), and it is likely that the polyptych of which they formed a part was executed for the Orfanotrofio-Ospizio di Santa Marta.

The relatively small scale of the panels and the *di sotto in su* rendering of the Magdalene's jar and the books held by Saints John the Evangelist and Peter led Perkins to suppose that they formed the upper tier of panels in a larger altarpiece. The elaborate and finely detailed tooling of the frame, as well as the decoration of the backs of the panels, militates against this reconstruction, and the saints represented are traditionally found in the main register of Sienese altarpieces. The central panel of the complex is untraced. It has been wrongly identified as the *Madonna and Child* by Lippo Memmi in the Cleveland Museum of Art (A. Caleca, "Tre polittici di Lippo Memmi, un ipotesi sul Barna e la bottega di Simone e Lippo," *Critica d'arte*, 42, 1977, p. 74), in which the framing decoration differs markedly from that of the present panels; as a panel of Saint Peter or Saint Gregory the Great formerly in the Parry collection and now in the Courtauld Institute Gallery, London (E. Sandberg-Vavalà, "Some Partial Recon-

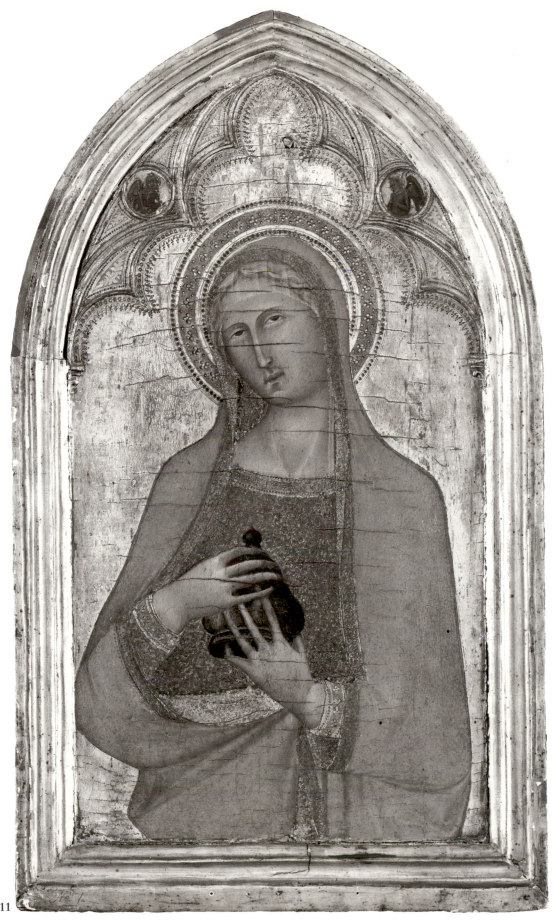

No. 11

27

structions—I," *Burlington Magazine*, 71, 1937, p. 177, n. 6), which has since been recognized as forming part of a diptych with a *Madonna* in the Volponi collection, Milan (L. Vertova, "Lippo Vanni versus Lippo Memmi," *Burlington Magazine*, 112, 1970, p. 437); and as the *Mystic Marriage of Saint Catherine of Alexandria* in the Pinacoteca Nazionale in Siena (no. 108; G. H. Edgell, "The Boston 'Mystic Marriage of St. Catherine' and Five More Panels by Barna Senese," *Art in America*, 12, 1923–24, pp. 49–52).

The authorship of the six panels is the subject of widespread disagreement. Originally attributed to a close follower of Lippo Memmi and to Barna, they were given by Weigelt ("Minor Simonesque Masters," *Apollo*, 14, 1931, pp. 6–9) to an independent Simonesque artist named, from one of the Siena panels, the Master of Saint Paul. This painter was later characterized by Vavalà (op. cit., p. 177) as dependent on the follower of Simone Martini known as the Master of the Palazzo Venezia Madonna, to whom the panels have since been reattributed by Volpe ("Precisazioni sul Barna," *Arte antica e moderna*, 10, 1960, p. 149), De Benedictis (*La pittura senese, 1330–1370*, 1979, pp. 22, 62, n. 34, 90), Caleca (loc. cit.), and Lonjon (in *L'art gothique siennois*, exh. cat., Musée du Petit Palais, Avignon, 1983, pp. 144–46, no. 44), who relates Nos. 11 and 12 to two generically similar panels by the Master of the Palazzo Venezia Madonna in the National Gallery, London. The panels are categorized by Torriti (*La Pinacoteca Nazionale di Siena: I dipinti dal XII al XV secolo*, 1977, pp. 92–94) as the work of an "artista senese affine al 'Maestro della Madonna di Palazzo Venezia.'" Zeri (review of Torriti, op. cit.; *Antologia di belle arti*, 6, 1978, p. 149) likewise regards the six panels as the work of a hand by whom no other paintings are known, while D'Argenio (loc. cit.), who also rejects the attribution to the Master of the Palazzo Venezia Madonna, notes affinities with the early work of Lippo Vanni and with Naddo Ceccarelli.

Though the authorship of the panels is elusive, there can be little doubt as to the context in which the paintings belong. This is established by the frescoes traditionally given to Barna da Siena in the Collegiata at San Gimignano, and specifically by three scenes (the *Transfiguration*, the *Raising of Lazarus*, and *Christ's Entry into Jerusalem*), as well as by six seated prophets in the vaults executed by an assistant on Barna's cartoons. A fresco of the Madonna and Child with Saints Paul and John the Baptist in San Pietro at San Gimignano is due to the same hand. The types of the two male saints in this last fresco are closely related to their counterparts among the four Siena panels,

while the Virgin is evidently related to the Lehman *Saint Mary Magdalene*. The master of the present panels is likely, therefore, to have been a member of the workshop of the anonymous master responsible for the frescoes in the Collegiata at San Gimignano.

CONDITION: The Magdalene's vermilion robe is worn, and the blue and gold of her dress have been abraded, but the flesh parts, save for a loss in the left hand, are well preserved.

PROVENANCE: Sir Philip Burne-Jones, London; Duveen Brothers, New York. Acquired by Philip Lehman in 1918.

EXHIBITED: Cincinnati Art Museum, *The Lehman Collection*, 1959, no. 9.

12. Saint Peter

1975.1.15

Tempera on panel. 44.6 × 27.7 cm. (17⅝ × 10⅞ in.), including the original side and bottom moldings of the frame. The panel has been cut obliquely across the top, not along the contour of the upper arch, and rather more of the original frame, which has been neither regessoed nor regilt, is therefore preserved than with No. 11.

The saint is represented in half-length, turned slightly to the left. He wears a yellow cloak, with a lining, over a tunic, and holds a book in his left hand and a gold and a silver key in his right. In the spandrels are two tondi, each with a half-length angel. The back of the panel is painted identically to that of No. 11, but the fictive wood or marble surround has not been overpainted black.

See No. 11.

CONDITION: The saint's cloak is abraded and overpainted, but his face and hands are relatively well preserved. The silver key in his right hand has oxidized to black. The angel in the right-hand tondo has been repainted.

PROVENANCE: J. A. Rambour, Cologne (see Rambour, *Katalog der Gemälde alter italienischer Meister [1221–1640] in der Sammlung des Conservators J. A. Rambour*, 1862, p. 18, no. 97, and G. Coor, "Trecento Gemälde aus der Sammlung Rambour," *Wallraf-Richartz Jahrbuch*, 18, 1956, p. 119); R. Langton Douglas, London. Acquired by Philip Lehman in 1916.

EXHIBITED: Cincinnati Art Museum, *The Lehman Collection*, 1959, no. 10.

No. 12

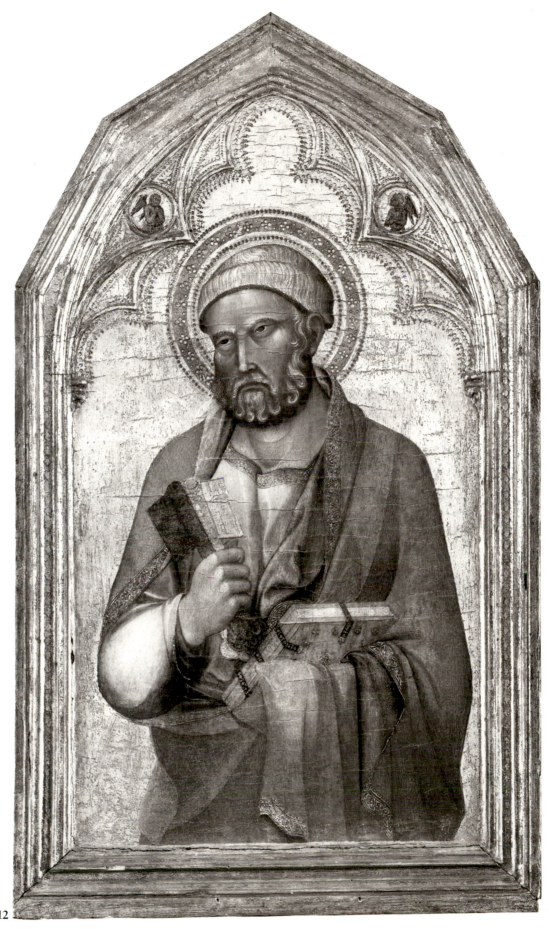

Bartolo di Fredi

The most important painter in Siena in the second half of the fourteenth century, Bartolo di Fredi is first recorded in 1356 as sharing a studio with Andrea Vanni. In the 1360s he was responsible for an extensive fresco campaign at San Gimignano, whither he returned to work intermittently over the next three decades. In the 1380s he undertook two major altarpieces and a number of frescoes for churches in Montalcino. Major commissions are recorded in Volterra in the 1370s and in Siena throughout his career. Bartolo di Fredi's last dated painting (at Chambéry) is of 1397, but he is known to have continued working up to his death in 1410.

13. The Adoration of the Magi

1975.1.16

Tempera on panel. 148.6 × 89.2 cm. (58½ × 35⅛ in.). The wood support is composed of three vertical pieces, of which that in the center is 73.3 cm. (28⅜ in.) wide and those at the sides are approximately 7.6 cm. (3 in.) wide. It has neither been thinned nor cradled and is approximately 3 cm. thick. There are traces of original gesso along the edges of the panel at right and left. The top has been cut (see below) and the bottom may have been trimmed slightly.

The Virgin is seated on the right beneath a marble tabernacle of which the frieze and canopy are inlaid in red. On the step before her is the crown of the first Magus, who kneels in the center kissing the feet of the Child. The Virgin wears a blue, gold-edged cloak over a red dress, and the Magus a pink robe and a red cloak with a white lining. The second Magus, wearing a white robe with a blue lining, kneels in profile on the left, with a rhyton in his right hand and his left hand on his chest. He is shown in conversation with the third king, clad in blue, who kneels between and slightly behind the other two, holding a gold container in his left hand. Behind the Child Christ is the standing figure of Saint Joseph, wearing a red, gold-edged cloak over a greenish blue tunic and likewise holding a gold vessel. Three attendants and the red hat of a fourth appear on the left, with the black, brown, and white heads of three horses behind them. The middle ground is filled by an ascending yellow cliff, and beyond it are two trees and a gray rocky path on which are seen the lower portions of two camels, two dogs, and two walking figures.

Regarded in the Ramboux collection (J. A. Ramboux, *Katalog der Gemälde alter italienischer Meister [1221–1640] in der Sammlung des Conservators J. A. Ramboux*, 1862, p. 20, no. 108) as a work of Barna da Siena or Bar-tolo di Fredi, this important panel was first decisively ascribed to Bartolo di Fredi by Crowe and Cavalcaselle (1864, vol. 2, p. 151); it was described by them as "much damaged, but in the true spirit of the master." It has since been universally recognized as a characteristic work of Bartolo di Fredi (F. M. Perkins, "Two Unpublished Pictures by Bartolo di Fredi," *Art in America*, 16, 1928, pp. 210–17; Berenson, 1936, p. 39, and subsequent editions, as a fragment; L. Rigatuso, "Bartolo di Fredi," *La Diana*, 9, 1934, p. 237; G. Coor, "Trecento-Gemälde aus der Sammlung Ramboux," *Wallraf-Richartz Jahrbuch*, 18, 1956, pp. 120, 122, 125; R. Traldi, "Due precisazioni per Bartolo di Fredi," *Prospettiva*, 10, 1977, pp. 50–54). The composition is closely related to that of the well-known *Adoration of the Magi* by Bartolo di Fredi in the Pinacoteca Nazionale, Siena (no. 104; 195 × 163 cm. For this see P. Torriti, *La Pinacoteca Nazionale di Siena: I dipinti dal XII al XV secolo*, 1977, pp. 164–65), though comparison of the two pictures has been vitiated by the incorrect dimensions (ca. 200 × 120 cm.) given for the present painting by Perkins (op. cit., p. 212), Rigatuso (loc. cit.), and in the Paris (1957) and Cincinnati (1959) catalogues of the Lehman Collection.

Two headless camels and the legs of two men and two dogs that appear in the upper left corner of the present painting imply that the procession of the Magi was originally represented there, as it is in the Siena altarpiece. A long gold ray descending from the upper edge of the panel to the Child's halo must originally have emanated from the Star of Bethlehem, which normally appears in representations of the Adoration of the Magi over the figure of Christ. A small *Journey of the Magi* (Fig. 16) in the Musée des Beaux-Arts at Dijon has been rightly identified as a fragment of the missing upper section of the present painting (F. Zeri, "Un appunto su Bartolo di Fredi," *Paragone*, vol. 13, no. 151, 1962, pp. 55–57; M. Guillaume, *Catalogue raisonné du Musée des Beaux-Arts de Dijon: Peintures italiennes*, 1980, p. 6, no. 11). The Dijon fragment is trapezoidal in shape and measures 27 cm. in height and 38 cm. in width at the base. It includes the bodies of two men and two dogs and the head of a camel corresponding to those cut off at the top edge of the Lehman painting. Since the gold sky in the Dijon fragment is punched along the upper edge and a strip of only 1 cm. seems to have been cut away between its lower edge and the top of the Lehman panel, the original height of the latter can have been no greater than approximately 176 cm. And since the Lehman panel appears not to have been cut at right or

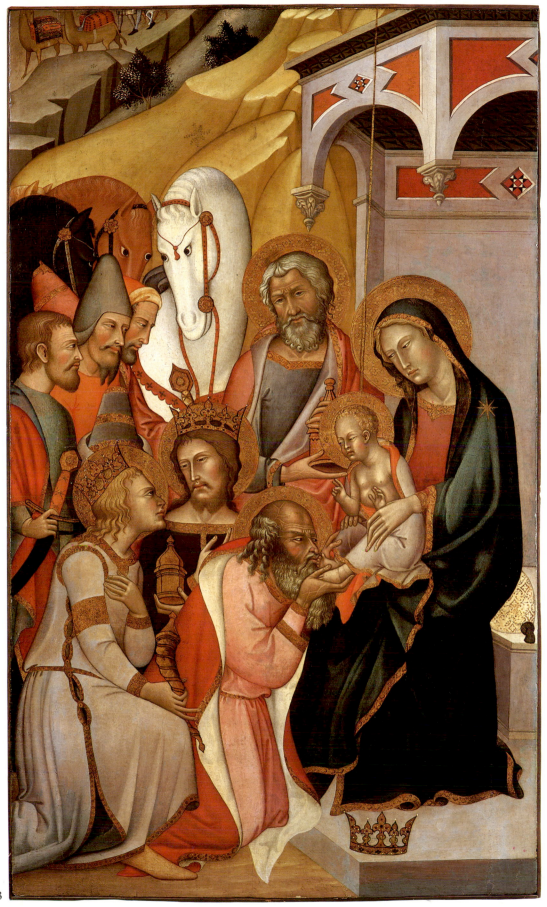

No. 13

left, its composition must always have been considerably narrower than that of the Siena *Adoration*. For this reason its design is simplified, with the retinue of the Magi limited to four grooms and the unruly crowd of camels and horses reduced to three horses. The elaborate gold brocades of the Siena picture have been largely suppressed in favor of simple, bright-colored fabrics, and the architectural detail of the aedicule under which the Virgin sits has been simplified, though the number of faces of which it is composed has been increased. The element of torsion in the figures in the Siena *Adoration* is reduced, so that the flattened head of Saint Joseph is represented frontally, the attendant on the extreme left is shown in profile, and the head of the central Magus is turned back and no longer faces the Virgin and Child. The figures are grouped more closely than in the Siena painting. Perkins (loc. cit.), who reconstructed the original dimensions of the present panel to ca. 270 × 150 cm., supposed that it preceded the Siena *Adoration*. There can, however, be little doubt that it was adapted from the Siena composition at a somewhat later date.

The Siena *Adoration of the Magi* has been identified with an altarpiece commissioned for the Arte dei Fornai in Siena in 1368 (G. Moran, "Bartolo di Fredi e l'altare dell'Arte dei Fornai del 1368: Nuova interpretazione di un documento," *Prospettiva*, 4, 1976, pp. 30–31). The arguments advanced to support this hypothesis are tenuous, and on stylistic grounds the picture is likely to have been painted somewhat later than the frescoes of scenes from the Old Testament in the Collegiata at San Gimignano, which are dated by inscription 1367. The Lehman *Adoration* shows a marked relaxation of the calligraphic tension in these early works, and most closely resembles the frescoes of the Birth and Dormition of the Virgin in Sant'Agostino at San Gimignano and an altarpiece in the Museo Comunale at Lucignano. It is wrongly identified by Carli (*San Gimignano*, 1962, pp. 85, 94, n. 7) with an altarpiece of 1374 described by Romagnoli (*Biografia cronologica de' bellartisti senesi*, 1830, p. 129) in San Domenico at San Gimignano. Bartolo di Fredi's chronology during the 1380s is established by two pictures painted for Montalcino, the *Deposition* altarpiece of 1382 and the *Coronation of the Virgin* of 1383–88 (for which see L. Kanter, "A *Massacre of the Innocents* in The Walters Art Gallery," *Journal of The Walters Art Gallery*, 41, 1983, pp. 17–28; G. Freuler, "Bartolo di Fredis Altar für die Annunziata-Kapelle in S. Francesco in Montalcino," *Pantheon*, 43, 1985, pp. 21–39; "L'altare Cacciati di Bartolo di Fredi nella chiesa di San Francesco a Montalcino," *Arte cristiana*, 73, 1985, pp. 149–66). The latter

originally included in one of its pinnacles a small panel of the Adoration of the Magi now in the possession of the National Trust at Polesden Lacey. The present panel, as Traldi (loc. cit.) has suggested, is likely to have been executed after 1388, in the last phase of the painter's career but before his altarpiece of 1397 from San Domenico, Siena, now in the Musée d'Art et d'Histoire, Chambéry. Bartolo di Fredi is documented as working in this period for the Università dei Calzolai (1389; G. Milanesi, *Documenti per la storia dell'arte senese*, vol. 2, 1854, p. 37), for Monte Oliveto Maggiore (1390; ibid.), and on an altarpiece for the altar of Saint Peter in the Duomo in Siena (1392; ibid.); but the Lehman *Adoration* cannot be associated with any of these three commissions. A possible hypothesis is that it was painted for the altar of the transept chapel in Sant'Agostino at San Gimignano, which has frescoed scenes from the Life of the Virgin by Bartolo di Fredi along the three walls. The frescoes are stylistically compatible with the altarpiece, and the subject of the Adoration of the Magi is conspicuously absent from them. Since the present altarpiece is relatively narrow, it may, like other Sienese altarpieces of its time, originally have been flanked by standing figures of saints.

CONDITION: The paint surface generally is not seriously abraded, but there are small paint losses scattered around the outer edges, along the joints in the support, and across the figures of Saint Joseph, the Virgin, the Child Christ, and the central Magus. The eldest Magus is well preserved, while small paint losses disfigure the profile, hands, and white robes of the kneeling Magus on the extreme left. The blue of the Virgin's cloak has been heavily reinforced. In the lower left-hand corner is an area of overpaint approximately 15 cm. (6 in.) square.

PROVENANCE: J. A. Ramboux, Cologne (see above); Wallraf-Richartz-Museum, Cologne, 1867 (J. Niessen, *Verzeichniss der Gemälde-Sammlung des Museums Wallraf-Richartz in Köln*, 1869, pp. 138–39, no. 763); Edward Hutton, London (letter of Mrs. A. E. Goodhart to the Frick Art Reference Library, December 20, 1934); Mr. and Mrs. A. E. Goodhart, New York, by 1924 (ms. note by R. Offner in the Frick Art Reference Library). Bequeathed by Mrs. Goodhart to Robert Lehman in 1952.

EXHIBITED: Metropolitan Museum of Art, New York, 1944, 1954–61; Musée de l'Orangerie, Paris, *La collection Lehman*, 1957, no. 2; Cincinnati Art Museum, *The Lehman Collection*, 1959, no. 14.

Niccolò di Buonaccorso

The most underestimated of the Sienese painters of the second half of the Trecento, Niccolò di Buonaccorso was active from the 1370s to his death in 1388. His name appears on a roll of Sienese painters mistakenly dated 1356, actually compiled close to 1380. With few exceptions, his surviving works are small in scale and rendered in a precious and remarkably sophisticated miniaturist technique. His only dated works are an altarpiece of 1387, two panels from which have recently been identified, and a *biccherna* cover of 1385. Reconstruction of his chronology, therefore, remains highly conjectural, as does an assessment of his proper place in the history of Sienese painting.

14. The Coronation of the Virgin

1975.1.21

Tempera on panel. Overall: 50.7 × 32.8 cm. (19¹⁵⁄₁₆ × 12⅞ in.); picture surface: 44.6 × 26.6 cm. (17⁹⁄₁₆ × 10⁷⁄₁₆ in.). The depth of the panel is 15 mm. (31 mm. with the molded surround). There is an unidentified wax seal on the reverse. All four outer edges of the panel were originally silvered and punched in a continuous pattern conforming to the margin decoration on the back.

The scene takes place beneath a seven-cusped arch. In the center Christ is depicted crowning the Virgin, whose head is covered with a veil and whose hands are crossed on her chest. Behind is a cloud of vermilion angel heads with outstretched wings extended forward to form a seat and platform for the two main figures. Above are the heads of seven four-winged seraphim, and at the top is a semicircle of nine blue cherubim. At each side of the angelic throne are seven angels, singing with parted lips. Beneath is a receding floor of red and blue tiles decorated with a geometric pattern, on which kneel four music-making angels, playing (*left to right*) a portative organ, a lute, a mandorla, and a vielle. Two further angels, playing on pipes, are shown hovering behind this group.

Two other panels are known with scenes from the life of the Virgin corresponding in style, size, and framing to the present panel. The first, with *The Presentation of the Virgin in the Temple* (Fig. 14), is in the Uffizi, Florence (no. P 1115; see L. Marcucci, *Gallerie Nazionali di Firenze: I dipinti toscani del secolo XIV*, 1965, p. 169, and L. Bellosi, in *Gli Uffizi: Catalogo generale*, 1979, p. 395), and the second, with *The Marriage of the Virgin* (Fig. 15), is in the National Gallery, London (no. 1109; see M. Davies, *National Gallery Catalogues: The Earlier Italian Schools*, 1961, p. 384). A metal stud appears on the left side of the

Uffizi panel and a metal hinge on the right. There are no hinges or hinge marks on the sides of the present panel. The backs of the Uffizi and National Gallery panels (for the latter see M. Davies, *Paintings and Drawings on the Backs of National Gallery Pictures*, 1946, pl. 24) conform exactly to the back of the present panel, which is silvered, punched, and painted with a pattern of diamond-shaped lozenges in blue and red. The complexity of this ornament leaves little doubt that the backs of the panels were designed to be exposed. In all probability they constituted a small portable polyptych of the class of the Orsini polyptych of Simone Martini or a *custodia* containing a sculptured statuette of the Virgin and Child. The London panel is inscribed across the base: NICHOLAVS: BONACHVRSI: DE SENIS: ME PN̄XT̄.

Evidence for the provenance of the panels is inconclusive. The inclusion of the words DE SENIS in the inscription on the London panel has been cited as an indication that the panels were commissioned for some other center than Siena (E. Hutton, *The Sienese School in the National Gallery*, 1925, p. 42). The London panel is variously stated to have been "seen by Fairfax Murray for sale in Florence in 1877" (Davies, *Earlier Italian Schools*, p. 384) and to have been bought by Fairfax Murray in Siena (F. M. Perkins, "Dipinti senesi sconosciuti o inediti," *Rassegna d'arte*, 14, 1914, pp. 98–99). The panel in Florence entered the Uffizi in 1900; it had previously been in the Spedale di Santa Maria Nuova (E. Ridolfi, "La Galleria dell'Arcispedale di S. Maria Nuova in Firenze," *Le Gallerie Nazionali Italiani*, 4, 1899, pp. 169–70; "Le gallerie di Firenze," ibid., 5, 1902, p. 11). Santa Maria Nuova at that time served as a repository for works of art removed from churches throughout Tuscany, and the presence of a panel there cannot be construed as proof of its Florentine origin. The source of the present panel is given by R. Lehman (1928, no. 36) as "Prince Sciarra, Siena." Douglas (in Crowe and Cavalcaselle, vol. 3, 1908, p. 133, n.) refers to the *Assumption of the Virgin* in the Sciarra collection, Rome, which would have formed part of the same cycle as the panels in London and Florence, and Perkins (loc. cit.) supposed the present painting, then in the possession of Vicomte Bernard d'Hendecourt in Paris, to be identical with the panel from the Sciarra collection despite the difference in subject. The collection of Prince Maffeo Barberini Colonna di Sciarra was sold at auction in 1899 at the Galleria Sangiorgi in Rome, but the present panel does not appear in the catalogue of that sale (*Catalogue des tableaux ayant appartenus à la Galerie Sciarra*

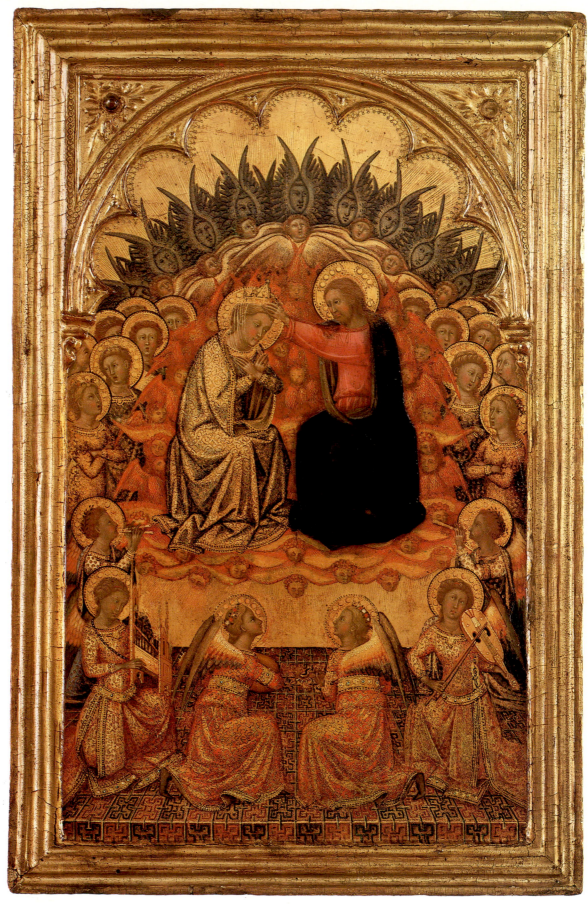

No. 14, reverse

et d'une collection d'objets d'art d'autres provenances, March 22–28, 1899). In a letter of June 8, 1914 (preserved in the Lehman Collection archives), however, d'Hendecourt spoke to Philip Lehman of the present picture as an "Assumption of the Virgin, formerly in the Sciarra collection . . . Prince Sciarra having sold it for a high figure fifteen years ago . . . as a Fra Angelico."

The three known panels of the present series are uniform in handling and of notably high quality, and on the strength of the inscription on the London panel they provide a norm for attributions to Niccolò di Buonaccorso. Only two dated works by Niccolò di Buonaccorso survive: a fragmentary polyptych formerly in Santa Margherita at Costalpino, of which the central *Virgin and Child*, now in the Kisters Collection, Kreuzlingen, at one time bore a signature and the date 1387 (see Boskovits, "Su Niccolò di Buonaccorso, Benedetto di Bindo e la pittura senesc del primo quattrocento," *Paragone*, vol. 31, nos. 359–61, 1980, pp. 3–22), and a *biccherna* cover of 1385 in the Archivio di Stato in Siena. There are no dated or approximately datable works in the preceding decade of Niccolò di Buonaccorso's activity, and the date of the portable altarpiece is therefore problematical. Doré (*L'art gothique siennois*, exh. cat., Musée du Petit Palais, Avignon, 1983, pp. 262–63, no. 98) regards its drawing as freer and therefore by implication later than that of a *Madonna of Humility* in the Louvre (acc. no. R.F. 1976–77), which is likely in any event to be one of Niccolò di Buonaccorso's earliest works. A date for the present panel of ca. 1380 is plausible.

CONDITION: The paint surface is very well preserved, with minimal abrasion and flaking. The profiles of the two angels kneeling at the base and the highlights on their robes have been reinforced. The head of an angel at the left on the level of the corbel arch is modern, and there is some reinforcement of the heads of the red cherubim.

PROVENANCE: Sciarra collection, Rome; Gardner and Vicomte Bernard d'Hendecourt, Paris; F. Kleinberger Galleries, New York; acquired by Philip Lehman in 1914; Pauline Ickelheimer, New York. Acquired by Robert Lehman in 1946.

EXHIBITED: F. Kleinberger Galleries, New York, *Loan Exhibition of Italian Primitives in Aid of the American War Relief*, 1917, no. 53; Colorado Springs Fine Arts Center, *Paintings and Bronzes from the Collection of Mr. Robert Lehman*, 1951–52; Metropolitan Museum of Art, New York, 1954–61; Musée de l'Orangerie, Paris, *La collection Lehman*, 1957, no. 298; Cincinnati Art Museum, *The Lehman Collection*, 1959, no. 19.

Workshop of Niccolò di Buonaccorso

15. The Lamentation over the Dead Christ

1975.1.20

Tempera on panel. Overall: 41 × 26.7 cm. (16⅛ × 10½ in.); picture surface: 39.4 × 25.5 cm. (15½ × 10 in.). The panel has been thinned to a depth of 7 mm., but has not been cradled. The original engaged frame has been cut away, but the beard of the paint edge is still visible.

Beneath a five-cusped arch rises the hill of Calvary. The upper part of the panel is divided vertically by the shaft of the cross, the bottom edges of its arms being visible in the cusps to left and right. Beneath this are two mourning seraphim and two gold angels. The body of Christ, wrapped in a gold-tooled shroud, lies horizontally across the laps of the Virgin and two seated women. A fourth Holy Woman is seated in profile on the ground to the left. Behind stand (*left*) Saint John the Evangelist, gazing upward, his hands clasped in grief, and (*right*) Joseph of Arimathaea and Nicodemus.

The panel is one of a number of devotional scenes produced in the workshop of Niccolò di Buonaccorso. It is of lower quality than the comparable panel of *The Coronation of the Virgin* in the Lehman Collection (No. 14). Though accepted as an autograph work of Niccolò di Buonaccorso by Zeri (review of P. Torriti, *La Pinacoteca Nazionale di Siena: I dipinti dal XII al XV secolo*, in *Antologia di belle arti*, 6, 1978, p. 151) and Boskovits ("Su Niccolò di Buonaccorso, Benedetto di Bindo e la pittura senese del primo quattrocento," *Paragone*, vol. 31, nos. 359–61, 1980, pp. 6, 16, n. 15), it appears, as Maginnis infers ("The Literature of Sienese Trecento Painting, 1945–1975," *Zeitschrift für Kunstgeschichte*, 40, 1977, p. 299), to have been executed from Niccolò di Buonaccorso's cartoon by a studio hand. A panel of *The Annunciation* (Fig. 17) in the Wadsworth Atheneum, Hartford (for which see K. Ames, "An *Annunciation* by Niccolò di Buonaccorso," *Wadsworth Atheneum Bulletin*, ser. 6, vol. 2, no. 2, 1966, pp. 24–31), is associated by Maginnis with the present panel. The two pictures correspond in size, in the tooling of their borders, in the gesso decoration of the spandrels, and in the fact that the engaged outer moldings have been removed. They share the same mannerisms in the rendering of hands and feet, the same drapery forms, and the same rather coarse facial types, and may originally have been associated as a diptych. A comparable diptych by Niccolò di Buonaccorso at Aquila, with the *Mystic Marriage of Saint Catherine of Alexandria* and the *Crucifixion*, is published by Carli ("Un dittico senese in Abruzzo," *Le arti*, 1, 1938–39, pp. 594–96). The Aquila diptych corresponds very closely in size and in its punched and gessoed decoration to the Lehman and Hartford panels.

CONDITION: The paint surface is generally well preserved. Two layers of gold are evident in the ground. One of these is old, but more recent than the paint surface, and where it has flaked away reveals an older, presumably original, layer of gold beneath.

PROVENANCE: E. F. Hines, London; Christie's, London, June 27, 1958, lot 81 (bt. Guidi); C. Bruscoli, Florence. Acquired by Robert Lehman, apparently in 1958 (on the back is a Florentine export stamp dated September 13 of that year).

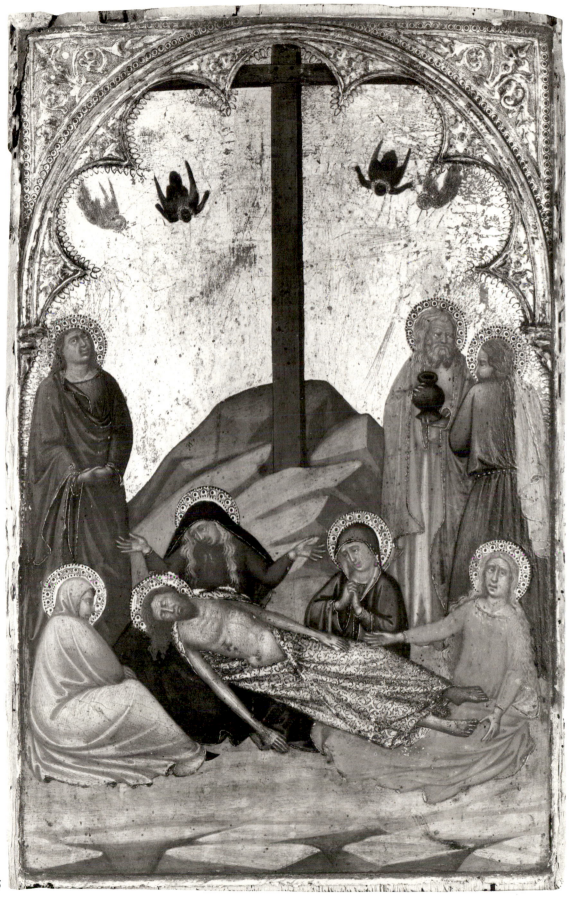

No. 15

Paolo di Giovanni Fei

Probably born in Siena in the 1340s, Paolo di Giovanni Fei is first recorded as a painter in that city in 1369. His only firmly datable works fall in the last decade of the fourteenth and the first decade of the fifteenth centuries. The pattern of his early development is unclear, though he may have received his artistic training in the workshop of Naddo Ceccarelli. By the middle 1390s he had developed a strongly personal style which influenced the leading painters of the next generation: Taddeo di Bartolo, Martino di Bartolomeo, and Andrea di Bartolo. Fei died in 1411.

16. Madonna and Child Enthroned with Saint John the Evangelist, Saint Peter, Saint Agnes, Saint Catherine of Alexandria, Saint Lucy, an Unidentified Female Saint, Saint Paul, and Saint John the Baptist, with Eve and the Serpent; *(in the spandrels)* **the Annunciation**

1975.1.23

Tempera on panel. With original engaged frame: 86.9 × 59 cm. (34¼ × 23¼ in.); picture surface: 70.9 × 43.9 cm. (27⅞ × 17¼ in.). The panel has not been thinned or cradled, but has been impregnated with wax. The back is surrounded by a thin molding interrupted halfway up each side by a horizontal batten set into the panel flush with its surface. There are traces of original paint on the outer edges and on the moldings at the back.

The scene is set beneath a six-cusped arch supported at the sides by spiral gesso colonnettes. The Virgin and Child are shown in the center on a white-and-gold cushion before a red-and-gold brocaded cloth of honor with a white lining. Nine angels with blond hair bound with white fillets, wearing red, blue, and gold tunics, fill the upper part of the panel. On the topmost step before the throne stand (*left*) Saint Agnes, clad in red and gold and holding a lamb with a cruciform halo, and Saint Catherine of Alexandria in blue and red with a gold crown, and (*right*) Saint Lucy holding a gold dish, and a female saint dressed in white and blue. Beneath them appear (*left*) Saint John the Evangelist in green and rose and Saint Peter in blue and yellow, and (*right*) Saint Paul in left profile in a red robe and Saint John the Baptist in a hair shirt covered with a pale blue and vermilion cloak. Before the throne is the reclining figure of Eve, in a transparent white veil and red-lined fur cloak, holding a scroll with the name EVA. Beside her is a diminutive tree; a serpent with a human head is coiled in its branches. The figures of the Angel of the Annunciation and the Virgin Annunciate appear in cusped tondi in the spandrels above.

Since it first came to notice, the panel has been universally regarded as a characteristic work, of high quality, by Paolo di Giovanni Fei. It is so accepted by Valentiner (*Catalogue of Early Italian Paintings Exhibited at the Duveen Galleries, New York, April to May, 1924*, 1926, no. 28), L. Venturi (*Pitture italiane in America*, 1931, pl. 86), Berenson (1932, p. 183; 1936, p. 159; 1968, vol. 1, p. 129), Van Marle (*Development*, vol. 2, 1924, p. 53), Laclotte ("A propos des 'primitifs' italiens de la collection Lehman," *L'information de l'histoire de l'art*, 2, 1957, p. 14, no. 18), and Mallory ("Towards a Chronology for Paolo di Giovanni Fei," *Art Bulletin*, 46, 1964, p. 536). The cartoon of the Child, with his head turned toward the spectator and his left hand on the Virgin's breast, is employed again in a *Madonna* by Fei in the Metropolitan Museum of Art. The present painting is probably of somewhat earlier date and is assumed by Mallory (*The Sienese Painter Paolo di Giovanni Fei*, 1976, pp. 110–12) to have been executed "around 1390 or a little earlier." An unconvincing dating in the vicinity of the *Presentation of the Virgin in the Temple* of 1398 in the National Gallery of Art, Washington, is proposed by Guiducci (in *L'art gothique siennois*, exh. cat., Musée du Petit Palais, Avignon, 1983, p. 278).

The association of the Virgin with Eve (for which see M. Q. Smith, *Burlington Magazine*, 104, 1962, pp. 65–66; E. Guldan, *Eva und Maria: Eine Antithese als Bildmotiv*, 1966; and H. W. van Os, *Marias Demut und Verherrlichung in der sienesischen Malerei 1300–1450*, 1966, p. 89, n. 39) occurs for the first time in Tuscany in a fresco by Ambrogio Lorenzetti at Montesiepi (for which see E. Borsook, *Gli affreschi di Montesiepi*, 1969, pp. 25–26). The fig that Eve holds in her hand, identifying her fall from grace, is a recurring symbol in all depictions of the Virgin and Eve (see G. Coor-Achenbach, "Neither a Rose nor an Apple but a Fig," *Burlington Magazine*, 104, 1962, p. 305). The presence of the serpent is likewise a common iconographic device. The serpent entwined in the Tree of Knowledge is, however, unusual, as is the fact that the serpent's neck is pierced by the sword of Saint Paul.

CONDITION: The paint surface is abraded and shows extensive losses from flaking. A vertical crack at the left runs the height of the panel and has been liberally retouched along both sides. Another split at the right rises to three-quarters the height of the panel. The figures of Saints John and Peter are rubbed but not retouched, though the key held by Saint Peter is false above the handle. The hands and palm of Saint Catherine are also new. There is extensive damage in the heads of the angels behind the throne. The vermilion of the Baptist's cloak has been scraped

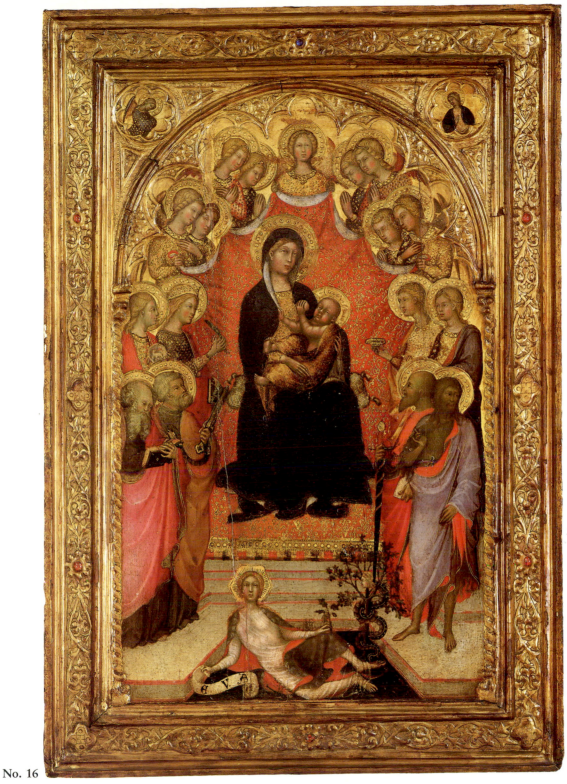

No. 16

down to its present bluish tone, and the serpent beneath has been
vandalized. There is some reinforcement or retouching in the
Virgin and Child. The gold is fairly well preserved throughout.

PROVENANCE: Chigi-Saracini collection, Siena; Luigi Grassi,
Florence; Mr. and Mrs. A. E. Goodhart, New York, by 1924.
Bequeathed by Mrs. Goodhart to Robert Lehman in 1952.

EXHIBITED: Duveen Brothers, New York, *Early Italian Paint-
ings*, 1924, no. 28; Musée de l'Orangerie, Paris, *La Collection
Lehman*, 1957, no. 18; Cincinnati Art Museum, *The Lehman
Collection*, 1959, no. 16.

Workshop of Paolo di Giovanni Fei

17. Diptych: *(left wing)* Madonna and Child Enthroned with Two Angels and Saints James the Great and John the Baptist and *(above)* the Annunciatory Angel; *(right wing)* the Crucified Christ with the Virgin, Saint Mary Magdalene and Saint John the Evangelist and *(above)* the Virgin Annunciate

1975.1.22

Tempera on panel. *Left wing.* Overall: 45.4 × 19.7 cm. (17⅞ × 7¾ in.); picture surface, with gable: 40.5 × 16.6 cm. (15⅞ × 6½ in.). *Right wing.* Overall: 45.6 × 19.7 cm. (18 × 7¾ in.); picture surface, with gable: 40.5 × 16.6 cm. (15⅞ × 6½ in.). The height of both wings, including the uppermost finial, is 51 cm. (20⅟₁₆ in.). The backs of both panels have been covered with black paint, but some original gesso and bole and traces of engraved decoration appear beneath. The moldings of both panels seem to be original, but have been regilt and repunched.

In the left-hand panel the Virgin sits enthroned before a red and gold brocaded cloth of honor with two adoring angels behind. The Child Christ wears a white and rose-colored tunic and carries a scroll with the words EGO·SVM. The Baptist *(left)* carries a reed cross and wears a vermilion cloak with a red lining over his hair shirt. Saint James *(right)*, in a rose-colored tunic covered by a yellow cloak, holds a book and pilgrim's staff with a small black scapular. The Angel of the Annunciation appears in three-quarter profile to the right in a tondo above. In the right-hand panel Saint Mary Magdalene embraces the foot of the cross, with her head turned to the spectator. Saint John the Evangelist *(right)*, in blue and rose, stands with hands clasped; the mourning Virgin *(left)* stands opposite him. In a tondo above appears the Virgin Annunciate with raised right hand and an open book.

The diptych was published by Perkins ("Some Sienese Paintings in American Collections, Part III," *Art in America*, 9, 1922, p. 6) as a late work of Paolo di Giovanni Fei, and an attribution to Fei is accepted by, among others, R. Lehman (1928, pl. 38), who also records the mistaken view of De Nicola that the diptych is by Francesco di Vannuccio; Van Marle (*Development*, vol. 2, 1924, p. 542, as a school work); and Berenson (1932, p. 183; 1968, vol. 1, p. 129). It is listed by Mallory (*The Sienese Painter Paolo di Giovanni Fei*, 1976, p. 216) among works incorrectly attributed to Fei, with the comment, "These squat figures with bulging eyes were painted by a follower of Fei and certainly not by the master himself."

As Perkins observed, a diptych in the Pinacoteca Nazionale at Siena (no. 146) provides a point of reference for the present diptych, from which it differs in the form of the throne, the pose of the Child, the substitution of Saints Catherine of Alexandria and Agnes for the male saints in the left wing, and the reversed posture of the Magdalene and the addition of two Holy Women in that on the right. The figures of the Annunciation appear in the Siena diptych in triangular gables, not within circular frames. There can be no doubt that the Siena diptych (for which see P. Torriti, *La Pinacoteca Nazionale di Siena: I dipinti dal XII al XV secolo*, 1977, p. 181), though damaged and partially repainted, is an autograph work by Fei, and is related to the Minutolo triptych in the Duomo in Naples, which is convincingly dated by Mallory to the years 1405–10. The present diptych, which is inferior to that in Siena, seems to have been produced in Fei's workshop in the first decade of the fifteenth century. The hand of the same studio assistant recurs in a small panel of the Crucifixion formerly in the collection of Mildred, Countess of Gosford, sold at Parke-Bernet, New York, on November 12, 1952 (no. 10).

CONDITION: The paint surface is lightly abraded and is covered with a thick layer of yellow varnish. There is some retouching in the left wing: the head of the left-hand angel, the right hand of the Virgin, the hair and left hand of Saint James, and the head of the Baptist. The left eye of Saint James covers a plugged wormhole. The pavement is much retouched. There is less abrasion in the right wing, but the outline of Christ's body has been reinforced, as has the bottom of the Magdalene's cloak.

PROVENANCE: Rev. John Fuller Russell, Greenhithe, Kent, after 1854 (see G. F. Waagen, *Galleries and Cabinets of Art in Great Britain*, 1857, p. 284, as Taddeo di Bartolo); Russell sale, Christie's, London, April 18, 1885, lot 107; Thomas Brocklebank, Wateringbury, Kent. Acquired by Philip Lehman before 1920.

EXHIBITED: Manchester, *Art Treasures Exhibition*, 1857, no. 40 (as Taddeo di Bartolo); Royal Academy, London, *Works of the Old Masters*, 1877, no. 152 (as Taddeo di Bartolo); Cincinnati Art Museum, *The Lehman Collection*, 1959, no. 17 (as Paolo di Giovanni Fei).

No. 17, left wing

No. 17, right wing

Taddeo di Bartolo

Born about 1362, Taddeo di Bartolo was employed on work for the Duomo at Siena in 1386. His earliest dated painting is a polyptych (now in a private collection) executed for San Paolo at Collegarli (1387). In 1393 and 1397 he was active in Genoa. His main center of activity throughout these years was Pisa, where he painted in 1395 two polyptychs (now in the Szépművészeti Múzeum, Budapest, and the Musée des Beaux-Arts, Grenoble) and in 1397 some frescoes in the church of San Francesco. Thereafter he was once more active in Siena, executing an influential altarpiece for the confraternity of Santa Caterina della Notte (1400) and a large polyptych for the Pieve (now the Duomo) at Montepulciano (1401). In 1403 he painted two altarpieces for Perugia (now in the Galleria Nazionale dell'Umbria). His most important work, a fresco cycle in the chapel of the Palazzo Pubblico, Siena, dates from 1406–7; the secular frescoes in the adjacent antechapel were completed in 1414. His latest dated painting is the *Madonna and Child* of 1418 in the Fogg Art Museum, Cambridge, Mass. The sources of Taddeo di Bartolo's early style have not been fully investigated. In Pisa and Liguria he came in contact with the work of Barnaba da Modena, and some experience of Emilian painting is evident in the Montepulciano altarpiece. A prolific artist with a substantial studio, Taddeo di Bartolo dominated Sienese painting in the first two decades of the fifteenth century, and his in part archaizing style formed a point of departure for Sassetta, Giovanni di Paolo, and their contemporaries. He died in 1422.

18. Head of the Virgin

1975.1.18
Tempera on panel. 19.8 × 13.7 cm. (7¾ × 5⅜ in.). The panel has been cut on all four sides and has been thinned down.

The Virgin's head, excised from a larger painting, is shown in full face with a white veil and the hem of a blue cloak. Traces of gold are visible around the edges of the figure to the level of her chin. The surrounding paint has been scraped away, and the vacant area is filled with white gesso.

This and the two related heads of angels (Nos. 19 and 20) are listed without comment by Symeonides (*Taddeo di Bartolo*, 1965, p. 240). They appear to have been excised from a painting of the Assumption of the Virgin, no other fragments of which are known to survive. A point of reference for the heads of the two angels is provided by a fresco

of the Dormition of the Virgin of 1397 in San Francesco at Pisa, and the heads seem to date from about this time. A number of fourteenth- and fifteenth-century altarpieces painted for San Francesco at Siena were cut down after the fire of 1655; an altarpiece of unspecified subject signed by Taddeo di Bartolo and dated 1408 is recorded in the church (P. Bacci, "L'elenco delle pitture, sculture e architetture di Siena compilato nel 1625–26 da Mons. Fabio Chigi, poi Alessandro VII, secondo il ms. Chigiano I.1.11," *Bollettino senese di storia patria*, n.s. 10, 1939, p. 319), but it is unlikely to have been the source of the present fragments.

CONDITION: The paint surface is well preserved. The losses are restricted to a small hole over the Virgin's left eyebrow and pinpoint flaking across her right cheek, chin, and throat. Three diagonal scratches run across the nose, cheek, and jaw.

PROVENANCE: Purchased by Robert Lehman in Arezzo in 1934.

EXHIBITED: Cincinnati Art Museum, *The Lehman Collection*, 1959, no. 21.

19. Head of an Angel in Full Face

1975.1.17
Tempera on panel. 15.6 × 11.9 cm. (6³⁄₁₆ × 4¹¹⁄₁₆ in.).

The angel's head is shown with parted lips, as though singing, and is turned slightly to the right. His brown hair is bound with a black fillet. Traces of gold and the remains of a punched halo appear round the edges of his hair.
 See No. 18.

CONDITION: A hole at the top of the angel's head has been filled in and painted green. Extensive flaking throughout the head has left the green underpainting exposed. As with No. 18, the surrounding paint has been scraped away, and the vacant area is filled with white gesso.

PROVENANCE: Acquired by Robert Lehman in Arezzo in 1934.

EXHIBITED: Cincinnati Art Museum, *The Lehman Collection*, 1959, no. 20.

No. 18

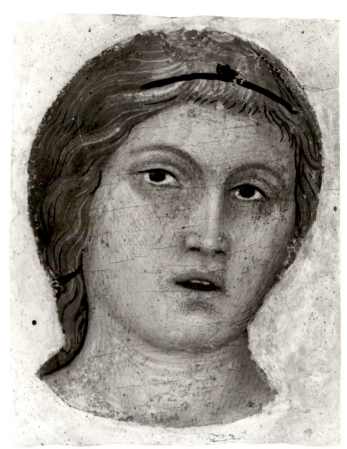

No. 19

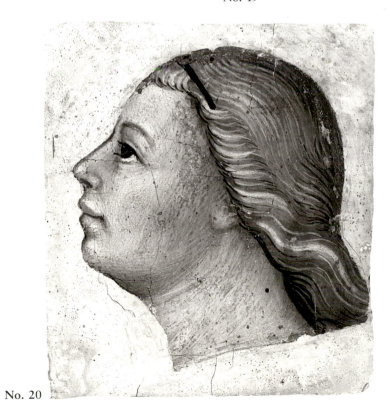

No. 20

43

20. Head of an Angel in Left Profile

1975.1.19
Tempera on panel. 14.9 × 13.3 cm. (5⅞ × 5¼ in.).

The head of the angel is shown looking upward in profile to the left. His hair is brown with white highlights and is bound by a black fillet. Traces of gold and of the punching of a halo are visible round the forehead and top and back of the head.

See No. 18.

CONDITION: The paint along the temple and upper jaw, through the throat, and at the back of the head has suffered extensive pinpoint flaking. There is no evidence of abrasion or retouching. As with No. 18, the surrounding paint has been scraped away, and the vacant area is filled with white gesso.

PROVENANCE: Acquired by Robert Lehman in Arezzo in 1934.

EXHIBITED: Cincinnati Art Museum, *The Lehman Collection*, 1959, no. 22.

FLORENCE
Fourteenth Century

Tuscan, First Quarter of the Fourteenth Century

21. Madonna and Child

1975.1.3
Tempera on panel. Overall: 16.2 × 11.8 cm. (6⅜ × 4⅝ in.);
picture surface: 12.3 × 8.4 cm. (4⅞ × 3½ in.).

The Virgin is shown in half-length, turned slightly to the right with her head inclined toward her left shoulder, gazing at the spectator. On her left arm she supports the Child, whose feet rest on her right wrist. He wears a linen tunic covered with a red cloth, and pulls at the Virgin's white veil with his right hand. This panel and No. 22 originally formed a diptych. Both have heavy engaged frames with triangular gables.

The two panels are works of modest quality, dating from the end of the first quarter of the fourteenth century. They are adduced by Stubblebine ("Segna di Bonaventura and the Image of the Man of Sorrows," *Gesta*, vol. 8, 1969, no. 2, pp. 7–8; *Duccio di Buoninsegna and His School*, 1979, p. 145, fig. 347) as evidence for the cult of the Man of Sorrows (see No. 22) in Siena in the early fourteenth century, and are ascribed by him to a follower of Segna di Bonaventura. Boskovits (verbally) gives them to a Florentine painter in the circle of Taddeo Gaddi and Jacopo del Casentino, and it is in the context of provincial Florentine, not provincial Sienese, painting that they belong. They are not attributable to a known hand.

CONDITION: The panel has been much abraded, especially in the two heads. The red cloth round the Child and the gold edges of this and of the Virgin's cloak are, however, well preserved. The right-hand and lower moldings of the engaged frame are modern. The backs of both this panel and No. 22 are covered with laid paper, apparently of the eighteenth century, which extends over the added lateral and base strips of the two frames.

PROVENANCE: Paolo Paolini, Rome. Date of acquisition not recorded.

EXHIBITED: Cincinnati Art Museum, *The Lehman Collection*, 1959, no. 5 (as Segna di Bonaventura).

22. Pietà

1975.1.4
Tempera on panel. Overall: 15.8 × 11.8 cm. (6³⁄₁₆ × 4⅝ in.);
picture surface: 12.1 × 8.6 cm. (4¾ × 3⅜ in.).

The naked figure of the dead Christ is shown frontally with hands crossed on his chest and his head turned to the spectator's left. At the base is the upper edge of a white loincloth. The panel shows traces of the gold outlines and white drapery of two mourning angels that originally flanked the dead Christ at the level of his shoulders.

See No. 21.

CONDITION: The surface is badly abraded, especially round the head of Christ, and the gold has been scraped down to the gesso; thin traces of bole and scattered flakes of gold survive.

PROVENANCE: See No. 21.

EXHIBITED: Cincinnati Art Museum, *The Lehman Collection*, 1959, no. 4 (as Segna di Bonaventura).

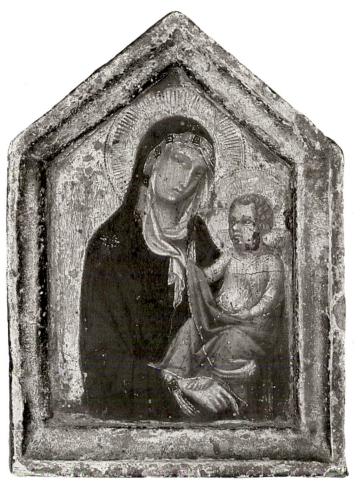

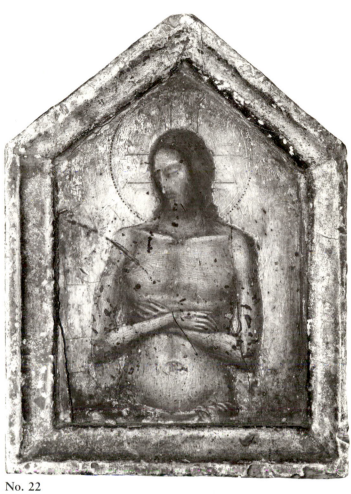

No. 21

No. 22

Bernardo Daddi

Perhaps the most gifted Florentine painter of the generation following Giotto's, Daddi, who was active by 1327 and who seems to have died in 1348, was responsible for the frescoed decoration of the Pulci-Berardi Chapel in Santa Croce and for a number of panel paintings. The latter include a triptych in the Uffizi from the Ognissanti (1328); a tabernacle in the Bigallo (1333); the high altarpiece of San Pancrazio, in the Uffizi; a Madonna in the tabernacle at Or San Michele (1346); and an altarpiece from San Giorgio a Ruballa in the Courtauld Institute Gallery, London (1348). Daddi was the head of a productive and highly organized workshop, and the works turned out from it exercised an active influence on Florentine painting for a generation after his death. None of the three panels in the Lehman Collection attributed to Daddi can be looked upon as autograph. One, a fragment of an important altarpiece, must have been commissioned from and formulated by the artist himself, though it was executed by a painter known to art history as the Assistant of Daddi. The second, a Madonna, repeats a design of Daddi's but was executed by a minor painter in his shop. The third, a small Nativity, represents a confluence of Daddi's style with features traceable to Giotto's direct pupil, Taddeo Gaddi (d. 1366).

23. The Assumption of the Virgin

1975.1.58

Tempera on panel. 108 × 136.8 cm. (42½ × 53⅞ in.). The panel, composed of two vertical planks joined approximately 41 cm. (16⅛ in.) from the left edge, has been neither thinned nor cradled, but has been cut at the bottom and at both sides. The profile of the gable is original.

The elderly figure of the Virgin is shown seated frontally in a blue mandorla. She wears a pink dress with a white veil across the forehead and round her neck, a white-and-gold cloak with a dark lining, and a jewel on her head; in her left hand she holds a blue, red-clasped book. With her extended right hand she drops her girdle to Saint Thomas, the top of whose halo and the fingers of whose upraised hands are visible in the lower left corner at the base of the panel. The area between the base of the mandorla and the edge of the panel is filled with lines of brownish gray cloud. The rim of the mandorla is supported by three flying angels at each side. The uppermost angels, who have green wings, are dressed in green; those in the center, with yellow and pink wings, have rose-colored robes; and

those at the base, whose heads are turned up toward the Virgin, are dressed in blue and have blue wings. The hair of all six angels is adorned with fillets of gold, ruby, and sapphire.

The panel, which has been cut on three sides, formed the upper part of a large altarpiece. As Boskovits observes (*A Critical and Historical Corpus of Florentine Painting*, sec. 3, vol. 9, 1948, pp. 72–73), the hands of Saint Thomas, visible at the lower left edge, indicate that he was painted on the same scale as the Virgin. If the apostle was shown kneeling, at least 60 cm. from the lower section would be missing. If he was shown standing, the missing area would be substantially greater. The bands of punched decoration along the upper margins of this panel must have continued along the lateral edges, which have been trimmed by a minimum of 5 cm. at each side. Boskovits supposes the original width of the panel to have been on the order of 200 cm., but 150 cm. would be sufficient to allow for the completion of the lower pair of angels and of Saint Thomas.

The legend of the Virgin dropping her girdle to Saint Thomas has close associations with the Pieve (now the Duomo) at Prato, where the Virgin's girdle (the Sacro Cingolo) is preserved. An altarpiece for the chapel of the Sacro Cingolo was commissioned and executed in 1337–39. The relevant payments (for which see F. Giani, "Documenti su antichi pittori pratesi," *Archivio storico pratese*, 1, 1917, p. 67) run from April 1337 to June 1338 and relate to "quamdam gloriosam et pulcerrimem tabulam ad honorem Dei et beate Virginis Marie et gloriosissimi eius Cingoli que poni debet ad eius altare in maiori plebe." The predella of this altarpiece, by Bernardo Daddi, is in the Pinacoteca Comunale at Prato (G. Datini, *Musei di Prato*, 1972, pp. 9–11). Though Marchini ("L'antica pala dell'altar maggiore del Duomo di Prato," *Archivio storico pratese*, 48, 1972, pp. 39–45; *La Cappella del Sacro Cingolo nel Duomo di Prato* [1975], p. 14; "Vicende di una pala," in *Studies in Late Mediaeval and Renaissance Painting in Honor of Millard Meiss*, 1977, pp. 320–23) reconstructs the altarpiece as a pentaptych, it is persuasively argued by Steinweg ("Contributi a due predelle di Bernardo Daddi," *Rivista d'arte*, 31, 1956, p. 40, n. 34) that the upper part of the painting comprised a single panel. It has been supposed that No. 23 was excised from the main panel of this altarpiece. The altarpiece was removed from the altar of the Sacro Cingolo in 1434, but after four years was returned to the Pieve. There is no later record of its whereabouts. The predella

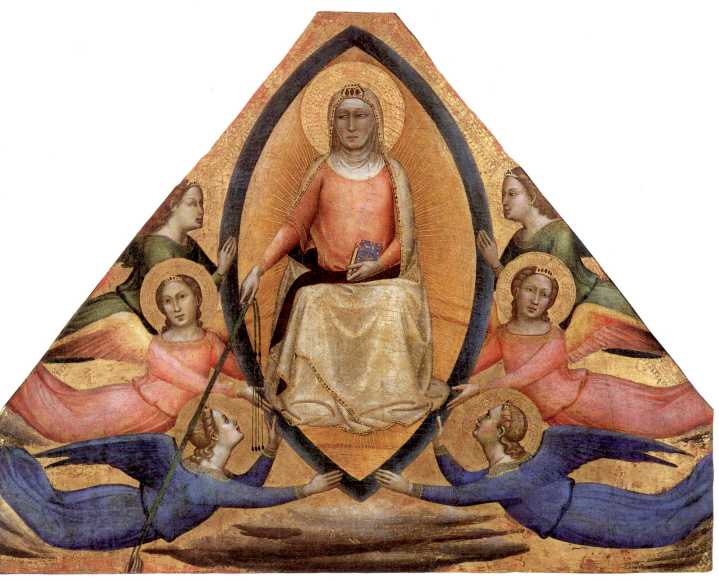

No. 23

was not returned to the church and seems to have remained in the convent of San Martino until the beginning of the eighteenth century.

Though the design of the present panel is certainly due to Bernardo Daddi, it was executed by a leading member of Daddi's shop named by Offner the Assistant of Daddi (Offner, *A Critical and Historical Corpus of Florentine Painting*, sec. 3, vol. 5, 1947, pp. 55–140). Counterparts to the head of the Virgin and to each of the six angels in the present painting are found in an altarpiece of the *Coronation of the Virgin* by this hand in the Accademia, Florence (no. 3449), which was first grouped by Van Marle (*Development*, vol. 3, 1924, p. 402) with a nucleus of two other paintings as the work of a Daddi follower working under the master's direct supervision. The homogeneity of Offner's grouping is generally recognized, though Marcucci (*Gallerie Nazionali di Firenze: I dipinti toscani del secolo XIV*, 1965, pp. 44–45) describes the paintings as late works by Daddi assisted by members of his shop. The Assistant of Daddi seems to have operated as a semi-independent member of Daddi's workshop. Two altarpieces predominantly executed by his hand, one of 1344 in Santa Maria Novella, Florence, and the other of 1348 in the Courtauld Institute Gallery, London (Gambier-Parry collection), are signed by Daddi (Offner, op. cit., sec. 3, vol. 3, 1930, pp. 80–81; sec. 3, vol. 5, 1947, pp. 87–92). The same assistant appears also to have intervened in the San Pancrazio altarpiece of the mid-1340s, in the Uffizi, and in the Or San Michele Madonna of 1347.

The painted motifs decorating the Virgin's robe and the cuffs and collars of the angels in the present painting, as well as the stamps used to punch the gold of the haloes and borders, recur regularly in works for which the Assistant of Daddi was responsible. One punch used along the border of the painting, a winged monster within a rounded lozenge, is of extreme rarity, but is found again in the Accademia *Coronation* as well as in a fragment from the *Coronation of the Virgin* at Christ Church, Oxford (for which see K. Steinweg, "Rekonstruktion einer orcagnesken Marienkrönung," *Mitteilungen des Kunsthistorischen Institutes in Florenz*, 10, 1961, pp. 122–27, and J. Byam Shaw, *Paintings by Old Masters at Christ Church, Oxford*, 1967, pp. 31–33). The use of this punch is discussed by Frinta ("An Investigation of the Punched Decoration of Mediaeval Italian and Non-Italian Panel Paintings," *Art Bulletin*, 47, 1965, p. 262) and Skaug ("Notes on the Chronology of Ambrogio Lorenzetti and a New Painting from His Shop," *Mitteilungen des Kunsthistorischen Institutes in Florenz*, 20, 1976, p. 328, n. 78).

Since all of the paintings executed by the Assistant of Daddi appear to date from the 1340s, there is a strong presumption that the present panel was painted in that decade as well. It may not, therefore, have formed part of the Prato altarpiece. The predella to that altarpiece was originally 240 cm. wide and could not have been accommodated beneath the present panel unless (i) it was flanked by panels of full-length standing saints, or (ii) it included other figures besides Saint Thomas in its lower section. Steinweg ("Contributi," p. 40, n. 34) has convincingly argued against the first hypothesis. The altarpiece cannot have shown, in addition to Saint Thomas, the other apostles standing around the empty tomb of the Virgin since that subject is represented in the initial scene of the predella. It is possible, however, that the lower section of the altarpiece represented the Dormition of the Virgin, as in Orcagna's tabernacle at Or San Michele. Offner (according to a letter to Robert Lehman of August 27, 1957, preserved in the Lehman Collection Archives) believed that, given the extremely high quality of the Prato predella, the main panel of the altarpiece would have been entirely autograph, and he concluded that the present panel was intended for some other commission, possibly for an altar in the Pieve di Santa Maria at Impruneta.

The Prato altarpiece was enlarged in 1367 (see Marchini, *Il tesoro del Duomo di Prato*, 1963, p. 99), and a mistaken attempt is made by Marchini ("Vicende," pp. 320–23) to date the present panel to that year and to ascribe it to Alesso di Andrea, a secondary artist who was active at Pistoia at this time. The style of Alesso di Andrea (for which see U. Procacci, "Quattro Virtù di Alesso di Andrea scoperte nella Cappella di S. Jacopo nel Duomo di Pistoia," in *Studien zur toskanischen Kunst: Festschrift für Ludwig Heinrich Heydenreich*, 1964, pp. 244–54, and M. Meiss, "Alesso di Andrea," in *Giotto e il suo tempo*, 1971, pp. 401–18) is wholly unrelated to that of the Lehman painting.

CONDITION: The paint surface throughout is heavily abraded, with extensive retouching of small paint losses along the craquelure. Larger paint losses are confined to the center of the top edge and to the left and bottom margins.

PROVENANCE: Lombardi-Baldi, Florence (oral communication to M. Boskovits by F. Zeri); Harold Parsons, Rome, 1954 (note on a photograph in the library of the Harvard Center for Renaissance Studies, Villa I Tatti, Florence); Carlo and Marcello Sestieri, Rome. Acquired by Robert Lehman before 1957.

EXHIBITED: Musée de l'Orangerie, Paris, *La collection Lehman*, 1957, no. 13 (as possibly part of the Prato altarpiece, "sorti de

l'atelier de Daddi, ou une composition qui reflète celle de Daddi et exécutée par un artiste de son entourage"); Metropolitan Museum of Art, New York, 1958–61 (as Bernardo Daddi); Cincinnati Art Museum, *The Lehman Collection*, 1959, no. 59 (as Bernardo Daddi).

Workshop of Bernardo Daddi

24. Madonna and Child Enthroned

1975.1.59

Tempera on panel, transferred to canvas. 25.6 × 9.5 cm. (10¹⁄₁₆ × 3¾ in.). The canvas transfer has been remounted on an old panel and cut on all sides to its present dimensions.

The Virgin, in a red dress covered by a blue, gold-edged cloak, sits enthroned before a gray and gold cloth of honor fringed at the top in red and blue. The throne is raised on a step, the front face of which is decorated with a perforated quadrilobe and an inlaid diamond design. The Virgin's head is turned toward the Child, whom she supports in a standing position on her left thigh. The Child, swaddled in white and red, reaches up to touch his mother's cheek.

The painting, which is given by Berenson (1968, vol. 1, p. 56) to Daddi, is a fragment from a slightly reduced variant of the *Madonna and Child with Four Saints* by Bernardo Daddi in the Pinacoteca Nazionale di Capodimonte, Naples (see R. Offner, *A Critical and Historical Corpus of Florentine Painting*, sec. 3, vol. 3, 1930, p. 30, pl. 5). Another close variant of the Naples *Madonna*, dated 1336, exists in the church of San Giorgio a Ruballa, near Florence (U. Procacci, "Restauri a dipinti della Toscana," *Bollettino d'arte*, 29, 1936, pp. 376–77), and a third was formerly in the collection of Frank Channing Smith at Worcester, Mass. (E. S. Vavalà, "Early Italian Paintings in the Collection of Frank Channing Smith, Jr.," *Worcester Art Museum Annual*, 3, 1937–38, pp. 25–28). In the present painting the Virgin's dress and cloak are not patterned as they are at Naples, and the border of her cloak falls outside her left leg, not between her knees. In the Naples panel the Child is naked beneath the cloth held round him by the Virgin. In its original form, before the paint film was reduced and transferred (see above), the central group may have been flanked by two or more lateral saints.

No. 24

The primacy of the Naples version is revealed in its superior handling and in the assurance of its drawing, which is fully consonant with the style of Daddi's early autograph works. The poor condition of the present painting accounts only in part for the weakness of its execution. Whereas at Naples the Child moves confidently toward his mother and grasps her collar tightly with his left hand while stroking her cheek with his right, in the present painting the Child stands uncertainly on the Virgin's thigh, his left hand hovers ambiguously in front of her, and his right reaches tentatively toward her face.

Offner (op. cit., sec. 3, vol. 4, 1934, p. 6) groups the present painting with a number of works by the shop and close following of Daddi executed "not only under the direct influence but also by the order of the master" (ibid., p. 1). Some of these betray idiosyncrasies sufficiently close to the Lehman painting as to suggest possible identity of authorship. These include the *Crucifixion* tabernacle, dated 1334, in the Fogg Art Museum (ibid., pp. 55–56, pl. 24); a tabernacle, dated 1338, in the National Gallery of Scotland (ibid., pp. 77–78, pl. 34); and the *Madonna and Child with Four Saints*, formerly in the Frank Channing Smith collection, which forms part of a diptych with a panel of the Crucifixion (ibid., pp. 75–76, pl. 33).

The Naples *Madonna* is commonly assigned (Offner, op. cit., sec. 3, vol. 3, p. 30) to the early 1330s and seems to have been produced after the Uffizi triptych of 1328 and before the Bigallo tabernacle of 1333. The present *Madonna* appears to date from the middle or second half of the decade.

The early provenance given for the painting by Offner (op. cit., sec. 3, vol. 4, 1934, p. 6), followed by Laclotte (in *La collection Lehman*, exh. cat., Musée de l'Orangerie, Paris, 1957, p. 11, no. 12), is incorrect. The picture is not identical with that sold as lot 127 in the Davenport Bromley sale (Christie's, London, March 6, 1897) and as lot 58 of the Charles Butler sale (Christie's, London, May 25, 1911), which was considerably larger and had an arched top. The Bromley-Butler *Madonna* measured 56.2 × 28 cm., and these dimensions are incorrectly assigned to the present panel by Offner, followed by Laclotte (loc. cit.), and in the catalogue of the Cincinnati exhibition of the Lehman Collection (p. 16, no. 58).

CONDITION: The gold ground is modern, though traces of the original gold and bole survive in the haloes. A painted craquelure has been added to the gold to reinforce the crackle still visible in the gesso layer beneath. The mordant gilding in the cloth of honor and in the border of the Virgin's cloak is largely original. Extensive losses throughout the figures have been inpainted. The dais and gable of the throne are overpainted.

PROVENANCE: R. Langton Douglas, London, 1928; Arthur Ruck, before 1934 (see Offner, op. cit., sec. 3, vol. 4, 1934, p. 195). The date of acquisition by Robert Lehman is not recorded.

EXHIBITED: Musée de l'Orangerie, Paris, *La collection Lehman*, 1957, no. 12; Metropolitan Museum of Art, New York, 1958–61 (as Bernardo Daddi); Cincinnati Art Museum, *The Lehman Collection*, 1959, no. 58.

Circle of Bernardo Daddi

25. The Nativity

1975.1.60

Tempera on panel. With original moldings: 29.5 × 21.3 cm. (11⅝ × 8⅜ in.); picture surface: 21.7 × 17.5 cm. (8½ × 6⅞ in.). The panel is 18 mm. thick. There are traces of a hinge 4 cm. from the bottom edge on the right-hand side. An area of gesso 7 cm. from the top on the right may conceal damage from a second hinge.

The Virgin, in a red robe and blue cloak, kneels at the upper left in a rocky landscape. She places the Child Christ in the manger beneath a shed. The ox and the ass look on from the right. In front of the manger sits Saint Joseph in a violet and blue cloak. At the upper left two angels in red robes fly into the stable. In the foreground is the Annunciation to the Shepherds, with two shepherds looking up at the Annunciatory Angel. A dog and a flock of sheep appear at the left. The back of the panel is painted in four quadrants with alternating fields of red and green bordered in yellow. In the center of each quadrant is a quatrefoil interlace with a rosette in its center.

The composition employs motifs that recur in paintings by artists in the following of Bernardo Daddi. The figure of the Virgin placing the Child in the manger has parallels in the left wing of a triptych formerly at Konopiště and now in the Národni Galerie, Prague (R. Offner, *A Critical and Historical Corpus of Florentine Painting*, sec. 3, vol. 4, 1934, p. 130, pl. 50) and in a panel of the Nativity formerly in the Ventura collection, Florence (ibid., sec. 3, vol. 8, 1958, pl. 31), in both of which the head is shown in profile, not as here in three-quarter face. The two shepherds in the foreground are related to those in the left wing of a triptych from the close following of Daddi, in the Staatliche Museen, Berlin-Dahlem (ibid., sec. 3, vol. 4, pl. 35). The attributional problem presented by the panel is complicated by its condition, but its style is more closely related to the early work of Taddeo Gaddi

No. 25

than to the work of Bernardo Daddi. It seems to have been executed ca. 1335–40 (Boskovits, verbally) by a minor Florentine painter who was familiar with both artists' works. The presence of hinge marks on the right side (see above) suggests that this was originally the left valve of a diptych and was paired with a panel probably representing the Crucifixion.

CONDITION: The paint surface is much abraded and has flaked extensively. Broad repaints fill the foreground and the central hill behind, and the green of the Virgin's dress and the green of the Annunciatory Angel's sleeves and robe are reinforced. The flock of sheep, the dog, and the faces of the shepherds exist only as underpaint. The paint surface on the back of the panel is well preserved save for a hole in the lower right quadrant, which has exposed the gesso and linen beneath the paint surface.

PROVENANCE: Acquired by Robert Lehman in Florence in 1913.

EXHIBITED: Metropolitan Museum of Art, New York, 1954–61 (as school of Giotto); Cincinnati Art Museum, *The Lehman Collection*, 1959, no. 68a (as follower of Giotto).

The painter, who was active in the second quarter of the fourteenth century, is the anonymous author of nine illuminations in a manuscript of Domenico Lenzi, *Specchio umano ovè si tracterà . . . quanto e venduto il grano e altra biada* (Biblioteca Medicea Laurenziana, Florence, cod. Laurenziano Tempiano 3). The illuminations appear to have been completed about 1340. The style of the artist springs from that of the Saint Cecilia Master and is influenced by the paintings of Bernardo Daddi. The same painter was also responsible for illuminating a page in the statutes of the Arte della Lana of 1333 (Archivio di Stato, Florence, Arte della Lana 4); for three illuminated pages in a manuscript of Dante's *Divina Commedia* (Biblioteca Palatina, Parma, ms. 3285); for thirty-eight illuminations in Brunetto Latini's *Tesoro* (Biblioteca Medicea Laurenziana, cod. Plut. 42.19); and for two panel paintings, one of which is discussed below.

26. The Last Judgment; Madonna and Child with Saints; The Crucifixion; The Glorification of Saint Thomas Aquinas; The Nativity

1975.1.99

Tempera on panel. Overall: 66.8 × 47.4 cm. (26⁵⁄₁₆ × 18¹¹⁄₁₆ in.); picture surface: 58 × 42.4 cm. (23¼ × 16⁵⁄₈ in.). The panel has been thinned and cradled. The original engaged frame has been cut away, but the paint preserves its lip at the sides and on the top. The present molded frame is modern.

The panel contains five scenes. In the triangular gable is the Last Judgment, with Christ in a mandorla supported by two angels with the instruments of the Passion and two angels with trumpets. Beneath are two empty tombs. On the left is a group of the Saved, represented as crowned figures in red or white robes watched over by an angel and presented to Christ by the Virgin. The angel holds a scroll with the words VENITE BENEDITT/PATER MEI EPOSIDETE. On the right are the Damned, forced by an angel into a crevasse in the rocky ground, and a standing figure of Saint John the Evangelist. The angel holds a scroll with the words GITE.MALLADITTI.INI/NGNAM ETTERNA. In the body of the panel are four horizontal scenes. Above *(left)* is a Virgin and Child enthroned with a bishop saint (Augustine?) and Saint Peter Martyr, the Child holding a finch and the Virgin a spray of flowers, and *(right)* the Crucifixion, with the fainting Virgin and the Holy Women on the left, the Magdalene isolated at the foot of the cross, a bearded male figure to the right, and at the far

right Saint John the Evangelist and a group of soldiers. Below *(left)* is the Glorification of Saint Thomas Aquinas, with Saint Thomas enthroned at a reading desk and Averroes beneath his feet. At the left is Saint Peter holding a scroll with the words ASCULTA OFILII P(RE)C/ETTA MAGISTRI, and on the right is a second bearded saint. A row of auditors in front includes figures in Franciscan, Dominican, and Carmelite habits. Below *(right)* is the Nativity, with the manger elevated on a cliff and two seated women in the foreground bathing the Child Christ.

This beautiful panel, which may have been the center of a tabernacle, was initially ascribed, in the Aynard collection (see below), to Pietro Cavallini. It was regarded by Sirén as Riminese (*A Descriptive Catalogue of the Pictures in the Jarves Collection Belonging to Yale University*, 1916, p. 30) and by Van Marle ("La scuola di Pietro Cavallini a Rimini," *Bollettino d'arte*, 1, 1921–22, pp. 248–61; *Development*, vol. 4, 1924, p. 288) as the work of a Cavallinesque painter active in Rimini. In the 1928 catalogue of the Philip Lehman Collection (pl. 73), the panel was ascribed by Robert Lehman to an unknown Marchigian painter active ca. 1300. The verbal opinions cited in the Lehman catalogue comprise "Berenson: Close to Daddi; De Nicola: Roman School; Offner: Partly Roman, largely Florentine derivation; Perkins: Early Romagnole-Giottesque showing strong Roman influence; Van Marle: School of Rimini—under influence of Cavallini." The panel was again described as Riminese in a discussion of its iconography by Alba Medea ("L'iconografia della scuola di Rimini," *Rivista d'arte*, 22, 1940, pp. 2, 4, 16, 29, 39), and was exhibited as "School of the Marches about 1300" at The Cloisters, New York, in 1968–69 (C. Gomez-Moreno, *Medieval Art from Private Collections*, exh. cat., 1968, no. 11).

Despite the tenacity with which the panel has been relegated to the Marches and to the Romagna, there can be no reasonable doubt that it is Florentine and that it is, as Offner indicated (*A Critical and Historical Corpus of Florentine Painting*, sec. 3, vol. 2, pt. 1, 1930, p. 46), the work of the Biadaiolo Illuminator, the artist responsible for nine miniatures in the Laurenziana manuscript of Domenico Lenzi's *Specchio umano ovè si tracterà . . . quanto e venduto il grano e altra biada* in the Biblioteca Medicea Laurenziana, Florence (cod. Laurenziano Tempiano 3), for which see Miglio ("Per una datazione del Biadaiolo fiorentino," *La bibliofilia*, 77, 1975, pp. 1–36), Pinto (*Il libro del Biadaiolo*, Florence, 1978), and Partsch (*Profane Buchmalerei der bürgerlichen Gesellschaft im*

No. 26

spätmittelalterlichen Florenz, Worms, 1981). The style of the Biadaiolo Illuminator is more fully discussed by Offner in a later volume of the *Corpus* (sec. 3, vol. 7, 1957, pp. iii–v, 3–6), where a number of further illuminations are ascribed to him. Two of these, in the Parma codex of the *Divina Commedia*, provide parallels for the nude figures and the angels in the gable of the present painting. A more inventive but older artist than the Master of the Dominican Effigies, with whom he is identified by Boskovits (*A Critical and Historical Corpus of Florentine Painting*, sec. 3, vol. 9, *The Painters of the Miniaturist Tendency*, 1984, p. 55) the Biadaiolo Master is placed by Offner (ibid., p. 5) "within the more modern trend in the second quarter of the century," in the circle of Bernardo Daddi.

Saint Thomas Aquinas was canonized on July 18, 1323. Though he is shown in half-length in the predella of Simone Martini's Pisa polyptych (1319), there is no precedent for the representation of his glorification in the present panel, which was later developed in an altarpiece in Santa Caterina at Pisa ascribed to Traini. The year 1323 can be accepted as a *terminus post quem* for the production of the present panel. Kaftal (*Iconography of the Saints in Tuscan Painting*, Florence, 1952, col. 982) observes that the pupils of Saint Thomas shown in the front plane include Saint Louis of Toulouse (canonized 1317).

CONDITION: The paint surface is extremely well preserved. There are minor retouches following a vertical crack 12.7 cm. (5 in.) from the left edge and along the bottom of the panel.

PROVENANCE: Edouard Aynard, Lyon, prior to 1877; Aynard sale, Galerie Georges Petit, Paris, December 1–4, 1913, no. 42; R. Langton Douglas, London. Acquired by Philip Lehman in 1916.

EXHIBITED: Palais des Beaux-Arts, Lyon, 1877; Metropolitan Museum of Art, New York, 1954–61 (as Unknown Painter of the Marches, dated about 1300); Cincinnati Art Museum, *The Lehman Collection*, 1959, no. 89 (as Unknown Master of the Marches); The Cloisters, New York, *Medieval Art from Private Collections*, 1968–69, no. 11 (as School of the Marches about 1300).

The Master of the Fabriano Altarpiece (Puccio di Simone)

Formerly confused with Allegretto Nuzi, the Master of the Fabriano Altarpiece is an independent follower of Bernardo Daddi, active from about 1340 through the 1360s. He was named by Offner after an altarpiece of Saint Anthony Abbot at Fabriano, where he apparently worked alongside Nuzi in the 1350s. Recently, the Master of the Fabriano Altarpiece has been identified with the Florentine painter Puccio di Simone, author of a much-repainted polyptych in the Accademia, Florence, and of a Madonna formerly in the Artaud de Montor collection. Puccio is documented in Florence in 1346 and in Pistoia in 1349; he apparently died in 1362. Though his identification with the Master of the Fabriano Altarpiece was strenuously denied by Offner, it has today gained general acceptance.

27. The Nativity

1975.1.105

Tempera on panel. 20.1 × 38.1 cm. (7⅞ × 15 in.). The panel, which has a horizontal grain, has been thinned to 11 mm. and cradled.

The scene is set in a rocky landscape with a crevasse in the foreground and hills curving up at either side. The Virgin, in a white cloak, kneels to the left of center beneath the stable roof. She places the Child, swaddled in white and red, in the manger, which is set before a cave. The ox and the ass appear behind it. To the right is Saint Joseph, dressed in yellow with a blue skullcap, seated in left profile on the ground. Among the plants depicted in the foreground are thistles and strawberries. A palm, a chestnut, and two other trees rise behind the hills against the gold ground.

The panel forms part of a predella, other sections of which are a *Pietà* (Fig. 18) in the Staatliche Museen, Berlin-Dahlem (no. 1059), and a scene with the Three Marys at the Tomb (Fig. 19) in the Statens Museum for Kunst in Copenhagen. Initially ascribed by Sirén (*Giotto and Some of His Followers*, 1917, vol. 1, p. 276) to Nardo di Cione, the present panel was given by Berenson ("Prime opere di Allegretto Nuzi," *Bollettino d'arte*, 1, 1922, pp. 298, 302, 308 [reprinted in *Studies in Medieval Painting*, 1930, pp. 63–74]; 1932, p. 400; 1936, p. 344) to Allegretto Nuzi. This attribution was retained by R. Lehman (1928, pl. 66) and by Serra ("La scuola fabrianese," *Rassegna marchigiana*, 6, 1927–28, p. 130; *L'arte nelle Marche*, 1929, p. 281). Offner, who first associated the

three surviving panels of the predella ("A Daddesque Predella," in *Studies in Florentine Painting*, 1927, pp. 43–48), gave them to a follower of Bernardo Daddi influenced by Orcagna. In a later analysis by Offner (*A Critical and Historical Corpus of Florentine Painting*, sec. 3, vol. 5, 1947, pp. 141, 163–71) they are given to the Master of the Fabriano Altarpiece, a follower of Bernardo Daddi responsible for a polyptych of 1353 at Fabriano. It is argued by Offner, correctly, that the panels precede the painting of 1353, and that their style therefore reflects the influence not of the Strozzi altarpiece of Orcagna in Santa Maria Novella, Florence (1357), but of some earlier painting by Orcagna which has not survived.

A fourth panel with Christ in the Tomb between Saint Mary Magdalene, the Virgin, and Saint John the Evangelist, formerly in the Nemes collection, Munich, was later identified by Offner (ibid., sec. 3, vol. 8, 1958, pp. 166–67) as part of the same predella, which would then have consisted of the present panel, a missing Adoration of the Magi, and three Passion scenes, with the Nemes panel (which is considerably wider than the remaining panels: 21 × 60 cm.) standing in the center. Though a predella by Giovanni da Milano in the Galleria Comunale, Prato, comprises three scenes from the infancy and three scenes from the Passion of Christ, it does not, as Offner claimed, offer a true analogy for this reconstruction. The connection of the Nemes panel with this predella is rightly contested, on grounds of dimensions, iconography, and style, by Longhi ("Una riconsiderazione dei primitivi italiani," *Paragone*, vol. 16, no. 183, 1965, pp. 8–16) and Boskovits (*A Critical and Historical Corpus of Florentine Painting*, sec. 3, vol. 9, *The Painters of the Miniaturist Tendency*, 1984, p. 77). It is established by Longhi that the predella included an Annunciation, on the Paris art market in 1962 and later in a private collection at Bergamo, which would have stood to the left of the present panel. In this reconstruction the missing central panel of the predella would have represented either the Crucifixion or some scene from the infancy of Christ. The panel from this predella in Copenhagen (for which see *Royal Museum of Fine Arts: Catalogue of Old Foreign Paintings*, 1951, pp. 367–68, no. 836) has an inscription in ink on the back that reads *Tavoletta di S. Domenico a Perugia*. It is suggested by Boskovits (loc. cit.) that the entire altarpiece may have originated from this church.

On the strength of a signed Madonna of 1360 formerly in the Artaud de Montor collection (sale, Sotheby's, London, June 24, 1964, lot 49), and of a polyptych in the

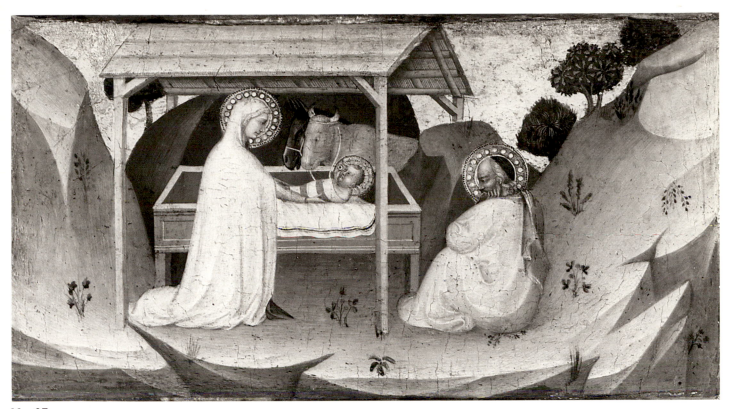

No. 27

Accademia in Florence, the Master of the Fabriano Altar-piece is identified by Longhi ("Qualità e industria in Taddeo Gaddi," *Paragone*, vol. 10, no. 111, 1959, p. 9; "Una riconsiderazione dei primitivi italiani," *Paragone*, vol. 16, no. 183, 1965, pp. 8–16, reprinted in *"Giudizio sul Duecento" e ricerche sul Trecento nell'Italia Centrale*, Florence, 1974) with the Florentine painter Puccio di Simone. It is suggested by Marabottini ("Allegretto Nuzi," *Rivista d'arte*, 27, 1951–52, pp. 23–55) that the author of these panels followed Allegretto Nuzi from Florence to Fabriano and had a profound influence on Nuzi's style. The identification of the painter with Puccio di Simone is accepted by Donnini ("On Some Unknown Masterpieces by Nuzi," *Burlington Magazine*, 117, 1975, p. 536), but is contested by Offner (*Corpus*, sec. 3, vol. 9, 1958, pp. 1–11, 185–92).

Offner points out that "the moment selected in the Lehman Nativity from the Pseudo-Bonaventura's account of Christ's infancy [Meditationes Vitae Christi, Opera omnia S. Bonaventurae, Paris, XII, 1871, cap. xlviii],

when the Virgin places the Child in the manger, occurs with relative frequency in Daddi's workshop in the thirties and early forties."

CONDITION: The paint surface, though covered with an uneven gray varnish, is generally well preserved. The white highlights on the Virgin's cloak have been strengthened, and a circular patch of white on her shoulder has been repainted and supplied with an engraved craquelure. The back of Saint Joseph's skull-cap has also been strengthened. The gold sky to the left of the stable and part of the gold background on the right are modern. The upper right corner of the panel has been repainted, and losses along the edges have been touched in.

PROVENANCE: Vicomte Bernard d'Hendecourt, Paris; pur-chased by Philip Lehman in 1915; Pauline Ickelheimer, New York. Acquired by Robert Lehman in 1946.

EXHIBITED: Musée de l'Orangerie, Paris, *La collection Lehman*, 1957, no. 297 (as Maître du Retable de Fabriano); Metro-politan Museum of Art, New York, 1958–61 (as Unknown Florentine).

Allegretto Nuzi

First recorded in Fabriano in 1345, Allegretto Nuzi traveled to Florence in 1346, where he came under the influence of Maso di Banco and Bernardo Daddi. He seems to have been associated with a painter in Daddi's circle, who is generally identified as Puccio di Simone (see No. 27). He returned with this artist to Fabriano and collaborated with him on a triptych, dated 1354, now in the National Gallery of Art, Washington: this is Allegretto's earliest dated painting. His later career was spent almost exclusively in the Marches and is documented by dated pictures of 1365 (Vatican), 1366 (San Severino Marche), 1369 (Urbino), and 1372 (Urbino). Allegretto Nuzi died between September 23 and November 20, 1373.

28. The Crucifixion

1975.1.106

Tempera on panel. 43.6 × 19.9 cm. (17⅛ × 7⅞ in.). The panel has been thinned to 2 mm., mounted on a thin piece of old wood, and cradled. At the sides are two raised strips which formed part of the original engaged frame, regilt to correspond with the modern frame moldings.

In the center is the crucified Christ. The arms of the cross overlap the tooled border of the panel and are cut, at the upper corners, by the gable of the engaged frame. From the top of the cross springs a tree in leaf bearing a nest with a pelican feeding two fledglings. Beneath the hands of Christ are two flying angels holding basins to catch the blood; a third angel with a basin appears at his left side. Opposite is an angel with head turned frontally and arms extended. The angels are dressed in red and blue. At the base of the cross is the kneeling Magdalene, in a red cloak, and isolated to the right is Saint John the Evangelist wearing a vermilion cloak over a blue robe. Behind to the left, supported by two Holy Women, is the Virgin, who looks sorrowfully upward at her Son.

The attribution of the panel to Allegretto Nuzi is due to Offner, and the panel is catalogued under Nuzi's name by R. Lehman (1928, pl. 65). The Lehman catalogue records verbal attributions by Berenson to a Bolognese painter, possibly Jacopo d'Avanzi, and by De Nicola to a Tuscan, probably Florentine, artist. Both Perkins and Van Marle ascribe the painting to Allegretto Nuzi or his workshop, and compare the panel with a diptych in Berlin (see below). This attribution was later accepted by Berenson (1932, p. 400; 1936, p. 344; 1968, vol. I, p. 304).

The panel is an early work by Allegretto Nuzi, painted under the strong influence of the Master of the Fabriano

Altarpiece (Puccio di Simone), and must originally have been part of a triptych or diptych. A somewhat later triptych from the same workshop, in the Kunstmuseum, Berne, shows the Crucifixion between two wings, each with paired saints, while a diptych in the Staatliche Museen, Berlin-Dahlem, shows a Madonna and Child with two saints in one wing and a Crucifixion in the other. The disposition of the main figures beneath the cross is repeated in the right wing of a triptych by Allegretto Nuzi in the Detroit Institute of Arts, and the three figures on the left recur in a panel of the Crucifixion by Francescuccio Ghissi, a close follower of Nuzi, in the Art Institute of Chicago (Ryerson collection).

CONDITION: Two vertical splits run through the body of Christ and to the left of the Magdalene. The picture is much abraded and has been liberally retouched. There are serious losses in the Magdalene's cloak and above the arms of the cross, where only fragments of the tree, nest, and pelican survive in their original state and the gold has been renewed. The back of the Magdalene's left hand and the fingers of Saint John are largely new. The profile of the Holy Woman turned to the left is new, as is part of the Virgin's jaw. The two outermost angels have been badly rubbed and reinforced; the inner angels and the body of Christ are more nearly intact.

PROVENANCE: M. Marignane, Paris. Acquired by Philip Lehman about 1918.

EXHIBITED: Smith College Art Museum, Northampton (Mass.), 1942–43; Cincinnati Art Museum, *The Lehman Collection*, 1959, no. 85.

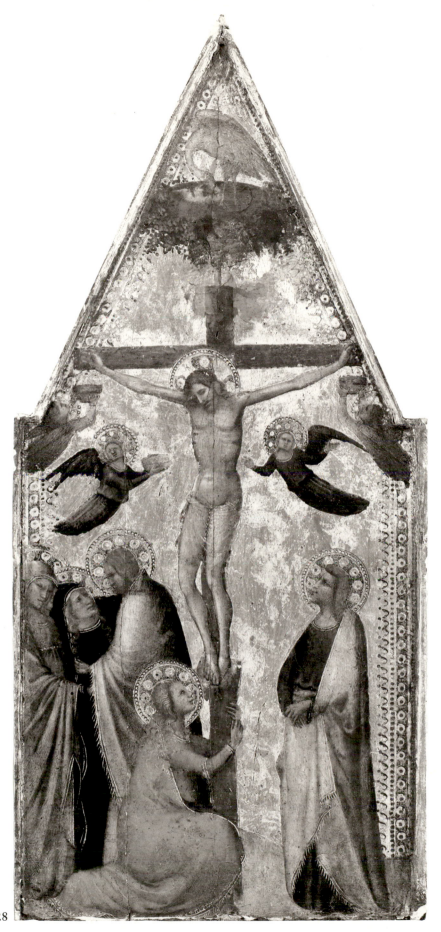

No. 28

Jacopo di Cione

Jacopo di Cione, younger brother of Andrea (Orcagna) and Nardo di Cione, was admitted to the guild of painters in Florence in 1369, though he had presumably been active as a painter for at least a decade before that. Upon the deaths of his brothers in 1366 and 1368 he inherited the direction of the family workshop, which he continued to operate in a semi-entrepreneurial fashion until his own death thirty years later. A *Coronation of the Virgin* in the Accademia in Florence is documented to the year 1373, and forms the basis for a reconstruction of the painter's oeuvre. A *Madonna and Child* formerly in the Stoclet collection is inscribed across its base with the date 1362. Once thought to be the artist's earliest work (Offner), it has recently been used as the basis for attributing to

Jacopo di Cione in a hypothetical youthful phase pictures that formerly bore ascriptions to the Master of the Infancy of Christ and the Master of the Prato Annunciation.

29. Six Angels

1975.1.65 A–F

Tempera on panel. Since before 1836 the angels, which are on ogival panels, have been framed with No. 32. The individual panels measure *(top left)* 24.6 × 9.9 cm. (9¾ × 3⅞ in.); *(top right)* 24.8 × 9.8 cm. (9¾ × 3⅞ in.); *(center left)* 28.3 × 13.3 cm. (11⅛ × 5¼ in.); *(center right)* 28.2 × 13.2 cm. (11⅛ × 5³⁄₁₆ in.); *(bottom left)* 25 × 9.7 cm. (9⅞ × 3¹³⁄₁₆ in.); *(bottom right)* 25.4 × 9.8 cm. (10 × 3⅞ in.). The gilded spandrels at the tops of the separate panels are original.

No. 29

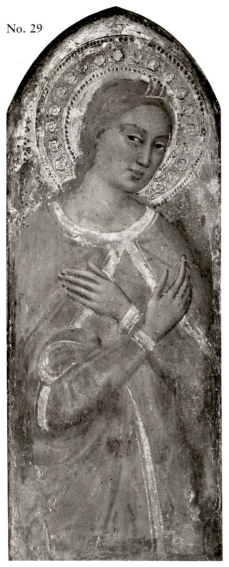
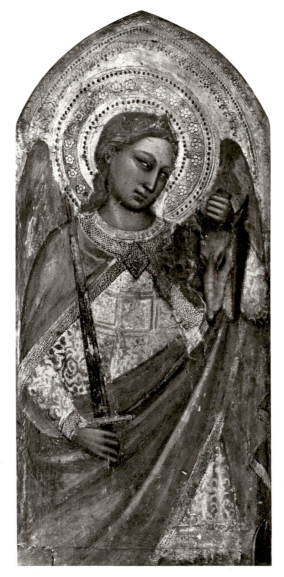
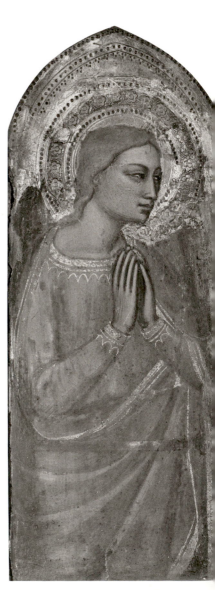

See the colorplate No. 32 for the present arrangement of the angels. They are portrayed in three-quarter length, those at the top and bottom facing inward in three-quarter face, and those in the center—*(left)* Saint Michael holding a sword and the head of a dragon; *(right)* the Archangel Raphael holding an ointment jar—in full face. The two upper and two lower angels are distinguished as cherubim *(right*, blue) and seraphim *(left*, red).

The six angels are given by Boskovits (*Pittura fiorentina alla vigilia del Rinascimento*, 1975, p. 328) to Jacopo di Cione. Offner (*A Legacy of Attributions*, supplement to *A Critical and Historical Corpus of Florentine Painting*, ed. H. B. J. Maginnis, 1981, p. 8) notes correctly that though the angels are probably from a single complex,

they are by two different hands. The two central angels are markedly superior to their companions. They appear to have formed the pinnacles of a small altarpiece.

CONDITION: Despite extensive losses and repainting in the draperies at the edges, the stylistic character of the panels has not been falsified.

PROVENANCE: See No. 32.

EXHIBITED: See No. 32.

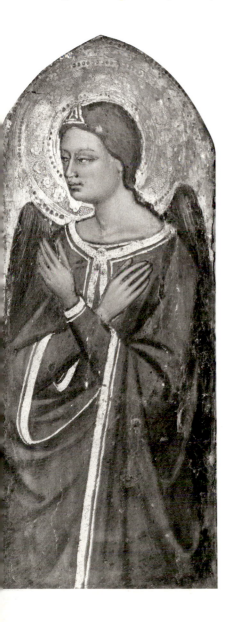
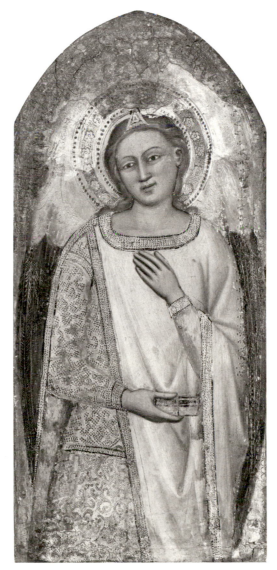
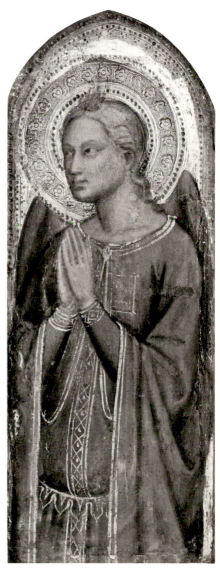

The Master of the Orcagnesque Misericordia

The Master of the Orcagnesque Misericordia, who was active in the second half of the fourteenth century, is so called after a *Madonna della Misericordia* in the Accademia in Florence. Evidently trained in Florence in the second quarter of the century in the circle of Bernardo Daddi, he later succumbed to the influence of Jacopo di Cione.

30. The Vision of Saint Catherine of Alexandria

1975.1.62

Tempera on panel. Overall: 21 × 34.2 cm. (8¼ × 13½ in.); picture surface: 20 × 32.8 cm. (7⅞ × 12⅞ in.). The thickness of the panel is 3.1 cm. On the back, in ink, are old attributions to Masaccio and Starnina. The panel seems not to have been thinned, though it has been shaved at the top and bottom and sawn through at the sides.

The scene is set before an oratory, on the end wall of which is a painting of the half-length Virgin and Child. On the left kneels Saint Catherine in right profile, in a light rose dress with arms extended in greeting to the Child Christ, who approaches from the right. On the far right is the standing figure of the Virgin wearing an ultramarine cloak over a pink robe. The Child points with his right hand toward Saint Catherine and turns his head back to his mother.

This rare scene recounts an early incident in the life of Saint Catherine of Alexandria, who after rejecting the suitors for her hand was told by a hermit that she would be the bride of Christ. On the same night she dreamt that the Virgin appeared to her with the Child Christ, but that Christ turned away declaring that she was insufficiently beautiful to be his bride (see J. Sauer, "Das Sposalizio der hl. Katharina von Alexandrien," in *Studien aus Kunst und Geschichte, Friedrich Schneider zum siebzigsten Geburtstage gewidmet von seinen Freunden und Verehrern*, 1906, pp. 339–51; Tito da Ottone, O.M.C., *La leggenda di Santa Caterina vergine e martire di Alessandria*, 1940; G. Kaftal, *Iconography of the Saints in Tuscan Painting*, 1952, col. 229). The panel forms part of a predella devoted to the life of Saint Catherine of Alexandria, of which other panels are in the Bromley Davenport collection, Capesthorne Hall, Macclesfield, Cheshire (*The Disputation of Saint Catherine of Alexandria*), and the Worcester Art Museum (*The Martyrdom of Saint Catherine of Alexandria*; Fig. 20). For the latter see Davies, *European Paintings in the Collection of the Worcester Art Museum*, 1974, pp. 357–58. It is possible that the central panel of the altarpiece beneath which this predella stood is the *Mystic Marriage of Saint Catherine* now in the Heinz Kisters collection at Kreuzlingen, Switzerland (see B. Berenson, "Quadri senza casa: il Trecento fiorentino," *Dedalo*, 11, 1930–31, p. 1058; M. Boskovits, *Pittura fiorentina alla vigilia del Rinascimento*, 1975, p. 369, fig. 217).

There is some disagreement on the attribution of the three predella panels. Given by R. Lehman (1928, pl. 9) to the school of Agnolo Gaddi, they were later ascribed by Vavalà (in P. B. Cott, "The Theodore T. and Mary G. Ellis Collection, 1: Continental European Paintings," *Worcester Art Museum Annual*, 4, 1941, p. 8, p. 25, n. 2) to the circle of Niccolò di Pietro Gerini, and by Berenson (1963, vol. 1, pp. 215–16) to a follower of Giovanni da Milano. They are regarded by Boskovits (op. cit., pp. 63, 370, fig. 208) as early works of the artist termed by Offner the Master of the Orcagnesque Misericordia. Though they are omitted by Zeri ("Sul catalogo dei dipinti toscani del secolo XIV nelle gallerie di Firenze," *Gazette des Beaux-Arts*, 71, 1968, pp. 74–75) from a list of works attributable to this painter, Offner's attribution to the Misericordia Master is reiterated by Maginnis (*A Legacy of Attributions*, supplement to R. Offner, *A Critical and Historical Corpus of Florentine Painting*, 1981, p. 12) and is likely to be correct.

CONDITION: A beard of paint is evident locally at the top, while 1.3 cm. of the paint surface at the base across the entire panel, including the Child's feet and the hem of the Virgin's robe, is new. The profile of Saint Catherine, including the chin, mouth, nose, and brow, is a modern restoration, as is the Virgin's right eye. Scattered losses through the architectural background and in the dress of Saint Catherine have been retouched.

PROVENANCE: Loebl, Paris. Acquired by Philip Lehman in 1924.

EXHIBITED: Cincinnati Art Museum, *The Lehman Collection*, 1959, no. 61 (as Agnolo Gaddi).

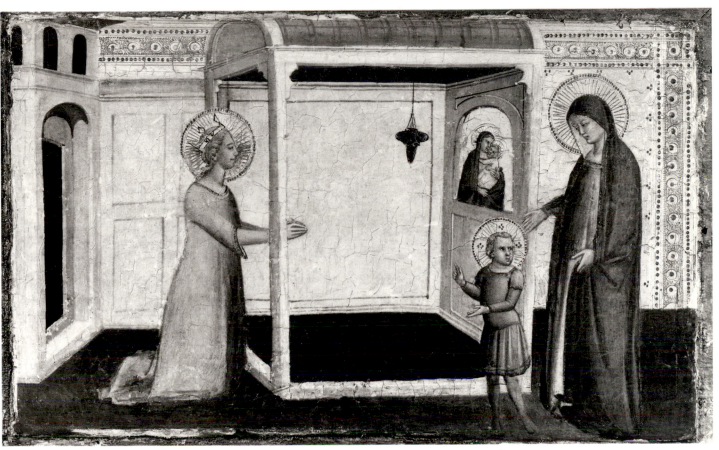

No. 30

The Master of Santa Verdiana

A follower of Jacopo di Cione, who came strongly under the influence of his contemporaries Agnolo Gaddi and Niccolò di Pietro Gerini, the Master of Santa Verdiana was a specialist in small-scale devotional paintings. He appears to have worked mainly in provincial centers around Florence. He is named for a panel in the High Museum of Art, Atlanta, which includes a representation of Santa Verdiana (W. Suida, *The Samuel H. Kress Collection, Birmingham Museum of Art*, 1959, pp. 20–21), and is identical with the painter christened by Offner the Master of the Louvre Coronation.

31. Triptych

1975.1.69

Tempera on panel. Central panel: 44.5 × 22.8 cm. (17½ × 8 in.); left panel: 42.8 × 11.4 cm. (16⅞ × 4½ in.); right panel: 43.5 × 11.5 cm. (17⅛ × 4⁹⁄₁₆ in.). The back of the triptych is painted red, with black trim on the shutters. The panels have not been reduced in depth. The hinges appear to be original.

The central panel shows *(above)* the Virgin enthroned suckling the Child, with *(left)* Saints Peter and Bartholomew and *(right)* Saints Catherine of Alexandria and Paul, and *(below)* the Nativity in a rocky landscape, with the Virgin, in right profile, caressing the Child, who lies in the manger, and Saint Joseph seated on the right. In the left wing are *(above)* the Annunciatory Angel, *(center)* the crucified Christ with the Virgin and Saint John standing in profile and Saint Mary Magdalene kneeling in full face beneath the cross, and *(bottom)* Christ as the Man of Sorrows, in his tomb, surrounded by the symbols of the Passion. In the right wing are *(above)* the Virgin Annunciate, *(center)* Saints Onophrius and Paphnutius, and *(bottom)* Saint Onophrius buried by Saint Paphnutius with the aid of two lions.

The triptych is ascribed by Boskovits ("Der Meister der Santa Verdiana," *Mitteilungen des Kunsthistorischen Institutes in Florenz*, 13, 1967, pp. 34–35; *Pittura fiorentina alla vigilia del Rinascimento*, 1975, pp. 230, n. 98, 386) to the Master of Santa Verdiana as an early work of ca. 1370–75. There can be no doubt that it is by the same hand as, and approximately contemporary with, the *Saint Michael and the Dragon* in the Walters Art Gallery, Baltimore, and the *Madonna of Humility* in the Philadelphia Museum of Art, also considered early works of the Master of Santa Verdiana by Boskovits. All these panels are by the same artist as the slightly later panel, in the High Museum of Art, to which this master owes his name.

The iconography of the Man of Sorrows in the left wing is of a type discussed by Berliner ("Arma Christi," *Münchner Jahrbuch der bildenden Kunst*, 6, 1955, pp. 55–60). The saints shown in the right wing are variously identified as Paul the Hermit and Anthony the Abbot (R. Offner, *A Legacy of Attributions*, supplement to *A Critical and Historical Corpus of Florentine Painting*, ed. H. B. J. Maginnis, 1981, p. 25, who lists the triptych as a work of the Rinuccini Master) and Onophrius and Paphnutius (C. Gomez-Moreno, *Medieval Art from Private Collections*, exh. cat., The Cloisters, New York, 1968, no. 14). On the analogy of an inscribed representation of Saint Onophrius in a polyptych by Puccio di Simone in the Accademia, Florence (no. 8569), and of a fresco ascribed to Traini in the Campo Santo at Pisa showing two lions assisting in the burial of the saint (for which see Kaftal, *Iconography of the Saints in Tuscan Painting*, 1952, c. 779, fig. 879), the second identification is likely to be correct.

CONDITION: The paint surface is in extremely good condition. The engaged molding of the central panel has been repainted red. At the top of the left wing the painted molding is modern, and the gold ground has flaked above the angel's head. On the right, the gold at the top is well preserved, but the back wall of the Virgin's chamber has been overpainted in brown, the original red paint being visible beneath.

PROVENANCE: Mr. and Mrs. A. E. Goodhart, New York. Bequeathed by Mrs. Goodhart to Robert Lehman in 1952.

EXHIBITED: Metropolitan Museum of Art, New York, 1954–61 (as Florentine, fourteenth century); Cincinnati Art Museum, *The Lehman Collection*, 1959, no. 69 (as Florentine Master, fourteenth century); The Cloisters, New York, *Medieval Art from Private Collections*, 1968, no. 14.

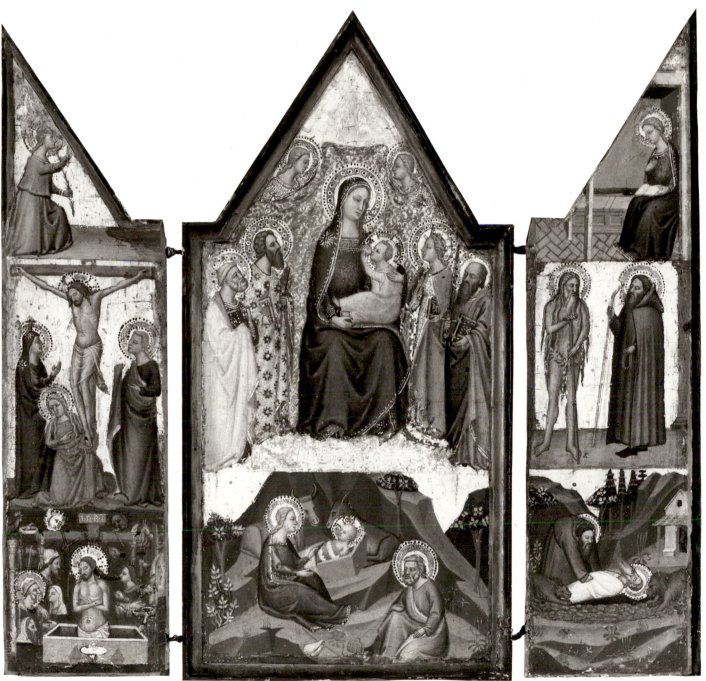

No. 31

Don Silvestro de' Gherarducci

A miniature painter of notably high quality, Don Silvestro de' Gherarducci was born in Florence in 1339. In 1352 he entered the monastery of Santa Maria degli Angeli, where he was engaged in decorating antiphonaries and graduals, some of which are in the Biblioteca Laurenziana in Florence. His work is also known through a number of excised illuminations. He appears to have been trained in the circle of Jacopo di Cione, though his work reflects the influence of mid-fourteenth-century Sienese painting. He died in 1399. A restricted number of paintings can be securely attributed to him, among which is the panel discussed below.

32. The Crucifixion

1975.1.65

Tempera on panel. Overall: 137.4 × 82 cm. (54⅛ × 32¼ in.). The back of the panel is covered in black wax and cradled.

Designed as the central pinnacle of an altarpiece, the panel is exceptional both in its form and height. A wide ogival molding at the base originally fitted over the main panel of the altarpiece. To judge from the strips of tooling at either side, the present panel retains its full width. Above the base are two lobes from which there rises a narrow panel culminating at the top in two further lobes and a gable. The cross extends to the full height of the panel, its arms occupying a median point in the upper lobes. The gable is filled with a tree growing atop the cross, with a pelican in her piety. Beneath the arms of Christ are eight flying angels, two of them superimposed on the tooled border of the panel. One holds a basin beneath the wound in Christ's side, and the remaining seven are shown in lamentation. At the base, the Magdalene clutches the bloodstained cross. To the left in the foreground is the fainting Virgin supported by a Holy Woman and Saint John. The heads of six more women are seen behind them. To the right in the foreground two bearded male figures, one in a yellow cloak and the other in a gray cloak over a blue robe, are shown in converse. Four more male figures appear behind them, one of whom, in an ermine-lined gray cloak and an ermine-trimmed hat, raises his right arm to the cross.

This splendid panel has had more than its fair share of attributional vicissitudes. Ascribed by Ottley to Taddeo Gaddi, it was given by Waagen (*Works of Art and Artists in England*, 1838, vol. 2, p. 124) to Spinello Aretino and was noted by Crowe and Cavalcaselle (1864, vol. 1, pp.

453–54) as "a fine production of the Florentine School." It was attributed by Sirén initially (*Giottino*, 1908, pp. 26, 29, 33, 91, 107) to Giottino and subsequently ("Pictures in America of Bernardo Daddi, Taddeo Gaddi, Andrea Orcagna and His Brothers: II," *Art in America*, 2, 1913–14, pp. 335–36; *Giotto and Some of His Followers*, 1917, pp. 259–60) to Jacopo di Cione. The attribution to an early phase in the work of Jacopo di Cione was later accepted by Van Marle (*Development*, vol. 3, 1924, p. 506) and Berenson (1932, p. 275, and later editions), but not by R. Lehman (1928, pl. 6), who ascribes it to Andrea Orcagna and assistants, or L. Venturi (*Pitture italiane in America*, 1931, pl. 47), who gives it to Andrea da Firenze. A *Noli Me Tangere* in the National Gallery, London (no. 3894), is correctly identified by Davies (*National Gallery Catalogues: The Earlier Italian Schools*, 1951, p. 309) and Offner (*A Legacy of Attributions*, supplement to *A Critical and Historical Corpus of Florentine Painting*, ed. H. B. J. Maginnis, 1981, p. 8) as a work by the same hand. The artist has since been identified as Don Silvestro de' Gherarducci, some of whose panel paintings and miniatures have been reassembled by Levi d'Ancona ("Don Silvestro de' Gherarducci e il Maestro delle Canzoni," *Rivista d'arte*, 32, 1957, pp. 3–37).

A convincing attempt is made by Boskovits ("Su Don Silvestro, Don Simone e la 'Scuola degli Angeli,'" *Paragone*, vol. 23, no. 265, 1972, pp. 35–61; *Pittura fiorentina alla vigilia del Rinascimento*, 1975, pp. 68–69, 328, 424, fig. 270) to identify the complex from which the present panel comes with an altarpiece of 1372 from the Sala del Capitolo of the Convento degli Angeli. In this reconstruction the altarpiece would have comprised two wings with saints, now in the Musée d'Histoire et d'Art in Luxembourg (Fig. 21) and in a Roman private collection (Fig. 22), a missing central panel with a Coronation of the Virgin, a left gable with the London *Noli Me Tangere*, the present panel as the central gable, a right gable of unspecified subject, and a predella panel with the Man of Sorrows now in the Denver Art Museum (Kress collection).

CONDITION: The paint surface is very well preserved, and abrasion is largely restricted to the red garments at the base. There is some flaking in the hair of the Magdalene over the gold ground, and some inpainting on the titulus, the tree above the cross, and the feet of Saint John. Local repairs have been made in the gold ground behind the Magdalene, and alongside the cross beneath Christ's feet.

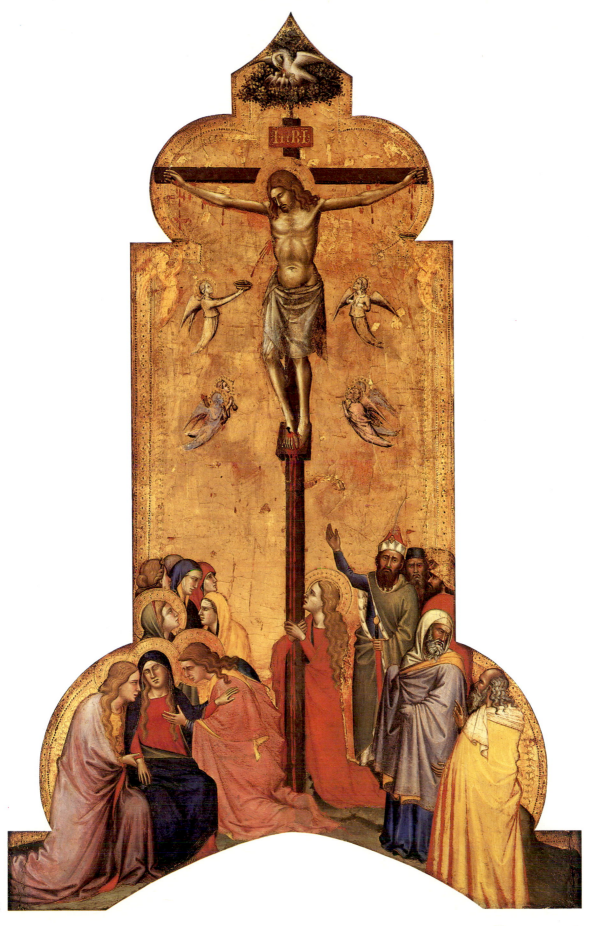

PROVENANCE: William Young Ottley, London, till 1836; Warner Ottley, London; Warner Ottley sale, Foster and Son, London, June 30, 1847, lot 20 (bought Grunnet; for this see E. K. Waterhouse, "Some Notes on William Young Ottley's Collection of Italian Primitives," in *Italian Studies Presented to E. R. Vincent*, 1962, p. 276); Sir Charles Eastlake by 1853 (see D. A. Robertson, *Sir Charles Eastlake and the Victorian Art World*, 1978, pp. 279–80); Lady Eastlake, London; Lady Eastlake sale, Christie's, London, June 2, 1894, lot 54; Harry Quilter, London; Quilter sale, Christie's, London, April 7, 1906, lot 75; Carfax Gallery, London; sold to Roger Fry, London, May 12, 1906; Léonce Rosenberg, Paris. Acquired by Philip Lehman prior to 1913.

EXHIBITED: Colorado Springs Fine Arts Center, *Paintings and Bronzes from the Collection of Mr. Robert Lehman*, 1951–52 (as Andrea Orcagna and Assistants); Metropolitan Museum of Art, New York, 1954–61 (as Orcagna and assistants); Musée de l'Orangerie, Paris, *La collection Lehman*, 1957, no. 43 (as Andrea Orcagna et son atelier); Cincinnati Art Museum, *The Lehman Collection*, 1959, no. 61 (as Andrea Orcagna and Assistants); The Cloisters, New York, *Medieval Art from Private Collections*, 1968–69, no. 12 (as Andrea Orcagna and Assistants).

Spinello Aretino

One of the leading Tuscan painters of the late fourteenth and early fifteenth centuries, Spinello Aretino was born in Arezzo, where he was active after 1373 and where he decorated a chapel in the Pieve in 1375. Thereafter he was engaged on major commissions for Lucca and Monte Oliveto Maggiore (see below), as well as on work in San Miniato al Monte, Florence, and the oratory of Saint Catherine at Antella (1387). In 1391–92 he undertook frescoes in the Campo Santo at Pisa, and in 1397 he executed an altarpiece for Santa Felicita, Florence. He died in 1411. The most remarkable of his late works is a cycle of scenes from the life of Pope Alexander III in the Sala di Balía of the Palazzo Pubblico in Siena.

33. Saint Philip

1975.1.63

Tempera on panel. Overall, excluding 2.9 cm. of frame at the bottom, presumably added by J. A. Ramboux: 52.5 × 18.8 cm. (20¹¹⁄₁₆ × 7³⁄₈ in.); picture surface, excluding the titulus (1.5 cm. high): 46.1 × 13.5 cm. (18⅛ × 5⅜ in.). There are traces of a horizontal batten 3 cm. deep about 30 cm. from the base of the panel. The left molding of the engaged frame is modern up to the springing of the arch. The corresponding molding on the right is original, but has been regilt.

The saint is represented in full face holding a book with both hands at his left side. The figure is contained in an ogival field set between spiral columns with gilt gesso decoration in the spandrels. At the base, also in gilt gesso, is the name S: PHILLIPPS:.

This panel and No. 34 formed part of an altarpiece executed by Spinello Aretino for the church of the monastery of Monte Oliveto Maggiore. The altarpiece is described by Vasari in the following terms:

Mentre che quest'opere si facevano, fu fatto don Jacopo d'Arezzo generale della congregazione di Monte Oliveto, dicianove anni poi che aveva fatto lavorare, come s'è detto di sopra, molte cose a Firenze ed in Arezzo da esso Spinello: perchè, standosi, secondo la consuetudine loro, a Monte Oliveto maggiore di Chiusuri in quel di Siena, come nel più onorato luogo di quella religione, gli venne desiderio di far fare una bellissima tavola in quel luogo. Onde, mandato per Spinello, dal quale altra volta si trovava essere stato benissimo servito, gli fece fare la tavola della cappella maggiore a tempera; nella quale fece Spinello in campo d'oro un numero infinito di figure, fra piccole e grandi, con molto giudizio: fattole poi fare intorno una orna-

mento di mezzo rilievo intagliato da Simone Cini fiorentino, in alcuni luoghi con gesso a colla un poco sodo, ovvero gelato, le fece un altro ornamento, che riuscì molto bello; che poi da Gabriello Saracini fu messo d'oro ogni cosa. Il quale Gabriello a piè di detta tavola scrisse questi tre nomi: *Simone Cini fiorentino fece l'intaglio, Gabriello Saracini la messe d'oro e Spinello di Luca d'Arezzo la dipinse l'anno 1385.*

C. Milanesi, in his annotation of Vasari's life of Spinello Aretino (Vasari, *Le vite de' più eccellenti pittori, scultori, e architetti, pubblicate per cura di una società di amatori delle arti belle*, ed. V. Marchese, C. Milanesi, G. Milanesi, C. Pini, vol. 2, 1848, p. 194, n. 2), records that he saw some sections of the altarpiece in 1840 at Rapolano. These included the two main lateral panels with Saints Nemesius and John the Baptist and Saints Benedict and Lucilla, with predella panels beneath them and parts of the *pastiglia* inscription transcribed by Vasari. They were sold two years later (see below) to the German collector J. A. Ramboux. The central predella panel with the *Dormition of the Virgin* was transferred in 1810 to the Accademia in Siena.

In annotations to a later edition of Vasari's *Vite* (vol. 1, 1878, p. 689), G. Milanesi summarizes a document according to which the altarpiece would have been commissioned from Spinello in Lucca in 1384 by Don Niccolò da Pisa, prior of the Olivetan convent of Santa Maria Nuova in Rome. This document was later published in full by Procacci ("La creduta tavola di Monteoliveto dipinto da Spinello Aretino," *Il Vasari*, 2, 1928–29, pp. 43–45). The contract is open to three interpretations: (i) that it refers to an altarpiece commissioned for Santa Maria Nuova in Rome, not to the altarpiece for Monte Oliveto Maggiore; (ii) that the altarpiece was painted for Santa Maria Nuova and at some later time transferred to Monte Oliveto Maggiore; or (iii) that the altarpiece was painted for Monte Oliveto Maggiore on the commission of the prior of Santa Maria Nuova in Rome. Nowhere is it stated explicitly in the commission that the altarpiece was designed for Santa Maria Nuova, and the provenance of the surviving panels from the vicinity of Monte Oliveto Maggiore is most readily consistent with the view that the altarpiece was executed for the church in which it is recorded by Vasari. It is, however, argued by Fehm ("Notes on Spinello Aretino's So-called Monte Oliveto Altarpiece," *Mitteilungen des Kunsthistorischen Institutes in Florenz*, 17, 1973, pp. 257–72) that the panels commonly associated with the Monte Oliveto Maggiore polyp-

tych in fact originate from the Roman altarpiece. This mistaken view is likewise adopted by Masetti (*Spinello Aretino giovane*, 1973, p. 13), who refers to "il grande polittico per S. Maria Nuova a Roma (1384–1385), detto comunemente di Monteoliveto per la sua successiva collocazione."

The surviving panels of the Monte Oliveto Maggiore altarpiece comprise:

(i) *Coronation of the Virgin* in the Pinacoteca Nazionale, Siena, which formed the central pinnacle over a lost *Madonna and Child*;

(ii) *Dormition of the Virgin* in the Pinacoteca Nazionale, Siena, which stood beneath the *Madonna and Child*;

(iii) a panel from the left side of the altarpiece, with Saints Nemesius and John the Baptist and scenes from their lives beneath (Fig. 23), in the Szépművészeti Múzeum, Budapest (J. A. Ramboux, *Katalog der Gemälde alter italienischer Meister [1221–1640] in der Sammlung des Conservators J. A. Ramboux*, 1862, no. 82);

(iv) a similar panel from the right side of the altarpiece, with Saints Benedict and Lucilla and scenes from their lives beneath (Fig. 24), in the Fogg Art Museum, Cambridge, Mass. (ibid., no. 83);

(v) the present pilaster panel of Saint Philip (ibid., no. 84);

(vi) No. 34: pilaster panel of an unidentified saint, possibly Saint James the Greater (ibid., no. 85);

(vii) a pilaster panel of Saint James the Less, formerly in the Rothermere collection, London, sold at Sotheby's, London, April 21, 1982, lot 72 (ibid., no. 87).

Two further pilaster panels with Saints Mary Magdalene and Bartholomew, in a private collection, have also been identified as originating from the Monte Oliveto altarpiece (H. D. Gronau, "Early Italian Paintings at Stuttgart," *Burlington Magazine*, 92, 1950, p. 325, n. 14). A number of other pilaster panels are assumed by Boskovits (*Pittura fiorentina alla vigilia del Rinascimento*, 1975, pp. 430–42) and Fehm (loc. cit.) to have formed part of the Monte Oliveto polyptych. These include panels of a Virgin Martyr at Saint-Louis-en-l'Isle, Paris, and of a male saint and Saint Agnes in the New York Hispanic Society. Since the Monte Oliveto altarpiece was, by the terms of the commission, closely based on an antecedent painting executed by Spinello for San Ponziano at Lucca (for which see L. Bellosi, "Da Spinello Aretino a Lorenzo Monaco," *Paragone*, vol. 16, no. 187, 1965, pp. 18–43; and A. González-Palacios, "Due proposti per Spinello,"

Paragone, ibid., pp. 44–51), these may originate from the San Ponziano painting or from some other altarpiece. Masetti (op. cit., p. 15) assumes that the present panels and eight other pilaster panels come from the San Ponziano polyptych. The provenance of the present panels from Rapolano proves that this is incorrect. A pilaster panel of a male saint in the Stichting Huis Bergh at 'sHeerenbergh, published by Van Os as part of the Monte Oliveto altarpiece ("An Unknown Panel from Spinello Aretino's Monte Oliveto Altarpiece," *Burlington Magazine*, 111, 1969, pp. 513–14, fig. 36), seems to have formed part of a third polyptych (for this see Masetti, op. cit., p. 15, n. 32). A conjectural reconstruction by Fehm (loc. cit.) of the Monte Oliveto painting includes the improbably large number of fourteen pilaster panels.

CONDITION: Save for minor paint losses, the paint surface is well preserved. The left foot of the saint is modern. A small section of the halo at the left has been regilt.

PROVENANCE: Monte Oliveto Maggiore, till 1810; small chapel or hayloft at Rapolano, 1840 (C. Milanesi, in Vasari, *Le vite de' più eccellenti pittori scultori e architetti, pubblicate per cura di una società di amatori delle arti belle*, ed. V. Marchese, C. Milanesi, G. Milanesi, C. Pini, vol. 2, 1848, p. 194, n. 2); J. A. Ramboux, Cologne, from 1842 (J. A. Ramboux, *Katalog der Gemälde alter italienischer Meister [1221–1640] in der Sammlung des Conservators J. A. Ramboux*, 1862, nos. 84–85; G. Coor, "Trecento-Gemälde aus der Sammlung Ramboux," *Wallraf-Richartz Jahrbuch*, 18, 1956, pp. 130–31; H.-J. Ziemke, "Ramboux und die sienesische Kunst," *Städel-Jahrbuch*, n.s., 2, 1969, p. 277; Ramboux sale, J. M. Heberle, Cologne, 1867, nos. 84–85; Wallraf-Richartz-Museum, Cologne (J. Niessen, *Verzeichniss der Gemälde-Sammlung des Museums Wallraf-Richartz in Köln*, 1869, nos. 58–59, and subsequent editions); sale, Hôtel Drouot, Paris, February 4, 1924, lot 110 (bought Durlacher, no. 34 only); no. 4, Lempertz, Cologne, December 14, 1926; K. W. Bachstitz, The Hague, 1928; F. J. Mather, Princeton, before 1936; Richard Ederheimer, New York, 1936, no. 3 (with No. 34). Acquired by Robert Lehman November, 1943.

EXHIBITED: Richard Ederheimer, New York, *A Selection of Paintings by the Old Masters*, 1936, no. 3 (with No. 34); Metropolitan Museum of Art, New York, 1954–56; Cincinnati Art Museum, *The Lehman Collection*, 1959, nos. 62–63.

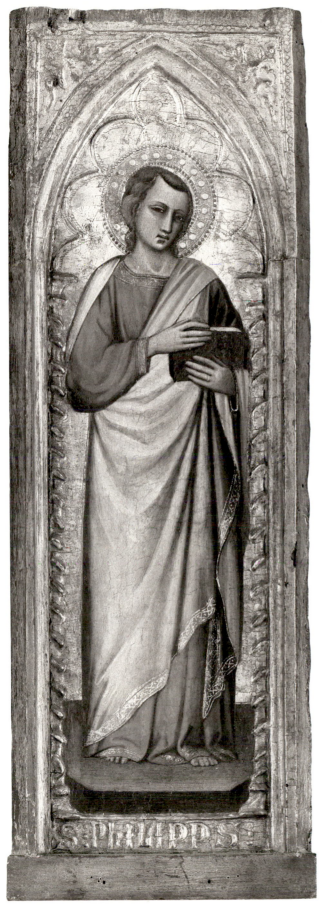

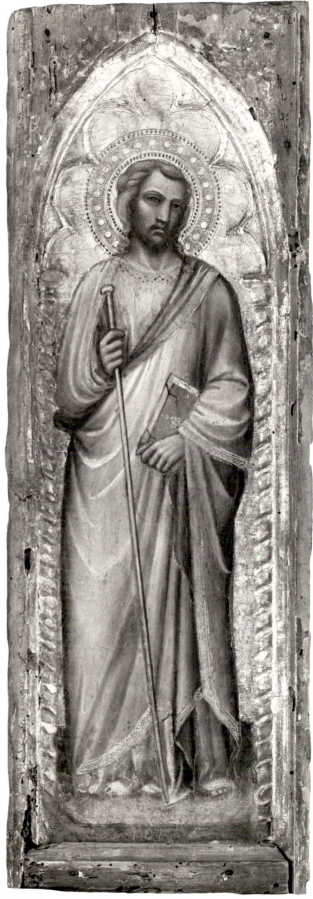

No. 33

No. 34

73

34. Saint James the Greater (?)

1975.1.64

Tempera on panel. Overall: 52.3 × 18.2 cm. (20⅝ × 7⅛ in.); picture surface: 46.2 × 13.7 cm. (18¼ × 5⅜ in.). The right side of the frame has been trimmed. On the back is an imperfectly legible heraldic wax seal. There are traces of a horizontal batten 3 cm. deep about 20 cm. from the base of the panel. At the base the titulus with the saint's name has been scraped off and an old piece of molding, with traces of gesso, has been nailed over it. The decoration of the spandrels is much damaged.

The saint is represented in full face holding a staff in his right hand and a book in his left. The figure is contained in an ogival field set between spiral columns with gesso decoration in the spandrels.

See No. 33.

The saint has been variously identified as Saint James the Greater and Saint James the Less, and is wrongly described by Berenson ("Quadri senza casa: il Trecento fiorentino, III," *Dedalo*, 2, 1930–31, p. 1318; *Homeless Paintings of the Renaissance*, 1969, p. 128) as Saint Philip. Berenson notes that "the suave, parsonish figure is so much like the Christ in the Siena *Dormition* of 1385 that this too must be of about the same date."

CONDITION: The paint surface is extremely well preserved, and losses are confined to areas of green paint in the lining of the saint's cloak and on the plinth at the base.

PROVENANCE: See No. 33.

EXHIBITED: See No. 33.

35. The Conversion of Saint Paul

1975.1.11

Tempera on panel. 30.2 × 29.6 cm. (11⅞ × 11⅝ in.). The panel, which has a horizontal wood grain, has been crudely thinned, and the edges are ragged and unevenly cut. A beard of paint is evident on the right, and the gold ground is punched in the upper left corner. There is no beard of paint or gesso at the bottom or top. A red wax seal of the Campo Santo at Pisa and an inscription with the name Spinello Aretino appear on the back of the panel.

Saint Paul, wearing a blue robe, is shown in the front plane lying on the rocky ground. His head is turned down, and he raises his right hand to protect his eyes from a shower of golden rays descending from above. His gesture is repeated by a standing soldier on the right. On the left are four standing soldiers, of whom the foremost extends his right arm and his shield-bearing left arm toward the saint.

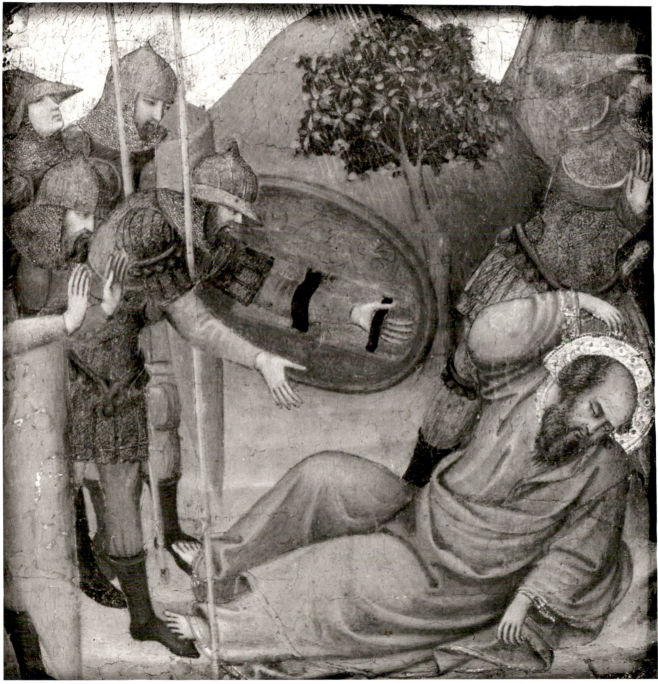

No. 35

Three of the four figures look down at Saint Paul on the ground. Behind is a hill and a fruit-bearing tree.

The panel was exhibited in Cincinnati in 1959 as the work of an anonymous Sienese fourteenth-century painter, the subject being misconstrued as the Betrayal. It has since been officially ascribed to Andrea Vanni (K. Baetjer, *European Paintings in the Metropolitan Museum of Art*, vol. 1, 1980, p. 189). A point of reference for its style is supplied by the fresco of *Saint Ephysius in Conflict with the Heathens* by Spinello Aretino in the Campo Santo at Pisa. Spinello's Pisan frescoes were executed in 1391–92, and the present panel is likely to have formed part of a predella painted by Spinello or in his workshop at this time.

CONDITION: The paint surface is abraded and extensive flaking has been touched in. The armor of the soldier at the right is heavily reinforced, as are the gold rays at the top of the panel. A segment of the halo of the saint has been regilt. The armor of the soldiers was originally silvered and painted with yellow, cinnabar, white, and ultramarine; the silver has oxidized and flaked. An old attempt to clean the helmets at the left has exposed some bole and gesso.

PROVENANCE: Carlo Lasinio (conservator of the Campo Santo, Pisa, 1807–38); Atri, Rome. Date of acquisition not recorded.

EXHIBITED: Cincinnati Art Museum, *The Lehman Collection*, 1959, no. 28 (as Sienese Master, fourteenth century).

UMBRIA

Thirteenth Century

The Master of Saint Francis

Active in the third quarter of the thirteenth century, the Master of Saint Francis derives his name from a panel of Saint Francis from the Porziuncula Chapel now in Santa Maria degli Angeli at Assisi. He was also responsible for a cycle of frescoes in the nave of the Lower Church of San Francesco at Assisi, and for crucifixes in the Pinacoteca Nazionale at Perugia (dated 1272) and in the Louvre. These works prove him to have been a painter and imagist of exceptional quality. His oeuvre also comprises thirteen panels from an altarpiece for San Francesco in Perugia. One of these is discussed below.

36. Saints Bartholomew and Simon

1975.1.104

Tempera on panel. 47.6 × 22.8 cm. (18¾ × 9 in.). The lateral edges are cut unevenly, and the width varies from 22.4 cm. at the top to 22.8 cm. at the base. The panel, which has a coarse horizontal grain, averages 16 mm. in thickness and has not been thinned or cradled. The top edge appears to have been painted. A wedge 6 × 70 mm. inserted at the top on the right is original. The tondi in the spandrels at the upper corners are cut into the panel through the canvas ground and are pigmented on gesso priming. They were originally, like the spandrels of the panels from this altarpiece at Perugia, filled with colored and gilded glass.

The two apostles are shown standing beneath an arch supported by porphyry half-columns with blue foliated capitals and yellow bases. The figures are superimposed and are depicted frontally. The foremost saint, Bartholomew, wears a yellowish brown tunic covered with a red cloak or toga decorated with a pattern of rectangles enclosing a red circle with a blue center. He holds a black book and looks out to the right. His hair and beard are black, and like his companion figure he wears flat sandals tied with cords to his feet. The rear saint, Simon, who looks to the left, has gray hair and a gray beard and wears a violet cloak over a red tunic. The names of the two apostles are inscribed in the arch. The floor is dark green and is separated from the gold ground by a white line.

The panel formed part of one of the greatest Italian altarpieces of the third quarter of the thirteenth century. Two further panels from it, with Saints James the Less and John the Evangelist, were also at one time in the Lehman Collection (R. Lehman, 1928, pls. 61, 62), but were sold in 1943 and are now in the National Gallery of Art, Washington (for these see F. R. Shapley, *Catalogue of the Italian Paintings*, 1979, vol. 1, pp. 324–25, nos. 810, 811). Three other panels from the same series are known: a *Saint Francis* and *Saint Matthew* in the Galleria Nazionale dell'Umbria at Perugia (for which see F. Santi, *Galleria Nazionale dell'Umbria: Dipinti, sculture e oggetti d'arte di età romanica e gotica*, 1969, inv. 23, 24, no. 7, pp. 30–31) and a *Saint Peter* in the Stoclet collection, Brussels. The attribution of the Perugia *Saint Francis* to the Master of Saint Francis is due to Thode (*Saint François d'Assise et les origines de l'art de la Renaissance en Italie*, 1885, vol. 1, p. 88), and has since been universally accepted. The connection of the Lehman panels with the series was first established by Vitzthum and Volbach (*Die Malerei und Plastik des Mittelalters in Italien*, 1924, p. 251).

Reconstruction of the altarpiece to which the panels belonged has proceeded through three stages. In the first (for which see E. B. Garrison, *Italian Romanesque Panel Painting: An Illustrated Index*, 1949, pp. 161–63, nos. 424–29 and reconstruction 4), the panels were reintegrated as a single-sided altarpiece in which the figures of (*left*) Saints Francis, John, and Peter and (*right*) Matthew, Simon and Bartholomew, and James were ranged on either side of a lost panel with the Virgin and Child enthroned. Garrison reconstructed at the same time a second single-sided altarpiece, also attributable to the Master of Saint Francis, which would have comprised (*left*) a panel with Isaiah in the Tesoro di San Francesco at Assisi, two lost Passion scenes, a lost Franciscan saint (possibly Saint Francis), a lost Crucifixion, a panel with Saint Anthony of Padua (Galleria Nazionale dell'Umbria, Perugia), panels of the Deposition and the Lamentation over the Dead Christ (Galleria Nazionale dell'Umbria, Perugia), and a lost figure of a prophet, perhaps Jeremiah. In the second stage (for which see J. Schultze, "Ein Dugento-Altar aus Assisi? Versuch einer Rekonstruktion," *Mitteilungen des Kunsthistorischen Institutes in Florenz*, 10, 1961–63, pp. 59–66, and "Zur Kunst des 'Franziskus Meisters,'" *Wallraf-Richartz Jahrbuch*, 25, 1963, pp. 141–45) it was established that the two sets of panels formed part of a double-sided altarpiece, and it was proposed that the apostles were grouped on either side of a lost panel with an enthroned Redeemer. In the third stage (for which see D. Gordon, "A Perugian Provenance for the Franciscan Double-sided Altarpiece by the Maestro di S. Francesco," *Burlington Magazine*, 124, 1982, pp. 70–77; K. Christiansen, "Fourteenth-Century Italian Altarpieces," *The Metropolitan Museum of Art Bulletin*, vol. 40, no. 1, 1982, pp. 14–17), the physical relationship between the panels was more closely analyzed, and it was shown from a study of the wood grain that the surviving panels from the Passion face comprised

No. 36

the entire right side of the altarpiece, in the sequence *Isaiah, Deposition, Lamentation, Saint Anthony of Padua*. It was also shown that the surviving Apostle panels comprised, as Schultze had assumed, the whole of the left side of the second face, in the sequence *Francis, Simon and Bartholomew, James, John, Matthew, Peter* (Fig. 25).

It was suggested by Garrison (loc. cit.) and Schultze ("Ein Dugento-Altar"), who based the hypothesis on the presence in the treasury at San Francesco of the panel representing Isaiah, that the altarpiece was painted for the high altar of the Lower Church of San Francesco at Assisi. There is, however, as Santi notes (loc. cit.), no reference to the panels in the Assisi inventories of 1338, 1370, 1430, or 1473 or in the later literature of the church, while the two Passion scenes in the Galleria Nazionale dell'Umbria were recorded as early as 1793 in the sacristy of San Francesco al Prato at Perugia. The remaining panels in Perugia have a Perugian provenance, and it was suggested by Scarpellini (*Il tesoro della basilica di San Francesco di Assisi: Le pitture*, 1980, pp. 42–46) that they were originally painted for the church of San Francesco al Prato. The present panel and three of its companion panels were purchased from the Arciconfraternità della Pietà del Camposanto Teutonico in Rome, in which one fourteenth-century panel formerly in San Francesco al Prato at Perugia is still preserved, and it is probable that they also originated from San Francesco al Prato. It is, moreover, argued by Gordon (loc. cit.) that the altarpiece is likely to have been commissioned for the main altar of San Francesco, where it would have stood over an Early Christian sarcophagus, now housed in the adjacent oratory of San Bernardino, which contained the body of Saint Francis's follower, the Beato Egidio (d. 1261/62). The form of the arcading throughout the altarpiece appears to derive from the sarcophagus, and the disposition of the two figures in the present panel (which was necessitated by the inclusion of Saint Francis on the apostle face) reflects the scheme of two figures in relief to the right of Christ on the sarcophagus. The *Crucifix* painted by the Master of Saint Francis for San Francesco al Prato, now in the Galleria Nazionale dell'Umbria, is dated 1272, and it is possible that the altarpiece dates from the same time.

CONDITION: The paint surface is extremely well preserved. There are minor flaking losses in the apostles' robes and feet, and the raised gilt decoration in the patterning of the cloak of Saint Bartholomew survives only in part.

PROVENANCE: San Francesco al Prato, Perugia (see above); Arciconfraternità della Pietà del Camposanto Teutonico, Rome (till 1921); "Monseigneur Del Val" (R. Lehman, pl. 63; prob-ably Anton de Waal, rector of the Camposanto Teutonico); Paolo Paolini, Rome. Acquired by Philip Lehman before 1928.

EXHIBITED: Colorado Springs Fine Arts Center, *Paintings and Bronzes from the Collection of Mr. Robert Lehman*, 1951–52; Metropolitan Museum of Art, New York, 1954–61; Musée de l'Orangerie, Paris, *La collection Lehman*, 1957, no. 36; Cincinnati Art Museum, *The Lehman Collection*, 1959, no. 84.

ROMAGNA

Fourteenth Century

The Master of Forlì

The Master of Forlì, so named for three panels by him preserved in the Pinacoteca at Forlì, was a Romagnole painter active in the first half of the fourteenth century (see E. B. Garrison, "Il Maestro di Forlì," *Rivista d'arte*, ser. 3, vol. 1, 1950, pp. 61–81; L. Cuppini, "Aggiunte al Maestro di Forlì e al Maestro di Faenza," *Rivista d'arte*, ser. 3, vol. 2, 1951–52, pp. 15–22). All his surviving works are small in scale and executed in a highly refined, almost miniaturist technique. His style, invariably reminiscent of his thirteenth-century antecedents, represents an archaizing artistic tradition in the Romagna, which was otherwise dominated by the new naturalism of Giotto and of Pietro Cavallini.

37. The Flagellation

1975.1.79

Tempera on panel. Overall: 19.9 × 13.2 cm. (7¾ × 5³⁄₁₆ in.); picture surface, excluding painted borders: 18.6 × 11.8 cm. (7⁵⁄₁₆ × 4⅝ in.). The panel has a vertical wood grain and is approximately 7 mm. thick. It has been cut on all four sides but has not been thinned. The back is covered with glue, and fragments of another panel adhere to this one. At the left edge of the back in ink is the foot of a letter or numeral continuing from a panel which stood to the right of the present scene.

Christ, naked save for a transparent cloth over his loins, is bound to the forward column of an arcaded hallway on the right. Two flagellants stand on either side of Christ: one (*left*) with his flail touching Christ's body and the other (*right*) with his left elbow raised. On the left, outside a doorway and beneath a protruding roof, stands the Virgin with three Holy Women wringing their hands in grief.

This and the following panel are published by Garrison (*Italian Romanesque Panel Painting: An Illustrated Index*, 1949, p. 242, nos. 692, 693), who ascribes them to the Master of Forlì. Two further panels from the same complex, representing *The Stripping of Christ* and *The Deposition* (Fig. 27), were formerly in the collection of Maitland Griggs, New York, and were subsequently with Julius Boehler, Munich (ibid., p. 238, nos. 674, 675). The panel with the Deposition is now in the Thyssen-Bornemisza collection, Lugano, with a tentative attribution to Pietro Cavallini (R. J. Heinemann, *Sammlung Thyssen-Bornemisza*, vol. 1, 1971, pp. 75–76, no. 58). The four panels formed the shutters of a portable triptych, with *The Flagellation* and *Stripping of Christ* in the left wing and *The Deposition* and *Entombment* in the right. A painted border of guilloche decoration at the bottom of the present panel would have

separated it from the scene below it, and a similar border at the top of No. 38 would have separated it from the panel above. The same border appears cropped at the bottom of *The Deposition* in the Thyssen collection. The central panel (untraced) would have represented the Crucifixion. A panel of that subject by the Master of Forlì in the Walker Art Gallery, Liverpool (no. 3042; see Walker Art Gallery, *Foreign Catalogue*, 1977, p. 118), probably originates from a different complex. A painting by the Master of Forlì with superimposed scenes of the Agony in the Garden and the Madonna and Child with Two Female Saints, in the Hermitage, Leningrad, has a decorative border closely related to that of the present panels, but is too large (57.5 × 35.5 cm.) to have stood between them in a triptych.

The Deposition, *The Stripping of Christ*, and the Liverpool *Crucifixion* were ascribed by Vavalà ("Italo-Byzantine Panels at Bologna," *Art in America*, 17, 1929, pp. 74–84) to a North Italian, probably Bolognese, artist. They were mistakenly regarded by Bettini (*Mosaici antichi di San Marco a Venezia*, 1944, p. 28) as Venetian. The present panels are considerably earlier in date than the panels in Forlì to which the master owes his name. The iconography of *The Flagellation*, with Christ behind the column, the flagellants striking alternating blows, and the Holy Women at the side, occurs in the Dugento, but is infrequent in the fourteenth century. The detail of the fainting Virgin in *The Entombment* is also unusual, and has a precedent in a fresco by the Master of Saint Francis at Assisi. These factors would be consistent with a dating at the end of the first quarter of the fourteenth century.

CONDITION: The paint surface is not abraded, but has suffered from local flaking. The ground in the upper right corner has been regilt, as have small patches beneath the arcade. The uppermost roof of the loggia has been repainted. A void area to the left of Christ's head extends through the column to which he is bound.

PROVENANCE: No. 37 and its companion panel No. 38 are noted by Garrison as having been on the art market in Rome in 1946. The date of their acquisition by Robert Lehman is unknown.

No. 37

38. The Entombment

1975.1.80

Tempera on panel. Overall: 20.3 × 13.1 cm. (8 × 5⅛ in.); picture surface, excluding painted borders: 18.8 × 12.4 cm. (7⅜ × 4⅞ in.). The panel has a vertical grain and is approximately 6 mm. thick. As with No. 37, the back of the panel reveals a number of wood fragments attached with glue.

The body of Christ, naked save for a loincloth, is laid by Joseph of Arimathaea and Nicodemus on a shroud draped over a marble tomb. A third male figure, probably Saint John the Evangelist, cropped at the left side, supports Christ's feet. Behind the tomb are the swooning Virgin and two Holy Women. A third Holy Woman, possibly Saint Mary Magdalene, with head bowed over her left shoulder, is silhouetted at the back against a rocky cliff. In the upper corners are two grieving angels with hands pressed to their cheeks.

See No. 37.

CONDITION: A wide diagonal scratch runs from the left margin through the head of Nicodemus to the face of the Virgin. There are holes in the paint surface, filled in with gesso, across the lower border, to the right of center on the sarcophagus, and locally on the cliff behind. The paint surface is otherwise well preserved.

PROVENANCE: See No. 37.

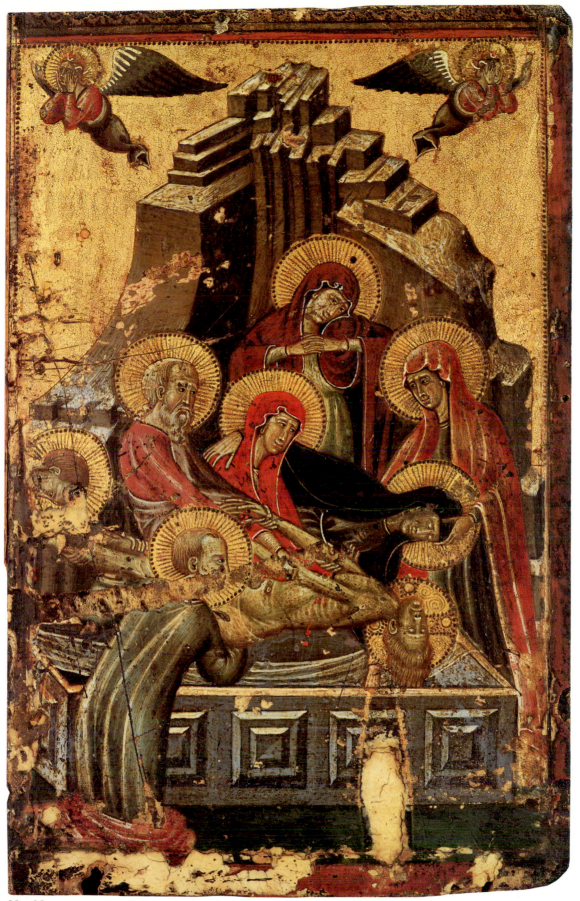

No. 38

The Master of the Life of Saint John the Baptist

An anonymous Romagnole master active in the first third of the fourteenth century, the Master of the Life of the Baptist is named for the cycle of paintings discussed below. He was first distinguished from his more prolific contemporary Giovanni Baronzio da Rimini by Offner, who pointed out the combined influences on his style of Giotto and Pietro Cavallini.

39. The Execution of Saint John the Baptist and the Presentation of the Baptist's Head to Herod

1975.1.103

Tempera on panel. 45.6 × 49.7 cm. (17^{15}/₁₆ × 19^{9}/₁₆ in.). The panel, which has a horizontal grain, is thinned to 9 mm. and cradled. Two red wax seals are preserved on the reverse, a rectangle with the letters C.M. / D.G. and a coat of arms.

On the left an executioner decapitates the Baptist at the window of his cell. Clad in a gray-green robe, with his head shown in profile against his halo and his hands extended in prayer, the saint's body is set horizontally beneath the window grille. The executioner, in a pink Oriental garment and a white headdress, stands frontally beside the body with his feet apart and with a sword above his head. In the lunette over the window is a horse's head. In the center and to the right, seated at table in a hall with a coffered roof and three Gothic windows, are Herodias with two ladies and Herod with two male guests, their bodies silhouetted against a hanging at the back. The robes of Herod and Herodias and the hanging behind are enriched with silver sgraffito decoration. In the foreground Salome, in a particolored red and white dress, is represented twice: on the right dancing before Herod, and on the left, in profile, carrying a dish with the Baptist's head. Four servitors are also shown in the foreground. A gold ground stamped with a foliated pattern is visible through the windows and above the roof. The scene is framed with a geometrical gold border that is fully preserved along the top and the left side and considerably reduced on the right.

This panel forms part of one of the most important surviving Riminese fourteenth-century altarpieces. Initially published by Sirén ("Giuliano, Pietro and Giovanni da Rimini," *Burlington Magazine*, 29, 1916, p. 320), it was associated by him with three narrative panels from the same cycle representing the Annunciation to Zacharias (last recorded in the collection of A. E. Street, Bath: see *Art Treasures of the West Country*, exh. cat., Museum and Art Gallery, Bristol, 1937, no. 192), the Birth, Naming, and Circumcision of the Baptist (formerly in the Harold I. Pratt collection, New York, now in the National Gallery of Art, Washington, Kress collection, no. 1147), and Saint John in Prison Visited by His Disciples (last recorded with the Annunciation to Zacharias: see *Art Treasures of the West Country*, no. 190), with an ascription to Giovanni Baronzio da Rimini. It was suggested by Sirén that the central panel of the altarpiece was a seated figure of the Baptist at Christ Church, Oxford; the case against this identification was presented by Borenius in a footnote to Sirén's article. The correct attribution for the present panel and its companion scenes was advanced by Offner ("A Remarkable Exhibition of Italian Paintings," *The Arts*, 5, 1924, p. 245), who linked them with the *Madonna and Child* from the Ouroussoff collection (then owned by Otto Kahn, now in the National Gallery of Art, Washington, Kress collection, no. 711), though an attribution to Baronzio was later endorsed by L. Venturi (1931, no. 94; 1933, vol. 1, no. 116), R. Lehman (1928, pl. 74), and Berenson (1932, p. 44; 1936, p. 38; cf. Berenson, 1968, vol. 1, p. 357, where it is listed as Anonymous Riminese, Master of the Life of the Baptist). Other panels from the same narrative series are a *Saint John in the Wilderness* (Pinacoteca Vaticana), a fragmentary panel of *Saint John and the Pharisees* (Seattle Museum of Art, Kress collection), a *Baptism of Christ* (National Gallery of Art, Washington, Kress collection, no. 242), and a *Saint John in Limbo* (formerly Loeser collection, Florence).

It was concluded by Brandi ("Conclusioni su alcuni discussi problemi della pittura riminese del Trecento," *Critica d'arte*, 1, 1936, pp. 236–37) that the Ouroussoff-Kahn *Madonna*, now in Washington, was the central panel of the altarpiece. This view is accepted by Volpe (*La pittura riminese del Trecento*, 1965, pp. 38–39, 80–81), Shapley (*Paintings from the Samuel H. Kress Collection: Italian Schools, XIII–XV Century*, 1966, pp. 68–69; *Catalogue of the Italian Paintings*, National Gallery of Art, Washington, 1979, pp. 316–18), and Christiansen ("Fourteenth-Century Italian Altarpieces," *The Metropolitan Museum of Art Bulletin*, vol. 40, no. 1, 1982, pp. 42–45). While the presence of a Madonna in the center of an altarpiece dedicated to the life of the Baptist is unusual, the relation in style, ornament, and facture is extremely close, and the grasshopper held by the Child may, as Shapley and Christiansen suggest, be intended as a symbol of converted paganism or of the locusts eaten by Saint John in the desert. It is possible (Volpe, op. cit.,

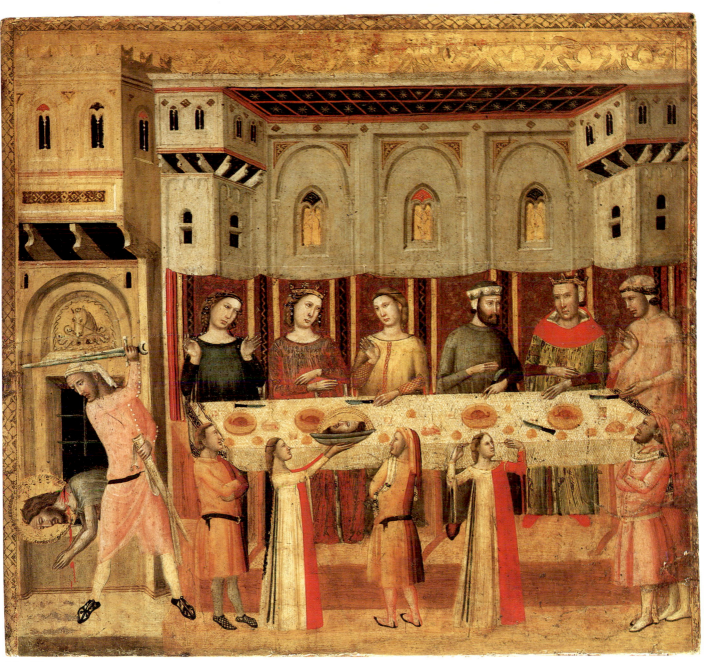

No. 39

pp. 38–39) but unlikely that the Washington *Madonna* was backed by a panel of Saint John the Baptist. With the exception of the present panel, which is horizontal in format, the individual scenes are vertical; it is assumed by Volpe that the altarpiece originally comprised two groups of six vertical panels on either side of the central *Madonna*, and that *The Execution of Saint John the Baptist and the Presentation of the Baptist's Head to Herod* served as a predella under the main panel. This is improbable. A more convincing reconstruction by Christiansen (Fig. 26) makes provision only for the *Madonna* and the eight known narrative scenes, of which four on the left would have been upright scenes in two tiers and four on the right would have consisted of *(above)* two upright scenes and *(below)* the present horizontal scene with a narrower vertical scene, the Loeser *Saint John in Limbo*, adjacent to it. There are precedents (e.g., in the wings of a diptych by Giovanni da Rimini at Alnwick) for such irregularities. The combined width of the Loeser and Lehman panels, neither of which has been significantly reduced laterally though both have been cut by at least 3 cm. at the bottom, is approximately equal to that of any two of the vertical scenes. The wood grain of the Kahn *Madonna* is vertical, while that of the eight narrative panels is horizontal. Christiansen's reconstruction seems, nevertheless, to be correct.

CONDITION: The paint surface is in extremely good condition, with little or no loss from abrasion or flaking. Old scratches through the faces of all the figures save the Baptist have been touched in. The only significant area of damage is along the lower part of the right side, where the whole of the right-hand servitor, and the figure of the adjacent servitor below the waist, have been repainted.

PROVENANCE: The arms on the reverse are those of the Conti Agnelli dei Malherbi, and the panel may have been preserved in the Agnelli collection in Rome or in the Casa Malherbi at Lugo (Ravenna); Galerie Trotti, Paris; Wildenstein, Paris. Acquired by Philip Lehman in January 1921.

EXHIBITED: Colorado Springs Fine Arts Center, *Paintings and Bronzes from the Collection of Mr. Robert Lehman*, 1951–52 (as Baronzio); Metropolitan Museum of Art, New York, 1954–61 (as Baronzio); Musée de l'Orangerie, Paris, *La collection Lehman*, 1957, no. 38 (as Maître de la Vie de Saint Jean-Baptiste); Cincinnati Art Museum, *The Lehman Collection*, 1959, no. 83 (as Baronzio).

NAPLES

Fourteenth Century

Neapolitan or Avignonese, Middle of the Fourteenth Century

40. The Adoration of the Magi

1975.1.9

Tempera on panel. With original engaged moldings: 66.7 × 46.7 cm. (26⅛ × 18⅜ in.); picture surface, including tooled border: 54.4 × 38.1 cm. (21⅜ × 15 in.). Thinned and cradled. Hinge marks are clearly apparent on both the right and left sides.

The panel, which is surrounded by a punched gold border on all four sides, shows the Virgin, to right of center, seated before the Gothic doorway of a palace, holding the Child on her knees. To the right are two angels in left profile, dressed in gold-patterned tunics, with their arms crossed on their chests. In the center kneels a bearded king, with head upturned, who extends a golden bowl toward the Child. A horizontal band of red glazing, perhaps a scarf, appears on the level of the Magus's knees, and his crown rests on the lower of two steps on the right. Behind him in the lower left corner are three diminutive attendants. On the left stand the two other kings, one in right profile with hands extended, in a red-glazed gold robe, and one set frontally with hands raised and head turned toward his companion. A rocky landscape extends from a point above the Virgin's halo through the left half of the panel. The upper trees are silhouetted against a gold ground, and in the center at the top is the Star of Bethlehem.

This beautiful though damaged panel forms part of the same complex as two panels with *The Annunciation* (Fig. 28) and *The Nativity* (Fig. 29) in the Musée Granet, Aix-en-Provence. The interconnection of the three panels is conclusively demonstrated by Boyer ("Le troisième volet du triptyque," *La Provence libérée*, March 19, 1966). The presence of hinge marks on the right side of the present panel suggests that there were originally at least four interrelated panels, of which the fourth may have been a Presentation in the Temple or a Flight into Egypt. According to the late eighteenth-century Aix scholar Fauris de Saint Vincens (for whom see D. Thiébaut in *L'art gothique siennois*, exh. cat., Musée du Petit Palais, Avignon, 1983, pp. 184–86, nos. 61, 62), the backs of the Aix panels at one time bore the now obliterated arms of Anjou and Aragon. An unidentified coat of arms at one time existed on the back of the present panel (R. Lehman, 1928, pl. 28), but was destroyed when the panel was thinned down to its present depth. The Aix panels were reputedly acquired by Fauris de Saint Vincens from the convent of Poor Clares at Aix, and it has been plausibly suggested

(Thiébaut, loc. cit.; idem, in M. Laclotte and Thiébaut, *L'école d'Avignon*, 1983, p. 193) that the polyptych was commissioned in Naples to be sent to the convent by King Robert of Anjou (d. 1343) and Queen Sancha (d. 1345).

Before the appearance of the present picture, the two Aix panels were variously ascribed to Lippo Memmi (M. Logan, "Note sur les oeuvres des maîtres italiens dans les musées de Provence," *Chronique des arts*, 1895, p. 397), to Bartolo di Fredi (Berenson, 1909, p. 139), and to a close follower of Barna, perhaps Catalan (Berenson, 1932, p. 528). The theory of a Catalan origin for the panels is tentatively accepted by Schneider (*Avignon et la Catalogne*, 1933, p. 104), but has otherwise been disregarded and is incorrect. In 1908 the Aix panels were ascribed by Perkins ("Due tavole d'Aix," *Rassegna d'arte senese*, 4, 1908, pp. 86–87) to an Avignonese follower of Simone Martini active soon after 1340.

The present panel was published for the first time by Perkins ("Some Sienese Paintings in American Collections," *Art in America*, 7, 1920, pp. 272, 274) as by an Avignonese painter related to but not identical with the artist of the Aix panels. An attribution to an Avignonese follower of Simone Martini is accepted for all three panels by most later students, among them Labande (*Les primitifs français: Peintres et peintres-verriers de la Provence occidentale*, 1932, pp. 150–51), Sterling (*Les peintres du Moyen-Age*, 1942, p. 16), Toesca (*Il Trecento*, 1951, p. 546), Bologna ("Les 'Primitifs méditerranéens'," *Paragone*, vol. 4, no. 37, 1953, pp. 82–83; *I pittori alla corte angioina di Napoli, 1266–1414*, 1969, pp. 314–17, 320–21), Laclotte ("A propos de l'exposition 'De Giotto à Bellini'," *La revue des arts*, 6, 1956, pp. 77, 79), Castelnuovo ("Avignone rievocata," *Paragone*, vol. 10, no. 119, 1959, p. 51, n. 29; *Un pittore italiano alla corte di Avignone*, 1962, pp. 41, 142, n. 3; *Matteo Giovannetti e la cultura mediterranea*, 1966, pls. 14, 15), Volpe ("Precisazioni sul 'Barna' e sul Maestro di Palazzo Venezia," *Arte antica e moderna*, 10, 1960, pp. 155, 158, n. 19), and De Benedictis ("Il polittico della Passione di Simone Martini e una proposta per Donato," *Antichità viva*, 15, 1976, p. 5; "Naddo Ceccarelli," *Commentari*, 25, 1974, pp. 144, 149, 150–53; *La pittura senese, 1330–1370*, 1979, p. 28). De Benedictis rightly rejects a tentative attribution by Van Marle (*Development*, vol. 2, 1924, p. 307) to Naddo Ceccarelli.

An alternative view, that the panels were painted in

No. 40

Naples by a Giottesque illuminator responsible for a *Bible moralisée* of about 1350 in the Bibliothèque Nationale, Paris (ms. fr. 9561), was advanced in 1956 by Meiss ("Primitifs italiens à l'Orangerie," *La revue des arts*, 6, 1956, pp. 142–45; "The Exhibition of French Manuscripts of the XIII–XVI Centuries at the Bibliothèque Nationale," *Art Bulletin*, 38, 1956, pp. 189–92). The panels were later given by Meiss (*French Painting in the Time of Jean de Berry*, 1967, pp. 28–29) to the workshop of the Master of the Angevin Bible. The presence of Florentine elements in the Aix panels is also noted by Gardner ("Paris: Les traits du gothique," *Burlington Magazine*, 124, 1982, pp. 120–21), who questions their association with the style of Simone Martini. The theory of Florentine influence on the three panels is contested by Bologna (loc. cit.), Castelnuovo (loc. cit.), and Thiébaut; the latter suggests that the angels on the extreme right of the present panel depend from the fresco in the lunette of the portal of Notre-Dame-des-Doms at Avignon.

If, as is likely, the panels were commissioned by King Robert of Anjou, they would date before the king's death in 1343. It is clear that the panels were painted either in Naples or Avignon. Insofar as they are Simonesque, they appear to depend from the style of the *Saint Louis of Toulouse* and its predella in the Pinacoteca Nazionale di Capodimonte in Naples (1317), not from the later Orsini polyptych, and this, in conjunction with the fact that they had no progeny at Avignon, argues in favor of a Neapolitan origin. Their oblique relationship to Giottesque painting would be more readily explicable at Naples than at Avignon.

CONDITION: The paint surface is much abraded. Losses along the heavy craquelure have been inpainted throughout, with results that are especially noticeable in the faces of the two angels on the right and in the faces of the Virgin and Child. The kneeling Magus in the center is the least well preserved of the figures, and his hair, like the head of the second of the small attendants behind him, is modern. The glazing and therefore the form of the gold robes is impaired. The architectural and landscape backgrounds are, on the other hand, almost perfectly preserved, as is the gold hem of the Virgin's robe. The green of the trees and the blue of the Virgin's dress and cloak now read as black.

PROVENANCE: The three panels belonged until 1819 to Fauris de Saint Vincens, Aix-en-Provence. After his death two, and possibly all three, panels were acquired for the Musée de la Ville d'Aix. Only two are catalogued there in 1851, and the present panel appeared in 1853 at the sale of the estate of M. Clérian, director of the École de Dessin at Aix (sale, Simonet, Paris, March 14–16, 1853, no. 28, as Giotto). It passed to the collection of the painter Jean-Léon Gérôme (d. 1904) in Paris. Purchased by Philip Lehman from Gimpel and Wildenstein, Paris, in February 1916.

EXHIBITED: Metropolitan Museum of Art, New York, 1944 (as Sienese School); Musée de l'Orangerie, Paris, *De Giotto à Bellini*, 1956, no. 42 bis (as Atelier Siennois d'Avignon, XIVᵉ siècle); Cincinnati Art Museum, *The Lehman Collection*, 1959, no. 12 (as Sienese Master, Avignon); Metropolitan Museum of Art, New York, 1974 (*Saints and Their Legends*).

Roberto d'Oderisio

Mentioned in a document of 1382 as court painter to Charles III of Durazzo and known through one signed painting, a *Crucifixion* from the church of San Francesco at Eboli now in the Museo del Duomo at Salerno, Roberto d'Oderisio has been the subject of much scholarly debate. He was formerly thought to have been active only at the end of the fourteenth century, and to reflect in his paintings the belated influence of Sienese masters such as Paolo di Giovanni Fei (q.v.) and Andrea Vanni. Recent criticism, however, has seen him as a direct follower of Giotto and Maso di Banco possibly active as early as the 1330s. Several important frescoes in Naples have been attributed to him, notably the scenes from the Old Testament and the Seven Sacraments in Santa Maria Incoronata, as well as a number of panels from the middle decades of the century.

41. Saint John the Evangelist and Saint Mary Magdalene

1975.1.102

Tempera on panel. 58.4 × 39.6 cm. (23 × 15 9/16 in.). The panel, which has a vertical grain, has been thinned to 7 mm. and cradled. The original engaged moldings have been cut away and the panel trimmed to the edges of the picture field, but a pronounced beard survives at right and left. Judging from the punching at the sides, the top of the panel has been cut by 2.6 cm. The corresponding painting in the National Gallery, London (see below), has been cut in the same way at the top but preserves rather more of the original panel at the bottom and sides.

The two figures are shown in rather more than half-length. Saint Mary Magdalene on the right is represented in left profile with hands clasped beneath her chin. She wears a red cloak over a blue dress, which is visible over the chest and at the cuff. Saint John the Evangelist, turned slightly to the left, is shown with his lowered right hand clasped over his left. He wears a greenish blue tunic and a brownish cloak, both with elaborate borders of gold thread. Above are two mourning angels in flight, dressed in red and in dark green. The panel is surrounded by a strip of decoration tooled with imitation Cufic script, which has been reduced at the top (see above). The figures and haloes of the saints and the wings of the two angels break the decorative border of the panel on three sides.

The panel formed one wing of a diptych, of which the left-hand panel, with *The Virgin with the Dead Christ* (Fig. 30), is in the National Gallery, London (no. 3895). The connection between these two panels was first estab-

lished by Gronau ("Notes on Trecento Painting," *Burlington Magazine*, 53, 1928, pp. 78–81). The panel in the National Gallery has a painted back showing the cross on Golgotha and four of the instruments of the Passion (spear, lance, nails, and hammer). Davies (*Paintings and Drawings on the Backs of National Gallery Pictures*, London, 1946, p. xii, pl. 37) observes that "the pendant picture is in the Lehmann [*sic*] Collection, New York; I do not know if that has a painted back, but it should have, since some of the Instruments of the Passion are missing from here." The present panel, before it was thinned down, is likely to have had a similar painted back, with instruments of the Passion including the column and flails of the Flagellation. The painted back proves that the London panel has not been reduced at the base. Its dimensions (painted surface: 58.5 × 38.5 cm.) correspond with the dimensions of the present painting.

The London panel, when that alone was known, and the present panel, after its publication in 1928, have been subjected to a large number of implausible or mistaken attributions. At one time associated, individually or jointly, with Ambrogio Lorenzetti (T. Borenius, "A Little-known Collection at Oxford—I," *Burlington Magazine*, 27, 1915, p. 27; E. Hutton, *The Sienese School in the National Gallery*, 1925, pp. 34–35) or generically with the Sienese School (R. Lehman, 1928, pl. 27), they were later regarded as Florentine (L. Venturi, *Pitture italiane in America*, 1931, pl. 42, as related to the San Remigio *Pietà* in the Uffizi, Florence; G. M. Richter, review of L. Venturi, *Burlington Magazine*, 59, 1931, p. 251, as reminiscent of the Maestro delle Vele at Assisi; H. D. Gronau, loc. cit., as Florentine between 1335 and 1340; B. Berenson, 1932, p. 236, with "anonymous contemporaries and immediate followers of Giotto"; S. Ameisenowa, "Opere inedite del Maestro del Codice di San Giorgio," *Rivista d'arte*, 2, 1939, pp. 118–19, as by the Master of the Saint George Codex after his return to Florence; L. Coletti, "Contributo al problema Maso-Giottino," *Emporium*, 47, 1942, pp. 461–78, associated with Maso di Banco; M. Davies, *National Gallery Catalogue: The Earlier Italian Schools*, 1951, pp. 148–49, as Florentine School). A *Crucifixion* in the Louvre (no. 1665 A) is rightly identified by Coletti (loc. cit.) as a work of the same hand.

The possibility that the panels were painted in Naples, not in Florence or Siena, was raised for the first time by Berenson (1936, p. 203). This suggestion is taken up by Bologna (*I pittori alla corte angioina di Napoli, 1266–1414*, 1969, pp. 301–2, 336, nn. 64–68, pl. VII-33, fig.

No. 41

37) with a convincing ascription to Roberto d'Oderisio. Points of reference for the style of the two panels occur in the signed *Crucifixion* by Roberto d'Oderisio formerly in San Francesco at Eboli and now in the Museo del Duomo, Salerno. The relationship of the present figures to, e.g., the Holy Woman in left profile supporting the Virgin and the Saint John the Evangelist in the Eboli *Crucifixion* is more than generic and extends to details of morphology. It is inferred by Bologna that the two panels date from the 1340s and were painted after the Eboli *Crucifixion* and before the *Sacrament* frescoes of 1352–54 in the church of the Incoronata in Naples. They would thus precede the *Pietà with the Instruments of the Passion* in the Fogg Art Museum, Cambridge, Mass., where the figures are less Giottesque.

The iconography of the London panel belongs to a class of representation discussed by Panofsky ("Imago Pietatis," *Festschrift für Max J. Friedländer zum 60. Geburtstage*, 1927, pp. 261–308) and Meiss ("Italian Primitives at Konopiště," *Art Bulletin*, 28, 1946, pp. 8–11). There is no precedent, however, for the distribution of four figures through the two wings of a diptych in the form in which they are shown here.

CONDITION: The paint surface is slightly abraded throughout, but the gold ground is very well preserved. Small flaking losses have been retouched round the forehead of Saint John and along the edge of his right shoulder and sleeve. Cracks in the Magdalene's robe have been inpainted. A large hole in the Magdalene's cuff and at the center of the bottom edge of the panel have been filled.

PROVENANCE: Duchess of Norfolk, Arundel Castle, Sussex; Swiss art market. Acquired by Philip Lehman before 1928.

EXHIBITED: Metropolitan Museum of Art, New York, 1954–61 (as Siena School, second part of XIV century); Musée de l'Orangerie, Paris, *La collection Lehman*, 1957, no. 32 (as Maître Florentin, vers 1340); Cincinnati Art Museum, *The Lehman Collection*, 1959, no. 68b (as Florentine Master, second quarter of XIV century).

VENICE

Fourteenth Century

Lorenzo Veneziano

A pupil of Paolo Veneziano, Lorenzo Veneziano executed an altarpiece for Sant'Antonio Abate in Venice in 1357. His established activity is confined within a period of fifteen years; his last dated work is the *Madonna* of 1372 in the Pinacoteca Comunale at Padua. Lorenzo Veneziano was also active in Bologna, where he undertook an altarpiece for San Giacomo Maggiore, and at Vicenza.

42. Madonna and Child Enthroned with Two Donors

1975.1.78

Tempera on panel. 108.3 × 65.7 cm. (42⅝ × 25⅞ in.), excluding added strips approximately 6 mm. wide on all sides. The original wood support has been thinned and marouflaged on to a new cradled panel. There is a vertical crack through the whole height of the panel approximately on center.

The Virgin is shown in full-length seated on an elaborate architectural throne, much of the upper part of which is hidden by her halo. She looks outward at the spectator, wearing a crown and a blue cloak woven with a foliated design in gold thread and with a gold border and a green lining, over a pink dress with a gilded collar and a strip of gold decoration down the front. In her left hand she holds a goldfinch. The Child Christ, wearing a red cloak over a gold tunic lined with ermine, with right hand raised in benediction and left arm outstretched, is seated on her left knee. The donors kneel at the bottom corners of the panel, the one on the right wearing an Augustinian habit and the other a red robe.

The panel is discussed by Shorr (*The Christ Child in Devotional Images in Italy during the XIV Century*, 1954, p. 20) in a review of representations of the Child Christ blessing with head turned to the front. This image is Byzantine in origin. The habit of the right-hand donor is described by Szabo (1975, p. 21) as Franciscan.

The first dated works by Lorenzo Veneziano that survive are a polyptych commissioned by Domenico Lion for Sant'Antonio Abate in Venice, now in the Accademia, begun in 1357 and completed two years later; the *Mystic Marriage of Saint Catherine*, also in the Accademia, dated 1359 (1360 new style); and a damaged *Madonna and Child* of 1361 in the Museo Civico at Padua. Save by Berenson (1957, p. 98), who regards it as a late work, the present panel is commonly dated in the vicinity of these three paintings. Pallucchini (*La pittura veneziana del Trecento*, 1964, pp. 170–71), noting the resemblance of the pose of the Virgin to that of the Accademia *Mystic Marriage of*

Saint Catherine and of the brocaded dress to that of the Padua *Madonna*, tentatively dates it about 1365. In this analysis the frontal head of the Child is ascribed to the influence of Tommaso da Modena and the form of the throne to that of a prototype by Guariento. The throne in the present painting may well have been inspired by the throne in Madonnas by Guariento of the class of those in the Staatliche Museen, Berlin-Dahlem, and in the Courtauld Institute Gallery, London; but its architecture is highly individual and is likely to predate the more orthodox throne shown in the panel of 1370 by Lorenzo, *Christ Presenting the Keys to Saint Peter*, in the Museo Correr, Venice. Laclotte (in *La collection Lehman*, exh. cat., Musée de l'Orangerie, Paris, 1957, p. 23, no. 29) regards the panel as an early work executed in the vicinity of the Lion polyptych.

CONDITION: The paint surface has been cleaned unevenly. An irregular strip of damage across the bottom has been repainted, notably in the corners, at the base of the Virgin's pink dress and in the red robe of the donor on the left. The donor on the right is well preserved. The Virgin's crown, the upper half of her halo, and most of the gold in the upper lobe of the panel have been renewed. Damage to the two main figures is minimal, and is largely restricted to the Virgin's left hand and cheek and the base of her throat. The throne has been reinforced along the edges, and its finials have partly flaked away. The seat cushion has been retouched.

PROVENANCE: Mr. and Mrs. A. E. Goodhart, New York. Bequeathed by Mrs. Goodhart to Robert Lehman in 1952.

EXHIBITED: Metropolitan Museum of Art, New York, 1954–57; Musée de l'Orangerie, Paris, *La collection Lehman*, 1957, no. 29; Cincinnati Art Museum, *The Lehman Collection*, 1959, no. 95.

No. 42

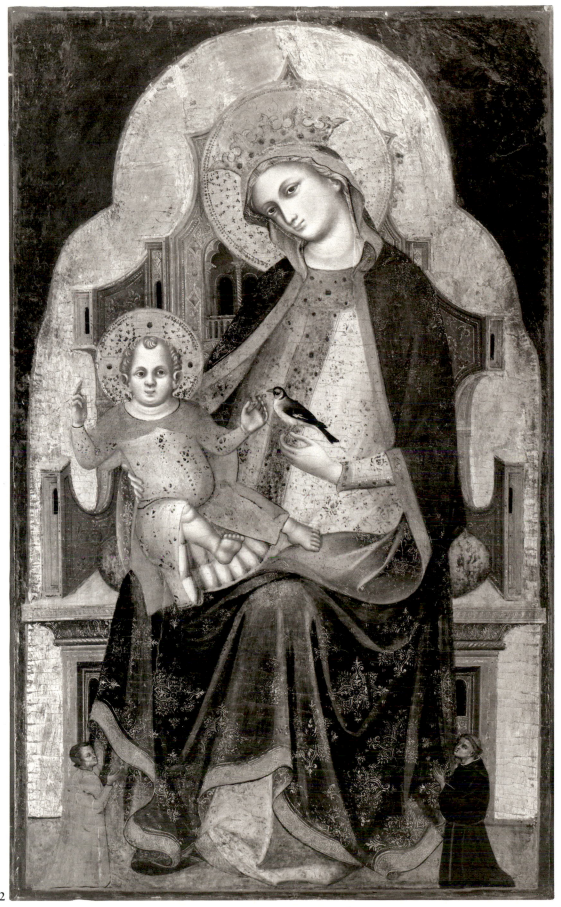

SIENA

Fifteenth Century

Born about 1400 in Cortona, Stefano di Giovanni, called Sassetta, appears to have been trained as a painter in Siena, where he emerges as the author of a major altarpiece (now disassembled) painted between 1423 and 1426 for the Arte della Lana. The highly unorthodox character of this work is continued in an altarpiece of the *Madonna of the Snow* painted for Siena Cathedral (Contini-Bonacossi Bequest, Palazzo Pitti, Florence). Here and in what is generally conceived to be his masterpiece, an altarpiece painted between 1437 and 1444 for San Francesco at Borgo San Sepolcro (panels in the Louvre, in the Harvard Center for Renaissance Studies at Villa I Tatti, Florence, in the National Gallery, London, and elsewhere), his imagery owes a substantial debt to the Franciscan Observant movement. He died in 1450. Early reconstructions of Sassetta's oeuvre (Berenson, Langton Douglas, Pope-Hennessy) included a number of works now given to the so-called Osservanza Master. The problems these present are here discussed under the rubric of that artist.

43. The Annunciation

1975.1.26

Tempera on panel. Overall panel: 76 × 43.3 cm. (30 × 17 1/16 in.); painted surface: 72.7 × 41 cm. (28 3/4 × 16 1/8 in.).

The Angel Gabriel kneels on the left with bowed head. His right hand, holding a spray of lilies, rests on his right knee, and his left hand is crossed over it. The Virgin stands on the right, turned three-quarters to the front and bending forward, with hands crossed on her chest. She wears a red and gold brocaded robe beneath a flowing dark blue cloak. On the marble pavement between the two figures is a gilded vase of lilies.

The panel seems to have been first associated with Sassetta by De Nicola, who, in an undated letter printed in a sale catalogue of 1934 (American Art Association, New York, January 13, no. 534), describes the Virgin as "almost identical with the Madonna generally recognized to be by Sassetta in the Cathedral at Grosseto." A letter by Offner, dated May 23, 1928, and printed in the same catalogue, describes it as "painted in the shop of Sassetta.... Sassetta himself furnished the design for this picture, and painted on it until he had determined its character—and especially on the Madonna—while an assistant worked on the sharp-fingered hands and on the head of the angel." It is mentioned by Van Marle (*Development*, vol. 9, 1927, p. 360) as a Sassetta of the same date as the Borgo San

Sepolcro altarpiece. Initially ignored by Berenson, it was later accepted by him (1968, p. 386) as a work of Sassetta. In 1939 it was wrongly ascribed (Pope-Hennessy, *Sassetta*, 1939, p. 170) to the author of the *Madonna of Humility* then in the Castelli-Mignanelli collection and now in the Magnani Foundation at Reggio Emilia. This connection was accepted by Brandi (*Quattrocentisti senesi*, 1949, p. 225). The Castelli-Mignanelli *Madonna* is given to Pietro di Giovanni d'Ambrogio by Volpe (review of E. Carli, *Sassetta e il Maestro dell' Osservanza, Arte antica e moderna*, 1, 1958, p. 86), who regards *The Annunciation* as "realizzata indubbiamente su un pensiero estremo del Sassetta." An attribution to Sassetta is accepted by Laclotte ("A propos des 'primitifs' italiens de la collection Lehman," *L'information de l'histoire de l'art*, 2, 1957, p. 50) with a dating in the mid-1430s.

Doubts as to the authorship of the painting have been due in the main to its condition. The traces of gold and silver decoration surviving in the wing of the angel and on the collar of the Virgin's dress are executed with a delicacy and sophistication unique to Sassetta, and there can be no doubt that the parts of the paint surface which are original (see below) are autograph.

In style and handling the panel closely recalls the panels of the double-sided altarpiece executed by Sassetta between 1437 and 1444 for the church of San Francesco at Borgo San Sepolcro. The altarpiece was disassembled between 1578 and 1583 (see P. Scapecchi, "La rimozione e lo smembramento della pala del Sassetta di Borgo San Sepolcro," *Prospettiva*, 20, 1980, pp. 57–58). Recent attempts to reconstruct it include those of Carli ("Sassetta's Borgo San Sepolcro Altarpiece," *Burlington Magazine*, 93, 1951, pp. 145–52; *Sassetta e il Maestro dell'Osservanza*, 1957, p. 54) and Laclotte (*Retables italiens du XIIIᵉ au XVᵉ siècle*, 1978, pp. 28–34). The front face of the altarpiece consisted of a Virgin and Child with Six Angels, now in the Louvre, flanked by figures of Blessed Ranieri Rasini (Harvard Center for Renaissance Studies at Villa I Tatti, Florence), Saint John the Baptist (I Tatti), Saint John the Evangelist (Louvre, Paris), and Saint Anthony of Padua (Louvre, Paris), with a predella from which two scenes from the life of Blessed Ranieri Rasini (Staatliche Museen, Berlin-Dahlem; Louvre, Paris) survive. On the back was the famous panel of *Saint Francis in Ecstasy* at I Tatti, flanked by eight scenes from the life of Saint Francis, of which seven are in the National Gallery, London, and the eighth is in the Musée Condé at Chantilly. In the center of the back, above the *Saint Francis in*

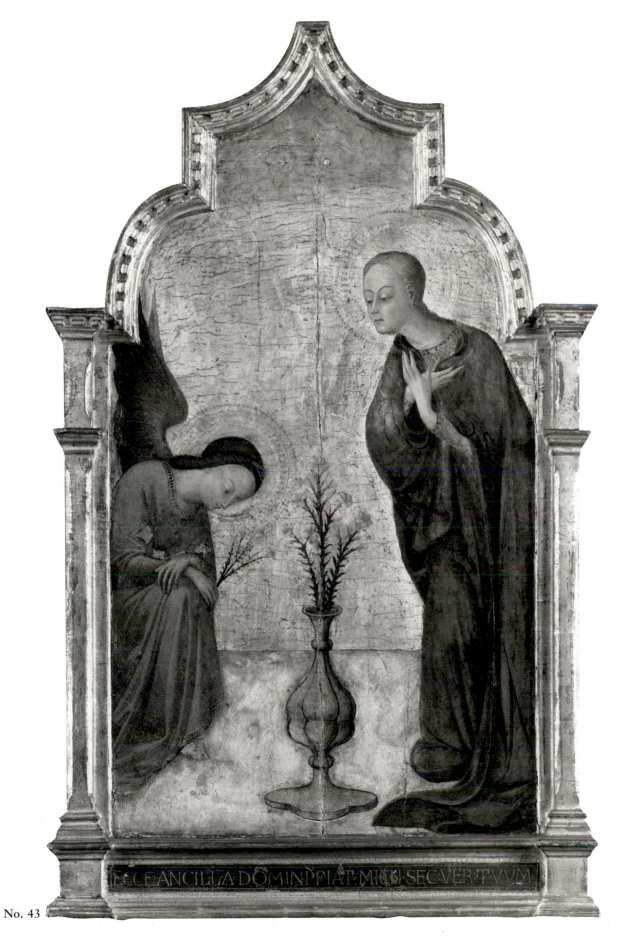

ECCE ANCILLA DOMINI FIAT MICHI SECVER TVVM

Ecstasy, was a pinnacle with *Saint Francis Kneeling Before the Crucified Christ* (Fig. 31), formerly in the collections of Prince Johann Georg of Saxony and Gerhard, Freiherr von Preuschen, Stuttgart, and now in the Cleveland Museum of Art (see R. Oertel, *Frühe italienische Tafelmalerei*, Stuttgart, 1950, p. 55; K. Bauch, "Christus am Kreuz und der heilige Franziskus," in E. Meyer, ed., *Eine Gabe der Freunde für Carl Georg Heise zum 28. VI. 1950*, pp. 103–12; Longhi, "Primitivi italiani a Stoccarda," *Paragone*, vol. 1, no. 7, 1950, p. 48; H. D. Gronau, "Early Italian Painting at Stuttgart," *Burlington Magazine*, 92, 1950, p. 322; and H. S. Francis, "Sassetta: Crucifixion with St. Francis," *Bulletin of the Cleveland Museum of Art*, 50, 1963, pp. 46–49). Two pinnacles from the lateral panels at the front of the altarpiece, an Evangelist in the Cini collection, Venice, and a bishop saint in a private collection in New York, have been identified by Zeri ("Tre argomenti umbri," *Bollettino d'arte*, 48, 1963, pp. 29–45), along with four pilaster panels, two from the front of the altarpiece (a bishop saint in the Cini collection, Venice, and a Saint Christopher formerly in the Perkins collection at Assisi and now in the Sacro Convento di San Francesco), and two from the back (a Saint Stephen and a Saint Lawrence in the Pushkin Museum, Moscow). It is likely that the present panel was originally the central pinnacle from the front of the San Sepolcro altarpiece. The presence of a central pinnacle is postulated by Carli (loc. cit.), who suggests that it would have represented the Redeemer.

The *Virgin and Child Enthroned with Angels* in the center of this altarpiece and the *Saint Francis in Ecstasy* in the center of the back were painted either on a single panel or on separate panels set back to back. The presumed central pinnacles with the Annunciation and Saint Francis Kneeling Before the Crucified Christ appear to have been treated in the same way. Both panels have been planed down: the maximum thickness of the Cleveland panel is now 2.4 cm., but its original thickness seems to have been of the order of 3.5 cm., and the depth of the present panel varies from 2 cm. to 3 cm. The sides and lateral lobes of the Cleveland panel have been cut, cropping the ends of the cross arm and the hands of the crucified Christ. The original width of the Cleveland panel, which now measures 40.5 cm., seems to have been approximately that of the Lehman panel (43.3 cm.), and the original height of the Lehman panel, which has been cut at the top and bottom, seems to have been approximately that of the Cleveland panel (90.8 cm.). Evidence for the original shape of the Lehman *Annunciation* is contradictory, but it is likely that it was reduced to its present form from a trilobe arch

similar to that of the Cleveland *Crucifixion*. At the spring of the arch, by the Virgin's shoulder and the angel's wing, a small area of the present panel was once covered by an engaged frame. A photograph of it taken in 1927 (Fototeca Berenson, Harvard Center for Renaissance Studies at Villa I Tatti, Florence) shows it with its present lateral elements and base but with a Gothic superstructure and spires rising from the lateral supports. The present upper section was added between that date and 1934, and the inscription on the base of the frame, which covers part of the original panel, dates from the same time. The tooling of the halo of Saint Francis in the Cleveland panel corresponds closely with that of the two haloes in the present panel, though Christ's halo necessarily has a cruciform design. In both panels the tooling shows a general correspondence with that in the main panels of the altarpiece. Their framing would presumably have conformed with that of the Saint Francis scenes.

CONDITION: The panel is very seriously damaged. The entire background has been regilt and incised with an artificial craquelure. The only areas that are reasonably well preserved are the faces and hands of the two figures, which, though worn, are intact save for the left eye and nose of the angel, and some edges where the outlines have been reinforced. The farther wing of the angel is a modern accretion, realized by leaving the original bole in that area exposed, and the hair is also new. In the robe of the angel the orange-yellow highlights and the patterning above the wrists are not original, though traces of original bright red paint survive. The remains of gold and silver ornamentation survive in the forward wing of the angel and on the collar of the Virgin's robe. In its present form the Virgin's cloak is a modern reconstruction. The marble floor is abraded; the lilies are damaged and retouched; and the gilt vase is a modern reconstruction.

PROVENANCE: The panel bears a Florentine export stamp dated April 7, 1927. Vicomte Bernard d'Hendecourt, Paris; Ercole Canessa, New York; A. Seligsberg; Sale, American Art Association, New York, January 13, 1934, no. 534. Acquired by Robert Lehman in 1934.

EXHIBITED: Fogg Art Museum, Cambridge (Mass.), 1940; Musée de l'Orangerie, Paris, *La collection Lehman*, 1957, no. 49; Metropolitan Museum of Art, New York, 1958–61; Cincinnati Art Museum, *The Lehman Collection*, 1959, no. 24.

The Osservanza Master

In Siena in the second quarter of the fifteenth century the dominant painter was Sassetta. The list of works with which he was credited at one time included three major complexes now given to a second artist named (from the location of one of the altarpieces) the Osservanza Master. These are: (i) a triptych of the Virgin and Child with Saints Jerome and Ambrose in the church of the Osservanza, outside Siena (the predella is in the Pinacoteca Nazionale, Siena); (ii) an altarpiece of the Birth of the Virgin in the Museo della Collegiata at Asciano (subsidiary panels are in the Harvard Center for Renaissance Studies at Villa I Tatti, Florence, and elsewhere); and (iii) a number of panels with scenes from the life of Saint Anthony the Abbot, discussed below. It was for some time supposed (by Berenson, Brandi, Pope-Hennessy, Torriti) that the Osservanza altarpiece, which bears the date 1436, was an early work of Sano di Pietro (whose first fully authenticated painting dates from 1444), and that the Birth of the Virgin at Asciano was also an early work of Sano di Pietro of approximately the same date. It has been established on valid documentary grounds (C. Alessi and P. Scapecchi, "Identificato in Francesco Alfei l'ignoto Maestro dell'Osservanza," *La nazione*, April 22, 1985) that the Osservanza altarpiece was commissioned not for the Osservanza but for the church of San Maurizio (suppressed in 1786), and that the date inscribed on it refers to the foundation of the chapel for which it was destined, not necessarily to the execution of the altarpiece. The term Osservanza Master is, however, still in general use. The earliest work by the artist that is securely datable, a *Dead Christ with Saints Sebaldus and Peter Volckamer* (Monte dei Paschi, Siena) was produced between April 1432 and November 1433 (H. M. von Erffa, "Der Nürnberger Stadtpatron auf italienischen Gemälden," *Mitteilungen des Kunsthistorischen Institutes in Florenz*, 20, 1976, pp. 1–12). An attempt has been made (Alessi and Scapecchi, loc. cit.) to identify the master with Francesco di Bartolomeo Alfei, who was born ca. 1421, is mentioned as active in Siena at various dates between 1453 and 1475, and also worked in the Marches and in Rome. The identification has no firm basis and is inherently improbable.

44. Saint Anthony the Abbot Tempted by a Heap of Gold

1975.1.27

Tempera on panel. Overall: 47.8 × 34.5 cm. (18¾ × 13⁹⁄₁₆ in.); picture surface: 46.8 × 33.6 cm. (18⁷⁄₁₆ × 13¼ in.). The panel, which has not been thinned or cradled, is 3.5 cm. thick. On the back, in addition to later labels, is painted No. 17 and the name Sano di Pietro. The wood grain is vertical. There are traces of saw cuts along the top, bottom, and left edges.

The bearded figure of Saint Anthony is seen in the foreground on the right, wearing a black habit and scapular, a mauve cloak, and a black cowl. His staff rests in the crook of his right arm. He gazes downward at a defaced area to the left of the path, which originally contained a pile of gold. In the extreme left foreground is a rabbit crouching beneath a barren tree. The stony path along which the saint walks winds away behind him to a pink church or monastery in the middle distance, set in a clump of cypresses. The church is partly concealed by a barren hill which rises on the right. The hillside and the edges of the path are lined with leafless trees. A deer, a stag, and two rabbits appear in the landscape. Behind, to the left, is a green lake which stretches to the horizon. On it are three islands and a small sailing vessel. On the right is a range of hills, one of them capped by the towers of a city. The sky is lit red and yellow by the sunset, with strips of gray and orange clouds reinforcing the curve of the horizon. A small strip of gilding appears through a break in the clouds at the right. To the left of center at the top are two flying birds.

The subject of the scene is identified by Kaftal (*Iconography of the Saints in Tuscan Painting*, 1952, pp. 67, 74, n. 9) as an incident from the life of Saint Anthony the Abbot described in the *Acta Sanctorum* (Januarii 11, p. 489, no. 222). It is sometimes described as Saint Anthony tempted by a golden porringer, but in contemporary paintings of the scene (from the workshop of Fra Angelico in the Museum of Fine Arts, Houston [Straus collection], and by an unidentified Florentine artist in the Musées Royaux des Beaux-Arts, Brussels, no. 631), a pile or lump of gold is shown. Cycles of scenes from the life of Saint Anthony the Abbot, traditionally regarded as the founder of Christian monasticism, were popular in Tuscany in the fourteenth and early fifteenth centuries. Frescoed cycles are found at Le Campora, Florence (close to Maso di Banco); in the Castellani Chapel in Santa Croce, Florence (Agnolo Gaddi); in the Oratorio di Sant'Antonio at Pescia

(Bicci di Lorenzo); and in San Lorenzo at San Giovanni Valdarno (anonymous, second quarter of the fifteenth century). A number of panels with scenes from the life of the saint, which seem originally to have formed part of altarpieces or votive images dedicated to Saint Anthony, are also known. These include a panel by Niccolò di Buonaccorso with two scenes from the life of Saint Anthony in the Museum of Fine Arts, Houston (Straus collection) and five panels by Martino di Bartolomeo in the Pinacoteca Vaticana.

The present panel formed part of the finest of these cycles, from which eight panels are preserved: 1. *Saint Anthony at Mass Dedicates His Life to God* (Staatliche Museen, Berlin-Dahlem; Fig. 32); 2. *Saint Anthony Distributes His Fortune in Alms* (National Gallery of Art, Washington, Kress collection; Fig. 33); 3. *Saint Anthony Receives the Blessing of an Old Monk Before Leaving for the Desert* (National Gallery of Art, Washington, Kress collection); 4. *The Devil Appears to Saint Anthony as a Beautiful Woman* (Yale University Art Gallery, New Haven, Jarves collection; Fig. 34); 5. *Saint Anthony is Beaten by Devils* (Yale University Art Gallery, New Haven, Jarves collection; Fig. 35); 6. *The Devil Tempts Saint Anthony by Putting a Heap of Gold in His Path* (Metropolitan Museum of Art, New York, Robert Lehman Collection); 7. *Saint Anthony Visits Saint Paul the Hermit* (National Gallery of Art, Washington, Kress collection; Fig. 36); 8. *The Funeral of Saint Anthony* (National Gallery of Art, Washington, Kress collection; Fig. 37). The wood grain in all but one of these, no. 4, is vertical, and it can be inferred from this that they were arranged vertically on either side of a painted or sculpted image of the saint. The construction of the panel in 4, composed of three different pieces of wood (for which see C. Seymour, "The Jarves 'Sassettas' and the Saint Anthony Altarpiece," *Journal of the Walters Art Gallery*, 15–16, 1952–53, p. 37, fig. 5) seems to indicate that it was set at the top on the left-hand side. Two of the panels (1 and 5) have been disfigured by candle burns, and these are likely to have stood at or near the base of the two sets of lateral panels. Reading from bottom to top, the sequence would then have been *(left)* 1, 2, 3, 4 and *(right)* 5, 6, 7, 8. The uppermost panels (4 and 8) are wider and less tall than those below. An analogy for this scheme is provided by the fresco at San Giovanni Valdarno, where a full-length figure of Saint Anthony is flanked by scenes from his life arranged vertically on either side. The sequence in the fresco starts from the bottom at the left, and the two uppermost scenes are horizontal.

There is no means of reconstructing the history of the panels before 1859, when panels 4 and 5 were bought by

Jarves for his collection. Panel 7 was purchased by Lady Selina Vernon in 1862, and 2 and 3 are recorded in 1870 in the Caccialupi collection at Macerata. The arms shown in *Saint Anthony Distributes His Fortune in Alms* are identified by Scapecchi ("Quattrocentisti senesi nelle Marche: Il polittico di Sant'Antonio abate del Maestro dell'Osservanza," *Arte cristiana*, 698, 1984, pp. 287–90) as those of the Sienese family of Martinozzi. In 1430 Niccolò Martinozzi was invested by Queen Joanna of Naples with the title of Conte di Castelluccio in Abruzzo. There is no evidence of a direct connection between the Martinozzi and the Caccialupi, from whom two of the Saint Anthony panels were acquired. The fact that in two of the panels (1 and 2) the action takes place in a setting that can only be construed as Siena militates against the view that the complex was commissioned for the Marches rather than for Siena or its vicinity. The Martinozzi Chapel in Sant'Agostino, Siena, was dedicated to Saint Anthony the Abbot (*Die Kirchen von Siena*, I, 1, 1985, p. 218); this may have been the site of the altarpiece, which is not, however, described in any inventory.

Until 1940 the Scenes from the Life of Saint Anthony the Abbot were universally attributed to Sassetta. Sassetta's authorship of one of the two panels at New Haven was accepted by its owner, James Jackson Jarves (*Art Studies*, 1861, p. 240), and both New Haven panels were included by Berenson ("A Sienese Painter of the Franciscan Legend," *Burlington Magazine*, 3, 1903, p. 180; *A Sienese Painter of the Franciscan Legend*, 1909, pp. 63–64) in his initial reconstruction of Sassetta's artistic personality. The present panel was identified as part of the same series of scenes as the New Haven panels by Mary Logan Berenson ("Il Sassetta e la leggenda di S. Antonio Abate," *Rassegna d'arte*, 11, 1911, pp. 202–3). Its attribution to Sassetta was later accepted by Borenius (in Crowe and Cavalcaselle, vol. 5, 1914, p. 170, n), Sirén and Brockwell (*Catalogue of a Loan Exhibition of Italian Primitives*, F. Kleinberger Galleries, New York, 1917, p. 138), Perkins ("Some Sienese Paintings in American Collections," *Art in America*, 9, 1921, pp. 13–15), Dami ("Giovanni di Paolo miniatore e i paesisti senesi," *Dedalo*, 4, 1923–24, pp. 286, 292), Van Marle (*Development*, vol. 9, 1927, p. 320), Offner (*Italian Primitives at Yale University*, 1927, pp. 7, 39–40), R. Lehman (1928, pl. 39), Waterhouse ("Sassetta and the Legend of Saint Anthony the Abbot," *Burlington Magazine*, 59, 1931, pp. 108–13), Berenson (1932, p. 513; 1936, p. 441), Gronau ("On Some Drawings of the Sienese School," *Old Master Drawings*, 7, 1932, p. 2), Gengaro ("Il primitivo del Quattrocento senese: Stefano di Giovanni detto il Sassetta," *La Diana*,

No. 44

8, 1933, pp. 11, 24, as *The Apparition of a Rabbit to Saint Anthony the Abbot*, wrongly identified as part of the Arte della Lana altarpiece), and Pope-Hennessy (*Sassetta*, 1939, pp. 69–77, 91–93).

In 1940, however, it was pointed out by Longhi ("Fatti di Masolino e di Masaccio," *Critica d'arte*, 5, 1940, pp. 188–89) that a number of works then ascribed to Sassetta were by a second, independent artist; the most important of these were an altarpiece dated 1436 in the church of the Osservanza outside Siena and an altarpiece of the Birth of the Virgin at Asciano. The authorship of the Saint Anthony panels was also questioned by Longhi, who urged "qualche giovane studioso a riesaminare in rapporto con questo nobile spirito anche le famose *Storie di S. Antonio* divise fra varie raccolte americane." A pupil of Longhi's, Alberto Graziani, before his death in 1942, prepared an article on the artist who has been known since that time as the Osservanza Master ("Il Maestro dell'Osservanza," *Proporzioni*, 2, 1948, pp. 75–88). Critical opinion thereafter was for some time divided between those scholars who accepted Graziani's findings in toto (C. Brandi, *Quattrocentisti senesi*, 1949, p. 84; F. Zeri, "Il Maestro dell'Osservanza: Una 'Crocifissione,'" *Paragone*, vol. 5, no. 49, 1954, pp. 43–44; E. Carli, *Sassetta e il Maestro dell Osservanza*, 1957, pp. 89–121; L. Castelfranchi Vegas, *Il gotico internazionale in Italia*, 1966, p. 52; and others) and those who distinguished between the hand responsible for the Osservanza and the Asciano altarpieces and the hands responsible for the Saint Anthony panels (B. Berenson, *Sassetta*, 1946, p. 52; Seymour, op. cit., pp. 30–45, 97; Pope-Hennessy, "Rethinking Sassetta," *Burlington Magazine*, 98, 1956, pp. 364–70; M. Laclotte, "A propos des 'primitifs' italiens de la collection Lehman," *Information de l'histoire de l'art*, 2, 1957, pp. 50–51; F. R. Shapley, *Paintings from the Samuel H. Kress Collection: Italian Schools XIII–XV Century*, 1966, pp. 141–43).

In 1946 it was argued by Berenson (*Sassetta*, p. 52) that the Osservanza triptych and the Asciano altarpiece and a number of paintings grouped around them by Graziani were early works by Sassetta's contemporary Sano di Pietro, who is known to have been active by 1428 but whose earliest dated painting was produced in 1444. This view was later adopted by Brandi (op. cit., pp. 69–87), Pope-Hennessy ("Rethinking Sassetta," p. 370), and Torriti (*La Pinacoteca Nazionale di Siena: I dipinti dal XII al XV secolo*, 1980, pp. 248–53; *Mostra di opere d'arte restaurate nelle provincie di Siena e Grosseto*, 2, 1981, pp. 83–85). It does not, however, follow that the Saint Anthony panels were commissioned from this artist, since their compositional sophistication, their palette, and their expressive range are incompatible with the highly conventional handling of the smaller narrative scenes associated with the Asciano and Osservanza altarpieces.

There can be no reasonable doubt that work on the Saint Anthony altarpiece was collaborative. This was argued on the basis of macrophotography by Seymour (op. cit.), who established that the panels at New Haven were executed by two different hands. Though the validity of Seymour's results has been contested by Volpe ("Sassetta e il Maestro dell' Osservanza," *Arte antica e moderna*, 1, 1958, p. 58), renewed study of the Yale panels shows conclusively that the distinction drawn by Seymour is correct. It was inferred by Pope-Hennessy ("Rethinking Sassetta," p. 366) that the Washington *Saint Anthony Visits Saint Paul the Hermit* and the Lehman *The Devil Tempts Saint Anthony* were executed by the author of the Yale *Temptation*. This inference is wrong. The artist of the New Haven *Flagellation* was responsible for these two panels. The painter cannot be identical with the painter of the predella of the Osservanza altarpiece, since (i) the figure drawing and the delineation of movement are incompatible, and (ii) the treatment of the trees in all three panels, and the path and interior of the cave in that in Washington differ markedly from these features in the *Saint Jerome in Prayer* in the predella. In all these respects, the New Haven *Temptation* and the Washington *Funeral of Saint Anthony* and *Saint Anthony Receives the Blessing of an Old Monk Before Leaving for the Desert* (where much of the paint surface and all of the gold ground are modern) correspond to the predella of the Osservanza altarpiece and to the panels of a somewhat later Passion predella divided between Philadelphia, Rome, Kiev, Detroit, and Cambridge, Mass. (see also No. 45).

In No. 44 and four of the other panels from the Saint Anthony altarpiece the projection of architectural space is more lucid, the landscapes are less schematic, and the movement and foreshortening of the figures is more articulate. They are closely related to the practice of Sassetta in *The Journey of the Magi*, now divided between the Monte dei Paschi, Siena (formerly Chigi-Saracini collection), and the Metropolitan Museum, New York (acc. no. 43.98.1), and the two predella panels with scenes from the life of the Blessed Ranieri Rasini in Berlin and Paris. The relationship of the Berlin *Saint Anthony at Mass* to these panels, as well as to the predella of the earlier Arte della Lana altarpiece, provides evidence that the artist responsible for its design was intimately involved with Sassetta. Like the *Scenes from the Life of Saint Francis* on Sassetta's Borgo San Sepolcro altarpiece (1437–44), the

present panel and the two panels in New Haven reveal the influence of French illuminations by, or from the circle of, Jacquemart de Hesdin, whose *Flight into Egypt* in the *Très Belles Heures du Duc de Berry* (Brussels) makes use of similar landscapes and of the same skeletal trees. It is likely that the Saint Anthony altarpiece was commissioned and executed in the mid-1430s.

There is no evidence as to whether the image flanked by the Saint Anthony panels was a painting or a sculpture. Attempts to identify the lost effigy of the saint with a fragmentary panel of Saint Anthony the Abbot in the Louvre (Graziani, loc. cit.) have been disproved by Laclotte (*Retables italiennes du XIIIᵉ au XVᵉ siècle*, 1978, pp. 28–34), who establishes that the panel originates from a polyptych and was paired with a fragmentary *Saint John the Baptist* in the Perkins collection at Assisi. A panel of Saint Anthony the Abbot, now in the collection of the Monte dei Paschi, Siena, published by Zeri ("Towards a Reconstruction of Sassetta's Arte della Lana Triptych," *Burlington Magazine*, 98, 1956, pp. 36–41) as part of Sassetta's Arte della Lana altarpiece, was wrongly proposed by Pope-Hennessy (1956) as the central panel of the Saint Anthony altarpiece. This panel seems rather to have originated from a third polyptych, of which a lateral panel of Saint Nicholas of Bari in the Louvre and a fragmentary Madonna at Grosseto also formed part (see C. Ressort in J. Foucart, ed., *Musée du Louvre: Nouvelles acquisitions du Département des Peintures [1980–1982]*, 1983, p. 8). But polychrome wooden statues of Saint Anthony the Abbot were produced in Siena in some numbers in the early fifteenth century. Two of the most notable of these are a figure in the church of San Domenico, which was commissioned in 1425–26 for the high altar of Sant'Antonio Abate a Fontebranda, where it was accompanied by narrative panels by Martino di Bartolomeo (for this see *Die Kirchen von Siena*, 1, 1985, p. 397), and a statue in the Misericordia (formerly Sant'Antonio Abate), which dates from the first quarter of the fifteenth century (ibid., pp. 362–63).

CONDITION: The paint surface is extremely well preserved. At the lower left, to the right of the rabbit, a void area that contained the heap of gold has been overpainted. The clouds on either side of the exposed strip of gold in the sky, between the church steeple and the right edge of the panel, have been retouched, and there is some abrasion in the halo of the saint. The turquoise blue of the distant lake has oxidized to green.

PROVENANCE: Prince Léon Ouroussoff, Vienna (see W. Suida, *Oesterreichische Kunstschätze*, vol. 1, 1911, no. 58, as by a Sienese artist of the late fourteenth century). Acquired by Philip Lehman before 1924.

EXHIBITED: Duveen Galleries, New York, *Early Italian Paintings Exhibited at the Duveen Galleries*, 1924, no. 29 (as Sassetta); Metropolitan Museum of Art, New York, 1944 (as Sassetta); Colorado Springs Fine Arts Center, *Paintings and Bronzes from the Collection of Mr. Robert Lehman*, 1951–52 (as Sassetta); Metropolitan Museum of Art, New York, 1954–61 (as Sassetta); Musée de l'Orangerie, Paris, *La collection Lehman*, 1957, no. 48 (as Sassetta); Cincinnati Art Museum, *The Lehman Collection*, 1959, no. 25 (as Sassetta).

45. Madonna and Child Enthroned with Two Cherubim

1975.1.41

Tempera on panel. 143.5 × 69.5 cm. (56½ × 27⅜ in.). The wood support has a thickness of 3.8 cm. and is composed of a broad central plank and two narrow sections, each approximately 4 cm. wide, joined with pegs at the sides. The original engaged frame with its crockets is preserved along the ogival arch to the level of the missing capitals, which are visible as new gold alongside the cherubs' heads. The lateral and base moldings are modern.

The Virgin is seated on a marble throne with a foliated molding. The gold floor upon which the throne rests is articulated by perspectival strips painted in an intarsia pattern composed of black, white, gold, and brownish red lozenges and triangles. At the base is a broader horizontal band of simulated intarsia with a succession of stylized flower buds set on their sides against a black ground, forming the vertical face of a step or molding below the inlaid floor. Behind the throne are two cherubim with heads upturned and with particolored wings set vertically. The Virgin wears a red dress embroidered in gold at the neck and wrist, covered by a dark blue cloak. The Child, covered with a pink cloth, raises his right hand in benediction and in his left holds a scroll with the inscription EGO:S. The halo of the Virgin is inscribed with the words MARIA · MATER · GRATIE · ET · MISER, and that of the Child with the words YESVS NAÇAR ENVS · R EX · IV [DAEORVM].

Since it was first published by Perkins ("Alcuni dipinti senesi sconosciuti o inediti," *Rassegna d'arte*, 13, 1913, p. 123; "La pittura alla Mostra d'Arte di Montalcino," *Rassegna d'arte senese*, 18, 1926, p. 70, n. 10), the picture has been universally accepted as a work of Sano di Pietro and is so regarded by Van Marle (*Development*, vol. 9, 1927, p. 483), Berenson (1932, p. 500, and later editions), and Gaillard (*Un peintre siennois au XVᵉ siècle, Sano di Pietro, 1406–1481*, 1923, p. 204). Though the form of the throne recalls that in the polyptych of 1444 from San Girolamo in the Pinacoteca Nazionale, Siena (no. 246), and less decisively that in the somewhat later *Madonna and Child with Four Angels* in the Osservanza at Siena, the expressive heads and the clarity of the spatial structure have no equivalent in these or later works, but find their closest parallel in the central panel of the triptych by the Osservanza Master.

A related *Madonna of Humility with Two Angels* at Altenburg (for which see R. Oertel, *Frühe italienische Malerei in Altenburg*, 1961, no. 74, pp. 95–96) is by the same hand. It is closely related to the only datable paint-

ing by this master, a *Pietà* from the Serristori collection now in the Monte dei Paschi, Siena, which may be firmly assigned to the year 1433. The triptych in the Osservanza appears to date from the early 1440s, and the present panel must occupy an intermediate position between these two works. The motif of the cherubim with vertical wings is used again in an abbreviated and less calligraphic form in altarpieces by Sano di Pietro of 1447 and 1449 in the Pinacoteca Nazionale, Siena (nos. 232, 255), and has a close parallel in the *Madonna of Humility* in the Brooklyn Museum (Frank L. Babbott Bequest), variously regarded as a late work of Domenico di Bartolo (d. 1447) and as a work executed by Sano di Pietro on Domenico di Bartolo's cartoon.

The inscription in the halo of the Child Christ is unusual and suggests, as Keith Christiansen has noted (verbally), that the altarpiece was completed with a predella with Passion scenes. This is likely to have comprised a *Crucifixion* in the Museum of Western Art in Kiev, a *Flagellation* in the Pinacoteca Vaticana, a *Christ Carrying the Cross* in the Philadelphia Museum of Art (Johnson collection), a *Resurrection* in the Detroit Institute of Arts, and a *Christ in Limbo* in the Fogg Art Museum, Cambridge, Mass., variously ascribed to Sano di Pietro and the Osservanza Master. The width of the Kiev *Crucifixion*, which would have stood beneath the present panel, is 65 cm.

CONDITION: The paint surface is in good condition. The Virgin's cloak has, however, been reinforced locally and the squared ends of the pink cloth beneath the Child's feet are repainted. There are minor flaking losses on the Child's right hand and in the head of the cherub on the right.

PROVENANCE: F. Mason Perkins, Lastra a Signa; Rita Lydig, New York; Lydig sale, American Art Association, New York, April 4, 1913, no. 126 (see catalogue by W. R. Valentiner); Morton Meinhard, New York; Mrs. Morton Meinhard, New York; Meinhard sale, Parke-Bernet Galleries, New York, May 4–5, 1951, no. 313. Acquired by Robert Lehman in 1951.

EXHIBITED: Metropolitan Museum of Art, New York, 1954–61; Musée de l'Orangerie, Paris, *La collection Lehman*, 1957, no. 45 (as Sano di Pietro); Cincinnati Art Museum, *The Lehman Collection*, 1959, no. 43 (as Sano di Pietro).

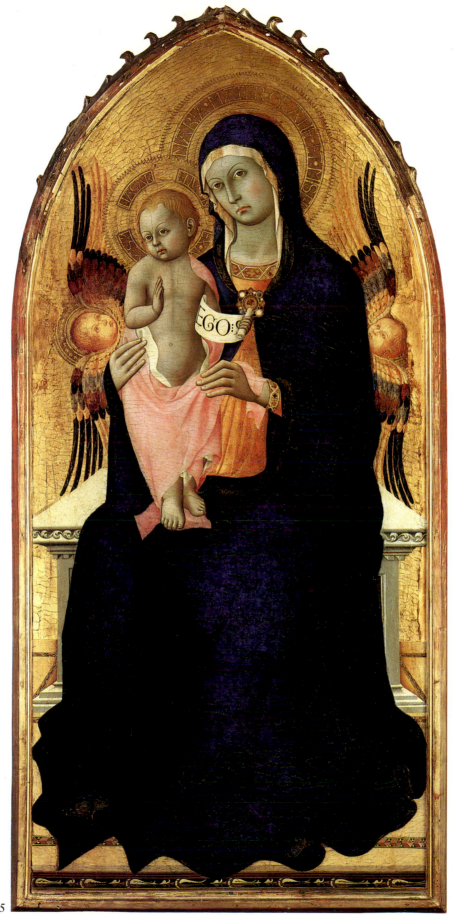

No. 45

Pietro di Giovanni d'Ambrogio

Pietro di Giovanni d'Ambrogio, born about 1409, is first recorded in Siena in 1428, when his name appears among the members of the painters' guild, but all his dated works come from the last decade of his life. He died in 1449. His early career must have been passed in the orbit of Sassetta, by whose *Madonna of the Snow* and Cortona altarpieces he was strongly influenced and to whom some of his works have been attributed. Though his career was short, Pietro di Giovanni d'Ambrogio was prolific, and his highly personal narrative style earned him commissions in Asciano, Città di Castello (1440), Borgo San Sepolcro (1444), and Lucignano (1448), as well as in Siena.

46. Saint Michael

1975.1.28 A

Tempera on panel. With engaged frame: 29.7 × 13.4 cm. (11¹¹⁄₁₆ × 5¼ in.); picture surface: 24.5 × 7.5 cm. (9¼ × 2¹⁵⁄₁₆ in.).

The saint is shown in full-length with his head turned slightly to the right. His sword, helmet, and wings are silver, his armor is gilt with a blue edge, and his shoulders and knees are protected with gilt lion masks. He holds the severed head of a dragon in his left hand. His right hand rests on a foreshortened shield inscribed with a cross, and he holds a sword erect parallel to the left side of the panel.

The figure is wrongly identified as Saint George by R. Lehman (1928, pl. 40), L. Venturi (*Pitture italiane in America*, 1931, pl. 126), McCall (*Catalogue of European Paintings and Sculpture from 1300–1800*, p. 169, no. 348), and Laclotte (in *La collection Lehman*, exh. cat., Musée de l'Orangerie, Paris, 1957, p. 42, no. 50). The presence of wings leaves no doubt that the Archangel Michael is represented.

This panel and No. 47 are fragments cut from larger panels to their present size. Their molded surrounds are new, and have been gilt and punched to correspond to the frame of a *Madonna* by Naddo Ceccarelli (see No. 10), to which they were attached in the nineteenth century and with which they were exhibited in 1893 (see below). A photograph preserved in the files of the Robert Lehman Collection, taken when the panels were in the possession of Langton Douglas, shows them reconstituted in this way. Traces of original punching are visible at the sides of both panels, but no original punching is apparent along the upper edges, and the panels are likely therefore to

have been somewhat reduced in height but not in width. It has been suggested (i) that they originally formed the wings of a small triptych, or (ii) that owing to the absence of cusps or gables at the tops of the panels they should be regarded as pilaster panels or as dividing panels in a predella (C. Brandi, "Pietro di Giovanni di Ambrogio," *Le arti*, 5, 1942–43, p. 137). The first of these explanations is almost certainly correct. Since the panels have been cut at the top they may originally have had gables, possibly with figures of the Virgin Annunciate and the Annunciatory Angel.

The attribution of the two panels to Sassetta seems to have originated with Langton Douglas (in Crowe and Cavalcaselle, vol. 3, 1908, p. 70, n.), and is accepted by Comstock ("Paintings by Sassetta in America," *International Studio*, 88, 1927, p. 41), R. Lehman (loc. cit.), Berenson (1932, p. 513; 1937, p. 441; 1968, vol. 1, p. 386, as close to Sassetta), L. Venturi (loc. cit.), Gengaro ("Il primitivo del Quattrocento senese: Stefano di Giovanni detto il Sassetta," *La Diana*, 8, 1933, pp. 24–25), Pope-Hennessy (*Sassetta*, 1939, pp. 68, 91, n. 30, 209), McCall (loc. cit.), and with some reserve Laclotte (loc. cit.). The panels are ignored by Carli (*Sassetta e il Maestro dell'Osservanza*, 1957). It is suggested by Longhi ("Fatti di Masolino e di Masaccio," *Critica d'arte*, 5, 1940, p. 189, n. 28, figs. 64–66) that they formed the wings of a *Madonna and Child Enthroned with Saints John the Baptist and Dorothy* in the Staatliche Museen, Berlin-Dahlem. The sizes of the Berlin panel and its supposed wings are generally compatible (the height to the spring of the gable within the molded frame of the Berlin *Madonna* is 24.3 cm. and the height of the picture surface in the present panels is 24.5 cm.), and what can still be seen of the punching along their margins corresponds. As halo decoration and figure style also correspond, the reconstruction of the three panels as a triptych is plausible.

There is some doubt as to the authorship of the Berlin panel, which has been given by Longhi (loc. cit.) to Domenico di Bartolo and has also been wrongly regarded as an early Vecchietta (Pope-Hennessy, "The Development of Realistic Painting in Siena—II," *Burlington Magazine*, 84, 1944, p. 143). It is officially assigned to the following of Sassetta (Gemäldegalerie Staatliche Museen Preussischer Kulturbesitz, *Katalog der ausgestellten Gemälde des 13.–18. Jahrhunderts*, 1975, p. 388). A distinction is drawn by Brandi (loc. cit., and *Quattrocentisti senesi*, 1949, p. 208, n. 71, p. 226, n. 107) between the *Madonna*, which he ascribes to a Sassetta follower, and

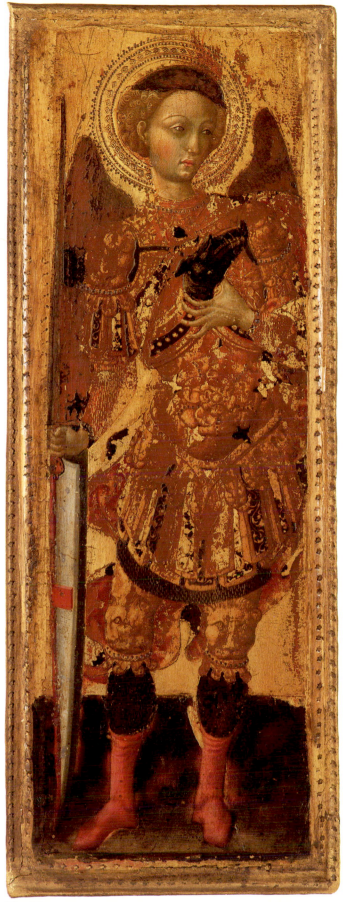

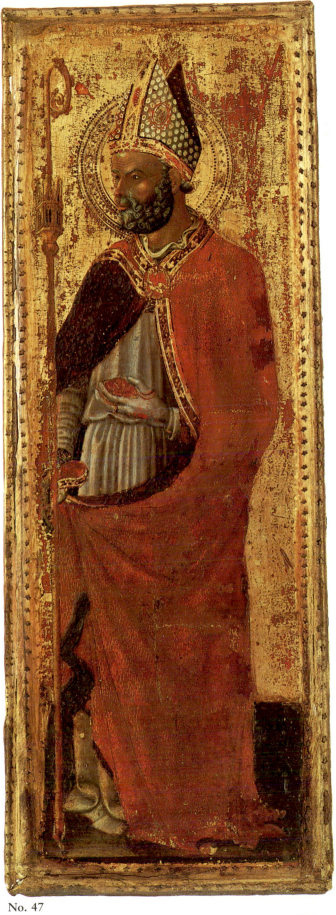

No. 46

No. 47

the present panels, which he attributes to Pietro di Giovanni d'Ambrogio.

Though it cannot be conclusively demonstrated, the attribution of the entire complex to Pietro di Giovanni d'Ambrogio is likely to be correct. The panels, if they are by him, would be the most Sassettesque, and thus probably the earliest, of his surviving paintings. A close analogy for the Saint Michael occurs in Sassetta's Cortona polyptych of the mid-1430s, and it is likely that the panels date from this time, not from the years 1442–44 to which they are assigned by Brandi.

CONDITION: The paint and gold have flaked extensively, exposing large areas of bole, but no retouching is in evidence. The head, hands, boots, and shield are largely intact. The gold armor, however, is much broken up, and the wings, sword, and helmet, originally silvered, survive only as engraved bole and islands of metal leaf with traces of glazing.

PROVENANCE: C. Fairfax Murray, Florence, till 1885; Charles Butler, Warren Wood, Hatfield, Herts. (a label on the back of No. 47 reads: "7/10/04. The *Wings* of the Triptych are painted by *Stefano di Giovanni called Sassetta Sienese*: Pupil or Relative of Lippo Memmi C[harles] B[utler] Bot. in Italy from Mr. C. F. Murray 1885"); Captain H. L. Butler; R. Langton Douglas, London. Acquired by Philip Lehman in 1918.

EXHIBITED: New Gallery, London, *Exhibition of Early Italian Art*, 1893–94, no. 62 (as "Triptych . . . Florentine School"); Metropolitan Museum of Art, New York, 1954–61 (as Sassetta); Musée de l'Orangerie, Paris, *La collection Lehman*, 1957, no. 50 (as Sassetta); Cincinnati Art Museum, *The Lehman Collection*, 1959, no. 26 (as Sassetta).

47. Saint Nicholas of Bari

1975.1.28 B

Tempera on panel. With engaged frame: 29.7 × 13.4 cm. (11 11/16 × 5 1/4 in.); picture surface: 24.5 × 7.5 cm. (9 1/4 × 2 15/16 in.).

The bearded saint is shown in full-length, facing left. On his head is a miter. He wears a white alb covered with a red and gold cope. In his left hand he holds three golden balls, and in his right hand a bishop's crozier, which runs the whole height of the panel parallel with the left edge.

See No. 46.

CONDITION: As with No. 46, the paint and gold has flaked extensively, but no retouching is in evidence. The red and gold surface of the saint's cope is all but lost, and there is some damage to the gold ground, but the figure is otherwise well preserved and abrasion is minimal.

PROVENANCE: See No. 46.

EXHIBITED: See No. 46.

Giovanni di Paolo

The most individual Sienese painter of the fifteenth century, Giovanni di Paolo seems to have been born about 1400. His signature appears for the first time in altarpieces of 1426 and 1427 executed under the influence of Gentile da Fabriano, who was for a short time active in Siena. Thereafter his development can be traced through a number of dated altarpieces until 1475. The study of his work nonetheless abounds in problems arising principally from the structure of disassembled altarpieces. Some of the eleven panels by him in the Robert Lehman Collection are directly relevant to these issues. They include a panel from his undated masterpiece, the *Scenes from the Life of Saint John the Baptist*; four panels from the problematical Pizzicaiuoli altarpiece painted for Santa Maria della Scala in Siena; a major altarpiece of uncertain provenance of *The Coronation of the Virgin*; a predella panel from the Guelfi altarpiece executed for San Domenico, Siena, in 1445 and now in the Uffizi; and two works that throw some light on his insufficiently discussed late style. Giovanni di Paolo died in 1482.

48. The Creation of the World and the Expulsion from Paradise

1975.1.31

Tempera on panel. 46.5 × 52 cm. (18 5/16 × 20 1/2 in.). The panel, which has been thinned to 8 mm., is uncut along the base, where the original beard of paint is visible with a 6-mm. strip of new paint added beneath it. An irregular strip of new paint approximately 5 mm. wide masks the original beard on the right side. The left edge of the panel is original, but the top has been sawn through.

From the upper left corner of the panel God the Father, supported by twelve blue cherubim, flies diagonally downward. He wears a light blue robe and a pale blue cloak shaded in mauve, and points with his right hand at a circular *mappamondo* (see below), which fills the lower part of the scene. On the right, in a meadow filled with flowers (among which lilies, carnations, and roses are visible), are the naked figures of Adam and Eve, walking to the right against a line of seven trees with golden fruit. Their heads are turned back toward a naked angel, who with outstretched arms expels them from Paradise. At the bottom on the right spring the four rivers of Paradise, which extend to the base of the panel.

This panel, which was first published by Perkins ("La pittura alla Mostra d'Arte Antica in Siena," *Rassegna d'arte*, 4, 1904, pp. 49–50), originates from the same disassembled predella as a scene of *Paradise* (Fig. 39) in the Metropolitan Museum of Art (acc. no. 06.1046; tempera on canvas, transferred from panel: 44.5 × 38.4 cm.). The latter has been cut on the right, but corresponds in its rich handling and its strong craquelure with No. 48. The connection is confirmed (Pope-Hennessy, *Giovanni di Paolo*, 1937, p. 21) by the setting, which includes similar trees at the back and similar plants, with rabbits playing among them, and by the type of the archangel, which recurs in an angel in the center of the *Paradise*, and that of the Adam, reproduced in an angel on the left of the same scene.

It is known from a number of sources that Giovanni di Paolo painted three altarpieces for the church of San Domenico in Siena. The first was executed in 1426 for the altar of the Pecci family, the second in 1427 for the Branchini altar (the central panels of both these altarpieces and some subsidiary panels from the earlier of them have been identified), and the third for the Guelfi chapel in the same church. The Guelfi altarpiece is described by Ugurgieri (*Le pompe sanesi*, 1649, vol. 2, p. 346) in the following terms: "E la terza fece nella Cappella de' Guelfi, che era accanto a quella di Colombini l'anno 1445, nella quale à dipinta la Beatissima Vergine con alquanti Santi, e nella predella vi è dipinto il giudizio finale, il diluvio e la creazione del mondo (cose bellissime), e perchè questa Cappella ancora fu rovinata, la tavola fu parimente trasportata nel refettorio del convento." Della Valle (*Lettere sanesi*, vol. 3, 1786, p. 50) was unable to trace this altarpiece, but there are two further references to it. The first occurs in 1575 in the "Visita pastorale" of Monsignor Egidio Bossio (ms. in the Curia Arcivescovile, Siena, c. 680), who describes it as "iconam perpulcram antiquam cum imagine Beatae Virginis et aliorum Sanctorum." The Guelfi chapel was dedicated to Saint Anthony, and since Bossio was accustomed to mention the presence of the titular saint in his accounts of chapel furnishings, it is likely that the lateral saints did not include Saint Anthony. The second reference occurs in a guide to the paintings, sculpture, and buildings of Siena prepared in 1625 by Monsignor Fabio Chigi (later Pope Alexander VII). In this text (for which see P. Bacci, "L'elenco delle pitture, sculture e architetture di Siena compilato nel 1625–26 da Mons. Fabio Chigi, poi Alessandro VII, secondo il ms. Chigiano I. 1. 11," *Bollettino senese di storia patria*, n.s. 10, 1939, p. 322), the relevant passage reads: "Il 4.° [altare] de' Guelfi *opus Iohannis de Senis 1426.*" Chigi does not mention Giovanni di Paolo's altarpiece of 1426 in the Pecci chapel, and the date given for the Guelfi altar

in his guide is evidently the result of a confusion with that painting.

A Dominican polyptych by Giovanni di Paolo of the Virgin and Child with Saints Dominic, Peter, Paul, and Thomas Aquinas in the Uffizi, Florence, signed OPUS JOHANNIS PAULI DE SENIS MCCCCXLV, is almost certainly the Guelfi altarpiece to which the present predella panel belonged. The identification of the Guelfi altarpiece with the Uffizi polyptych is denied by Brandi (*Giovanni di Paolo*, 1947, pp. 76–77), who nonetheless accepts a dating ca. 1445 for the present panel and for that in the Metropolitan Museum. Confirmation of a dating ca. 1445 for the present panel is provided by comparison with a *gabella* cover of that year with the Annunciation in the Pinacoteca Vaticana.

The Guelfi predella seems to have consisted of (i) the present panel, on the extreme left; (ii) a lost panel of corresponding size with the Flood on the extreme right; and (iii) a single panel or three individual panels in the center, with (*left*) Paradise, (*center*) Christ in Judgment, and (*right*) Hell. The facts that the panel in the Metropolitan Museum has been cropped on the right, where rays from the judgment seat are clearly visible, and that at a considerably later date Giovanni di Paolo depicted the three scenes on a single panel, now in the Pinacoteca Nazionale in Siena, suggest that for the central part of the predella a single panel of unusual width was employed.

It is argued by Baránszky-Jób ("The Problems and Meaning of Giovanni di Paolo's *Expulsion from Paradise*," *Marsyas*, 8, 1957–59, pp. 1–6) that the left half of the present panel does not show the Creation of the World, as was assumed by Ugurgieri (loc. cit.) and Pope-Hennessy (loc. cit.), and is not Dantesque in inspiration, as was suggested by Rossi ("L'ispirazione dantesca in una pittura di Giovanni di Paolo," *Rassegna d'arte senese*, 14, 1921, p. 149) and Bargagli Petrucci ("Il Mappamondo di Ambrogio Lorenzetti del Palazzo Pubblico di Siena," *Rassegna d'arte senese*, 10, 1914, pp. 8–9), but illustrates a conception of the universe derived from the *De natura rerum* and the *Etymologiae* of Isidore of Seville and shows the earth surrounded by eight spheres containing the planets, the sun, and the circle of the Zodiac. Baránszky-Jób interprets its appearance in conjunction with the gesture of God the Father as the banishment of Adam and Eve to earth, as was also suggested by Jacobsen (*Das Quattrocento in Siena*, 1903, p. 44). Dixon ("Giovanni di Paolo's Cosmology," *Art Bulletin*, 67, 1985, pp. 604–13) demonstrates that the writings of Johannes Sacrobosco, not Isidore of Seville, are the source for the *mappamondo* in the present panel, which shows, around the earth, a green

ring (for water), a blue ring (for air), and a red ring (for fire) in addition to the concentric circles of the seven planets. A similar representation appears already in the first quarter of the fourteenth century in an illuminated initial from the workshop of Pacino di Bonaguida (Milan, Castello Sforzesco, Biblioteca Trivulziana, cod. 2139; see R. Offner, *A Critical and Historical Corpus of Florentine Painting*, sec. 3, vol. 6, 1956, pl. 62 A). Though the depiction of the earth depends from contemporary cartographic practice, the interpretation of it in Dixon's article is overspecific, as is the claim that the index finger of God the Father is designed to indicate the date of the Annunciation. A Sienese prototype for this manner of portraying the Creation of the World is provided by Bartolo di Fredi's fresco of that subject on the left wall of the nave in the Collegiata at San Gimignano (see also J. Zahlten, *Creatio Mundi: Darstellungen der sechs Schöpfungstage und naturwissenschaftliches Weltbild im Mittelalter*, 1979, passim). The two scenes in the present panel were undoubtedly intended to be read as separate incidents in a consecutive narrative.

Both the surviving sections of the Guelfi predella are loosely related to Florentine Dominican paintings produced by Fra Angelico or in his circle. A precedent, though not necessarily a prototype, for the central panel or panels is found in the *Last Judgment* of ca. 1431 painted for Santa Maria degli Angeli, now in the Museo di San Marco. In at least three altarpieces of the Annunciation by Angelico or from his workshop, the Expulsion from Paradise appears in the background. The three naked figures in the present panel also contain conscious recollections of the relief of the Expulsion on Jacopo della Quercia's Fonte Gaia in Siena.

CONDITION: The paint surface is well preserved and free from abrasion. A hole in the panel measuring 1.2 × 2.5 cm. at the left side below the horizon has been filled and inpainted. Minor flaking has occurred between the rays surrounding God the Father and the gold of his halo, and in the halo and wings of the angel. The wings were originally glazed in red, only traces of which survive. The mordant gilding of the signs of the Zodiac has flaked heavily. The azurite of the four rivers of Paradise at the bottom left has discolored to black.

PROVENANCE: Albin Chalandon, Paris; Georges Chalandon, Paris; Camille Benoît, Paris (see M. Logan, "L'exposition de l'ancien art siennois," *Gazette des Beaux-Arts*, ser. 3, vol. 32, 1904, pp. 210–11; Crowe and Cavalcaselle, *New History*, vol. 3, 1914, p. 178); F. Kleinberger, Paris. Acquired by Philip Lehman in January 1917.

No. 48

49. The Coronation of the Virgin

1975.1.38

Tempera on panel. 179.9 × 131.3 cm. (70⅝ × 51¹¹⁄₁₆ in.).
The panel has been thinned to 4 mm. and cradled, and has
been sawn through at the top, where the point of the arch is
completed by a section of old wood covered with modern
gilding 7.6 cm. wide. Cleaned 1978.

Christ and the Virgin are seated on a marble throne, the
upper corners of which are cut by the edges of the ogival
panel. The front faces of the supports to the right and left
are decorated with black and gold inlay. The back of the
throne, the seat, and the forward step are covered by a
patterned red velvet brocade with a repeated floriated
motif in gold. The two figures sit on cushions of green and
gold. The Virgin, with her hands crossed over her breast,
wears a white mantle embroidered in gold and lined with
olive green. Christ, who holds out a jeweled crown to-
ward her, has a pink robe and a blue cloak bordered in
gold and lined with dull green. Behind the throne are the
heads of thirteen fair-haired angels. The tunics of the out-
er angels are visible over the arms of the throne at either
side. The lowest step of the throne rests on a gray-green
floor on which are seated two music-making angels. The
angel to the left, playing a portative organ, wears a pink
tunic and a dark green cloak; the other, playing a harp,
wears a dull green tunic and a pink cloak.

This panel is one of Giovanni di Paolo's finest and best-
preserved paintings and is so regarded by Perkins ("An-
cora dei dipinti sconosciuti della scuola senese," *Rassegna
d'arte senese*, 3, 1907, p. 82; "Dipinti senesi sconosciuti o
inediti," *Rassegna d'arte*, 14, 1914, pp. 136–41), Breck
("Some Paintings by Giovanni di Paolo," *Art in America*,
2, 1914, p. 280), Van Marle (*Development*, vol. 9, 1927,
p. 438), Mayer ("Die Sammlung Philip Lehman," *Pan-
theon*, 5, 1930, p. 115), Berenson (1932, p. 246, and later
editions), Gengaro ("Eclettismo e arte nel Quattrocento
senese," *La Diana*, 7, 1932, pp. 230–31), L. Venturi
(*Italian Paintings in America*, 1933, vol. 1, pl. 162), Pope-
Hennessy (*Giovanni di Paolo*, 1937, pp. 71–72, 106),
and Brandi (*Giovanni di Paolo*, 1947, pp. 83–84). Most
writers who comment on the date of the painting concur
in the view that it postdates the related *Coronation of the
Virgin* in Sant'Andrea at Siena, though King ("Notes on
the Paintings by Giovanni di Paolo in the Walters Collec-
tion," *Art Bulletin*, 18, 1936, p. 233, n. 34) regards it as
earlier than the painting in Siena, and Laclotte (in *La col-
lection Lehman*, exh. cat., Musée de l'Orangerie, Paris,
1957, p. 15, no. 19) considers the two works contempo-
rary. It is inferred by Lusanna (in *Die Kirchen von Siena*, I,

1, pp. 284–85) that the two paintings "gingen auf ein und
denselben Entwurf zurück." Differences between the two
cartoons militate against this view.

The Coronation of the Virgin in Sant'Andrea (Fig. 38)
is inscribed at the base of the central panel OPUS
JOHANNIS MCCCCXLV. The inscription has been renewed,
but the date 1445 is corroborated by a *gabella* cover of
that year, with the Annunciation, in the Pinacoteca Vati-
cana, and by an altarpiece of 1445 in the Uffizi, Florence,
where the cursive formulation of the Virgin's cloak offers
a close parallel to that in the Sant'Andrea *Coronation*. The
Sant'Andrea altarpiece was disassembled prior to 1835,
when it is recorded by Romagnoli (*Biografia cronologica
de' bellartisti senesi*, vol. 4, pp. 319–30) in the sacristy of
the church. It has now been reconstituted with a largely
modern frame. Parts of the original framing are visible in
old Lombardi photographs; these show that the frame
corresponded with that of the Uffizi altarpiece, and it can
be inferred that the two altarpieces were produced in
close proximity.

Though the compositions of the present painting and of
that in Sant'Andrea are generally similar, they differ in a
number of significant respects. The Sant'Andrea altar-
piece is a triptych whose wings, with figures of Saints
Andrew and Peter, are integrated in the space of the cen-
tral scene. Nine angels appear behind the throne, and four
are placed in the two wings. The music-making angels in
the front plane are shown in the side panels, not in the
central panel, and the foreground is not marbled but is
marked out with inlaid orthogonals. The composition of
the present panel, on the other hand, is self-contained.
The architecture of the throne is more clearly defined, and
its height is reduced so that it intersects the figure of
Christ at the level of his shoulders while the Virgin's
bowed head rises above the brocaded surface behind her.
In all these respects the present panel is more sophisti-
cated in design than and superior in quality to that in
Siena; it is more likely to represent a revision of the design
of the Sant'Andrea altarpiece than to be a prototype from
which the Sant'Andrea painting derives.

The moldings of the throne recall those of the Virgin
and Child in an altarpiece in the Pinacoteca Nazionale at

Siena (no. 191), generally dated to 1455–60, and the present painting may, as most earlier scholars assumed, have been painted just after the middle of the decade. As Breck noted (loc. cit.), the cartoons of the two foreground angels were reused in the central panel of a disassembled polyptych in the Chiesa Parrocchiale at Poggioferro, a coarse, late work of about 1470.

To judge from the richness of its facture, the Lehman *Coronation of the Virgin* must have been an altarpiece of consequence, but it is not certain whether, like the Sant'Andrea altarpiece, it was originally supported by lateral panels with single or paired saints. An altarpiece by Sano di Pietro of about 1450–55 in the Pinacoteca Nazionale at Siena (no. 269) shows a Coronation of the Virgin of closely related width and height flanked by panels with (*left*) Saints Francis and Jerome and (*right*) Saints Bernardino and Augustine.

It is likely that the predella to this altarpiece comprised three panels: one (Fig. 40) with Saint Bartholomew, the Entombment of the Virgin, and the mourning Virgin (Fitzwilliam Museum, Cambridge, no. 2323, 18.4 × 46.7 cm., formerly in the Ramboux collection; see Fitzwilliam Museum, Cambridge, *Catalogue of Paintings*, vol. 2, *Italian Schools*, 1967, pp. 67–68); one (Fig. 41) with Christ as the Man of Sorrows (private collection, New York, 26.6 × 39.3 cm.; see Matthiesen Fine Art Ltd., London, *Early Italian Paintings and Works of Art, 1300–1480*, exh. cat., 1983, no. 34); and one (Fig. 42) with the mourning Saint John the Evangelist, the Assumption of the Virgin, and Saint Ansanus (El Paso Museum of Art, Kress collection, 18.8 × 48.3 cm., formerly in the Ramboux collection; see F. R. Shapley, *Paintings from the Samuel H. Kress Collection, Italian Schools XIII–XV Century*, 1966, p. 149). The Cambridge and El Paso panels have been reduced in height but not substantially in width. This predella corresponds to the Lehman *Coronation* in figure style, in palette, in details of halo punching, and in the marbling of the tombs and pavement. The aggregate width of the predella conforms to that of the present painting. The predella appears to have been set well forward of the main panel of the altarpiece. A void 30 cm. square at the center of the base of the present panel between the feet of the music-making angels, now filled and painted to match the surrounding pavement, may originally have contained a sacrament tabernacle, which would have rested on the upper edge of the predella.

In a number of respects the panel is faithful to the traditional iconography of the Coronation of the Virgin as it appears in an altarpiece by Bartolo di Fredi of 1383–88 in the Museo Civico at Montalcino, where the act of coronation takes place in the upper part of an ogival panel, the gable above is filled with six music-making angels, and six more angels appear below, two of them kneeling and playing a portative organ and a violin. There is no record of the appearance of the most important Sienese Trecento painting of the theme, a fresco painted by Lippo Vanni in 1352 in the Ufficio della Biccherna of the Palazzo Pubblico, but a manifest connection exists between the fresco with which it was replaced, begun by Domenico di Bartolo in 1443 and completed by Sano di Pietro in 1445 (see E. Carli, *Il Palazzo Pubblico di Siena*, 1963, pp. 198–203), and Giovanni di Paolo's altarpiece in Sant'Andrea, in respect to both of the main figures and of the angels behind the throne. The influence of this fresco is also evident in the present panel.

CONDITION: The paint surface is, in general, extremely well preserved. There are scattered paint losses in the pavement and across the steps of the throne, in the green robe of the angel on the right, and in the hand and robe of the angel playing a portative organ in the lower left corner. The nose of the angel in profile above the Virgin's head, the gold floriated ornament beside the organ at the lower left, and the reds in the cloth of honor have been reinforced. The extensive silvering in the embroidered foliage, the wings of the angels, and the pipes of the portative organ has blackened.

PROVENANCE: The early provenance is unknown. The painting is illustrated in photographs of the Galleria Bardini, Florence, made about 1890 (for which see F. Scalia and C. de Benedictis, eds., *Il Museo Bardini a Firenze*, vol. 1, 1984, pls. 73, 74), and was published in 1907 as in the possession of Stefano Bardini (F. M. Perkins, "Ancora dei dipinti sconosciuti della scuola senese," *Rassegna d'arte senese*, 3, 1907, p. 82). According to an unconfirmed report, Bardini owned the painting for some thirty years. At some date after 1907 it was purchased by Alphonse Kann, Paris, from whom it was acquired by Philip Lehman in November 1913. Bequeathed by Philip Lehman to Pauline Ickelheimer. Acquired by Robert Lehman in 1946.

EXHIBITED: William Rockhill Nelson Gallery of Art, Kansas City (Mo.), 1942–44; Colorado Springs Fine Arts Center, *Paintings and Bronzes from the Collection of Mr. Robert Lehman*, 1951–52; Musée de l'Orangerie, Paris, *La collection Lehman*, 1957, no. 19; Cincinnati Art Museum, *The Lehman Collection*, 1959, no. 31.

50. The Angel Gabriel Announcing to Zacharias the Birth of a Son

1975.1.37

Tempera on panel. 75.8 × 43.2 cm. (29⅞ × 17 in.), excluding added strips at the bottom and sides. The thickness of the panel is 2.3 cm.

The polygonal temple in which the scene takes place is composed of alternating semicircular and ogival arches supported by thin columns with capitals surmounted by statuettes. To the right of the altar is the Angel, shown as though newly alighted with the right foot free of the ground, and to the left stands Zacharias with his left hand on his chest and his right holding the chain of a gold censer that rests on the altar. Behind is a gold Gothic tabernacle. The spectators below are confined to two archways at the sides. Above the level of the temple roof, in the upper part of the ogival panel, is a cupola with three exedrae. On the reverse of the panel is a fragmentary figure of the Annunciatory Angel (Fig. 43) in full-length, striding to the right across a marbleized pavement.

The scene illustrates the account of the Annunciation to Zacharias given in the first chapter of the Gospel of Saint Luke:

And it came to pass, that while he executed the priest's office before God in the order of his course, according to the custom of the priest's office, his lot was to burn incense when he went into the temple of the Lord. And the whole multitude of people were praying without at the time of incense. And there appeared unto him an angel of the Lord standing on the right side of the altar of incense. And when Zacharias saw him, he was troubled, and fear fell upon him. But the angel said unto him, Fear not, Zacharias: for thy prayer is heard; and thy wife Elizabeth shall bear thee a son, and thou shalt call his name John.

The panel forms part of a cycle of twelve scenes from the Life of the Baptist, of which eleven survive in whole or in part. Though the function of the panels is unclear (see below), it is generally agreed that they were originally disposed in four groups of three, of which those at the top were ogival in form and those below rectangular. The correct distribution of the panels has been established by Meiss (*Three Loans from the Norton Simon Foundation*, exh. cat., The Art Museum, Princeton University, 1973). The left wing comprised (*upper register*) the present panel and *The Birth and Naming of the Baptist* (Westfälisches Landesmuseum, Münster; Fig. 44); (*central register*) *The Young Baptist Entering the Wilderness* (Chicago Art In-

stitute) and *The Preaching of the Baptist* (Musée du Louvre, Paris, formerly in the Carvallo collection, Tours; cut down); (*bottom register*) a missing panel of *The Baptism of the Multitude*, and *Ecce Agnus Dei* (Chicago Art Institute). The right wing comprised (*upper register*) *The Baptism of Christ* (Norton Simon Museum, Pasadena; Fig. 45) and *The Baptist Preaching Before Herod* (Westfälisches Landesmuseum, Münster; Fig. 46); (*central register*) *Saint John in Prison* (Chicago Art Institute) and *The Banquet of Herod* (Chicago Art Institute); (*bottom register*) *The Decollation of the Baptist* (Chicago Art Institute) and *The Presentation of the Baptist's Head to Herod* (Chicago Art Institute).

It was suggested by Schubring ("Opere sconosciute di Giovanni di Paolo e del Vecchietta," *Rassegna d'arte*, 12, 1912, p. 162; *Cassoni*, 1, 443–50, 1915, p. 324) that the three ogival panels with which he was familiar (the two at Münster, and the present panel, which he saw with the dealer Simonetti in Rome in 1912) formed part of "ein Altartabernakel, das Giovanni di Paolo vermutlich für eine Taufkapelle gemalt hat," and that the remaining panels (those now in Chicago, which were then in Paris in the hands of the dealer Kleinberger) were designed as the sides of an octagonal ciborium. This erratic reconstruction was rejected by De Nicola ("The Masterpiece of Giovanni di Paolo," *Burlington Magazine*, 33, 1918, pp. 45–55), who postulated that the panels formed part of an altarpiece of which the three ogival panels (with a missing ogival panel of the *Baptism of Christ*) formed the upper register, flanking a missing panel of the Baptist, with the six scenes in Chicago in the lower register. De Nicola's reconstruction was iconographically unacceptable and was dismissed by L. Venturi (*Pitture italiane in America*, 1931, p. 135), who suggested that the panels were originally distributed between the two wings of an altarpiece or shrine. Venturi's scheme was adopted, with some modification, by Pope-Hennessy (*Giovanni di Paolo*, 1937, pp. 80–83), Brandi (*Giovanni di Paolo*, 1947, p. 44), and Carli ("Problemi e restauri di Giovanni di Paolo," *Pantheon*, 19, 1961, pp. 163–74).

Some importance attaches to the Annunciatory Angel on the reverse of the present panel. It was proposed by L. Venturi (loc. cit.), and has been accepted by all subse-

No. 50

quent writers, that the figure was originally intended to be seen when the left wing of the complex was closed, and would have been accompanied by a Virgin Annunciate on the back of the corresponding panel on the extreme right, *The Baptist Preaching Before Herod*, now at Münster, which has been planed down. Physical examination of the Lehman panel suggests that this inference is correct. An iron band 20 cm. from the bottom of the verso, cut into the panel and originally covered with gesso and paint, has been rightly explained as a hinge which would enable the panel to be closed. The Angel is cut on the left, where the edge of the paint surface cuts the rear ankle and foot. The corresponding area on the obverse shows a beard of paint and is intact. The top of the panel with the Angel was originally lobed; traces of a cusp survive on the left near the shoulder. Beneath the Angel appear the remains of a gesso molding and gilt *pastiglia* decoration, which is likely to have been continued in the panels beneath. As Meiss noted (loc. cit.), the only other panel in the series that has not been planed down or cradled is *The Baptism of Christ* in the Norton Simon Museum, the back of which is covered with traces of red pigment, perhaps as ground for gilding. The *Baptism* does not retain its hinge, but the nails by which it was attached are still embedded in the panel. This corroborates the suggestion of Eisenberg ("A Late Trecento *Custodia* with the Life of St. Eustace," in *Studies in Late Mediaeval and Renaissance Painting in Honour of Millard Meiss*, vol. 1, 1977, p. 143) that the panels formed part of a *custodia* with hinged wings.

There is no direct evidence as to the function the *custodia* was intended to fulfill. It is suggested by Brandi (loc. cit.) that the two wings may have been designed for a reliquary cupboard, analogous to the Arliquiera of Vecchietta (which was painted for Santa Maria della Scala and is now in the Pinacoteca at Siena) and to the cupboard painted by Benedetto di Bindo for the sacristy of Siena Cathedral (Museo dell'Opera del Duomo, Siena). He goes on to argue that "per espliciti riferimenti ai bassorilievi del Fonte senese" the wings might have served to close an aperture in the apse behind the font in the Baptistery. Since motifs from the six reliefs on the font are adopted for Giovanni di Paolo's panels (in the present panel the figures of Zacharias, the Angel, and the spectators on the left derive loosely from Jacopo della Quercia's relief of the same scene; in the *Ecce Agnus Dei* in Chicago the two main figures recall those in the related font relief by Turino di Sano and Giovanni Turini; the Pasadena *Baptism of Christ* and the Münster *Baptist Preaching Before Herod* derive, in part, from the two related reliefs by Ghiberti; and *The Banquet of Herod* and *The Presentation of the Baptist's*

Head to Herod contain figures adapted from the relief of the latter subject by Donatello), it is highly unlikely that the series was designed for exhibition in the vicinity of the baptismal font. The proportions of the two wings are unusual (their approximate height, with molded interstices, is 250 cm. and their approximate width is 80 cm. each), and it is for this reason improbable that the central element was a painted figure of the Baptist, which would have been considerably over life-size. It is, on the other hand, possible that the scenes were intended to flank a niche containing a sculpture of the Baptist. The most notable statues of the Baptist commissioned for Siena in the third quarter of the fifteenth century were a wooden figure carved by Francesco di Giorgio for the Compagnia di San Giovanni Battista della Morte in 1464 (a date somewhat later than the probable date of the present panels), and a bronze statue by Donatello delivered to the cathedral in 1457 but placed on exhibition only at a considerably later time. The height of Donatello's statue is 185 cm. There is, however, no record of the panels in Siena, and the only three of them with a provenance prior to the late nineteenth century were in a Neapolitan collection.

The Scenes from the Life of the Baptist have been variously dated ca. 1436–38 (R. L. Douglas, review of Pope-Hennessy, *Giovanni di Paolo, Burlington Magazine*, 72, 1938, p. 43), ca. 1445–49 (De Nicola, loc. cit.; Brandi, op. cit., p. 82), and ca. 1455–60 (Pope-Hennessy, op. cit., p. 89; M. Laclotte, *La collection Lehman*, exh. cat., Musée de l'Orangerie, Paris, 1957, p. 167, no. 294). The chronology of Giovanni di Paolo's narrative panels is the subject of some disagreement, and no dating of the present scenes is acceptable, which does not take account of the landscape convention employed in the panels in Chicago and of the architecture in three of the four upper panels. The architecture has Northern parallels in the work of Broederlam, and both the patterned foreground of the present panel and the rock forms and diminished foregrounds of the Chicago panels recall the miniatures of the Boucicaut Master. Patterned fields appear, in a simpler, less schematic form, in the work of Giovanni di Paolo in the *Madonna of Humility* in the Museum of Fine Arts, Boston, but the system of projection with incised parallel lines found throughout the Saint John scenes has its closest parallel in the pavement in the *Miracle of Saint Nicholas of Tolentino* in the Gemäldegalerie der Akademie der Bildenden Künste, Vienna, which seems to have been painted in 1456. The whole series is most readily datable to the second half of the 1450s.

The central cupola and exedrae in the upper part of the present panel are inspired by Brunelleschi's cupola of the

Duomo in Florence and recur, in a somewhat similar form, complete with lantern, in the upper part of Giovanni di Paolo's Pizzicaiuoli altarpiece of 1447 (Pinacoteca Nazionale, Siena). They are shown without the lantern and with one unfinished exedra in an illumination of ca. 1438–44, *Folco Inveighing Against the Corruption of the Florentines*, on fol. 154r in the Yates-Thompson codex of the *Divina Commedia* in the British Library (Pope-Hennessy, *A Sienese Codex of the Divine Comedy*, 1947, p. 10).

CONDITION: The paint surface, though dirty, is very well preserved. The bole beneath the gilding is exposed in the haloes and in the Angel's wings, whereas the gilding of the central tabernacle with its original red glazes is intact. In the upper part of the panel there is extensive flaking in the sky, where the exposed bole has been painted over and the original blue has darkened to black. The clouds, which were originally silver, have sustained considerable loss. Traces of silver survive in the cupola and the exedrae.

PROVENANCE: Cardinal Rinaldi, Naples (see below); Principe Santangelo, Naples (see the *Catalogo della pinacoteca dei Marchesi Santangelo di Napoli*, 1876, pp. 17–18, where the panel is attributed to Taddeo Gaddi, with Cardinal Rinaldi named as the owner in the seventeenth century; no further panels of this series are listed, but the two panels at Münster were bought from the dealer Maurer in 1898 with a Santangelo provenance); private collection, Rome (P. Schubring, "Opere sconosciute," p. 163, n.); Attilio Simonetti, Rome; purchased by Philip Lehman in 1914 (F. M. Perkins, "Dipinti senesi sconosciuti o inediti," *Rassegna d'arte*, 14, 1914, p. 163); Pauline Ickelheimer, New York. Acquired by Robert Lehman in 1946.

EXHIBITED: Colorado Springs Fine Arts Center, *Paintings and Bronzes from the Collection of Mr. Robert Lehman*, 1951–52, no. 10; Metropolitan Museum of Art, New York, 1944, 1954–61; Musée de l'Orangerie, Paris, *La collection Lehman*, 1957, no. 294; Cincinnati Art Museum, *The Lehman Collection*, 1959, no. 39; Metropolitan Museum of Art, New York, *Giovanni di Paolo: Paintings*, 1973, no. 12.

51. Saint John the Evangelist Raising Drusiana

1971.1.36

Tempera on panel. 23.7 × 22.3 cm. (9⁵⁄₁₆ × 8¹³⁄₁₆ in.), excluding added strips. The panel has been cut on all four sides and its thickness has been reduced to 1.8 cm. A strip of wood 1.2 cm. deep has been added at the top and another 1.1 cm. deep has been added at the bottom; these are incorporated in the paint surface.

The chamber in which the scene is set is framed in the front plane by lateral supports. To the left is an arched doorway, and at the back are two further arches opening onto a second room with a bench set against the rear wall. The two rooms are unified by a paneled yellow ceiling with orthogonals receding to the right. In the foreground on a bier or litter is a female figure clad in light blue with hands raised toward the bearded saint, who is depicted with right hand raised in benediction behind the bed. He wears a light blue robe covered with an orange-red cloak and is accompanied on the right by a youthful attendant in a green mantle with arms crossed over a book. Behind the bedridden figure crouches a bearded man with hands raised in wonder at the miracle. A youthful female figure stands in the doorway on the left.

When in the Fuller Maitland collection the panel was twice exhibited as the work of Sano di Pietro and was accepted as such by Borenius (in Crowe and Cavalcaselle, vol. 5, 1914, p. 173, n. 4). It is recorded by Reinach (*Répertoire des peintures du Moyen-Age et de la Renaissance 1280–1580*, vol. 4, 1918, p. 564) in the Stoclet collection, Brussels. It was later in the Wendland collection in Paris, where it was ascribed to the school of Matteo di Giovanni. The correct attribution to Giovanni di Paolo seems to have been due to Reinach and is accepted by Mayer ("Die Sammlung Philip Lehman," *Pantheon*, 15, 1930, p. 115), Berenson (1932, p. 246, and later editions), Pope-Hennessy (*Giovanni di Paolo*, 1937, pp. 75, 104, n. 42), and Brandi (*Giovanni di Paolo*, 1947, p. 121). It is mistakenly regarded by King ("Notes on the Paintings by Giovanni di Paolo in the Walters Collection," *Art Bulletin*, 18, 1936, p. 237) as a school work.

The subject is traditionally explained as Saint Peter Raising Tabitha and is listed by Brandi as a Miracle of Saint Paul. The representation does not correspond closely with the account of the raising of Tabitha given in the Acts of the Apostles, and the scene is correctly described by Reinach as Saint John the Evangelist Raising Drusiana. One other panel by Giovanni di Paolo is known which represents a scene from the life of that saint and which can reasonably be supposed to have originated from the same predella. Formerly in the Martin Le Roy collection, Paris, and later sold in London (Christie's, July 29, 1979, lot 58), it shows the Attempted Martyrdom of Saint John the Evangelist before the Porta Latina. Its height (24.9 cm.) is in approximate agreement with that of the present panel, in which the upper and lower edges have been reconstructed and the right side cropped (see above). The haloes in both panels are identical, and the paint surface is in a comparably deteriorated state.

The Martin Le Roy panel was tentatively identified by Pope-Hennessy (op. cit., pp. 108–9, n. 56) with a panel described in 1863 by Brogi (*Inventario generale degli oggetti d'arte della provincia di Siena, compilato da F. Brogi (1862–65) e pubblicato a cura della onorata Deputazione Provinciale Senese*, 1897, p. 305) in the sacristy of the Venerabile Compagnia degli Artisti in Montepulciano, where it was accompanied by two other scenes. Though denied by Brandi (op. cit., pp. 78–79, n. 58), the identification has recently been confirmed by Chelazzi-Dini (*Il gotico a Siena*, 1982, p. 362, where the dimensions are incorrectly reported and the scene is identified as the Martyrdom of Saint Ansanus). Brogi's description reads: "San Giovanni Apostolo dentro una caldaia d'olio. Vedesi un manigoldo alimentare il fuoco, un altro portare una fascina, e tre spettatori del martirio. Piccole figure dipinte a tempera con fondo a colore—alcune teste sono deturpate."

The second of the three scenes described by Brogi at Montepulciano was a *Baptism of Christ*: "San Giovanni Battista nel Giordano battezza Gesù: a sinistra vedonsi quattro discepoli, ed altri nell'indietro. Nella gloria vi è Iddio Padre." As Brandi noted (loc. cit.), this panel is possibly identical with a *Baptism of Christ* in the Ashmolean Museum, Oxford (no. A 333; C. Lloyd, *A Catalogue of the Earlier Italian Paintings in the Ashmolean Museum*, 1977, pp. 84–86), which was purchased in Siena in 1875 by J. R. Anderson. Its dimensions (25.3 × 35.8 cm.) and the decorations of the haloes correspond with those of the Martin Le Roy panel.

The third of the three scenes from Montepulciano represented the Crucifixion ("Ai lati della Croce stanno due giudei a cavallo; a sinistra vi è la Vergine svenuta, retta dalle Marie, e appresso San Giovanni; a destra vi sono tre altre figure"). This description corresponds closely with a

No. 51

panel of the Crucifixion formerly in the hands of R. Heinemann, New York.

If the present panel originates from the same altarpiece as the three panels described by Brogi, it would have stood beneath one of the pilasters, and would have been separated from the remaining fragments of the altarpiece before 1863. Two panels of the Annunciatory Angel and the Virgin Annunciate, also described by Brogi and also untraced, seem to have formed part of the same altarpiece.

The structure of the room in No. 51 closely recalls that in the scenes from the life of Saint Catherine of Siena by Giovanni di Paolo (see Nos. 52, 53), especially that in the *Mystic Marriage of Saint Catherine with Christ* in the Heinemann collection, New York. The tooling of the halo of the saint is of a type used throughout these scenes. A dating about 1460 is very probable.

CONDITION: The paint surface is badly abraded throughout and has been extensively retouched, especially along the heavy craquelure. The white highlights in the garments and bedclothes are largely new. Local losses have been filled, especially in the robe and lower part of the face of Drusiana, in the head of the youth on the right, and in the dark gray of the rear wall.

PROVENANCE: W. Fuller Maitland, Stansted Hall (before 1857); Stoclet collection, Brussels (see Reinach, loc. cit.); Wendland collection, Paris; sale, Hôtel Drouot, Paris, Oct. 26, 1921, no. 19, as *La guérison miraculeuse*, ascribed to the school of Matteo di Giovanni; R. Langton Douglas, London. Acquired by Philip Lehman in 1921.

EXHIBITED: Manchester, *Art Treasures Exhibition*, 1857, no. 54 (as Sano di Pietro); New Gallery, London, *Exhibition of Early Italian Art*, 1893–94, no. 33 (as Sano di Pietro); Metropolitan Museum of Art, New York, 1954–61; Cincinnati Art Museum, *The Lehman Collection*, 1959, no. 37.

52. Saint Catherine of Siena Beseeches Christ to Resuscitate Her Mother

1975.1.33

Tempera on panel. 28.3 × 22 cm. (11 × 8⅝ in.). The panel, which is 4.1 cm. thick and has a vertical grain, has been incised vertically and horizontally on the reverse and reinforced with wedge-shaped strips of wood inserted vertically to correct or retard warpage. The reverse of the panel from the same series in the Metropolitan Museum of Art (*The Miraculous Communion of Saint Catherine of Siena*, acc. no. 32.100.95) has been treated in the same way. A strip of wood 1.5 cm. wide has been added at the base, and another 0.3 cm. wide has been added on the left, both visible as repaint on the surface. A third strip of wood 4 cm. wide has been added at the top but is not integrated in the picture surface. Nail heads appear in four places on the back.

The panel shows the interior of a room seen through an architectural frame. On the right is a curtain suspended from a rail that runs horizontally across the entire panel. To the left, in profile, kneels Saint Catherine of Siena, with hands clasped in prayer and head raised to a crucifix in a niche on the left wall. Above her, in the upper left corner, is a vision of Christ, surrounded by cherubim, with his right hand raised in benediction. The center and the right side of the panel are occupied by a bed with a gilded footboard on a platform with paneled coffers. On it, in an upright position, sits the mother of Saint Catherine, wearing a blue robe and a white coif. Behind are (*left to right*) a woman in orange advancing from the back with a raised arm; a man wearing a black cap and a dark cloak under a light pink mantle, with his right hand raised in wonder at the miracle; and a female figure turned to the left.

The scene is identified by Kaftal (*St. Catherine in Tuscan Painting*, 1949, pp. 84–86) with an incident described in Raymond of Capua's life of Saint Catherine of Siena (*Vita miracolosa della serafica S. Caterina da Siena composta in Latino dal Beato Frate Raimondo da Capua*, printed in *Acta sanctorum*, Aprilis III, 1866). The text describes how Saint Catherine first begged Christ to prolong the life of her worldly mother, Lapa, so that she might die penitent. After her life had been prolonged, her mother nonetheless died without contrition, whereupon the saint addressed Christ with the words: "See, O Lord, I lie here prostrate before Thy divine Majesty, and will not rise out of this place until my mother be restored to life again, and I ascertained of her salvation, that Thy promise may be verified and my soul comforted." The passage continues: "While the holy maid was thus praying, there were a number of women in the chamber, some of the household, and some of the neighbours that came hither at that time (as the manner is) to mourn and to do such things as were to

be done about the dead corpse. Among these women, some there were also that gave diligent ear to the holy maid, and heard distinctly the words that she spoke in her prayer. But they saw all this, and were witnesses of the same, that soon after the holy maid had ended her prayer, the soul returned to the body again, and the woman lived afterwards a convenient time to repent her of her former offences, and so died in a state of grace" (translation by Father John Fen, first published at Louvain in 1609 and reprinted as *Doctor Caterinus Senensis: The Life of the Blessed Virgin S. Catherine of Siena Translated into English by John Fen and Re-edited by James Domnick Aylward, O.P.*, 1867). The woman in the background on the left is represented overhearing the saint's prayer. The miracle occurred in October 1370.

The problems presented by this painting and its companion panels (Nos. 53–55) are of great complexity. There is widespread disagreement both as to their date and as to the structure of which they formed part, and the evidence is insufficient to admit of a definitive conclusion. In 1447 the Arte dei Pizzicaiuoli commissioned an altarpiece from Giovanni di Paolo for their chapel dedicated to the Purification of the Virgin in the hospital church of Santa Maria della Scala in Siena (for the documentation of this painting see G. Milanesi, *Documenti per la storia dell'arte senese*, vol. 2, 1854, pp. 241ff., and P. Bacci, in *Le arti*, 4, 1941–42, pp. 23–24). The painting was to be completed by November 1, 1449, and was to be "in illa forma et compositione, figuris et storiis eidem magistro Johanni per dictos rectores demonstrandis et assignandis." The altarpiece was seen in the church in 1575 by Monsignor Egidio Bossio ("Visita pastorale," ms. in the Curia Arcivescovile, Siena, c. 114), who gives no details of its composition. There is no further reference to it till the third quarter of the eighteenth century, when it was described by Carli (*Notizie di belle arti*, ms. Bibl. Com., Siena cod. VII–20, c. 86v., published by Brandi, "Giovanni di Paolo," in *Le arti*, 3, 1940–41, pp. 320–21) in the following terms:

Nello Spedale grande di Siena un gran Quadro in tavola, che prima stava nel Camposanto nell'altare dismesso di S. Cristina, . . . è stato ridotto in tanti Quadretti da porsi nelle stanze del Rettore, e i pezzi grandi nel nuovo Dormentorio delle Balie. Lo credo fatto verso la meta del sec. XV. Ci è qualche fondo d'oro ma in pochi

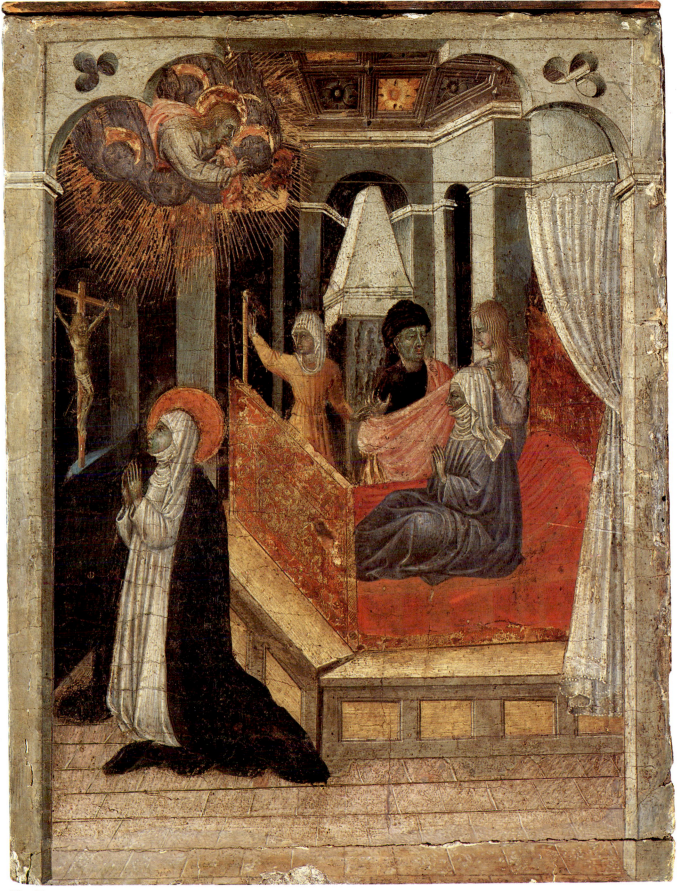

No. 52

luoghi. 10 Quadrettini rappresentano lo Sposalizio di S. Caterina, S. Caterina che da il manto a un povero, il B. Raimondo che scrive le sue rivelazioni, la Santa che parla al Papa (co' Cardinali vestiti di rosso), Cristo che la communica, la Santa che ricupera la salute a un'inferma, la sua morte, 3 Santi che le danno l'abito, Mutazione del cuore, le Stigmate. . . . No ho veduto la Crocifissione del Signore, che udisco è presso il Legnajolo. Vi sono 6 quadretti assai bislunghi co' seguenti Santi, B. Ambrogio Sansedoni, S. Galgano, S. Bernardino, S. Caterina, B. Andrea Gallerani, un Martire francescano. . . . Il Quadro grande, che era in mezzo, rappresenta la Purificazione di Maria, con una grande Architettura del Tempio.

In the nineteenth century the last-named panel, the *Presentation in the Temple*, was transferred to the Accademia in Siena; it is now in the Pinacoteca Nazionale (no. 211). The other "pezzi grandi" alluded to by Carli have not been identified. Nine of the ten scenes from the life of Saint Catherine were purchased by Johann Anton Ramboux and are now distributed among the Cleveland Museum of Art (*Saint Catherine Invested with the Dominican Habit, Saint Catherine and the Beggar*: Ramboux, *Katalog der Gemälde alter italienischer Meister in der Sammlung des Conservators J. A. Ramboux*, 1862, nos. 113, 115; Figs. 53, 54), the Metropolitan Museum of Art, New York (*The Miraculous Communion of Saint Catherine of Siena*: Ramboux, no. 116; Fig. 55), the Heinemann collection, New York (*The Mystic Marriage of Saint Catherine of Siena, Saint Catherine Exchanging Her Heart with Christ*: Ramboux, nos. 114, 120; Figs. 56, 57), the Detroit Institute of Arts (*Saint Catherine Dictating Her Dialogues to Raymond of Capua*: Ramboux, no. 118; Fig. 58), and the Thyssen-Bornemisza collection at Lugano (*Saint Catherine Before the Pope*: Ramboux, no. 119; Fig. 59). The eighth panel, *The Death of Saint Catherine of Siena* (Ramboux, no. 121; Fig. 60), was formerly in the Minneapolis Art Institute (incorrectly supposed by Maginnis, *Art Bulletin*, 57, 1975, p. 609, to be a copy) and is now untraced; the ninth is the present panel (Ramboux, no. 117). A panel of the Crucifixion formerly in the Aartsbischoppelijk Museum in Utrecht was also owned by Ramboux and has been identified with the panel of that subject mentioned but not seen by Carli. Ramboux also owned four of the six "quadretti assai bislunghi," those with Saint Galganus, Blessed Ambrogio Sansedoni, Blessed Andrea Gallerani, and a Franciscan martyr (see Nos. 54, 55 below).

Three views have been expressed on the relationship of the scenes from the life of Saint Catherine to the Siena *Presentation in the Temple*. The first is that they formed part of the original commission for the altarpiece and like the main panel were painted between 1447 and 1449 (see particularly Brandi, loc. cit., *Giovanni di Paolo*, 1947, pp. 36–39, and *Quattrocentisti senesi*, 1949, pp. 98–100, 201–7; H. Van Os, "Giovanni di Paolo's Pizzicaiuoli Altarpiece," *Art Bulletin*, 53, 1971, pp. 289–302). The second is that they were additions made to the Pizzicaiuoli altarpiece after the canonization of Saint Catherine of Siena in 1461 (see Pope-Hennessy, *Burlington Magazine*, 89, 1947, pp. 138f., 196; St. John Gore, *The Art of Painting in Florence and Siena from 1250 to 1500*, Wildenstein, London, 1965, p. 55). The third is that they are not related to the Pizzicaiuoli altarpiece but surrounded a full-length panel of Saint Catherine (this view, advanced and later retracted by Pope-Hennessy, *Giovanni di Paolo*, 1937, pp. 131ff., 145, 172, is reaffirmed by F. Zeri, *Italian Paintings: A Catalogue of the Collection of the Metropolitan Museum of Art: Sienese and Central Italian Schools*, 1980, pp. 24–27).

The polemic surrounding the first and second hypotheses arises from the nature of the Saint Catherine panels. Though Saint Catherine is shown on the Arliquiera of Vecchietta of 1445 with the rays of a *beata*, not with the halo of a saint, there are a number of cases in the fifteenth century in which *beati* are depicted with the haloes of saints. To include a cycle of scenes from the life of Saint Catherine in a major altarpiece would, nonetheless, have been irregular before she had been canonized—the more so that in 1447 there was no reason to anticipate her early canonization, which resulted from the election in 1458 of Aeneas Sylvius Piccolomini as Pope Pius II. The palette and structure of the panels are, moreover, difficult to reconcile with the style of narrative panels executed by Giovanni di Paolo at the time of the commissioning of the altarpiece. In the middle of the fifteenth century Giovanni di Paolo's style and palette underwent a decisive change, recorded in the contrast between the polyptych of 1445 in the Uffizi, Florence, which is characterized by rich handling and strong color, and the Pienza altarpiece of 1463, with its dry handling and pallid tonality. Whereas the Pizzicaiuoli altarpiece of the Presentation in the Temple is a typical work of the late 1440s, the handling and palette of the Saint Catherine scenes are those of the Pienza painting. Their distorted architectural settings are also consistent with a dating about 1460. There is, therefore, a strong case for supposing either that the narrative panels were a later accretion to the altarpiece, or that they were designed for a different structure.

There is no firm basis for reconstructing the original appearance of the complex. It is proposed by Brandi (loc.

cit.) that six of the scenes formed part of the predella of the altarpiece and that six more panels were arranged in two superimposed groups of three at either side. Coor ("Quattrocento-Gemälde aus der Sammlung Ramboux," *Wallraf-Richartz Jahrbuch*, 21, 1959, pp. 82–85) suggests that the predella consisted of four narrative panels on each side of the Utrecht *Crucifixion* with two further panels at right angles to them. An alternative scheme proposed by Ouroussoff de Fernandez-Gimenez ("Giovanni di Paolo: The Life of St. Catherine of Siena," *Bulletin of the Cleveland Museum of Art*, April 1967, pp. 103–11) provides for a two-tiered predella, with the *Crucifixion* formerly at Utrecht and four scenes from the life of Saint Catherine in the upper register and six further scenes beneath. Van Os (loc. cit.) supposes that the main panel of the altarpiece was flanked by lateral panels with full-length saints, and that the ten narrative scenes were arranged horizontally with two narrow panels beneath the pilasters and four scenes on each side of the *Crucifixion*.

None of these reconstructions takes into account the physical evidence of the panels themselves. Four of the Saint Catherine scenes are painted on panels with a horizontal wood grain. These are *The Mystic Marriage of Saint Catherine* in the Heinemann collection and *Saint Catherine Giving Her Mantle to a Beggar* in Cleveland, which were once joined as a pair (see Van Os, op. cit., fig. 21), and *Saint Catherine Dictating Her Dialogues* in Detroit and *Saint Catherine Before the Pope* at Lugano, which also formed a pair (ibid.). These and the *Crucifixion* are thus likely to have been the only panels in the predella, and their total width (176.7 cm.) is approximately that of the Siena *Presentation in the Temple* (172.1 cm.). The five scenes of narrower format—*Saint Catherine Invested with the Dominican Habit* in Cleveland, *Saint Catherine Exchanging Her Heart with Christ* in the Heinemann collection, *The Miraculous Communion of Saint Catherine* in the Metropolitan Museum of Art, and *Saint Catherine of Siena Receiving the Stigmata* and *Saint Catherine Beseeches Christ to Resuscitate Her Mother* in the Lehman Collection—are all painted on panels with a vertical wood grain and were thus almost certainly superimposed.

It must also be noted that *The Miraculous Communion of Saint Catherine* is gilt along both its sides, and that the *Saint Catherine Beseeches Christ* is gilt along its left side. Its right side (Fig. 52) bears traces of an architectural setting for a scene that must have been set at right angles to it on that side. This would be intelligible only if the *Saint Catherine Beseeches Christ* were situated at the base of a pilaster, either on the front face of that on the right or on the lateral face of that on the left. From the standpoint of

narrative sequence the latter position is the more probable. The front of the right-hand pilaster base would have been occupied by *The Death of Saint Catherine* formerly in Minneapolis, which has a vertical wood grain. Approximately 2.64 cm. of the paint surface at the right of this panel are modern and may have been added when the contiguous scene along the outside of the pilaster was sawn off. At least two scenes from the life of Saint Catherine are therefore missing: one to complete the fragmentary scene along the right edge of *Saint Catherine Beseeches Christ to Resuscitate Her Mother*, and another to restore an even number of panels. Some scenes that appear in other Saint Catherine cycles are omitted from the present series, such as the Healing of Palmerina, the Presentation of the Two Crowns, the Curing of Laurentia, and the Return of the Pope from Avignon.

The emphasis throughout the present panels is on the saint's interior life, and it is likely that the author of the program took as his model an illuminated manuscript of the life of Saint Bridget of Sweden (for which see P. D'Ancona, "Il *Liber celestium revelationum Sanctae Brigidae* illustrato da un miniatore senese della prima metà del sec. XV," *La bibliofilia*, 14, 1912, pp. 1–5, and C. Nordenfalk, "Saint Bridget of Sweden as Represented in Illuminated Manuscripts," M. Meiss, ed., *Essays in Honor of Erwin Panofsky*, 1960, vol. 1, pp. 370–93). A miniature of Saint Bridget from the Compagnia dei Disciplinati della Madonna sotto lo Spedale, ascribed to Andrea di Bartolo (Biblioteca Comunale, Siena, cod. I.V.–25, reproduced in *Il gotico a Siena*, 1982, p. 315), offers a precedent for certain features of these scenes.

CONDITION: A hole 3 × 2 cm. to the left of Saint Catherine's head has been filled in, and the base of the niche with the crucifix has been incorrectly redrawn as a semicircle. The repainted area covers the legs of Christ below the knee. The face of Saint Catherine is rubbed, and her halo and those of the cherubim are new. In the headboard of the bed, islands of original bole and gold survive; the bole on the board at the foot of the bed is largely intact, the gold being irregularly worn. There is a hole about 1 cm. in diameter above the head of the orange-clad attendant.

Along the left vertical edge of the panel there is gold leaf ending in a beard; on the right vertical edge is part of a scene (Fig. 52). Despite damages due to the saw incisions, losses, dirt, and attached pieces of newspaper, certain elements are legible: a blue-gray architectural background with an open doorway, the door sharply foreshortened; a pavement leading up to a boxlike table (or altar); a tiled overhang above the door; a molding higher still. This edge shows no lip, and linen underlies the entire paint surface. Along this same edge on the back of the panel are remnants of another piece of wood (of a thickness up to 2.6 cm.) once attached there.

PROVENANCE: Spedale della Scala, Siena (see above). Johann Anton Ramboux, Cologne (*Catalogue des collections d'objets d'arts de la succession de M. Jean Ant. Ramboux, conservateur du Musée de la Ville de Cologne*, Heberle, Cologne, May 23, 1867, p. 23, no. 117); Professor A. Müller, Düsseldorf; Fürstliches Hohenzollern'sches Museum, Sigmaringen (F. A. Lerner, *Verzeichnis der Gemälde*, 1871, pp. 53–55, no. 186; ibid., 1883, pp. 58ff., no. 186); F. Kleinberger & Co., New York. Acquired by Philip Lehman after 1928 and before 1932.

EXHIBITED: Musée de l'Orangerie, Paris, *La collection Lehman*, 1957, no. 245; Cincinnati Art Museum, *The Lehman Collection*, 1959, no. 34; Metropolitan Museum of Art, New York, *Giovanni di Paolo: Paintings*, 1973, no. 8.

53. Saint Catherine of Siena Receiving the Stigmata

1975.1.34

Tempera on panel. 27.8 × 20 cm. (10^{15}/₁₆ × 7⅞ in.). The panel, which has a vertical grain, has been cut on all four sides and thinned to a thickness of 14 mm. Four nails are visible on the back.

The saint, turned to the right, is shown in a half-kneeling posture with both arms raised. She is dressed in white, and her black mantle lies on the ground behind her on the left. To the right is an altar with a fringed altarcloth, an altar frontal, and a gold crucifix. Above the crucifix appears a vision of the crucified Christ at an angle to the wall. In the back, through a double archway supported by a thin column, is a view of the transept of a chapel or small church.

The subject of this panel (which was first published by M. Salinger in *Bulletin of the Metropolitan Museum of Art*, n.s. I, no. 1, 1942, pp. 21–28) is one frequently illustrated (for this see Kaftal, *St. Catherine in Tuscan Painting*, 1949, pp. 78–79). Raymond of Capua, at the saint's request, said mass in the chapel of Saint Cristina in Pisa. After receiving the sacrament, the saint fell on the ground in a trance in the presence of her confessor and other observers. "Suddenly as they beheld her the body that lay prostrate upon the ground was raised up, and she kneeled upon her knees, stretching up her arms and hands, and showing in her face a marvellous goodly and clear brightness." When she was restored to her bodily senses, she explained to her confessor that she had seen "our Lord fastened upon the Cross coming down towards me and environing me round about with a marvellous beautiful light. With which gracious sight my soul was so ravished and had such a passing desire to go and meet with our

Lord, that my body was constrained by the very force of the spirit to set itself up as you might see." In the present painting the saint's black mantle is shown on the ground where she had been lying, and she is depicted in the act of rising to her feet. Whereas in later representations the stigmata are represented by gold rays, they are here, as indeed they are stated to have been, invisible.

The panel is one of the ten scenes from the life of Saint Catherine of Siena recorded by Carli ("Notizie di belle arti," ms. Biblioteca Comunale, Siena, cod. VII–20, c. 86v.: "le Stigmate") in the hospital church of Santa Maria della Scala in Siena. For the reconstruction of the complex from which they came, see No. 52. Nine of the scenes were purchased by Ramboux, but the present panel seems to have been separated from them at an earlier stage.

CONDITION: The paint surface has been badly abraded and extensively retouched. The pink of the floor is new, as are the white highlights of the saint's dress and an area in the upper right corner, including the center and right arm of the cross, part of Christ's halo, and his left arm. Also new is the saint's dress beneath her left knee. Her discarded black mantle has been heavily reinforced.

PROVENANCE: Spedale della Scala, Siena (see above); William Wetmore Story (acquired conjecturally after 1847); Waldo Story (from 1894); Mrs. Waldo Story; Dr. and Mrs. H. H. M. Lyle, New York (1942); J. H. Weitzner, New York. Acquired by Robert Lehman in 1947.

EXHIBITED: Society of the Four Arts, Palm Beach (Fla.), *Early European Paintings*, 1949, no. 12; Metropolitan Museum of Art, New York, 1954–61; Musée de l'Orangerie, Paris, *La collection Lehman*, 1957, no. 21; Cincinnati Museum of Art, *The Lehman Collection*, 1959, no. 35; Metropolitan Museum of Art, New York, *Giovanni di Paolo: Paintings*, 1973, no. 7.

54. The Blessed Ambrogio Sansedoni

1975.1.56

Tempera on panel. 52.4 × 17.8 cm. (20⅝ × 7 in.) including original engaged frame; picture surface: 49.3 × 12.7 cm. (19¼ × 4⅞ in.). The upper horizontal molding of the engaged frame has been cut; the bottom molding is missing. The frame has been extended with modern additions above and below. The back edge of the chamfered colonnette on the left is silvered, and the back of the panel on this side shows evidence of the attachment of another panel, approximately 2.2 cm. thick, at a right angle to it. The back edge of the right-hand colonnette preserves original linen and gesso beneath modern yellow paint.

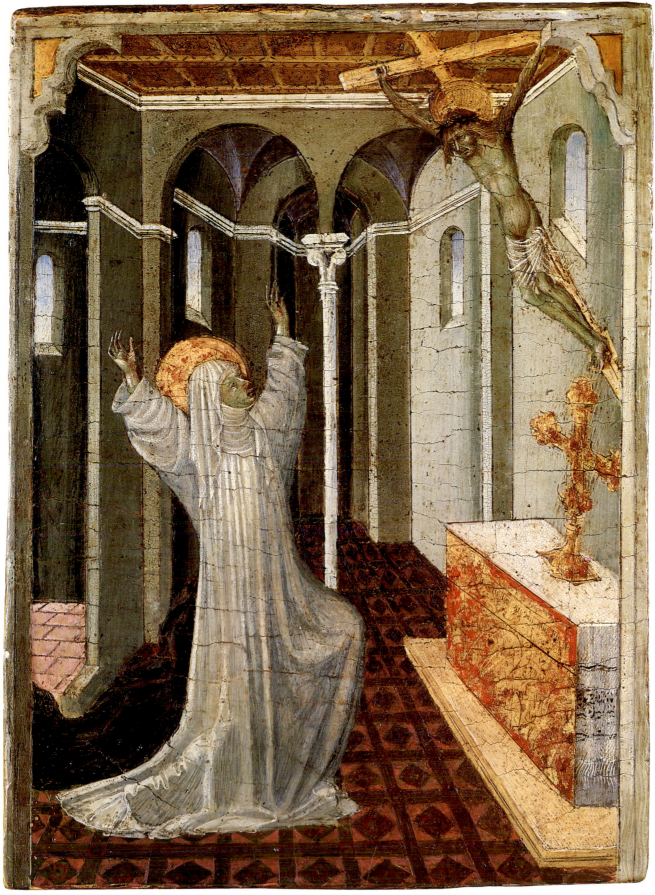

No. 53

The saint is shown in full-length, turned to the left. He wears a Dominican habit and holds a book in his left hand. A small dove whispers in his ear.

This and the companion panel (No. 55) are certainly identical with two of six panels described by Carli ("Notizie di belle arti," ms. Biblioteca Comunale, Siena, cod. VII–20, c. 86v.) in the Spedale della Scala in Siena: "Vi sono 6 quadretti assai bislunghi co' seguenti Santi, B. Ambrogio Sansedoni, S. Galgano, S. Bernardino, S. Caterina, B. Andrea Gallerani, un Martire francescano." These panels were believed by Carli to have formed part of a dismembered altarpiece of the Presentation in the Temple (or Purification of the Virgin) then in the Dormentorio delle Balie of the Hospital, now in the Pinacoteca Nazionale, Siena (no. 211). For a discussion of the problems involved in a reconstruction of this altarpiece see No. 52.

The present panels, along with panels of San Galgano and a Franciscan saint, were purchased in Siena by Ramboux (*Katalog der Gemälde alter italienischer Meister in der Sammlung des Conservators J. A. Ramboux*, Cologne, 1862, p. 29, nos. 150–53) with an attribution to Sassetta. After the death of Ramboux (October 2, 1866), his collection was sold at auction (J. M. Heberle and H. Lempertz, Cologne, May 23, 1867). The panels with San Galgano (53.5 × 17.7 cm.) and a Franciscan saint (51.5 × 17.3 cm.; Fig. 51) passed by way of the Van Heukelom collection to the Aartsbischoppelijk Museum in Utrecht, where they were noted under an ascription to Sassetta by Van Marle ("Italiaansche Schilderkunst," *Oudheidkundig Jaarboek*, ser. 3, 4, 1924, pp. 26–27; and *Development*, vol. 9, 1929, p. 346) and were ascribed to the workshop of Sassetta by Berenson (1932, p. 513). The correct identification of these panels as parts of the Pizzicaiuoli altarpiece is due to Coor ("Quattrocento-Gemälde aus der Sammlung Ramboux," *Wallraf-Richartz Jahrbuch*, 21, 1959, pp. 82–86) and is accepted by Van Os (*Catalogue of Sienese Paintings in Holland*, 1969, nos. 33, 34). They are nonetheless described by Torriti (*La Pinacoteca Nazionale di Siena: I dipinti dal XII al XV secolo*, 1977, p. 316) as lost. The four panels are given by Van Os (loc. cit.) and Szabo (1975, figs. 24, 25) to Pellegrino di Mariano. There is no evidence of Pellegrino di Mariano's intervention in the altarpiece, and the panels bear no relation to his signed works.

The representation of the Blessed Ambrogio Sansedoni is conventional and conforms, e.g., to that in a fresco by Taddeo di Bartolo in the Palazzo Pubblico at Siena. The direction of his stance suggests that he stood in the right pilaster of the altarpiece. The Franciscan saint, formerly in Utrecht, holds the palm of martyrdom and is perhaps the Blessed Peter of Siena. The engaged frame on this panel has been cut at the top while that of the Utrecht San Galgano is preserved on both sides and at top and bottom. Both panels come from the left-hand pilaster, which also contained the Blessed Andrea Gallerani (No. 55). The fifth and sixth panels, presumably from the right-hand pilaster, with Saints Catherine and Bernardino, are untraced. Vecchietta's Arliquiera, which was commissioned for Santa Maria della Scala two years before Giovanni di Paolo's Pizzicaiuoli altarpiece, contains representations of five of these saints with, in addition, the Blessed Agostino Novello, the Blessed Pier Pettinaio, and the Blessed Sorore.

CONDITION: Though the panel is largely regilt, more of the original gold survives than in the companion panel. There are small losses in the habit and scratches across the left hand, but the paint surface is not abraded and is generally well preserved.

PROVENANCE: Spedale della Scala, Siena; J. A. Ramboux, Cologne (till 1867, see above). Acquired by Robert Lehman in Bruges in 1923.

EXHIBITED: Cincinnati Art Museum, *The Lehman Collection*, 1959, no. 38 (as Two Saints); Metropolitan Museum of Art, New York, *Giovanni di Paolo: Paintings*, 1973, both panels listed as no. 10.

55. The Blessed Andrea Gallerani

1975.1.55

Tempera on panel. 51.4 × 17.8 cm. (20¼ × 7 in.) including engaged frame; 48.3 × 12.7 cm. (19 × 4⅞ in.) picture surface. The original engaged frame includes horizontal moldings at the top and bottom, but has been extended with modern additions above and below. Original bole is preserved along the back edge of the projecting colonnette of the frame on the right.

The saint is shown turned to the right. He wears a cloak, on one side of which is the letter *M* surmounted by a cross, the emblem of the Confraternity of the Misericordia.

See No. 54.

CONDITION: The gilding on the panel and the frame is new, and old gold survives in traces only. The halo follows the original impressions in the bole with some reinforcement. The figure is well preserved. There are scratches across the right hand, and a circular loss, caused by a nail head, is by the right elbow.

PROVENANCE: See No. 54.

EXHIBITED: See No. 54.

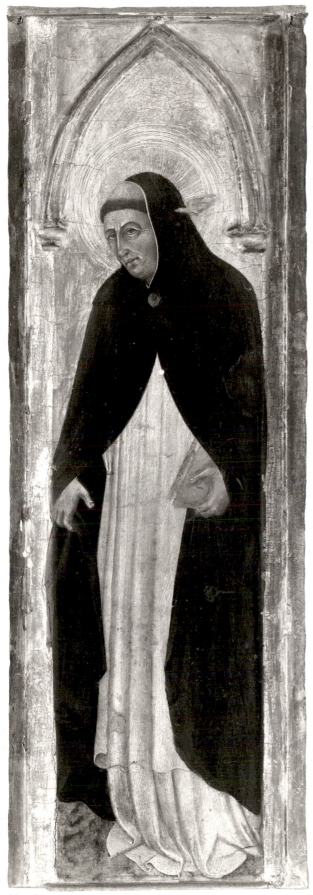

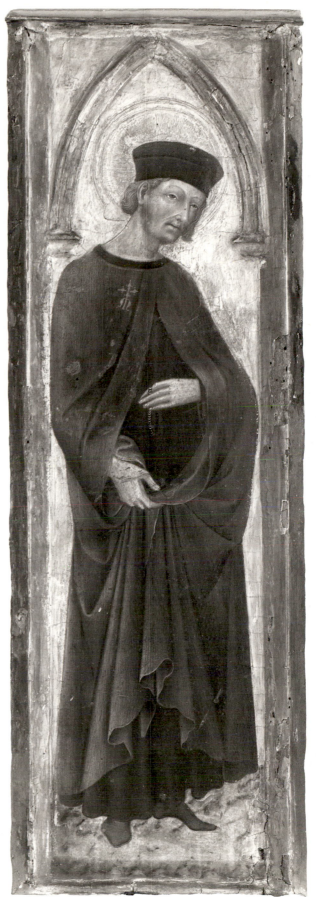

No. 54 No. 55

56. Saint Ambrose

1975.1.30

Tempera on panel. 60.4 × 36.8 cm. (23¹³⁄₁₆ × 14⁷⁄₁₆ in.) excluding added strips at top, bottom, and on the left-hand side. The panel has been cut on all four sides, and its gold field has been reshaped by the superimposition of painted black spandrels.

The mitred saint is shown bust-length with head turned three-quarters to the right. He wears a pallium over a dalmatic with an orphrey embroidered with medallions showing Christ in benediction and three seraphim. The vestment appears originally to have been painted in blue, white, red, and gold with red glazes, now darkened. He holds a flail in his right hand and an open book in his left.

The attribution to Giovanni di Paolo of this and a companion panel, showing a bishop saint holding a book and cross, is due to Berenson (1909, p. 177), who saw both paintings in the collection of Lady Horner. The companion panel was purchased for the Arthur Sachs collection, New York, and is now in the Fogg Art Museum, while the present panel entered the Ickelheimer collection, New York. Both panels appear to have been cut to their present size from full-length standing figures, and in both the ogival arch of the gold ground has been modified.

There has been some confusion as to the identity of the two saints. That in the Fogg Art Museum represents Saint Augustine (Fig. 47), but was published by Comstock ("Pictures by Giovanni di Paolo in America," *International Studio*, August 1927, p. 54) as Saint Ambrose. The present figure has been described as Saint Fabian (Pope-Hennessy, *Giovanni di Paolo*, 1937, p. 125) and as a holy bishop (Perkins, "Some Sienese Paintings in American Collections," *Art in America*, 9, 1921, p. 46). The flail is a regular emblem of Saint Ambrose, and this saint alone can be represented in the present panel.

A third panel from the same series, with the upper part of a figure of Saint Gregory the Great turned to the right (Fig. 48), is published as homeless by Berenson (1968, vol. 1, p. 182; vol. 2, fig. 599). It can be inferred that the panels formed part of a pentaptych, in which a central panel, presumably of the Virgin and Child, was flanked by the four fathers of the church. A fragmentary *Madonna and Child with Two Angels* at Mount Holyoke College, which corresponds to the Lehman and Sachs saints in style and in the treatment of the haloes, may have been excised from the central panel of the altarpiece. The fourth lateral panel, presumably showing Saint Jerome, is untraced. Two panels with Saint Jerome appearing to Saint Augustine (Staatliche Museen, Berlin-Dahlem) and Pope Gregory the Great staying the Plague at the Castel Sant'Angelo (Musée du Louvre, Paris) are likely to have formed part of the predella (Figs. 49, 50). All these panels are late works by Giovanni di Paolo, dating from 1465–70.

CONDITION: The gold ground is largely intact, though holes at the upper right and lower left have been regilt. The paint surface is conspicuously well preserved, save for a circular repaint on the saint's right cheek. The whites throughout retain their original impasto, and the glazed panels on the orphrey are intact.

PROVENANCE: William Graham; Lady Horner, Mells Park, Frome, Somerset (perhaps identical with lot 4 in the Horner sale, Christie's, London, July 11, 1919: "Crivelli: Two Bishops in a shaped panel. On panel—23½ in. by 14 in. each. Exhibited at Burlington House, 1879." Bt. Moore); Durlacher, New York; Henry Ickelheimer, New York, before 1921; Pauline Ickelheimer, New York. Acquired by Robert Lehman in 1941.

EXHIBITED: Cincinnati Art Museum, *The Lehman Collection*, 1959, no. 30.

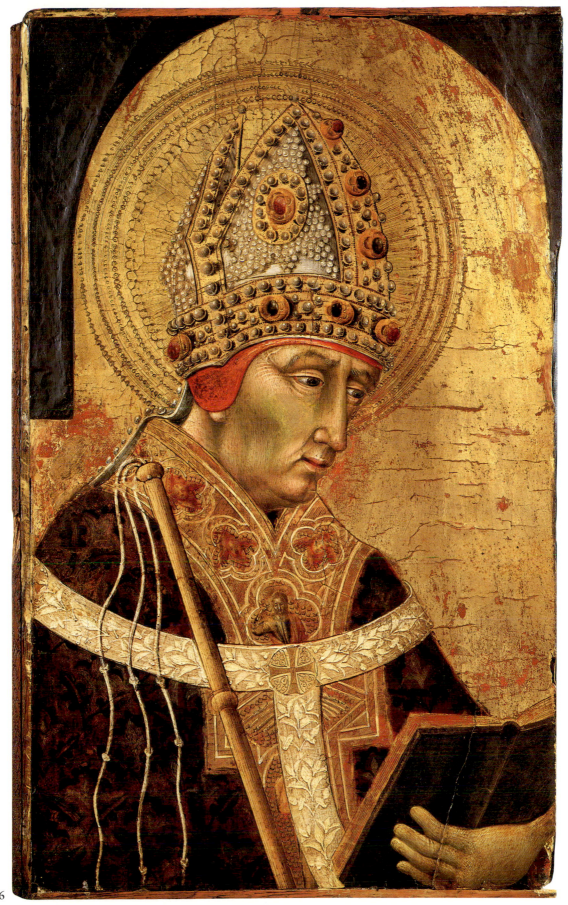

No. 56

137

57. Madonna and Child with Saints Jerome and Agnes

1975.1.32
Tempera on panel. 32 × 24.7 cm. (12⅝ × 9¾ in.) exclusive of added strips on all four sides. The panel has a vertical grain and is 2.4 cm. thick.

The Virgin is shown standing in three-quarter length wearing a dark blue cloak over a dark red-glazed, gold-brocaded dress. She holds the Child on her right arm in a veil or towel, the ends of which hang down at either side. The Child is dressed in a white sleeveless tunic, partly covered with a dark green cloth. Saint Jerome, standing frontally at the left, wears a cardinal's hat and red cloak over a green robe and lawn surplice. Saint Agnes, on the right, holds a diminutive lamb against her white and gold dress.

The panel is published by Berenson ("Quadri senza casa," *Dedalo*, 11, 1931, p. 629; "Homeless Paintings," *International Studio*, 97, 1931, p. 27; *Homeless Paintings of the Renaissance*, 1969, p. 50, fig. 69) as a work of Giovanni di Paolo's studio, with the comment: "Probably it was painted on a cartoon from his hand, and it would be idle to ascribe it to one or other of his anonymous assistants." It appears in the Berenson lists as a work of Giovanni di Paolo (1932, p. 246; 1937, p. 212; 1968, p. 179), on the last occasion with a qualifying "r." (ruined, restored, repainted). This comment (see below) is unjustified. The panel is accepted as autograph by Pope-Hennessy (*Giovanni di Paolo*, 1937, pp. 94, 112, pl. 27a) and Brandi (*Giovanni di Paolo*, 1947, p. 121), but is ascribed by King ("Notes on the Paintings by Giovanni di Paolo in the Walters Collection," *Art Bulletin*, 18, 1936, p. 237) to the artist's workshop. The Child in the present panel, with his round head turned toward the spectator, recalls the Child in a polyptych in the Pinacoteca Nazionale, Siena, dated by Torriti (*La Pinacoteca Nazionale di Siena: I dipinti dal XII al XV secolo*, 1977, pp. 326–29, no. 191) about 1460. A similar cartoon appears in reverse about 1450 in the central panel of a disassembled altarpiece in San Simeone at Rocca d'Orcia and about 1470 in a small panel by a workshop assistant formerly in the Platt collection. The present panel seems to have been produced in the mid-1460s. Though it is loosely executed, there is no reason to question its autograph character. The back of the panel is porphyry-colored with two coats of arms at the bottom (*left*: a shield, bendy of ten, azure, and or; *right*: or, lion and demi-eagle conjoined, gules, surmounted by a crown). The coats of arms are respectively those of (*left*) Chiavelli-Pini and (*right*) the Aldobrandeschi, counts of Santa Fiora.

CONDITION: Beneath a grimy, nearly opaque varnish, the paint surface is very well preserved. Minor flaking in the Virgin's robe has been touched in. The only significant losses are in the red glazes that originally covered the gold of the Madonna's dress.

PROVENANCE: J. Gerry (American Art Association Galleries sale, New York, February 3, 1928, lot 125); Knoedler & Co., New York. Acquired by Robert Lehman in 1928.

EXHIBITED: Cincinnati Art Museum, *The Lehman Collection*, 1959, no. 33.

No. 57, reverse

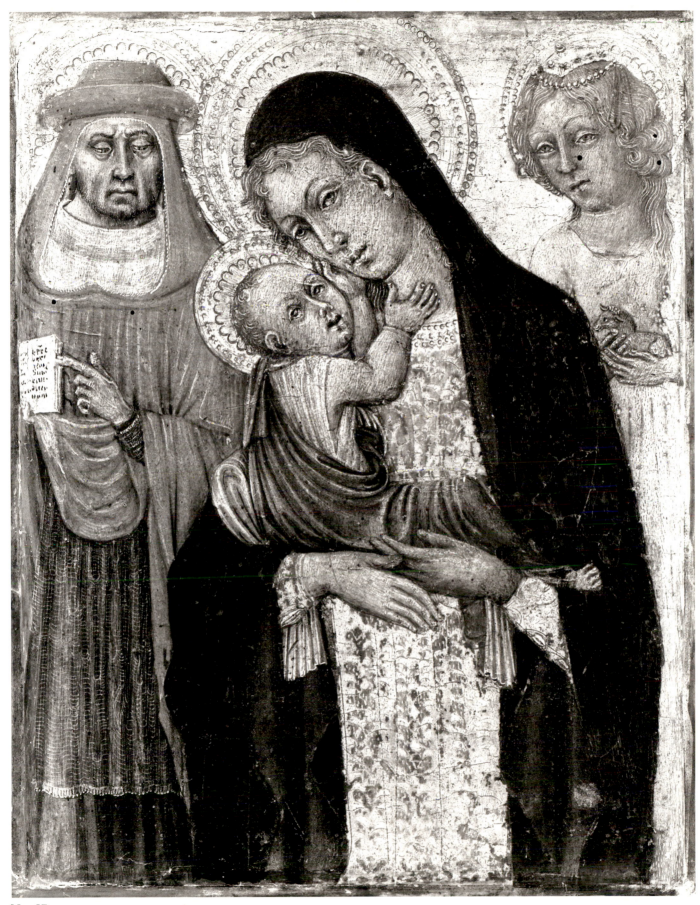

No. 57

58. The Exaltation of Saint Nicholas of Tolentino

1975.1.35

Tempera on panel. 48.6 × 31.1 cm. (19⅛ × 14¼ in.). All moldings are original and only the lowest profile of the bottom molding has been made up. The back was originally reinforced with two horizontal battens, now cut away. Written across the bottom at the back: *S. Nicolaus a Tolentino.*

The saint, dressed in his Augustinian habit and supported by two flying angels, is shown in full-length turned to the left, with a book and a spray of lilies in his left hand. Over his extended right hand is a star with the head of an angel at the center. The saint is framed by two sprays of lilies intersecting above his head. At the top is a flying figure of Saint Augustine supported by two angels; he points downward to Saint Nicholas with his right hand and in his left holds a scroll.

The panel has an engaged frame with a triangular gable, and its back is painted dark porphyry with a light porphyry surround. The lack of any evidence of hinges or spikes on its sides, and the shape of the panel—slightly wider at the base than at the foot of the gable—suggest that it was not designed as part of any larger complex but was intended as an isolated image for devotional purposes. It is accepted as an autograph work of Giovanni di Paolo by Pope-Hennessy (*Giovanni di Paolo*, 1937, pp. 78, 108), Brandi (*Giovanni di Paolo*, 1947, p. 121), and Berenson (1968, vol. 1, p. 178). Saint Nicholas of Tolentino was canonized in 1446, and the handling suggests that the panel was painted soon after that date. The tooling of the haloes recalls that in paintings by Giovanni di Paolo of about 1445.

The lily is a regular attribute of Saint Nicholas, while the star with an angel's head alludes to a miraculous star that was seen moving from Castel Sant'Angelo in the Romagna to the altar at Tolentino where the saint celebrated mass. A full-length figure of Saint Nicholas, painted by Giovanni di Paolo for Sant'Agostino at Montepulciano, is dated 1456. Two scenes with the saint's miracles, which seem originally to have formed part of the same complex, are in the Kunstakademie, Vienna, and the Johnson collection, Philadelphia Museum of Art.

CONDITION: The paint surface is abraded, and bole is everywhere exposed. The angels were originally red and gold with red glazes, now much impaired; the green of the wreath has deteriorated to brown, and there is some flaking in the white flowers.

PROVENANCE: Export stamp of the dogana of Florence, no. 6, 31 marzo 1928; Edward Hutton, London. Acquired by Robert Lehman in 1929.

EXHIBITED: Smith College, Northampton (Mass.), 1942–43; Musée de l'Orangerie, Paris, *La collection Lehman*, 1957, no. 296; Cincinnati Art Museum, *The Lehman Collection*, 1959, no. 36.

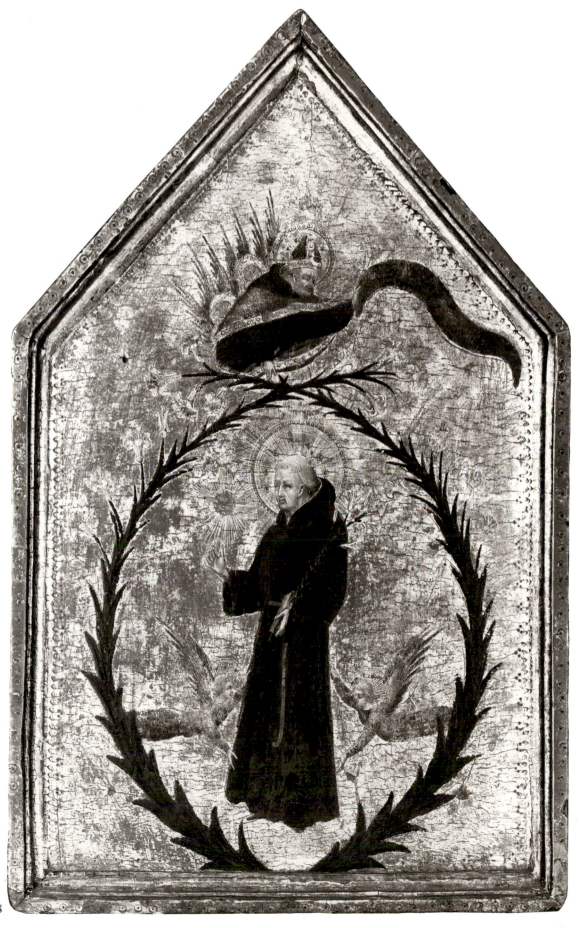

Sano di Pietro

The most popular and prolific artist in Siena in the fifteenth century, Sano di Pietro is also one of the least studied. Born in 1406 and closely associated first with Sassetta (see No. 43) and the Osservanza Master (see Nos. 44, 45), and then with Domenico di Bartolo, he directed a large workshop in which a number of major artists active in the later fifteenth century appear to have been trained. Some of the problems presented by his early work are discussed in the individual entries in this catalogue. Sano di Pietro's career after 1444 can be traced through many dated altarpieces. He died in 1481. The archaic character of his style derives from a current of doctrinal thinking in Siena which has not been fully investigated.

59. The Birth and Naming of Saint John the Baptist

1975.1.44

Tempera on panel. Overall: 24.5 × 47.9 cm. (9⅝ × 18⅞ in.); paint surface excluding lateral gilt bands: 20.7 × 42.9 cm. (8⅛ × 16⅞ in.). The paint surfaces at top and bottom, and the extension of the gilt decoration on the left, are partially obscured by the modern engaged frame. The panel, which has a horizontal wood grain, has not been thinned or cradled.

The scene is set in the interior of a room behind two slender, unevenly spaced columns in the foreground. On the left, the bed of Saint Elizabeth recedes diagonally into the picture space. The bed's head and foot are red; it has a green coverlet and is screened at the left and in front by a white curtain. On a wooden coffer alongside the bed sits Zacharias; he is wearing a red tunic and blue robe and is writing his son's name in the presence of an older man, who is dressed in red and green, and bends over him. At the back on the right, a midwife in orange, seated on the ground, holds the newly born child before a fireplace. A female attendant in left profile places a basin of water on the ground beside her. The panel terminates at either end in strips of punched gold decoration: (*left*) a sequence of lozenge shapes, and (*right*) the same lozenges alternating with rosettes, of which only a single cusp is preserved.

The panel is an autograph work of Sano di Pietro, and is so regarded by Van Marle (*Development*, vol. 9, 1927, p. 530 n.), Berenson (1932, p. 505; 1936, p. 434; 1968, vol. 1, p. 377), and Vavalà ("Early Italian Paintings in the Collection of Frank Channing Smith, Jr.," *Worcester Art Museum Annual*, 3, 1937–38, pp. 30–41). An antiphonal in the Piccolomini Library in Siena (no. 15), illuminated by Sano di Pietro in or about 1465, contains a miniature

of the Birth of the Baptist, in which use is made of the same columns as in the present panel and of a similar cartoon for the midwife seated on the ground (F. Sapori, "Appunti intorno a Sano di Pietro miniatore senese del secolo XV," *Rassegna d'arte*, 1, 1915, p. 223). The present panel relates stylistically to the predella of the Scrofiano altarpiece in Siena, dated 1449, and seems to have been painted shortly after 1450.

The predella to which the present panel belonged has not been identified. It may have comprised a cycle of scenes from the life of the Baptist or have been composed of individual panels related to the lives of the saints depicted in the body of the altarpiece. One predella by Sano di Pietro dedicated to the life of the Baptist is known. It comprises a *Presentation of the Baptist's Head to Herod* in Budapest (Szépművészéti Múzeum, no. 23; see G. Coor, "Quattrocento-Gemälde aus der Sammlung Ramboux," *Wallraf-Richartz Jahrbuch*, 21, 1959, p. 82, pl. 31); a *Beheading of the Baptist* in Moscow (Pushkin Museum, no. 248; see *Mostra dell'antica arte senese, catalogo generale*, 1904, p. 316, no. 491, lent by Carlo Giuggioli); and an unidentified scene from the youth of the Baptist, formerly in the collection of Otmar Strauss, Cologne (Helbing, Frankfurt-am-Main, May 21–24, 1935, lot 92). The present panel is consistent in style with these panels, but is incompatible with them in size (each of the three measures 23.5 × 33 cm.), and differs in the punching of haloes and flanking strips of gilt decoration.

CONDITION: The paint surface is very well preserved and retains many of the original glazes. The lower left edge is damaged and repainted to the level of the first column. The green robe of the elderly man beside Zacharias has been reinforced. Three metal spikes in the panel at the left do not protrude through the paint surface. A horizontal crack at the right edge near the base extends two-thirds the width of the panel.

PROVENANCE: Earl of Ashburnham; Frank Channing Smith, Jr., Worcester (Mass.), by 1925; M. Knoedler & Co., New York, 1952; Julius Weitzner, 1954. Acquired by Robert Lehman before 1959.

EXHIBITED: Smith College Museum of Art, Northampton (Mass.), 1932; Worcester Art Museum, 1933; Berkshire Museum, Pittsfield (Mass.), 1935; Fogg Art Museum, Cambridge (Mass.), *An Exhibition of Italian Paintings and Drawings*, 1939, no. 35; Museum of Fine Arts, Boston, *Art in New England: Paintings, Drawings and Prints from Private Collections in New England*, 1939, no. 120; Smith College Museum of Art, Northampton (Mass.), 1949; Cincinnati Art Museum, *The Lehman Collection*, 1959, no. 46.

No. 59

60. Madonna and Child

1975.1.40

Tempera on panel. 17.9 cm. (7 in.) diameter with attached frame; picture surface: 12.7 cm. (5 in.) diameter. The panel has been thinned and is 2 cm. deep at its thickest point.

The Virgin is shown in half-length on a circular panel with an engaged frame. She wears a red dress and a blue cloak with a green lining, and is turned slightly to the left with her head bent over her right shoulder. She supports the Child in her right arm and with her free hand wraps his legs in her cloak. The Child, who wears swaddling clothes and has a red blanket edged in gold, looks outward to the left, in the same direction as the Virgin. His feet are extended to the base of the panel, and he holds a bird that pecks his thumb.

This roundel, which is of exceptionally high quality, is discussed by Ioni (*Affairs of a Painter*, 1936, pp. 333–34) as an example of an authentic picture unjustly attributed to him as a forgery. He records a letter written by a former assistant informing him that "your two 'Sano di Pietro' roundels, for which I made the frame, are I think now in America." Ioni comments: "Now these two little roundels belonged to a gentleman in Siena, and were at the Exhibition of early Sienese Art. They are described on page 316 of the catalogue (Room XIX [*sic*, for XXIX], 531: *Virgin and Child with a Swallow* and 532: *S. Francis Receiving the Stigmata*, by Sano di Pietro, panel, diameter 118 mm.), but [my assistant] had only to find out that the two little pictures had been bought by a Sienese dealer to jump to the conclusion that they were my work. And to think that this was the considered opinion of an expert in technique, who scatters his views broadcast!" Both pictures were later owned by F. Mason Perkins, who, in a letter of July 31, 1928 (with Knoedler & Co., New York), noted that the frames were modern. The present whereabouts of the *Stigmatization of Saint Francis* (Fig. 64) is unknown. The tooling of the saint's halo in it is inconsistent with that of the haloes in the present panel.

The cartoon of the Child employed in the present panel recalls that used for the central panel of a triptych of the *Madonna and Child with Saints Bartholomew and Lucy* in the Pinacoteca Nazionale, Siena, which is signed by Sano di Pietro and dated 1447. Rectangular versions of the composition are preserved in the Museum of Fine Arts, Boston (no. 6064), and in the Lindenau Museum, Altenburg (R. Oertel, *Frühe italienische Malerei in Altenburg*, 1961, no. 75, pp. 100–1). They vary only in the position of the Child's left arm. An inferior version on an octagonal panel, stated to have come from the William

Graham collection, appeared at auction in New York at the Parke-Bernet Galleries on November 28, 1951, no. 60. A rectangular version (22 × 15.9 cm.) included in the exhibition *Masterpieces of Painting and of Craftsmanship*, organized by the *Burlington Magazine* at Sotheby's Galleries, London, in January 1940, is reproduced in the *Burlington Magazine*, 76, 1940, fig. 10, as in the hands of Paul Cassirer, Ltd.

CONDITION: The paint surface is almost perfectly preserved, with minimal paint losses beneath the Virgin's eyes, at the base of her throat, and in the hair of the Child.

PROVENANCE: Giulio Grisaldi del Taia, Siena, 1904; F. Mason Perkins, Lastra a Signa; E. Ventura, Florence; Knoedler, 1928; R. Frank, New York, December 1937; Knoedler, 1941. Acquired by Robert Lehman in November 1949.

EXHIBITED: Siena, *Mostra d'antica arte senese*, 1904, no. 531; Detroit Institute of Arts, *The Sixteenth Loan Exhibition of Old Masters*, March 8–30, 1933, no. 52 (lent by Knoedler & Co.); Milwaukee Art Institute, *Ten Centuries of Christian Art*, November 1949 (lent by Knoedler & Co.); Museum of Art, Columbia (S.C.), *A Special Loan Exhibition from the Collection of M. Knoedler and Company, New York: Masterpieces of Italian Religious Painting, XIV to XVIII Century*, 1949, no. 4; Musée de l'Orangerie, Paris, *La collection Lehman*, 1957, no. 47; Cincinnati Art Museum, *The Lehman Collection*, 1959, no. 42.

No. 60

61. Madonna and Child with Saints Jerome, Bernardino, John the Baptist, Anthony of Padua, and Two Angels

1975.1.42
Tempera on panel. Overall: 74 × 51.6 cm. (29⅛ × 20⁵⁄₁₆ in.); picture surface: 61.9 × 39.7 cm. (24⅜ × 15⅝ in.). The panel is 31 mm. thick and has not been thinned or cradled. The frame, in five sections, is original.

The Virgin supports the Child on her right arm. He holds a goldfinch in his right hand and rests his left hand on the embroidered collar of the Virgin's dress; she is looking out to the left. The dress of the Virgin and the tunic of the Child are worked with a stippled pattern, bordered at the neck and wrists by bands of punchwork. The Child's tunic is covered with a rose-colored mantle, and the Virgin's dress by a dark blue cloak. Saint Jerome at the lower left has a red cloak almost covering the blue-gray dress beneath, and above him the Baptist carries a cross glazed in red over the gold ground. The habits of the saints on the right vary in color: that of Saint Anthony of Padua above is grayish, and that of San Bernardino below is light brown. The two angels at the top have blond hair, decorated with stylized garlands of leaves and flowers.

The attribution to Sano di Pietro of this characteristic panel is universally accepted, e.g., by Gaillard (*Sano di Pietro*, 1923, pl. 130), Van Marle (*Development*, vol. 9, 1927, p. 512: "One of the good examples of Sano's art"), Berenson (1932, p. 500, and subsequent editions), Salmi ("Dipinti senesi nella Raccolta Chigi-Saraceni," *La Diana*, 7, 1933, p. 82), and Vavalà ("Early Italian Paintings in the Collection of Frank Channing Smith, Jr.," *Worcester Art Museum Annual*, 3, 1937–39, pp. 38–40).

The cartoon of the Virgin and Child was employed by the artist with some frequency, notably in panels in the National Gallery of Art, Washington (K. 92: F. R. Shapley, *Paintings from the Samuel H. Kress Collection: Italian Schools, XIII–XV Century*, 1966, p. 146, fig. 392); the Metropolitan Museum of Art, New York (acc. no. 41.100.10: Zeri, *Italian Paintings: A Catalogue of the Collection of the Metropolitan Museum of Art: Sienese and Central Italian Schools*, 1980, p. 81, pl. 56); the Art Gallery of New South Wales; the Harvard Center for Renaissance Studies at Villa I Tatti, Florence; the Museum of Fine Arts, Houston; the Art Institute of Chicago; and elsewhere. Forgeries incorporating the two figures are also known. The Lehman and Washington panels are of high and equivalent quality. The same cartoon is employed in at least two larger works: an undated *Madonna and Child Enthroned with Twenty-two Saints and Two*

Angels in the Pinacoteca Nazionale, Siena (no. 273), and a polyptych of 1458 in San Giorgio at Montemerano. The *Madonna* in the Metropolitan Museum of Art is dated by Zeri (loc. cit.) to the late 1460s, and the present painting may be a substantially autograph work of the same time.

CONDITION: The paint surface and gilding are very well preserved. There is some modern reinforcement at the base of the Child's right foot, at his collar, and at the top of his head. The green wreaths in the angel's hair have discolored to brown.

PROVENANCE: Earl of Ashburnham; R. Langton Douglas; Frank Channing Smith, Jr., Worcester (Mass.), by 1925; M. Knoedler & Co., New York, 1952; Julius Weitzner, 1954. Acquired by Robert Lehman before 1959.

EXHIBITED: Smith College Museum of Art, Northampton (Mass.), 1932; Worcester Art Museum, 1932; Berkshire Museum, Pittsfield (Mass.), 1935; Fogg Art Museum, Harvard University, Cambridge (Mass.), *An Exhibition of Italian Paintings and Drawings*, 1939, no. 36; Metropolitan Museum of Art, New York, 1954–61; Cincinnati Art Museum, *The Lehman Collection*, 1959, no. 45.

No. 61

62. Madonna and Child with Saints John the Baptist, Jerome, Peter Martyr, Bernardino, and Four Angels

1975.1.43

Tempera on panel. Overall: 71.5 × 56.1 cm. (28⅛ × 22¹⁄₁₆ in.); picture surface: 63 × 47.3 cm. (24¾ × 18⅝ in.). The frame is old but not integral with the panel, and its attachment is modern. The panel has not been thinned or cradled.

The Virgin holds the Child Christ on her right arm and supports his foot and leg with her left hand. He presses his cheek against the veil covering the Virgin's cheek and holds a white and black bird with a red hood in his right hand. Behind the main figures are (*left*) Saint John the Baptist holding a red cross and a scroll inscribed ECCE A., and Saint Peter Martyr in a Dominican habit with a wound across his scalp, and (*right*) Saint Jerome robed as a cardinal, and San Bernardino holding the monogram of Christ engraved on a gold tablet in his right hand. The upper part of the panel is filled with the heads of four wreathed angels. In the Virgin's halo are the words AVE GRATIA PLENA DOMIN, and in that of the Child the name YHS XPO.

The cartoon for the heads of the Virgin and Child was employed with some frequency in Sano di Pietro's workshop. Characteristic examples of its use are in a *Madonna and Child with Saints Jerome and Bernardino and Four Angels* in the Lindenau Museum, Altenburg (R. Oertel, *Frühe italienische Malerei in Altenburg*, 1961, p. 100, no. 73), and a *Madonna and Child with Saints Jerome and Bernardino and Six Angels* from the Kingsley Porter collection (Fogg Art Museum, Cambridge).

The painting is instanced by Coor (*Neroccio de' Landi*, 1961, p. 16, fig. 92) as an example of a class of Madonna by Sano di Pietro which influenced such early works by Neroccio as the *Madonna* of ca. 1467 in the Visconti Venosta collection.

CONDITION: The paint surface is evenly abraded, with bole showing in places through the gold and green underpaint visible locally beneath the flesh tones. Scattered minor flaking losses have been touched in, and the broad craquelure across the Virgin's face has been partially overpainted. Holes in the Virgin's left cheek and on the wrist and hands of Saint Jerome have been inpainted.

PROVENANCE: Vicomte Cartier de Vance, Château de la Fauconnière, Gannat, Allier; Henry Schniewind, New York; Richard Ederheimer, New York, 1936. Acquired by Robert Lehman in May 1938.

EXHIBITED: Ederheimer, *A Selection of Paintings by the Old Masters*, New York, 1936, no. 5; The New School, New York, February 25–March 18, 1946; Metropolitan Museum of Art, New York, 1954–61; Cincinnati Art Museum, *The Lehman Collection*, 1959, no. 44.

No. 62

63. Madonna and Child

1975.1.51
Tempera on panel. With original frame: 41.5 × 30.9 cm.
(16⅜ × 12⅛ in.); picture surface: 33.3 × 22 cm. (13⅛ × 9 in.).

The Virgin, seen in bust-length, holds the Child against her left shoulder. His face is pressed to and partly concealed by her left cheek. His right hand is raised in benediction, and he holds a goldfinch in his left. The Virgin's dark blue cloak has a green lining over a gold dress, and the Child wears a red tunic with a gold collar and gold sleeves.

The panel is reproduced by Gaillard (*Sano di Pietro*, 1923, pl. 36) and is listed by him (p. 204) as a work of Sano di Pietro. It is a seemingly autograph work of about 1450, and its quality, though undistinguished, is markedly superior to that of No. 67. As R. Lehman (1928, pl. 42) and Edgell (*A History of Sienese Painting*, 1932, p. 212) note, the motif of the Child's right cheek concealed behind the Virgin's face is a seemingly conscious recollection of a well-known *Madonna* by Ambrogio Lorenzetti, formerly in the convent of Santa Petronilla at Siena and now in the Pinacoteca Nazionale (no. 77). It appears again in a *Madonna and Child with Six Saints* by Sano di Pietro at Christ Church, Oxford (J. Byam Shaw, *Paintings by Old Masters at Christ Church, Oxford*, 1967, p. 47, pl. 20), and in a number of related workshop panels.

CONDITION: The panel, excised from its frame, has been thinned and cradled. The paint surface is abraded, but there are no significant paint losses or reinforcements.

PROVENANCE: Paolo Paolini, Rome. Acquired by Philip Lehman in 1916.

EXHIBITED: Cincinnati Art Museum, *The Lehman Collection*, 1959, no. 40.

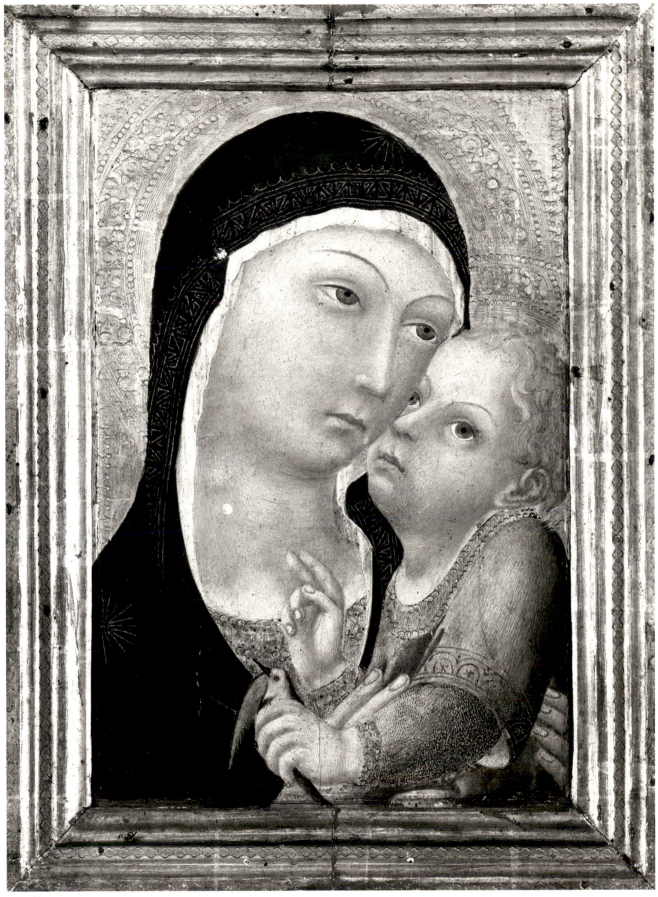

No. 63

64. San Bernardino

1975.1.46

Tempera on panel. 24.2 × 22.1 cm. (9½ × 8¹¹⁄₁₆ in.). The panel, which has a vertical wood grain, has not been thinned or cradled and is 29 mm. thick. The left edge is gilt and the right edge is painted porphyry.

The saint is shown in three-quarter length, turned slightly to the left. He wears a light brown habit bound by a rope and holds before him a tablet inscribed with the sacred monogram YHS in gold on a blue ground bordered in gold and red. Punched decoration runs along the top and sides of the gold ground.

This and No. 65 are of notably high quality and were once part of a single complex. Similar panels appear at the base of the pilasters of a triptych by Sano di Pietro in the Osservanza in Siena. The vertical wood grain in both panels is consonant with this position, as is the punched decoration of the gold ground along the top and sides but not along the base of the panels. The pilaster bases of the Osservanza triptych are treated in the same way. Related panels appear beneath the pilasters of an altarpiece from the Convento dei Gesuati now in the Pinacoteca Nazionale at Siena (no. 233). The altarpiece from which the present panels came cannot be identified. The treatment of their edges (see above) suggests that the panels projected forward from the plane of the rest of the predella, with the gilded edges abutting on the predella proper and the porphyry edges on the outside of the altarpiece. The type of the saint in the present panel differs from the conventional image of San Bernardino produced in the workshop of Sano di Pietro. This is due to the defective condition of the head (see below). Both panels are autograph works by Sano di Pietro, probably dating from the 1450s.

CONDITION: The paint surface has been extensively restored, and large areas of the saint's habit are modern, as are his jaw and the back of his neck. There are smaller areas of repaint in his cheek and nose. The hands and book, however, are well preserved, and actual paint losses do not appear to be as extensive as the overpainting. The gold ground has been repaired over nail damage at the lower left and right corners, at the edge of the saint's right sleeve, and to the right of his waist.

PROVENANCE: Baroness Marochetti, Château de Vaux-sur-Seine; J. Seligmann and Co. Date of acquisition not recorded.

EXHIBITED: Smith College Museum of Art, Northampton (Mass.), 1942–43; Metropolitan Museum of Art, New York, *The Lehman Collection*, 1954–61; Cincinnati Art Museum, *The Lehman Collection*, 1959, no. 47 (San Bernardino) and no. 52 (Saint Francis).

No. 64

65. Saint Francis

1975.1.50

Tempera on panel. 23.9 × 22.1 cm. (9⁷⁄₁₆ × 8¹¹⁄₁₆ in.). The panel, which has a vertical grain, has not been thinned or cradled and is 31 mm. thick. The right edge of the panel is gilt and the left edge is colored porphyry.

The saint, in a grayish brown habit, is shown in half-length facing three-quarters to the right. He holds a red bound book in his left hand, and with his right pulls back his habit to expose the wound in his side. The marks of the stigmata are visible on the backs of his hands. Punched decoration runs along the top and sides of the gold ground.

See No. 64.

CONDITION: The paint surface and gold ground are almost perfectly preserved save for nail damage in the lower corners, which has been repaired. A lip is visible along the lower edge.

PROVENANCE: See No. 64.

EXHIBITED: See No. 64.

No. 65

Workshop of Sano di Pietro

66. San Bernardino

1975.1.45

Tempera on panel. 17.8 × 10.6 cm. (7 × 4³⁄₁₆ in.). The panel is 20 mm. thick and has a vertical grain. It has been cut along all four sides.

The saint is represented in half-length, turned three-quarters to the left against a blue ground. He wears a gray Franciscan habit and holds before him a gold, blue, and red tablet with the sacred monogram YHS surrounded by the inscription IN NOMINE YHV./OMNE. GENV./FLETATVR. CELESTIVM/TERESTI ET INFERNORV.

To judge from its back, which is gessoed and painted off-white, the panel did not form part of the pilasters or predella of an altarpiece but was designed for private devotional use. Neither the head, with its skillfully painted hair and eyebrows, nor the treatment of the cowl is wholly compatible with Sano di Pietro's late works, and the panel is likely to have been executed, about 1460–70, by a younger artist in Sano di Pietro's workshop.

CONDITION: The paint surface is very well preserved, though minor flaking losses in the saint's fingers and at the top of his head have been inpainted. The blue ground is modern.

PROVENANCE: Vittorio Forti, Rome; Jandolo, Rome. Acquired by Robert Lehman in August 1948.

EXHIBITED: Cincinnati Art Museum, *The Lehman Collection*, 1959, no. 48.

No. 66

67. Madonna and Child

1975.1.39

Tempera on panel. Panel: 63.2 × 44.7 cm. (24⅞ × 17⅝ in.); picture surface: 54.9 × 36.1 cm. (21⅝ × 14⅛ in.). The panel, which is 29 mm. thick, has not been thinned or cradled. The frame moldings, if old, are regessoed and regilt.

The Virgin is shown a little over bust-length, turned to the left. She wears a blue cloak lined with gold over a red and gold dress. On her right arm she supports the Christ Child, who clutches at her cloak with his left hand and makes a gesture of benediction with his right, pressing his face against his mother's cheek. He is dressed in a pink and gold tunic, with a violet undergarment of which the sleeves are visible. The Virgin's halo is inscribed with the words AVE.MARIA.GRACIA.PLENA.DO, and in the cruciform halo of the Child are the words EGO.SVM.LVX.MV.

The panel records one of Sano di Pietro's most popular designs. The motif of the Child with face pressed directly against the Virgin's cheek appears in the autograph central panel of an altarpiece from San Francesco at Colle Val d'Elsa (now in the Pinacoteca Nazionale, Siena, no. 224), which is dated by Torriti (*La Pinacoteca Nazionale di Siena: I dipinti dal XII al XV secolo*, 1977, p. 264) to the years 1448–50. The present panel is a workshop variant of this Virgin and Child.

CONDITION: The paint surface is evenly abraded; paint losses are confined to scratches across the back of the Virgin's left hand and to small holes in the gold at the back of her head and in the lining of her cloak above the Child's right thumb. The blue of the Virgin's cloak has been heavily reinforced, and its gilt edging has been renewed, though fragments of the original pattern survive.

PROVENANCE: M. J. Homberg, Paris (sale, Galerie Georges Petit, Paris, May 11, 1923, no. 34); M. Knoedler & Co., New York; Henry Ickelheimer, December 1923; Pauline Ickelheimer. Acquired by Robert Lehman in 1946.

EXHIBITED: Cincinnati Art Museum, *The Lehman Collection*, 1959, no. 41.

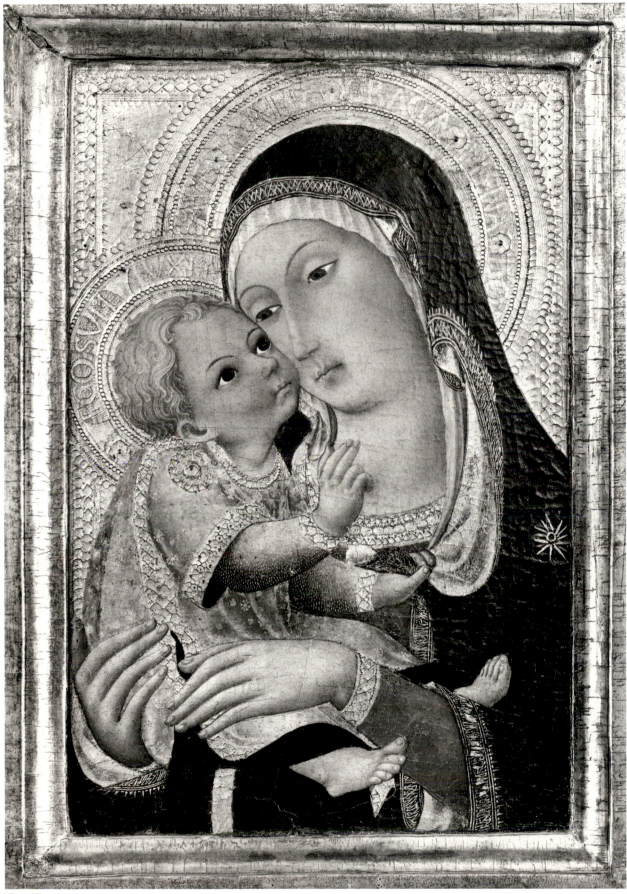

No. 67

Matteo di Giovanni

Matteo di Giovanni was active after 1452 and emerges as an independent artist in 1462–63 with two altarpieces commissioned for the newly built cathedral of Pienza. Despite their conventional technique, these reveal the influence of Castagno and the young Antonio Pollaiuolo. Matteo di Giovanni's development can be charted in terms of his response to external influences, notably those of the miniaturists Girolamo da Cremona and Liberale da Verona and of Domenico Ghirlandaio. At the same time he produced a large number of conventional half-length Madonnas in which the idiom, though not the style, recalls the work of Sano di Pietro. The chronology of these panels, one of which is in the Lehman Collection, has not been satisfactorily established. The earliest of them precede the Pienza altarpieces, and the latest date from the last half decade of the painter's life. Matteo di Giovanni died in 1495.

68. Madonna and Child with Saints Anthony of Padua and Catherine of Siena

1975.1.52

Tempera on panel. 65.4 × 42.9 cm. (25¾ × 16⅞ in.) excluding modern frame. The panel has been thinned slightly and cradled.

The Virgin is shown on a gold ground in half-length, turned to the right. The gold hem of her dark blue cloak touches the base of the panel, and her red dress has a gold border at the throat and wrist. The Child, clad in a tunic of transparent lawn, sits with his right leg extended on the Virgin's left arm and holds the edge of her cloak with his right hand. Saint Anthony of Padua (*left*) wears a Franciscan habit and holds a book and red cross, and Saint Catherine of Siena (*right*), in the habit of a Dominican nun, has a book in her left hand and in her right holds a spray of lilies, which extends behind the halo of the Christ Child. In a strip following the segmented form of the upper part of the arched panel are the words AVE.MARIS.STELLA.DEI.MAT. In the halo of the Virgin are the words REGINA.CELI.LETARE.ALLELV.

The painting is a characteristic work of Matteo di Giovanni and is so regarded by Hartlaub (*Matteo da Siena und seine Zeit*, 1910, p. 76, pl. viii), Valentiner (*Illustrated Catalogue of the Rita Lydig Collection*, 1913, p. 321), Berenson (1932, p. 321; 1968, vol. I, p. 259), Van Marle (*Development*, vol. 16, 1937, pp. 331–32), Perkins (in Thieme-Becker, *Künstler-Lexikon*, vol. 25, 1930, p. 256), and Coor (*Neroccio de' Landi*, 1961, p. 32). References

to it are confused by the fact that (i) two other paintings of the Virgin and Child ascribed to Matteo di Giovanni were at one time in the Lehman Collection, a *Madonna and Child* by the forger Ioni and a *Madonna and Child with Saints Jerome and Mary Magdalene*, now in the Metropolitan Museum of Art (acc. no. 65.234), and (ii) the lateral saints have been mistakenly identified as Bernardino (Valentiner, Coor), Francis (Berenson), and Clare (Berenson).

None of the half-length Madonnas of Matteo di Giovanni is exactly datable, and the only means whereby their sequence can be established is through analogies with dated altarpieces. The type of the Virgin in the present panel is later in style than that of the central panel of the Servi altarpiece of 1470 in the Pinacoteca Nazionale, Siena, and closely recalls that in the *Madonna della Neve* of 1477 (Oratorio della Madonna della Neve, Siena) and the Placidi triptych of 1479 (San Domenico, Siena). A dating about 1476–80 is therefore possible. Van Marle suggests that the panel was "inspired by such a Neroccio painting as the *Madonna with Saints Jerome and Catherine of Siena* in Philadelphia." There is no substance in this point. In a *Madonna* by Matteo di Giovanni in the Harvard Center for Renaissance Studies at Villa I Tatti, Florence, the legs of the Child are disposed in the same fashion, and in a later *Madonna* by Matteo of about 1480–85 in the Barber Institute of Fine Arts, Birmingham, the pose is reversed. A number of Madonnas with segmented or semicircular tops—that of the present example is impaired by the addition of a modern frame—were made by Matteo di Giovanni in the late 1470s; typical of these is a *Madonna and Child with Saints Jerome and Bernardino and Two Angels* in the Walters Art Gallery, Baltimore. The powerful, simplified underdrawing visible throughout the present painting is found in other Madonnas by Matteo di Giovanni, notably in panels in Santa Eugenia, Siena, in the Uffizi, Florence, and in the Musée Bonnat, Bayonne.

The words stippled into the upper border are those of the hymn AVE MARIS STELLA. Affixed to the back of the panel with four seals beneath a Franciscan *stemma* is a nineteenth-century label reading:

> MATTEO.DA.SIENA.DIPINSE
> QUESTO.QUADRO.DELLA
> MADONNA.SANTISSIMA
> PER.IL.PRIMO.ALTARE
> A.MANCA.DETTO.DI
> S.ANNA.

The panel therefore originates from an altar dedicated to Saint Anne in a Franciscan church. According to Brogi

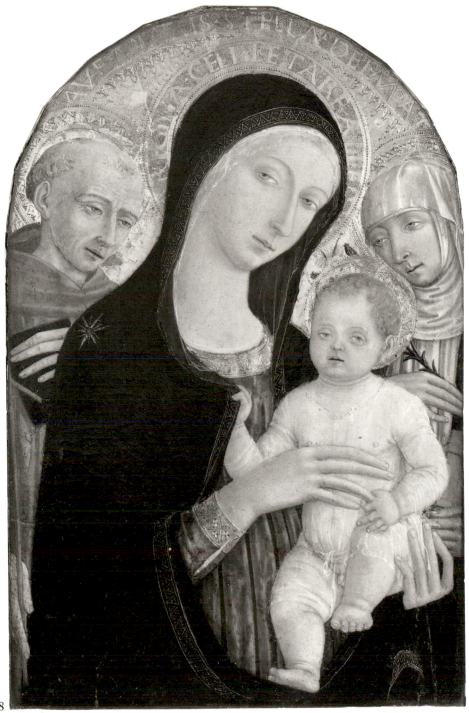

No. 68

(*Inventario*, p. 156), the first altar on the right, not the left, of the church of San Francesco at Colle Val d'Elsa was dedicated to Saint Anne. There is, however, no reference in the inventory to a Madonna by Matteo di Giovanni in this chapel.

CONDITION: The paint surface is abraded throughout, exposing areas of *terra verde* underpainting and orange bole. Some scratches and small local losses have been crudely retouched, and underdrawing is apparent through the thinned surface layers of paint.

PROVENANCE: F. Mason Perkins, Lastra a Signa, 1910; Rita Lydig, New York, before 1913; Lydig sale (Valentiner, op. cit., April 4, 1913, no. 127, with measurements that include the present frame); bt. Morton Meinhard; Mrs. Morton Meinhard, New York (sale, Parke-Bernet Galleries, New York, May 4/5, 1951, no. 315). Acquired by Robert Lehman in 1951.

EXHIBITED: William Rockhill Nelson Gallery of Art, Kansas City, 1942–44; Metropolitan Museum of Art, 1944; Cincinnati Art Museum, *The Lehman Collection*, 1959, no. 54.

Benvenuto di Giovanni

Benvenuto di Giovanni was born in 1436. His early style, unlike that of his contemporary Matteo di Giovanni, is local, and he is likely to have been trained in Siena in the workshop of Sano di Pietro. For a time he also served as an assistant to Vecchietta. In the 1470s he was, like Matteo di Giovanni, strongly influenced by the miniaturists Girolamo da Cremona and Liberale da Verona. After these two artists left Siena his style stratified. In his youth, however, he was a painter of extraordinary accomplishment, notably in an altarpiece of the Annunciation of 1466 in San Girolamo, Volterra, which forms a point of reference for the early panel discussed below. Benvenuto di Giovanni, whose late work merges with that of his son Girolamo di Benvenuto, died in or about 1518.

69. Madonna and Child

1975.1.54

Tempera on panel. 70.4 × 46 cm. (27¹¹⁄₁₆ × 18⅛ in.) with engaged frame; picture surface: 61.5 × 37.4 cm. (24¼ × 14¹¹⁄₁₆ in.). The panel, which has a vertical grain, has been thinned and cradled; its depth ranges from 9 to 22 mm. along the warpage. On the back of the tabernacle frame are old iron hooks, and at the top are old hinges.

The Virgin is shown on a gold ground in half-length, standing behind a marbled parapet which is cut back in the center and extends to the front plane at right and left. Turned slightly to the left, she is wearing a dark blue cloak over a brocaded dress ornamented with jewels on the neck and chest, and she gazes downward at the Child, who is seated on the left on a double brocaded cushion. She holds a pomegranate, which the Child touches with his right hand. Naked save for a pale blue sash, he reaches up with his left hand to play with a lace of the Virgin's bodice. In the Virgin's halo are the words AVE.GRATIA. PLENA.DOM.

The panel is a characteristic work by Benvenuto di Giovanni of the highest quality, and is so regarded by Berenson (1897, p. 134; 1909, p. 148; 1932, p. 77; 1938, p. 40), Hutton (in Crowe and Cavalcaselle, vol. 3, 1909, p. 118), Van Marle (*Development*, vol. 16, 1937, p. 396), Edgell (*A History of Sienese Painting*, 1932, p. 253, fig. 375), Coor (*Neroccio de' Landi*, 1961, p. 67, n. 223), and Fredericksen and Davisson (*Benvenuto di Giovanni, Girolamo di Benvenuto, Their Altarpiece in the J. Paul Getty Museum and a Summary Catalogue of Their Paintings in America*, 1966, p. 27). It is dated to the early 1470s by Edgell and Coor, and is related by Fredericksen and Davisson to an altarpiece of the Ascension of 1491 in the Pinacoteca Nazionale, Siena. The later of these datings is untenable.

A basis for the reconstruction of Benvenuto di Giovanni's early work is provided by two altarpieces of the Annunciation in San Girolamo at Volterra (1466) and in San Bernardino at Sinalunga (1470). It is suggested by Shapley (National Gallery of Art, Washington, *Catalogue of the Italian Paintings*, vol. 1, 1979, pp. 65–66) that a *Madonna and Child with Saints Bernardino and Jerome*, formerly in the Widener collection and now in the National Gallery of Art (no. 599), is the earliest recorded half-length Madonna by the artist, and that it dates from ca. 1465, before the Volterra Annunciation. The present painting is more mature in style and is likely to have been painted about 1466–70, soon after the Volterra altarpiece.

According to R. Lehman (1928, pl. 54), "the panel, as is borne out by the coat of arms on the back, was once owned by Pope Pius II, a great patron of Sienese and Umbrian art." Possibly the Piccolomini arms were removed from the back when the picture was thinned down and cradled. There is no independent confirmation of their presence on the painting, and the inference is contradicted by the date of the Pope's death (1465). Fredericksen and Davisson (loc. cit.) supposed the arms, which they had not seen, to relate to Pope Pius III Piccolomini (d. 1503). The back of the tabernacle frame is incised with the arms of Griffoli of Siena (see Grassi-Malevolti, *Arme delle famiglie nobili di Siena*, 1706, pl. 9). This frame, which is of exceptionally high quality, is of the period and may be original, though it is not now integral with the panel and has been adapted to receive the panel's warpage. The frame is decorated beneath its scroll console with clusters of acorns, possibly a heraldic allusion to its original ownership.

CONDITION: The picture is exceptionally well preserved. Minor flaking has been inpainted, but abrasion is minimal. Some pinpoint flaking in the area of the Child's arms, fingers, and left leg, and across the back of the Virgin's hand is evident. The lining of the Virgin's cloak, originally violet, has decomposed to black.

PROVENANCE: Ernest Odiot, Paris (*Catalogue des objets d'art de M. Ernest Odiot*, Hôtel Drouot, Paris, April 26/27, 1889, p. 30, no. 15, as fourteenth-century Sienese school); M. Chabrières-Arlès, Oullin, nr. Lyon; Duveen Bros., New York. Acquired by Philip Lehman in 1916.

EXHIBITED: Duveen Galleries, New York, *Loan Exhibition of Important Early Italian Paintings at the Galleries of Duveen Brothers*, 1924, no. 41; Colorado Springs Fine Arts Center, *Paintings and Bronzes from the Collection of Mr. Robert Lehman*, 1951–52; Metropolitan Museum of Art, New York, 1954–61; Cincinnati Art Museum, *The Lehman Collection*, 1959, no. 55 (noted as withdrawn).

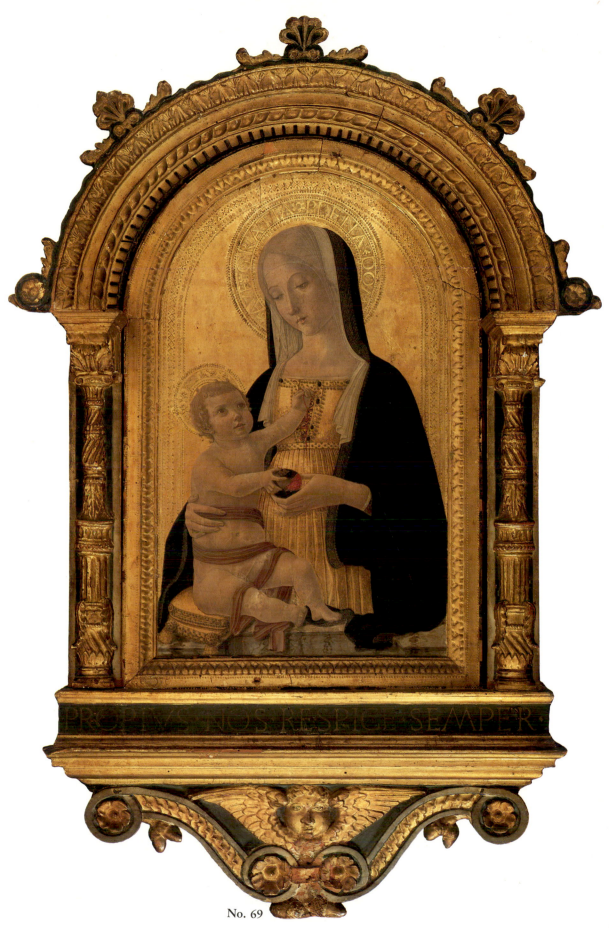

No. 69

70. San Bernardino

1975.1.53

Tempera on panel. 23.7 × 25.7 cm. (9⁵⁄₁₆ × 10⅛ in.). The panel, which has been thinned and cradled, ranges in thickness from 5 to 11 mm. along the warpage.

The saint is shown in three-quarter length, turned to the right, holding a tablet inscribed with the sacred name. The figure is set on an oval ground within a gilded *pastiglia* garland of fruit.

The panel is one of six three-quarter length figures acquired by Robert Lehman from the Satinover Galleries in October 1920. Two of these, with Christ in Benediction and Saint Dominic (Figs. 61, 62), were presented by Robert Lehman to the Nelson-Atkins Museum of Art, Kansas City, in 1945; another, with Saint Peter Martyr, was presented by him to the Yale University Art Gallery in 1946; the fourth, apparently with Saint Philip, was given by him to A. Merriman Paff (untraced); the fifth, with Saint Francis (Fig. 63), was sold to M. W. Newton (later sold at auction, Sotheby Parke-Bernet, New York, October 22, 1970, no. 2, and now in the Houston Museum of Fine Art); and the sixth, the present panel, was retained in the Lehman Collection. The grain of the present panel is horizontal, and the six figures are likely to have been set horizontally in the predella or upper section of an altarpiece. Since the panel with Christ in Benediction would have occupied a central position, the complex must originally have comprised seven panels, not five as suggested by Seymour (*Early Italian Paintings in the Yale University Art Gallery*, 1970, p. 188, no. 140), with an overall width of at least 190 cm.

The figures are accepted as the work of Benvenuto di Giovanni by Berenson (1932, p. 77; 1968, vol. 1, p. 40), Van Marle (*Development*, vol. 16, 1937, p. 416), Fredericksen and Davisson (*Benvenuto di Giovanni, Girolamo di Benvenuto, Their Altarpieces in the J. Paul Getty Museum and a Summary Catalogue of Their Paintings in America*, 1966, pp. 25–27, as possibly from a predella "closely related in style to the Biccherna panel of 1474 in the Archivio di Stato in Siena representing the Allegory of Good Government"), and Bandera ("Qualche osservazione su Benvenuto di Giovanni," *Antichità viva*, 13, 1974, pp. 8–9). Bandera reproduces five of the six roundels and relates them stylistically to the altarpiece by Benvenuto di Giovanni from San Michele Arcangelo at Montepertuso (dated 1475). She suggests that the panels originate from the same dismembered altarpiece as six pilaster panels of full-length saints in the Kress collection, distributed between Bucknell University, Lewisburg, and the Isaac Delgado Museum, New Orleans (given by Shapley, *Paintings from the Samuel H. Kress Collection: Italian Schools XIII–XV Century*, 1966, p. 161, to Girolamo di Benvenuto, and by Zeri, "Early Italian Pictures in the Kress Collection," *Burlington Magazine*, 109, 1967, p. 477, to Benvenuto di Giovanni). The *pastiglia* garlands around the present figures are explained by Bandera as derivations from the *pastiglia* ornament on Sienese cassone panels. No closely comparable feature occurs in any predella by Benvenuto di Giovanni, though the *Scenes from the Life of the Virgin* in the Pinacoteca Comunale at Volterra, which formed the predella of the *Annunciation* altarpiece of 1466 at San Girolamo, are divided by foliated pilasters in *pastiglia*.

CONDITION: The gold ground is badly worn and has been partly regilt, especially along the bottom half of the wreath and around the head of the saint. The paint surface is lightly abraded, and paint losses at the back of the saint's head and along his right shoulder and sleeve have been inpainted. The profile of his left sleeve is a modern reconstruction. There are minor scratches across the face.

PROVENANCE: Satinover Galleries, New York. Acquired by Robert Lehman in 1920.

EXHIBITED: Cincinnati Art Museum, *The Lehman Collection*, 1959, no. 56.

No. 70

FLORENCE

Fifteenth Century

Lorenzo Monaco

Born about 1370, Piero di Giovanni entered the Camaldolese monastery of Santa Maria degli Angeli in Florence in 1391, taking the name of Don Lorenzo. He appears to have been trained in the workshop of Agnolo Gaddi, and his earliest panel paintings, datable to the last decade of the fourteenth century, reflect Gaddi's style. Santa Maria degli Angeli was the seat of a well-known school of illuminators. The development of Lorenzo Monaco's style can be reconstructed from documented altarpieces of 1404, 1406–10, and 1414, from a late altarpiece and fresco cycle in the Bartolini Chapel of Santa Trinita in Florence, and from a number of other dated panels and miniatures. The most highly regarded painter in Florence until the arrival in 1420 of Gentile da Fabriano, Lorenzo Monaco died in 1426.

71. The Crucified Christ between the Virgin and Saint John the Evangelist

1975.1.67

Tempera on panel. 85.4 × 37 cm. (33⅝ × 14½ in.). The panel is 27 mm. thick, with a vertical wood grain. The horizontal molding elements of the frame are modern accretions, while the vertical elements and the gable are regilt but original. The profile of the ogival arch has been altered to appear less recessive. There is an old horizontal batten across the bottom of the back of the panel.

The cross rises from a rock in the foreground and, with the superscription attached by a peg at the top, extends almost to the extremity of the ogival arch. The arch cuts the cross pieces to right and left of Christ's hands. The head of Christ is bent over his right shoulder, and blood pours from his hands down his wrists and elbows, from his feet, and from the wound in his side. The Virgin (left), seated with her hands crossed and gazing at her Son, and Saint John (right), kneeling on the left knee with his left hand raised in exposition, are silhouetted against two hills which meet in an inverted ogival form beneath the suppedaneum. Across the foreground runs a rocky cleft.

The attribution of this panel to Lorenzo Monaco goes back to Sirén (*Don Lorenzo Monaco*, 1905, pp. 42–43) and has since been universally accepted (e.g., Berenson, 1932, p. 299 and later editions; Van Marle, *Development*, vol. 9, 1927, pp. 145–48; Pudelko, "The Stylistic Development of Lorenzo Monaco—I," *Burlington Magazine*, 73, 1938, p. 248; Bellosi, *Lorenzo Monaco*, 1965; González-Palacios, "Indagini su Lorenzo Monaco," *Paragone*, 241, 1970, pp. 33–36; and Boskovits, *Pittura fiorentina alla vigilia del Rinascimento*, 1975, p. 350). A dating

ca. 1405 proposed by Sirén is accepted by all authorities save Van Marle.

It is argued by González-Palacios that the panel formed the central pinnacle of an altarpiece of *The Virgin and Child between Saints Donnino and John the Baptist and Saints Peter and Anthony the Abbot* of 1404 in the Museo della Collegiata at Empoli (Fig. 65), which retains two lateral pinnacles, with the Annunciatory Angel and Virgin Annunciate. The width at the top of the Empoli Madonna is 43.5 cm., and the width of the present panel with its lateral framing elements is 41.6 cm. The pilasters which frame the panel are closely similar to the pilasters superimposed on spiral columns that flank the central panel of the Empoli altarpiece. There is no precise correspondence between the tooling of the haloes in the altarpiece and in the present panel, but this does not necessarily invalidate González-Palacios's proposal, since the same discrepancy occurs in the Monteoliveto altarpiece. An earlier attempt by Sirén (op. cit., p. 39) to identify a Man of Sorrows in the Accademia Carrara at Bergamo as the central pinnacle of the Empoli altarpiece is rejected by Pudelko (op. cit., p. 242, n. 24) and is manifestly incorrect. The style of the present panel is closely related to that of the panels at Empoli, and it probably originates from the same complex. The cartoon of the Christ recalls that of the *Crucified Christ with Saints Benedict, Francis and Romuald* of about 1404 in the Lindenau Museum at Altenburg.

Bellosi (loc. cit.) notes that the diminutive size of the Christ in the present panel in relation to the figures of the Virgin and Saint John invests it with the character of a devotional image presented by them to the spectator. Berenson ("Due illustratori italiani dello Speculum Humanae Salvationis," *Bollettino d'arte*, 5, 1925–26, pp. 300–301) cites this as the earliest Crucifixion in which the artist "abbia deliberatamente disposte per terra le due figure, con intenzione drammatica, e non già perchè gli mancava spazio da tenerle in piedi."

CONDITION: The paint surface is extremely well preserved. Pinpoint flaking across the face of Saint John has been lightly brushed over with a false craquelure added, but no significant abrasion is apparent in any part of the panel. A vertical crack runs down the panel from a point to the left of the superscription through the Virgin's knee.

PROVENANCE: Bardini, Florence (*Catalogue of . . . Pictures and other Works of Art . . . the Property of Signor Stephano Bardini of Florence*, Christie's, London, May 30, 1902, no. 627, as Spinello Aretino; bt. Frank Loeser, Florence. Acquired by Robert Lehman in 1958.

EXHIBITED: Cincinnati Art Museum, *The Lehman Collection*, 1959, no. 64.

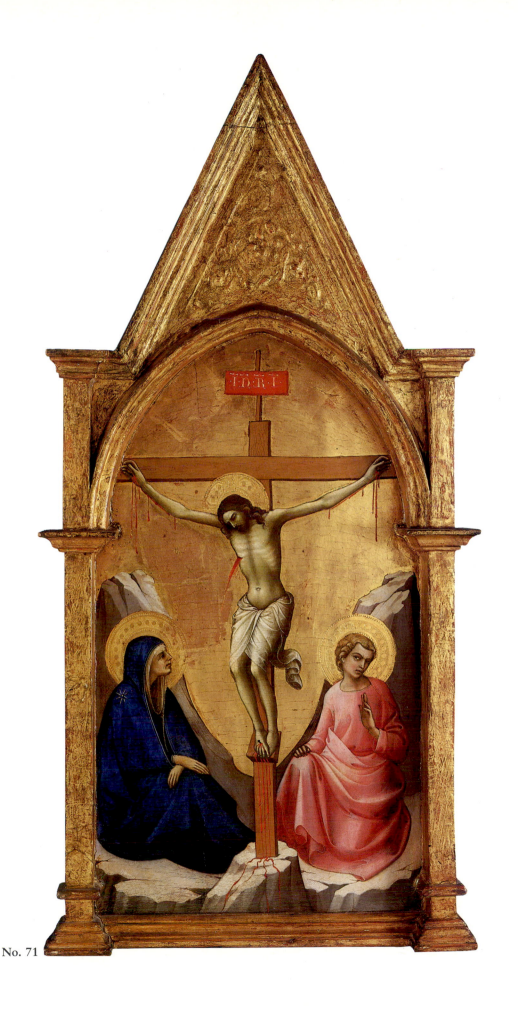

No. 71

72. The Nativity

1975.1.66

Tempera on panel. 21.4 × 31.2 cm. (8¾ × 12¼ in.). A strip
of wood 7 mm. wide has been added on the right. This was
removed from the left side of the panel when the predella
was dismembered, and was inverted and reattached at the
right. The panel, which is 16 mm. thick, has been thinned
but not cradled, and has a horizontal grain. The upper edge
of the panel is original, while the bottom edge has been re-
duced by approximately 12 mm.

In the center of the quatrefoil panel is the stable, the roof
of which rests on two thin forward supports. The manger,
behind which appear the heads of the ox (right) and the
ass (left), is set parallel to the picture plane and central-
ized; in front of it, surrounded by gold rays, lies the Child
Christ. Behind the forward support of the stable (left)
kneels the Virgin, with hands clasped, gazing at the Child.
Above her head is a glory of angels. Outside the stable
(right) sits Saint Joseph with his back turned, looking up
at the heavenly vision. The Virgin wears a pale blue cloak
lined with pale green over a violet-blue dress, and Saint
Joseph has a pink cloak over a yellow tunic. Above (right)
are two shepherds dazzled by the radiance of the Annuncia-
tory Angel. The forward plane (center and left) is broken
by rocky clefts. Light falls on the upper surfaces of four
rocky hills (left) and the foliage of adjacent trees.

The panel is associated by Frizzoni ("Ricordo di un vi-
aggio artistico oltralpe: La galleria Kaufmann in Berlino,"
L'arte, 5, 1902, pp. 291–92) and Sirén (Don Lorenzo
Monaco, 1905, pp. 56–57) with panels of the Visitation
and Adoration of the Magi in the collection of Sir Hubert
Parry at Highnam Court, Gloucester, and of the Flight into
Egypt in the Lindenau Museum at Altenburg (Figs. 66–
68). The Parry panels are now in the Courtauld Institute
Gallery, London. The interconnection of the four panels
has been universally accepted (e.g., by Balniel and Clark,
A Commemorative Catalogue of the Exhibition of Italian
Art at Burlington House, 1930, p. 18, no. 49; L. Venturi,
Pitture italiane in America, 1931, pl. 143; R. Oertel,
Frühe italienische Malerei in Altenburg, 1961, pp. 131–
32, no. 90). The two panels in the Courtauld Institute
Gallery certainly formed part of the same predella as the
present scene, and they have been similarly cut down on
all four sides. In the panel at Altenburg the frame has been
made up, only the central angle at the base and the right
lower lobe being original; the haloes have been regilt, cov-
ering an inner punched circle like that in the other scenes.
Though the colors of the robes of the Virgin and Saint
Joseph differ from those in the present scene, the Alten-
burg panel seems to originate from the same predella.

The present panel is regarded by Berenson (1899,
p. 119) as an early work, and a dating about 1405–10 is
accepted by Pudelko ("The Stylistic Development of Lo-
renzo Monaco—II," Burlington Magazine, 74, 1939, p. 77),
L. Venturi (loc. cit.), Vavalà ("Early Italian Paintings in
the Collection of Frank Channing Smith, Jr.," Worcester
Art Museum Annual, 3, 1937–38, pp. 34–38), Oertel
(loc. cit.), Bellosi (Lorenzo Monaco, 1965), and Bosko-
vits (Pittura fiorentina alla vigilia del Rinascimento,
1975, p. 350). A late dating proposed by Van Marle (De-
velopment, vol. 9, 1927, pp. 150, n., 166–68) is untenable.
It is demonstrated by Vavalà (loc. cit.) on compositional
grounds that the present panel is earlier than the predella
panel of the Nativity in the Uffizi Coronation of the Virgin
of 1413 and is considerably earlier than the correspond-
ing scenes in the predella of the Santa Trinita Annunci-
ation. A close parallel for the bright, clear palette and the
fluid but not yet calligraphic draftsmanship of the present
panel and its companion panels in London and Altenburg
is provided by the small tabernacle of the Agony in the
Garden, the Resurrection, and the Three Marys at the
Tomb, dated 1408, now divided between the Galerie
Národni, Prague, and the Musée du Louvre, Paris.

It was tentatively suggested by Sirén (loc. cit.) that this
predella might have formed part of an altarpiece of the
Annunciation with Four Saints from the Badia, now in the
Accademia, Florence (no. 8458). A similar sequence of
scenes appears in the predella of the later Annunciation
by Lorenzo Monaco in Santa Trinita. The width of the
Accademia altarpiece would, however, necessitate the
presence in the predella of a fifth panel, and the style of
the central Annunciation, which must postdate 1413, is
not fully congruent with that of the predella. Possibly the
predella originated from the Madonna and Child En-
throned with Four Saints from the Camaldolese abbey of
Monte Oliveto, now in the Uffizi, commissioned from Lo-
renzo Monaco in 1406 and completed by 1410. The style
of the spandrels and pinnacles from this altarpiece, show-
ing two prophets, the Annunciation, and the Salvator
Mundi, corresponds closely to that of the predella.

The most perceptive account of this beautiful panel is
that of Vavalà (loc. cit.):

There is no more perfect example of Lorenzo at his best
performance. He works, as ever, when on this scale,
with an enchanted brush. There are, as it were, two col-
our ranges. The background of night effect and rela-

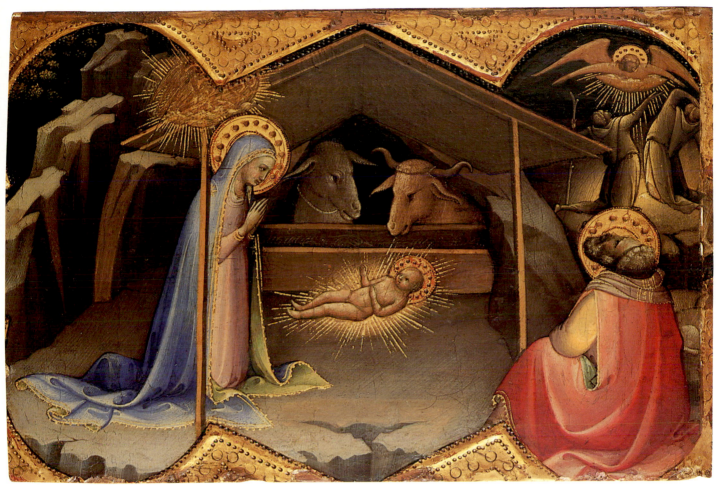

No. 72

tively neutral tones take in the gilded, moonlit figures of the shepherds and the angel, the fantastic woodland of giant step-like rocks, and the trees lightly touched on the left. Between these episodes the pent-roofed shed comes admirably into tangency with the point of the Gothic frame. The neutral zone of foreground, a rocky crevassed platform, belongs to this basic plane of colour. Before it, in an amazingly startling colour contrast, are the exquisitely tinted figures of Mary, with her lilac and blue dress, and Joseph in a rose-red cloak with, between them, the rayed form of the recumbent, resplendent Babe. This is Lorenzo's most characteristic method. The very disassociation between near and far in the colour scheme helps to enhance the effect of the calligraphic, ringing line, which is, at the same time, studied and casual—studied in its relation to the sought-after, Gothic total effect, and casual, in fact arbitrary, in its relation to the things represented. Mary's figure is borne like a stem on the floating base of her drapery. . . . This is the free, rampant linearity with which a Lorenzo Monaco or a Botticelli wove continual and never-failing enchantments.

CONDITION: The paint surface is well preserved, but has suffered some abrasion, especially in the body of the Child and in the figure of Saint Joseph, whose yellow sleeve and head have been reinforced. The gilding of the surround has been in part overpainted along the top but is well preserved at the base and on the right side.

PROVENANCE: Perhaps identical with a painting in the James Dennistoun sale, Christie's, June 14, 1855, lot 14 ("Don Lorenzo Monaco, the Nativity: the Virgin kneeling, Saint Joseph seated on the ground, the Infant in a manger, the shepherds and angels above. From the collection of M. Lauriani, Librarian at the Vatican"). The Dennistoun panel reappears in the sale of the Rev. Walter Davenport Bromley, Christie's, June 12–13, 1863, lot 46 ("Andrea Orcagna, The Virgin kneeling before the Infant in a cradle; on the right is Saint Joseph seated asleep, two figures in the background. This agrees with a picture by the same Master in the National Gallery [573]. From the collection of Mr. Dennistoun"). The Dennistoun sale included as no. 9 two panels of the Visitation and Adoration of the Magi ascribed to Taddeo Gaddi, which also appear as nos. 14 and 15 in the Davenport Bromley sale with an attribution to Giottino. These are identical with the related panels by Lorenzo Monaco in the Courtauld Institute Gallery. Richard von Kaufmann, Berlin (*Die Sammlung Richard von Kaufmann, Berlin*, Cassirer and Helbing, Berlin, December 4, 1917, no. 5); Frank Channing Smith, Jr., Worcester (Mass.), from 1921. Acquired by Robert Lehman in 1934.

EXHIBITED: Fogg Art Museum, Harvard University, Cambridge (Mass.), 1927; Smith College Museum of Art, Northampton (Mass.), 1932; Worcester Art Museum, 1933; Berkshire Museum, Pittsfield (Mass.), 1935; Cleveland Museum of Art, *The Twentieth Anniversary Exhibition of the Cleveland Museum of Art*, 1936, no. 134; Fogg Art Museum, Harvard University, Cambridge (Mass.), *An Exhibition of Italian Paintings and Drawings*, 1939, no. 29; Museum of Fine Arts, Boston, *Art in New England: Paintings, Drawings, and Prints from Private Collections in New England*, 1939, no. 71; Musée de l'Orangerie, Paris, *La collection Lehman*, 1957, no. 28; Cincinnati Art Museum, *The Lehman Collection*, 1959, no. 65.

Bicci di Lorenzo

Son of the painter Lorenzo di Bicci, Bicci di Lorenzo was born in Florence in 1373. He was enrolled in the guild of the Medici e Speziali before 1408, and in the Compagnia di San Luca in 1424. Bicci di Lorenzo's earliest dated painting, an altarpiece of 1414 at Stia in the Casentino, proves him to have been a conservative imitator of his father's Late Gothic style. In the second half of the 1420s he came increasingly under the influence of Gentile da Fabriano and of Masolino. Bicci di Lorenzo and his son, Neri di Bicci (Nos. 76, 77), were both highly prolific painters. The number and importance of the commissions they received testifies to the continuance of a conservative trend in Florentine painting in the second and third quarters of the fifteenth century. Bicci di Lorenzo died in May 1452 and was buried in the church of the Carmine in Florence.

73. Saints John the Baptist and Matthew

1975.1.68

Tempera on panel. 123.5 × 73.7 cm. (48⅝ × 29 in.) excluding added strips at bottom and sides. The panel, which has a vertical grain, has been thinned to a depth of 7 mm. and cradled.

The two saints, each under an ogival arch, stand on an elaborately patterned gold carpet. The Baptist, who wears a gold-edged cloak over his hair shirt, points with the index finger of his right hand to a cross held in his left, in which he also holds a scroll with the words ECCE.AGN. Saint Matthew, shown writing in a volume of the Gospels, has a gray beard and tufts of gray hair over his forehead and behind his head. He wears a dress covered by an ample gold-edged cloak.

This fine panel is identified by Zeri ("Una precisazione su Bicci di Lorenzo," *Paragone*, vol. 9, no. 105, 1958, pp. 67–71) as part of an altarpiece painted by Bicci di Lorenzo for the Florentine church of San Niccolò in Caffaggio (destroyed 1787), of which a second lateral panel with Saints Benedict and Nicholas in the abbey at Grottaferrata and a *Virgin and Child Enthroned with Four Angels* (Fig. 69) in the Pinacoteca Nazionale at Parma also formed part. The primary source for identification of the altarpiece is Richa (*Notizie istoriche delle chiese fiorentine*, 7, 1758, p. 35), who describes in the church of San Niccolò in Via del Cocomero, also known as San Niccolò in Caffaggio, "una porta di buon disegno, sopra la quale in una lunetta dell'Arco avvi un S. Niccolò a fresco di mano di Lorenzo di Bicci, siccome del medesimo Pittore è il quadro nella testata della Tribuna dipinto sull'asse, e che rappresenta Maria col suo Bambino, ed a' lati i Santi Gio: Batista, Matteo, Niccolò, e Benedetto."

The central panel of this altarpiece has long been identified with the Madonna at Parma, which has on the reverse a label with the words "Lorenzo di Bicci—Fu nella Chiesa delle soppresse Monache di San Niccolò—Acquistato in Firenze nel 1787." The design closely follows that of Gentile da Fabriano's Quaratesi altarpiece, which was painted in 1425 for San Niccolò oltr'Arno. Salmi (*Enciclopedia italiana*, vol. 6, 1930, p. 973) wrongly identified the missing laterals to the Parma Madonna with the *Saints Thomas, John the Baptist, James, and Nicholas of Bari* in the Pinacoteca Stuard, Parma (cf. G. Copertini, *La Pinacoteca Stuard di Parma*, 1926, nos. 5, 6). This identification was generally accepted (A. O. Quintavalle, *La Regia Galleria di Parma*, 1939, pp. 167–70; idem., *Mostra Parmense di dipinti noti ed ignoti dal XIV al XVIII secolo*, 1948, pp. 30–31, no. 54) until Zeri (loc. cit.) demonstrated the iconographic and stylistic reasons for associating the Lehman and Grottaferrata panels with the San Niccolò altarpiece. It is established by Zeri that five predella panels, in the Ashmolean Museum, Oxford, the Metropolitan Museum of Art, the Wawel Museum, Cracow, and a New York private collection, three of which are variants of panels in the predella of Gentile's altarpiece, also formed part of the San Niccolò in Caffaggio painting. There is some doubt whether the right-hand saint in the present panel represents Saint Matthew, as Richa states, or Saint John the Evangelist.

The central panel in Parma is inscribed with the date 1433, and a document published by Cohn ("Maestri sconosciuti del Quattrocento fiorentino," *Bollettino d'arte*, 44, 1959, pp. 61–68) proves that payment for the altarpiece was made jointly to Bicci di Lorenzo and his "chonpagno" Stefano d'Antonio. It is inferred by Cohn, almost certainly correctly, that the lateral panel at Grottaferrata, which is inferior in quality to the present panel, is due to Stefano d'Antonio (see also Padoa Rizzo and Frosinini, "Stefano d'Antonio di Vanni," *Antichità viva*, 23, 1984, pp. 5–33). The altarpiece was valued on completion by Fra Angelico and Rossello di Jacopo Franchi, and was assessed at 186 florins and 18 soldi.

CONDITION: The paint surface is remarkably well preserved, with minimal losses from abrasion or flaking. Two vertical cracks, from the top of the panel through the right side of the Baptist's head to his extended index finger, and from the base of the panel through the Baptist's left foot to the hem of his red

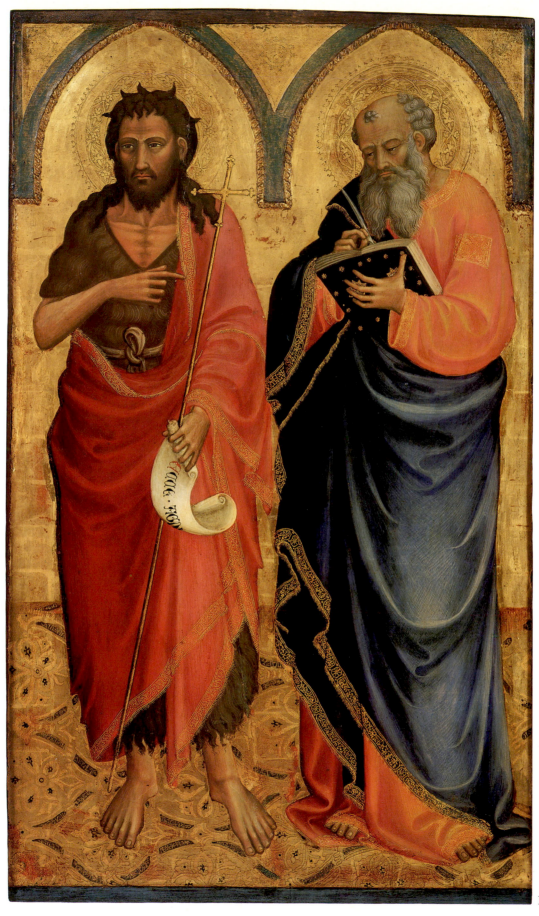

garment, have resulted in some local paint loss. Infrared reflectography reveals the presence of extensive and free underdrawing beneath the paint surface. The spandrels and the rope moldings are original, but have been repainted or regilt.

PROVENANCE: San Niccolò in Caffaggio, Florence, till 1787; Marchese Tacoli Canacci, Parma (with the corresponding panel now at Grottaferrata, for which see J. Bocalosi, *Catalogue raisonné de plusieurs excellents tableaux des plus célèbres écoles d'Italie, de Flandre . . . qui existent dans un receuil appartenant au Marquis de Tacoli Canacci*, Parma, 1796, p. 88, nos. 434, 435, as Lorenzo di Bicci); Marchese Coccapani, Modena (R. Lehman, 1928, no. 8, unconfirmed); Marchese Menafoglio (Lehman, loc. cit., also unconfirmed); Pietro Foresti da Carpi till 1913 (*Catalogue de la galerie et du musée appartenants à Mr. le chevalier (Pietro) Foresti da Carpi*, Palazzo Cova, Milan, May 12–17, 1913, no. 176, as Spinello Aretino); E. Hutton, London. Acquired by Philip Lehman before 1928.

EXHIBITED: Cincinnati Art Museum, *The Lehman Collection*, 1959, no. 66.

Fra Filippo Lippi

One of the greatest Florentine painters of the middle of the fifteenth century, Lippi was born ca. 1406. His career can be traced with some confidence from his beginnings at the church of the Carmine in Florence to the mid-1460s, when he completed his masterpiece, the frescoes in the choir of the cathedral at Prato. From the late 1440s on, Lippi made extensive use of studio assistants in executing his cartoons, and in old age—especially in his last work, a fresco cycle in the Duomo at Spoleto—this practice increased. Attempts, in large part unsuccessful, have been made to isolate the personalities of individual assistants; this problem is bound up with the two panels discussed below. Lippi died in 1469 and is buried in Spoleto.

Workshop of Fra Filippo Lippi

74. Saint Bernard of Clairvaux

1975.1.70 B

Tempera on panel. 48.2 × 12.6 cm. (19 × 4¹⁵⁄₁₆ in.). The panel has been thinned to a depth of 17 mm. but has not been cradled.

The saint, depicted in full-length in a white Cistercian habit, is turned to the left. He stands on a pink marble platform before a rounded niche in a violet wall. His right hand rests on a green book supported on his left forearm. Twisted round his left hand is a leash attached to the collar of a small dragon. On the front face of the platform is a variegated marble insert, cropped at the bottom of the panel.

This and the following panel form part of a group of eighteen panels purchased in Italy by Sir John Leslie. The complete series was exhibited at the Royal Academy, London, in 1885 (*Works by the Old Masters, Winter Exhibition*, nos. 252, 256, two frames each containing nine panels). The figures were then attributed to Filippino Lippi and were stated to have come from the church of the Carmine in Florence. Sold at auction in 1926 with other paintings from the Leslie collection (Christie's, London, July 9, 1926, lot 129), they were described as "Our Saviour with the twelve Apostles and other Saints: a group of eighteen small full-length figures in two frames" and were again stated to have been "at one time in the Church of the Carmine, Florence." The purchaser at auction is named as Buckley. By the autumn of 1926 all eighteen panels appear to have been owned by Viscount Lee of Fareham, who retained four of them in his own collection.

These are now in the Courtauld Institute Gallery, London, and represent Saint Dominic, Saint Peter, Saint James the Less (?), and a Female Saint with a Flail (Figs. 71–74). Two further panels, of Saint Catherine of Alexandria and an unidentified saint, were sold in October 1926 through Langton Douglas to T. T. Ellis, Worcester (Mass.), and are now in the Worcester Art Museum (Theodore T. and Mary G. Ellis collection; for these see M. Davies, *European Paintings in the Collection of the Worcester Art Museum*, 1974, pp. 377–79, nos. 1940.37A, 37B). Four panels from the series were purchased in 1928 by Robert Lehman. Two of these (Figs. 75, 76) were subsequently sold by him to Arthur Lehman, and were bequeathed in 1965 to the Fogg Art Museum (see C. Virch, *The Adèle and Arthur Lehman Collection*, 1965, pp. 30–32, where the saints are conjecturally identified as John the Evangelist and Nicholas of Bari); the present panels were retained in the Robert Lehman Collection. Six panels (for which see Shapley, *Paintings from the Samuel H. Kress Collection: Italian Schools XIII–XV Century*, 1966, p. 109) were sold through Contini-Bonacossi, Florence, to the Samuel H. Kress collection and are now in the Honolulu Academy of Arts (no. K. 441A, B, C, D, *Four Unidentified Saints*, Figs. 77, 78) and the University of Georgia, Athens (no. K. 503A, B, *Two Unidentified Saints*). The two outstanding panels appeared at auction in London (Sotheby's, July 3, 1985, lots 6, 7), where they were presumed to represent Saint John the Evangelist and a female saint with a martyr's palm. All eighteen panels are reproduced from photographs made before their sale in 1926 by Pittaluga (*Filippo Lippi*, 1959, figs. 170, 171). They show eighteen saints lit uniformly from the left. No figure of Christ is included. The saints represented include the founders of two religious orders—Saint Dominic and Saint Bernard—but no Carmelite saint.

There is no means of establishing the purpose that the panels originally served. They were regarded by Van Marle (*Development*, vol. 10, 1928, p. 578) and Langton Douglas ("Photographic Evidence," *Burlington Magazine*, 60, 1932, pp. 287–88) as parts of a *dossale* or antependium designed for the Compagnia dei Preti della Santissima Trinita at Pistoia, the altarpiece for which was executed by Pesellino and Fra Filippo Lippi and is now in the National Gallery, London (for the relevant documents see P. Bacci, "La 'Trinità' del Pesellino della National Gallery di Londra [Nuovi documenti]," *Rivista d'arte*, 2, 1904, pp. 172–74). The antependium to this altarpiece was later conclusively identified by Bacci (in *Le arti*, 3, 1941, pp. 432f.)

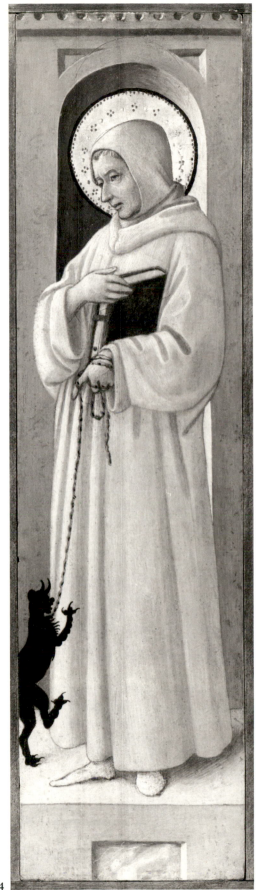

No. 74

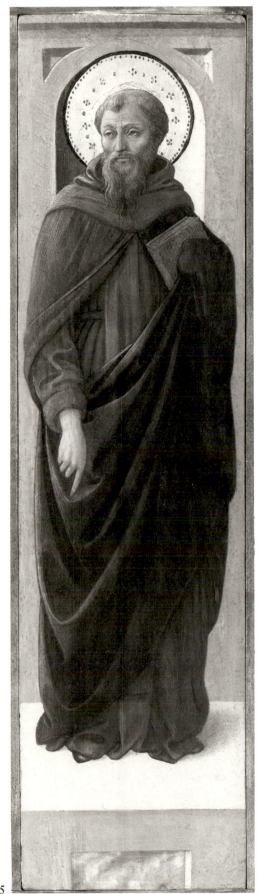

No. 75

with a Madonna of Mercy now in the Staatliche Museen, Berlin-Dahlem. The eighteen panels of saints are unlikely to have been connected with this commission.

The present panels, as well as a number of the related figures, have sustained damage along the sides, which would be explicable if they had been removed from an engaged frame. The fact that the wood graining throughout is vertical would suggest that they were disposed vertically as pilasters and not horizontally in a predella. There are substantial differences between the sixteen known panels in the projection of the wall behind each saint, and the marble inserts on the front faces of the steps also vary both in height and width. The wide insert in No. 75 corresponds with that of a panel in Honolulu (acc. no. K. 441D), and the narrow insert in No. 74 corresponds with that of a panel at Athens, Georgia (acc. no. K. 503B). In one panel, in Honolulu, the wall behind is crowned by a dentillated molding, of which traces survive along the upper edge of No. 74. The height of the sixteen known panels has been reduced. Though presently they vary only between 48.2 and 48.6 cm., in their original form the painted area in each panel seems to have extended to 52–53 cm. The late altarpieces by or from the workshop of Fra Filippo Lippi vary in height from 187 cm. (*Madonna del Ceppo*, Galleria Comunale, Prato) to 203 cm. (*Annunciation*, Alte Pinakothek, Munich). If the panels were originally double pilasters, with four superimposed panels on each side of the plane of the altarpiece and four superimposed panels on each side at right angles to them, this would account for the placing of only sixteen of the eighteen panels. The possibility that the figures decorated a sacristy cupboard must be borne in mind.

The eighteen panels are attributed by Van Marle (loc. cit.) to Fra Filippo Lippi; by Langton Douglas (loc. cit.) to Fra Filippo Lippi and his workshop; by Berenson initially (1936, p. 248) to the school of Fra Filippo Lippi, and later (1963, vol. I, p. 59) to Fra Diamante; by Pudelko ("Per la datazione delle opere di Fra Filippo Lippi," *Rivista d'arte*, 18, 1936, p. 56) to the workshop of Fra Filippo Lippi, in part to the so-called Scolaro di Prato; and by Pittaluga (op. cit., pp. 207, 211, 215) in part to Lippi's assistant Fra Diamante and in part to his workshop. An attribution to Fra Diamante is accepted for the Kress panels by Shapley (loc. cit.) on the basis of a reconstruction of Fra Diamante's artistic personality by Pittaluga ("Fra Diamante collaboratore di Fra Filippo Lippi," *Rivista d'arte*, 23, 1941, pp. 29–46), which is, however, of doubtful validity. The figures in the series appear to have been executed by at least three different hands, and the best of them may derive from drawings by Fra Filippo Lippi. The present panels

are perhaps the most distinguished of the entire series, but the hand responsible for them cannot be identified.

CONDITION: Extensive losses round the edges of the panel have been inpainted. There is some local retouching in the face, the right sleeve, and the lower part of the saint's habit. The dragon is severely damaged, and only the front of its face and chest and the two raised claws are original.

PROVENANCE: Carmine, Florence (unconfirmed); Sir John Leslie before 1885; Leslie collection (sale, Christie's, London, July 9, 1926, lot 129, bt. Buckley); Viscount Lee of Fareham; R. Langton Douglas, London. Acquired by Robert Lehman in November 1928.

EXHIBITED: Royal Academy, London, *Works by the Old Masters, Winter Exhibition*, 1885, nos. 252, 256; Fogg Art Museum, Harvard University, Cambridge (Mass.), 1931; Cincinnati Art Museum, *The Lehman Collection*, 1959, no. 72.

75. Unidentified Male Saint

1975.1.70 A

Tempera on panel. 48.2 × 12.6 cm. (19 × 4⁵⁄₁₆ in.). The panel, with a vertical wood grain, has been thinned to a depth of 18 mm. but is not cradled.

The panel shows the full-length figure of a bearded saint dressed in a gray cloak over a brown habit. He stands on a pink platform before a rounded niche with recessed spandrels. His left shoulder is retracted, and he looks outward to his right, pointing downward with his right hand. He holds a book in his left arm. On the front face of the platform is a variegated marble inset cropped at the bottom of the panel.

See No. 74.

CONDITION: Losses round the edges of the panel have been inpainted. The figure of the saint is well preserved, but the architectural setting has been reinforced.

PROVENANCE: See No. 74.

EXHIBITED: See No. 74.

Neri di Bicci

Born in 1419, Neri di Bicci was trained by his father, Bicci di Lorenzo, and seems to have been active as an independent painter from 1444. His workshop became one of the largest and most productive in Florence, and his *Ricordanze* (*Neri di Bicci: Le Ricordanze*, ed. Bruno Santi, 1976) permit a reconstruction of the many heterogeneous activities undertaken in his studio and of the public for which he worked. An innocent and appealing artist, Neri di Bicci painted not only, as his style might suggest, for the *piccola borghesia* in Florence and for provincial churches but also for the *alta borghesia* of the Florentine guilds and for members of prominent Florentine families. He died in 1491. The paintings discussed below are typical products of Neri di Bicci's shop.

76. The Archangel Raphael and Tobias

1975.1.71

Tempera on panel with original engaged frame. Overall: 30.1 × 23 cm. (11⅞ × 9¹⁄₁₆ in.); paint surface: 26.2 × 19 cm. (10⁵⁄₁₆ × 7⁷⁄₁₆ in.). The panel is 24 mm. thick. On the back is a painted sunburst with the monogram of the holy name, YHS, in yellow on a brown ground.

The Archangel, shown walking to the left, holds a gold box in his right hand. His head is turned back, and he looks down at Tobias, to the right, whom he leads with his left hand. He wears a yellow robe trimmed with gold and a red fur-lined cloak. Tobias, whose head is surrounded by rays and who holds a golden fish in his left hand, wears a blue tunic trimmed with fur and a red, yellow-lined cloak. Behind is an open landscape and in the foreground a small white dog.

The subject of the Archangel Raphael and Tobias enjoyed great popularity in Florence after about 1465 (for this see G. M. Achenbach, "The Iconography of Tobias and the Angel in Florentine Paintings of the Renaissance," *Marsyas*, 3, 1946, pp. 71–86, and E. H. Gombrich, *Symbolic Images: Studies in the Art of the Renaissance*, 1972, pp. 26–30), giving rise to altarpieces like that by Francesco Botticini in the Uffizi, which shows the Archangel Raphael with Tobias between the Archangels Michael and Gabriel, and large votive panels like that of the Archangel Raphael with Tobias by Piero del Pollaiuolo in the Pinacoteca Sabauda, Turin. The Uffizi altarpiece was painted for the altar of Il Raffa (a society dedicated to the Archangel Raphael) in Santo Spirito, and the painting in Turin may be identical with a painting of the subject said by Vasari to have been painted for Or San Michele. Votive panels of

this type are known to have been produced in the workshop of Sellajo (Münster-in-Westfalen), and by local artists in the following of Baldovinetti (Santa Maria delle Grazie, San Giovanni Valdarno) and of Gozzoli. A high proportion of them are, however, due to Neri di Bicci, whose *Ricordanze* (*Neri di Bicci: Le Ricordanze [10 marzo 1453–24 aprile 1475]*, ed. Bruno Santi, 1976) record the commissioning on January 27, 1457, of "una chortina dentrovi l'angelo Rafaello e Tubia e uno fregio d'atorno" (no. 134); on October 3, 1460, of a large "cholmo apuntato, dentrovi dipinto l'angelo Rafaello e Tubia" (no. 297); on February 17, 1462, of an altarpiece for Santo Spirito with "nel mezo l'angelo Rafaello e Tubia e da lato l'angelo Santo Michele e da l'altro l'angelo Gabriello e nella predella istorie de l'angelo Rafaello" (no. 350); and on February 28, 1463, of an altar frontal with a figure of the Archangel Raphael and "dua Rafaegli gli dipinsi per le monache di Santo Ghagio" (no. 391). The last reference may well be to paintings of the class of those under review. The appearance of the sacred monogram with a sunburst on the back of No. 76, however, suggests that this was made for a Franciscan Observant community. The principal Raphael societies in Florence were Il Raffa (see above) and La Scala, which, as its name denotes, convened in the church of the Ospedale della Scala (for these see Monti, *Le Confraternite Medievali dell'Alta e Media Italia*, vol. 1, 1927, p. 183). Devotional paintings of the same type by or from the workshop of Neri di Bicci are recorded in the former Platt collection, Englewood (N.J., sale, Parke-Bernet, New York, January 9, 1947, lot 26; see Perkins, "Dipinti italiani nella raccolta Platt," *Rassegna d'arte*, 11, 1911, pp. 1–2); in the Kérészteny Muzeum, Esztergom (where the Archangel and Tobias are shown on the left and Saint Jerome on the right); at Christ Church, Oxford (where the three archangels are shown above and four saints below: see J. Byam Shaw, *Paintings by Old Masters at Christ Church, Oxford*, 1967, no. 34); and, on a somewhat larger scale, in a panel formerly in the Loeser collection (sale, Sotheby's, London, December 9, 1959, lot 33), where the Archangel and Tobias are shown with three small donors and a roundel of God the Father in the gable. The figures in the panel at Esztergom are based on the same cartoon as those in No. 77.

There is no reason to suppose that either this or No. 77 is necessarily autograph, since Neri di Bicci's *Ricordanze* list nineteen assistants to whom no works can be individually attributed.

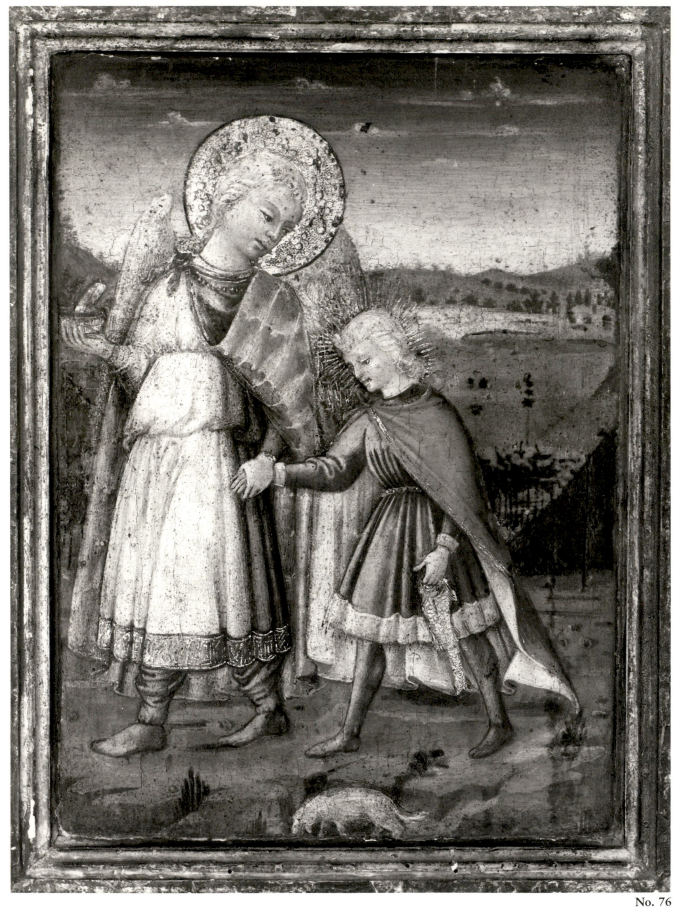

CONDITION: The paint is laid on in a rapid, coarse technique and has discolored where dirt has accumulated in the paint troughs. The surface is unevenly preserved. The chin, forehead, and hair of Tobias and the face of the archangel have been reinforced, and the fingers of the archangel's right hand and Tobias's left hand are modern. The box held by Raphael and the upper part of the fish have been regilt, and the mordant gilding throughout is false. The subsidiary parts of the picture are well preserved.

PROVENANCE: Bellini, Florence. Acquired by Robert Lehman in 1925.

EXHIBITED: Cincinnati Art Museum, *The Lehman Collection*, 1959, no. 71.

77. The Archangel Raphael and Tobias

1975.1.72

Tempera on panel. Overall: 19.6 × 14.7 cm. (7¹¹/₁₆ × 5¾ in.); paint surface: 18.7 × 14 cm. (7⅜ × 5½ in.). The panel is 11 mm. thick. The original moldings have been cut away, but the bearded edge of the paint surface is visible on all four sides. The back was originally painted in yellow and brown, but the paint has flaked extensively and the design is no longer legible.

The Archangel is shown walking to the left. He holds a gold box in his right hand. His head is turned back, and he looks down at Tobias, whom he leads with his left hand. He wears a red robe trimmed with fur, a blue cloak with a yellow lining, and blue boots, and he has red wings. Tobias, whose head is surrounded by rays, wears a blue fur-trimmed tunic with gold buttons over a red dress, and blue boots. He holds a fish in his left hand and is followed by a white dog. Behind the figures is a deep panoramic landscape. The sky is painted in two shades of blue and is broken up by gold and red stars and lines of cloud emitting golden rays.

See No. 76.

CONDITION: The paint surface, though covered by dense discolored varnish, is very well preserved. The profile of Tobias has been reinforced. The gold leaf of the archangel's halo is largely worn down to the gesso, as is the right profile of his face, but the mordant gilding of the stars and of the aureole of Tobias is substantially intact. A hole in the sky above the right wing of the archangel has been filled.

PROVENANCE: John Murray, Florence. Acquired by Robert Lehman in 1923.

EXHIBITED: Cincinnati Art Museum, *The Lehman Collection*, 1959, no. 70.

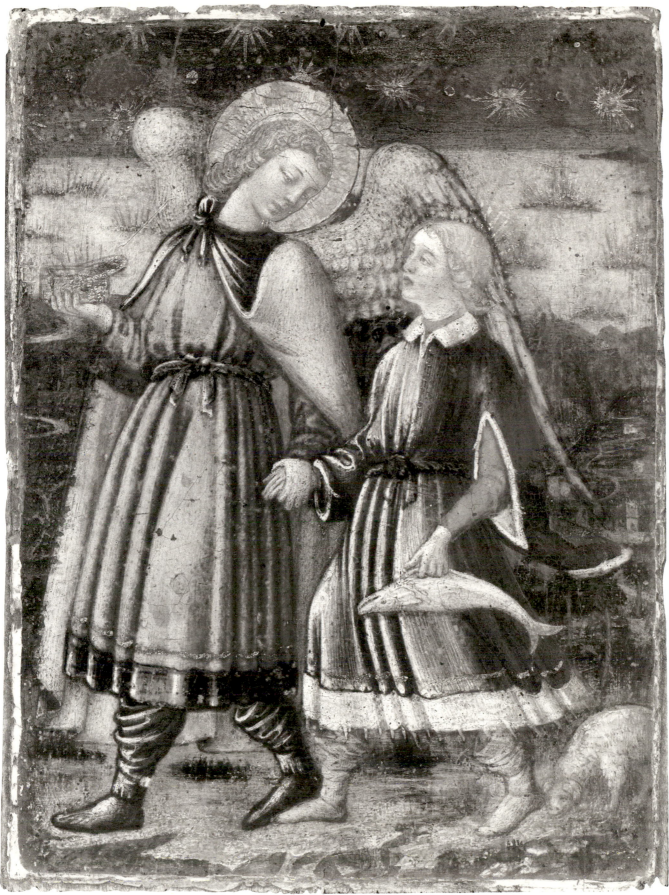

No. 77

Cosimo Rosselli

Born in 1439, Cosimo Rosselli is mentioned as a pupil of Neri di Bicci in that artist's *Ricordanze* between 1453 and 1455, and developed under the influence of Benozzo Gozzoli, Baldovinetti, and Domenico Ghirlandaio. In the 1470s and 1480s he painted a number of distinguished frescoes, in the Annunziata and Sant'Ambrogio in Florence and in the Sistine Chapel in Rome, but his late works, such as an altarpiece of 1492 in the Accademia, Florence, and a *Coronation of the Virgin* of ca. 1505 in Santa Maria Maddalena dei Pazzi, Florence, are stolid and conventional. These latter works provide a basis for study of the panel discussed below. The painter died in 1507.

78. Madonna and Child with the Young Saint John the Baptist

1975.1.73

Tempera and oil on panel. Overall: 45.2 × 36 cm. (19¹³/₁₆ × 14⅛ in.); paint surface: 43.8 × 34.3 cm. (17¼ × 13½ in.). The panel, which has a vertical grain, varies in thickness between 12 and 16 mm. It has not been thinned, but two horizontal grooves have been cut in the back with battens inserted to prevent warpage. These are much worm-eaten and may be original. The back is painted grayish white.

The Virgin is depicted in half-length, suckling the Child Christ, who lies on a green embroidered cushion on a gray ledge in the foreground with both hands on his mother's right breast. Posed in three-quarter face, she looks down at the Child. Beyond her shoulder on the left appears the young Baptist, wearing a hair shirt and with hands clasped in prayer. In the crook of his right arm he carries a tall reed cross, the top of which is silhouetted against the sky. Behind the Virgin is a woven cloth of honor, to the right of which is a tree-filled landscape backed by mountains. A rocky landscape appears behind the Baptist on the left.

After a period of hesitancy—the painting is categorized by R. Lehman (1928, pl. 12) as "not a thoroughly convincing" work of Cosimo Rosselli, was given by Perkins (verbally) to an anonymous Umbro-Roman artist of the early sixteenth century, and by De Nicola (verbally) to Bartolomeo di Giovanni—an unqualified attribution to Cosimo Rosselli was proposed by Berenson (1932, p. 492; 1963, vol. 1, p. 191). The types of the Virgin and the young Baptist find a close parallel in an altarpiece with the *Madonna and Child and the Young Baptist with Saints James and Peter* by Cosimo Rosselli in the Accademia, Florence, dated 1492, and the panel is likely to have been produced about this time.

The composition is framed by incised lines. At the left, these mark the limit of the paint surface, while the ledge and cloth of honor extend beyond the lines at the bottom and top. The right-hand margin is incised inside the picture field. Initially no provision was made for the inclusion of the Baptist in the painting. Infrared reflectography reveals that the black brocaded pattern of the cloth is complete beneath him, while the underdrawing for his figure does not encroach on the area of the Virgin's blue cloak. The insertion of the third figure is, however, due to Cosimo Rosselli.

CONDITION: The paint surface is abraded, and verdaccio priming is visible in the flesh parts. Repairs to the Virgin's right cheek and brow cover a scratch starting in her shoulder. The Child's legs and forehead have been reinforced to cover areas of abrasion rather than paint losses. The figure of the Baptist and the landscape at both sides are well preserved, and the gilding of the haloes is original.

PROVENANCE: R. Langton Douglas, London. Acquired by Philip Lehman before 1928.

EXHIBITED: Metropolitan Museum of Art, New York, 1942; Cincinnati Art Museum, *The Lehman Collection*, 1959, no. 77.

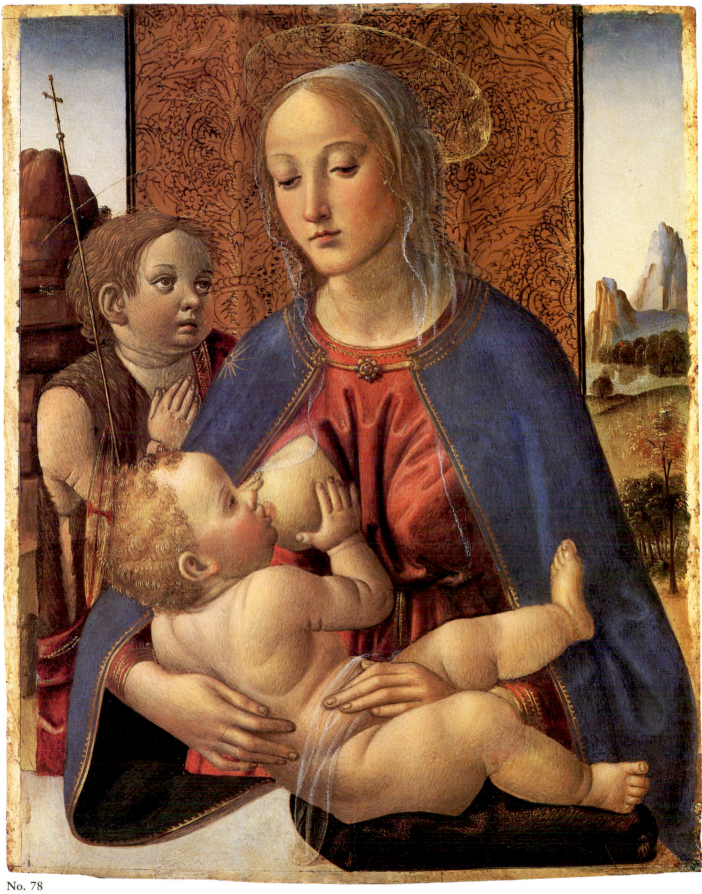

No. 78

185

Alunno di Benozzo

The highly characteristic works of the Alunno di Benozzo (so called from the presumption that he was a pupil of Benozzo Gozzoli) or the Maestro Esiguo (so called from the thinness of the figures in a number of his panels) were first isolated in the 1930s. The panels can be dated only by reference to their relationship to dated paintings by Benozzo Gozzoli (1420–97). There is no corroboratory evidence for the theory that the painter was Gozzoli's son, Alessio di Benozzo, but it is reasonably certain that he was a member of Gozzoli's shop.

79. The Annunciation

1975.1.77

Tempera on panel. Overall: 41.3 × 37 cm. (16¼ × 14⁹⁄₁₆ in.); paint surface: 40.6 × 36 cm. (16 × 14⅛ in.). The panel, which has a depth of 25 mm., is composed of two pieces of wood with a vertical grain joined 13.4 cm. from the right edge. The panel has been cut on all four sides, but the paint surface has not been reduced.

The scene takes place in a monastic cloister, with a colonnade and doorway on the right and an arcade behind. Over the cloister roof appears the upper story of a conventual building, with, at the back, three cypresses outlined against a cloudy sky. The floor is tiled. The angel (*left*), wearing a green robe, kneels on the right knee with a spray of lilies in his right hand, and his left hand is extended toward the Virgin, who is represented in three-quarter face kneeling on a low platform set before an inlaid seat. She wears a blue cloak over a red dress. The dove is isolated against an archway to the right of center, and the hands of God the Father appear from a cloud in the upper left corner.

The panel, which was first published by Berenson ("Quadri senza casa," *Dedalo*, 12, 1932, p. 840; *Homeless Paintings of the Renaissance*, 1970, p. 19; 1963, vol. 1, p. 3, fig. 903), is a characteristic work by a follower of Benozzo Gozzoli described by Longhi as the Maestro Esiguo and by Berenson as the Alunno di Benozzo. In a panel by this artist of the *Lamentation over the Dead Christ* in the Coster collection, Florence, the type of the Magdalene kneeling behind the Virgin corresponds with the Virgin in the present painting, and in a panel of the *Adoration of the Magi* in Dresden the dress of a kneeling king recalls that of the Annunciatory Angel. The composition derives from the frescoed *Annunciation* by Benozzo Gozzoli over the Tabernacolo della Visitazione at Castelfiorentino. Berenson ("I disegni di Alunno di Benozzo," *Bollettino d'arte*, 11, 1931–32, p. 296) associates a drawing of the Annunciatory Angel (Florence, Uffizi, 136F)

with the present panel. The angel in the drawing, however, faces left.

The style practiced by the Alunno di Benozzo depends on works executed by Gozzoli in the 1470s and 1480s, notably on the frescoes at Castelfiorentino and the last Pisan works (*Meeting of Solomon and the Queen of Sheba* in the Campo Santo, *Crucifixion and Saints* in the Ospizio di Mendicità). His hand may be traced in two paintings on canvas which were sold from Gozzoli's studio in Pistoia at his death in 1497: the *Deposition* in the Museo Horne, Florence, and the *Resurrection of Lazarus* in the National Gallery of Art, Washington (see A. Chiapelli, "Di due ultimi lavori finora sconosciuti di Benozzo Gozzoli e della morte di lui secondo nuovi documenti pistoiesi," *Bollettino storico pistoiese*, 23, 1921, p. 83). The Alunno di Benozzo has been confused with a Pistoiese imitator of Gozzoli's style, Amadeo da Pistoia, author of a signed altarpiece formerly on the art market in Florence (W. Suida, *The Samuel H. Kress Collection of Paintings and Sculpture: Denver Art Museum*, 1954, p. 34; Laclotte, 1957, no. 1). Recently it has been suggested (A. Padoa Rizzo, "Note su un 'San Girolamo penitente' di Benozzo," *Antichità viva*, 19, 1980, 3, pp. 14–19) that the Alunno di Benozzo is to be identified with Benozzo's son Alessio di Benozzo (1473–1528). The present panel is likely to have been painted about 1480–1500.

As Coor observes ("The Original Aspect of a Painting of the Pietà in the Art Museum," *Record of the Art Museum, Princeton University*, 20, 1961, pp. 16–21), the numerous small-scale works by the Alunno di Benozzo were probably intended as independent devotional images rather than parts of larger complexes. The presence of the holy monogram YHS surrounded by a sunburst, in the form commonly associated with San Bernardino, above the doorway on the right in the present panel, suggests that it was executed for a Franciscan patron or community.

CONDITION: The paint surface is in a near-perfect state of preservation. A vertical split in the panel at the right has resulted in minimal paint loss in the area of the loggia. Minor losses in the background and in the angel's robe have been made good.

PROVENANCE: Von Bülow (on a label on the back: EX LIBRIS BERNHARD ERNST VON BULOW 1815–1879); Mr. and Mrs. A. E. Goodhart, New York, by 1925. Bequeathed to Robert Lehman in 1952.

EXHIBITED: Musée de l'Orangerie, Paris, *La collection Lehman*, 1957, no. 1 (as Amadeo de Pistoia); Cincinnati Art Museum, *The Lehman Collection*, 1959, no. 79 (as Master of the Goodhart *Annunciation*).

No. 79

Botticelli

Born in Florence in 1445, Alessandro di Mariano Filipepi, known in his lifetime and subsequently as Botticelli, was trained in the workshop of Fra Filippo Lippi. From 1470 until his death in 1510 he was one of the most highly regarded artists in Florence. He was a draftsman of the utmost sensibility, and his development can be followed in detail in dated or datable works between 1470 and 1500. Botticelli's work has been studied very thoroughly, though problems still arise from his early and late works and from the composition of his workshop, which may have remained active through the second decade of the sixteenth century.

80. The Annunciation

1975.1.74

Tempera on panel. 19.1 × 31.4 cm. (7½ × 12⅜ in.). The panel, of a horizontal wood grain, has been thinned and marouflaged into a second panel 24.2 × 36.8 cm. (9½ × 14½ in.) in size. A lip of gesso round the four edges of the original panel indicates that the paint surface has not been reduced in size.

The scene shows two chambers in the Virgin's house, divided from each other by a row of piers receding into depth to the right of center. On the left is a similar row of engaged piers. The composition is closed in the right foreground by a single pier. To the right, revealed by a white curtain drawn back and looped up on the central pier, is the Virgin kneeling in left profile on a wooden dais with a lectern covered with a veil in front of her. Two red-bound books, a circular box, and an inkstand appear on a ledge behind her. A doorway at the back gives access to her bedroom. In a passage on the left, closed at the back by a wall with two arched windows, is the figure of the Angel Gabriel, wearing a red dress and buff cloak. His wings cover most of the window on the left, and he holds a spray of lily in his left hand. From the doorway behind him descends a shower of golden rays.

This small but celebrated painting is generally and rightly accepted as an autograph work by Botticelli. There is no indication of the purpose for which it was made. It was believed by Ulmann (*Sandro Botticelli*, 1893, p. 81) to have formed part of the predella of the San Barnaba altarpiece, now in the Uffizi, Florence. This view was rejected by Mesnil ("Botticelli à Rome," *Rivista d'arte*, 3, 1905, pp. 122–23) on the conclusive grounds (i) that the Annunciation is represented in roundels in the main panel of the altarpiece, and (ii) that the lateral scenes in the predella, of which four are preserved in the Uffizi, relate not to the life of the Virgin but to the legends of the saints shown in the altarpiece. Though its size corresponds closely with the individual panels of the San Barnaba predella, it appears to have been painted as an independent devotional panel. It is, however, described as a predella panel in the latest edition of Berenson's lists (1963, vol. 1, p. 37).

The panel is one of a number of representations of the Annunciation by Botticelli or from his workshop: (i) a fresco painted for San Martino alla Scala (1481), in the Uffizi; (ii) an altarpiece in the Uffizi painted for Cestello (1489); (iii) a panel in the predella of the San Marco *Coronation of the Virgin* (1490) in the Uffizi; (iv) a small panel in the Hyde collection, Glens Falls (undated); (v) a panel from San Barnaba, Florence, in the Glasgow Art Gallery (undated, variously assigned to ca. 1493 and ca. 1500); (vi) a panel formerly in the Kaiser Friedrich Museum, Berlin; (vii) a panel formerly in the Graham collection (untraced); (viii) a panel in the Niedersächsische Landesgalerie, Hanover; and (ix) two roundels formerly in the Galleria Corsini, Florence. A group of the Annunciation (x) also appears in Botticelli's drawing for *Purgatorio*, Canto x in Dante's *Divina Commedia* (Kupferstichkabinett, Staatliche Museen, East Berlin). These paintings reveal substantial differences in the treatment of the scene. In (i) the angel flies down from the left and the Virgin is shown kneeling on the extreme right. In (ii) the angel is depicted kneeling and the Virgin, rising to her feet, stretches out her hands toward him. In (iii) the angel is depicted kneeling and the Virgin is seated on a low stool on the right. In (iv) the figures are shown in an elaborate architectural setting, the angel in the act of genuflection and the Virgin kneeling frontally with head turned in profile on the right. In (v) the angel and the Virgin are both depicted standing in an architectural setting of markedly different form. In (vi) the angel depends from that in the Cestello altarpiece. In (vii) the angel is about to genuflect and the Virgin is seated, while in (viii) both figures kneel, the Virgin in profile with bowed head. In (x) the angel stands and the Virgin kneels in a pose related to that in (viii).

The present panel has been variously dated ca. 1474 (Yashiro, *Sandro Botticelli*, 1929, p. 239, followed by L. Venturi, *Pitture italiane in America*, vol. 2, 1931, pl. 192; English edition, vol. 2, 1933, pl. 245); ca. 1480 (Bode, "Eine Verkündigung Botticellis in der Sammlung Huldschinsky zu Berlin," *Jahrbuch der königlich preuszischen Kunstsammlungen*, 27, 1906, pp. 247–48, and *Die Sammlung Oscar Huldschinsky*, 1909, p. 38); ca. 1485–

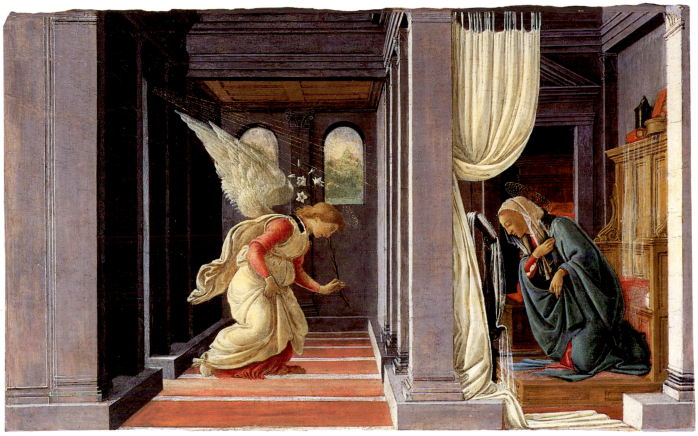

No. 80

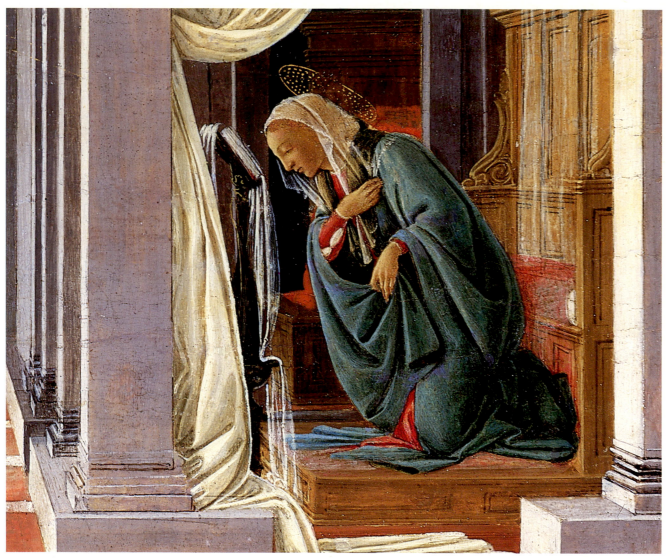

No. 80, detail

90 (Van Marle, *Development*, vol. 12, 1931, p. 148); ca. 1490 (Bode, *Sandro Botticelli*, 1921, pp. 158–59; 1925, p. 113, and *Botticelli*, in *Klassiker der Kunst*, 1926, pp. 44, 140; C. Gamba, *Botticelli*, 1937, p. 177; M. Laclotte, 1957, no. 5; G. Szabo, 1975, pp. 53–54); and after 1490 (F. Hartt, *Sandro Botticelli*, 1954, pl. 29; R. Salvini, *Tutta la pittura del Botticelli*, 1958, vol. 2, pp. 23, 49; English edition, 1965, vol. 3, pp. 110, 136; G. Mandel, *L'opera completa del Botticelli*, 1967, no. 121; English edition, 1967, no. 121; R. Olsen, *Studies in the Later Works of Sandro Botticelli*, Ph.D. diss., Princeton University, 1975, 1, pp. 20, 60, 402–404, 432, 444–45; S. Legouix, *Botticelli*, 1977, p. 77, no. 56; and R. Lightbown, *Sandro Botticelli*, 1978, vol. 1, p. 116, vol. 2, pp. 79–80, no. B69). Olsen mistakenly regards the panel as one of Botticelli's best preserved works.

On the basis of the figures alone the late dating adopted by most recent students is difficult to justify. Though the Virgin shows a general correspondence with that in the *Purgatorio* drawing, her pose is less tense and less compact than those that characterize Botticelli's work during the 1490s, and especially that in the Hanover *Annunciation* (viii), which was executed by a pupil from Botticelli's cartoon. The cursive treatment of the angel's robe is evidently earlier than that of the angel's robe in the San Marco *Annunciation* (iii). The probability, therefore, is that both figures date from after the frescoed *Annunciation* of 1481 (i) and from before the Cestello altarpiece (ii) and the San Marco predella panel (iii). In terms of figure style a date ca. 1485 is probable. The architecture differs from that of the Hyde *Annunciation* (iv) and the *Annunciation* at Glasgow (v), but finds a close analogy in the

predella of the Convertite altarpiece in the Johnson collection, Philadelphia Museum of Art, where two of the panels, *The Conversion of the Magdalene* and *The Last Communion of the Magdalene*, are punctuated in the foreground by rectangular piers closely similar to those in the present painting. The projection system (of which an analysis is provided by Kern, *Jahrbuch der königlich preuszischen Kunstsammlungen*, 27, 1906, pp. 247–48) also conforms to that of the Convertite predella. The light violet of the architecture has been reinforced locally, notably in the pier on the extreme left and along the upper face of the step beneath the receding piers on the same side and the upper molding in the center. The architectural forms are otherwise perfectly preserved. The Convertite altarpiece is not exactly datable, but seems to have been painted ca. 1485–90.

As always with Botticelli, the perspective structure of the architecture is incised in the priming and is visible beneath the paint surface. The only comparable paintings in which the structure has been fully analyzed are the Epstein tondo in the Chicago Art Institute (E. Fahy, "A Tondo by Sandro Botticelli," *Museum Studies*, Chicago, 4, 1969, pp. 14–25) and the Glasgow *Annunciation* (v), which penetrates more deeply into space and where the architectural forms are indebted to Giuliano da Sangallo. Kemp ("Botticelli's Glasgow 'Annunciation': Patterns of Instability," *Burlington Magazine*, 119, 1977, pp. 181–84) notes that in that panel, in the interests of expressiveness, the painted architecture deviates significantly from the incised scheme. There is no trace of any such distortion in the present panel. The symbolic light cast across the panel from a source above the angel on to the Virgin's face is, however, common to both paintings.

The early attributional history of the panel was governed by its condition prior to its cleaning about 1930. Morelli (*Kunstkritische Studien über italienische Malerei: Die Galerien Borghese und Doria Pamfili in Rom*, 1890, pp. 106–107; English edition, 1900, p. 83), followed by Plunkett (*Sandro Botticelli*, 1900, p. 117), regarded it as a poor product of Botticelli's school. It was rejected by Mesnil (op. cit.) as a school work, was ignored by Horne (*Sandro Botticelli*, 1908), and was dismissed as the work of a miniaturist by A. Venturi (*Botticelli*, 1925, p. 117; 1929, p. 103). It was first accepted as an autograph work by Ulmann (loc. cit.), and was so regarded by Bode (loc. cit.), Schmarsow (*Sandro del Botticelli*, 1923, pp. 98f.), Berenson ("An Annunciation by Botticelli," *Art in America*, 12, 1924, p. 188; 1963, p. 37), M. Friedländer ("Die Sammlung Oscar Huldschinsky," *Der Cicerone*, 20, 1928, p. 4), Yashiro (loc. cit.), Van Marle (loc. cit.), L. Venturi

(loc. cit.), Gamba (loc. cit.), Heinrich ("The Lehman Collection," *Bulletin of the Metropolitan Museum of Art*, 12, 1954, p. 220), Hartt (loc. cit.), Laclotte (loc. cit.), Salvini (loc. cit.; also *Encyclopedia of World Art*, vol. 2, 1960, p. 583), Mandel (loc. cit.), Olsen (loc. cit.), and Lightbown (loc. cit.).

CONDITION: The paint surface is well preserved despite local losses from abrasion. This affects chiefly the figure of the angel, the upper part of whose head has been largely reconstructed. There is some reinforcement of the angel's wings immediately above the shoulder; the right hand is modern, as is the front of the white dress and part of the cloak, and the halo is also new. The head, headdress, and hands of the Virgin are intact, save for a small area over the temple and forehead and for local retouching in the dress. The view through both windows is repainted. The architecture is well preserved, except for losses at the base of the central pier and along short horizontal cracks scattered through the panel. The gilding throughout has been reinforced. According to L. Venturi (loc. cit.), the painting was cleaned shortly before 1931. Information in the Lehman archive indicates that it was worked on once more in 1932. Reproductions of it in 1905 and 1906 show it before cleaning, in a partly overpainted state.

PROVENANCE: Palazzo Barberini, Rome. The Barberini inventories (for which see M. A. Lavin, *Seventeenth-Century Barberini Documents and Inventories of Art*, 1975, pp. 211, 357) list two panels of the Annunciation. One, in the inventory of Don Taddeo Barberini of 1648–49, no. 496, is considerably larger than the present painting, while the other, in that of Cardinal Francesco Barberini of 1679, no. 91, was "un quadretto in tavola con l'Annunciata con Cornici dorate," for which no dimensions are given. The panel is recorded in the second half of the nineteenth century in the Palazzo Barberini (A. Nibby, *Itinéraire de Rome et de ses environs . . . rédigé par A. Nibby d'après celui de Vasi*, 1863, p. 282: "troisième salle . . . une Annonciation, d'Alexandre Botticelli"; J. Murray, *A Handbook of Rome and its Environs*, 9th ed., 1881, p. 278: "93. Sandro Botticelli. A good small annunciation"); E. Volpi, Florence. Exported from Italy, July 1905 (dated customs stamp on reverse of panel); Oscar Huldschinsky, Berlin, from 1906; Huldschinsky sale, Cassirer and Helbing, Berlin, May 10–11, 1928, no. 54. Bought by Böhler and Steinmeyer for Robert Lehman.

EXHIBITED: Akademie, Berlin, *Ausstellung von Werken alter Kunst aus dem Privatbesitz von Mitgliedern des Kaiser Friedrichs-Museums-Vereins*, 1914, no. 9; New York World's Fair, *Masterpieces of Art*, May–October 1939, no. 20; Metropolitan Museum of Art, New York, 1944, 1954–61; Colorado Springs Fine Arts Center, *Paintings and Bronzes from the Collection of Robert Lehman*, 1951–52; Musée de l'Orangerie, Paris, *La collection Lehman*, 1957, no. 5; Cincinnati Art Museum, *The Lehman Collection*, 1959, no. 76; Metropolitan Museum of Art, New York, *Masterpieces of Fifty Centuries*, 1970–71, no. 184.

81. The Nativity

1975.1.61

Tempera on panel. 77.2 × 57.2 cm. (30⁷/₁₆ × 22½ in.). The panel is thinned to a depth of 6 mm. and cradled. It is cut diagonally across the top right and top left corners, and these areas have been filled in with wood. A vertical split runs the whole height of the panel through the Virgin's left cheek, lips, and right forearm.

The Virgin kneels in the center with hands clasped in prayer, bending forward in adoration of the Child. She wears a red dress laced at the wrists over a white undergarment, a blue cloak, and a transparent veil and white kerchief. Below (*left*), the Child, lying on her cloak and supported by a straw-filled cushion, reaches up to her with both arms outstretched. Behind (*center*) is a ruined wall with rough wood supports for the roof. In the middle distance (*left*) is a view of the Castel Sant'Angelo with a statue of Saint Michael on the parapet, a generalized papal coat of arms (red shield with a diagonal band surmounted by a tiara) on the wall beneath, and a relief with Christ and Saint Thomas over a portico at the entrance to the Ponte Sant' Angelo. An unidentified church appears in the distance.

The picture is attributed by Sirén (in a letter cited in a 1934 auction catalogue, see below) to the so-called Master of the Gothic Buildings, an imitator of Botticelli supposedly responsible for Madonnas in the Fitzwilliam Museum, Cambridge, the Pinacoteca Sabauda in Turin, the Yale University Art Gallery (Jarves collection), the Liechtenstein collection, and elsewhere (for these see Sirén, "Early Italian Pictures at Cambridge," *Burlington Magazine*, 37, 1920, pp. 290–99). The paintings assembled by Sirén are by a number of different hands and have in common only the fact that they depend in whole or in part on works by Botticelli. The present painting is regarded by Offner (manuscript certificate cited in the sale catalogue of 1934, see below) as "very likely also painted under Botticelli's immediate influence." The two figures have equivalents in other paintings from Botticelli's workshop, and may depend from cartoons by Botticelli. Thus the Child (which depends in reverse from the Child in Botticelli's Bardi altarpiece of 1484 in Berlin) finds a parallel in the Child in a painting of the *Virgin and Saint John the Baptist Adoring the Child Christ* in the National Gallery of Scotland (for which see R. Lightbown, *Sandro Botticelli* 1978, vol. 2, p. 135, no. C36), sometimes wrongly regarded as an autograph work, where the positioning of the left hand and the right foot are somewhat different. The Virgin has a less close parallel in the so-called *Antinori Madonna* in the Isabella Stewart Gardner Museum, Boston (for which see Lightbown, pp. 135–36, no. C37), and a tondo in the Faringdon collection at Buscot Park (Lightbown, p. 138, no. C42). The irregular cutting of the upper corners of the panel, now masked by modern wood inserts and repaint, suggests that the present painting, like that in Edinburgh, was originally circular and has been cut down.

CONDITION: The paint surface has been lightly abraded throughout. The Virgin's cloak, where indications of a gold hem survive, and the folds in her dress have been reinforced. Her halo is regilt, but that of the Child is apparently original. The entire sky is a modern restoration, including the view through the upper window, but the vegetation in the foreground, the landscape, the distant buildings, and the ruined structure behind the Virgin are well preserved. The condition of the picture was misread both by Sirén (manuscript letter to Sabin, quoted in American Art Association sale catalogue, see below: "It has the great advantage of being very well preserved") and by Offner (manuscript letter: "The state of the picture is very good and shows only inessential restorations").

PROVENANCE: Frances, Countess of Eglinton; John Carrick Moore, Corsewall, Wigtonshire, Scotland; Mary Carrick Moore, London; Alfred F. Seligsberg; sale, American Art Association, New York, January 13, 1934, no. 535. Acquired by Robert Lehman in 1934.

EXHIBITED: Cincinnati Art Museum, *The Lehman Collection*, 1959, no. 80 (as Master of the Gothic Buildings).

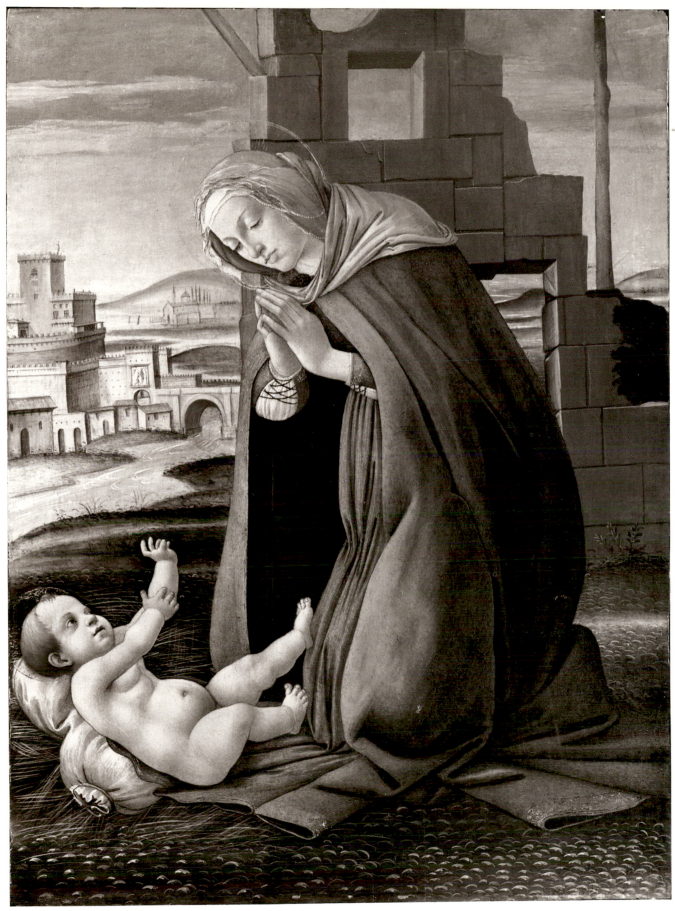

No. 81

The Master of Marradi

The Master of Marradi, for the reintegration of whose work see below, derives his name from a group of paintings in the Badia del Borgo at Marradi. He was active in Florence in the late fifteenth and early sixteenth centuries, where he seems to have been trained in the workshop of Domenico Ghirlandaio and specialized in producing "historical scenes in contemporary dress" (Fahy), two of which are in the Lehman Collection.

82. The Rape of Lucretia

1975.1.75

Tempera on panel. Overall: 40.1 × 70.6 cm. (15¾ × 27¾ in.); paint surface: 38.2 × 70 cm. (15⅟₁₆ × 27½ in.). The panel, which has a horizontal grain, has been thinned to 9 mm. and cradled. The panel has been reduced on the right, where the trailing skirt of a running woman and part of the base and shaft of a column are still visible. It may also have been cut on the left.

In the center foreground are Brutus and Collatinus in conversation, approached (*left*) by Sextus Tarquinius, who is identified by the inscription SESTᴼT. Tarquinius is accompanied by a Negro page. On the extreme left are two horses with grooms. On a flight of steps in the middle ground, Lucretia bids Sextus Tarquinius and his page enter the palace. On the extreme left, through the bars of an upright window, Lucretia and Sextus Tarquinius are seen at table, and in the center, through the grating of a horizontal window, Lucretia is shown in bed accosted by Tarquinius with a sword in his right hand. The right side shows the departure of Sextus Tarquinius, who takes leave of Lucretia, standing on a step inscribed with her name, and of a maid framed in the pink palace door.

This and the companion panel (No. 83) depict two episodes from the story of Lucretia. A third panel, in a private collection (Fig. 79), was associated with them until 1867. It shows a banquet with Brutus, Collatinus, and other guests seated behind a table and in the foreground (*right*) Lucretia stabbing herself with a dagger. The three panels are uniform in height, but that with the Death of Lucretia measures only 56.8 cm. (22⅜ in.) in width. In the narrative sequence the third panel forms a middle term between the present paintings, and it was suggested for that reason by Schubring (*Cassoni: Truhen und Truhenbilder der italienischen Frührenaissance*, 1915, p. 278, nos. 261–63), who initially knew the panels only from outline reproductions in the catalogue of the Artaud de Montor collection (see below), that the scenes were

"vielleicht nicht Cassoni, sondern Einsatzbilder." Szabo (1975, pp. 67–68) suggests that the present panels "probably were the long sides of a cassone; we know of the existence of one of the short sides only from an engraving published in 1843 in the catalogue of the collection of Artaud de Montor." Fifteenth-century cassoni were normally set against a wall, and no double-sided example, with back and front painted with narrative scenes, is known. All three panels have been reduced in width and it is not possible to ascertain their original size. In these circumstances, it is more likely that they formed part of the decoration of a small room or of some other piece of furniture than a cassone.

The three panels are the work of a follower of Domenico Ghirlandaio initially described by Suida (*Italian Paintings and Northern Sculpture from the Samuel H. Kress Collection*, 1958, pp. 16–19) as the Master of the Apollini Sacrum after two panels, a *Tribute to Apollo* and a *King with his Counsellors*, in Atlanta. The painter was later identified by Zeri ("La mostra 'Arte in Valdelsa' a Certaldo," *Bollettino d'arte*, 48, 1963, pp. 245–48) as the author of a group of panels in the Badia del Borgo at Marradi and has since been known as the Master of Marradi. The list of this painter's works was consolidated and extended by Fahy ("Some Early Italian Pictures in the Gambier-Parry Collection," *Burlington Magazine*, 109, 1967, pp. 128–39, and *Some Followers of Domenico Ghirlandaio*, 1976, pp. 181–85), to whom the attribution of the present panels is due. Their style finds a close counterpart in two cassone panels, with *The Assassination of Julius Caesar* in the University Museum at Lawrence, Kansas, and *The Triumph of Jason* formerly in the Bergman collection, Monroe, Michigan (sold Parke-Bernet, New York, March 14, 1951, lot 88).

Schubring (loc. cit.) interprets the sculptured lion on the newel post of the staircase in No. 82 as an allusion to Donatello's *Marzocco*, and relates the bearded head in the roundel in the gable of the circular building on the right of No. 83 to the central head in the gable of Donatello's tabernacle of the Parte Guelfa on Or San Michele. The Roman setting of No. 83 is established (Schubring) by a column on the extreme right, representing the column of Marcus Aurelius, and a column in the background on the left, representing Trajan's Column.

CONDITION: The paint surface has suffered extensive abrasion and paint loss, and is freely retouched throughout. The faces and hands of the figures have all been reconstructed, and the head of the negro page, which appears in two places, is modern. The gilt-brocaded garments are largely new, though the hel-

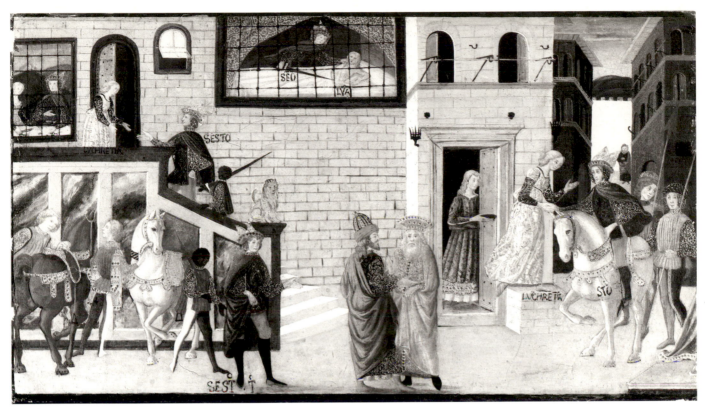

No. 82

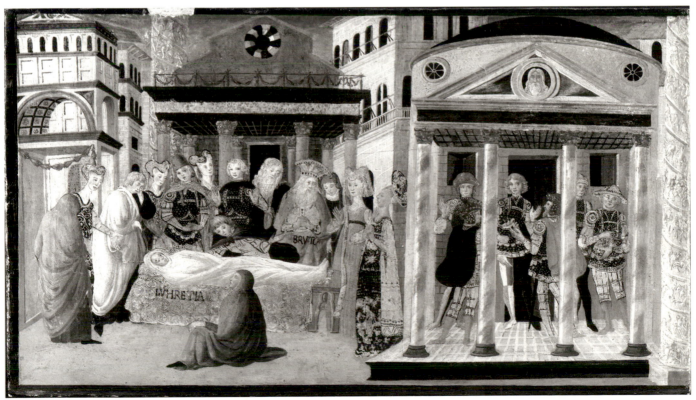

No. 83

mets, hats, saddles, and the gilt lion of the newel post of the staircase are original. In the window (*center*) the gilding of the curtains is partly new and partly old, and the figures are rubbed down to near illegibility. The sword of Tarquinius, twice shown as black with a modern gold hilt, was originally silver gilt. According to Szabo (1975, p. 67), "the inscriptions accompanying the figures on these panels are later, probably seventeenth century additions." The inscriptions on the horse of Tarquinius on the extreme right of No. 82 and on the bier of Lucretia in No. 83 do not correspond with those in the engravings accompanying the Artaud de Montor catalogue and are likely therefore to have been modified in the late nineteenth century. The remaining inscriptions, though somewhat strengthened during restoration, are original.

PROVENANCE: Artaud de Montor, Paris, by 1811 (for this see Ebersman, *Artaud de Montor and the Italian Primitives*, M.A. thesis, Institute of Fine Arts, New York University, 1966, 2, p. 239). The three panels appear as nos. 98–100 in Artaud's *Considérations sur l'état de la peinture en Italie dans les quatre siècles qui ont précédé celui de Raphael*, 1811, pp. 94–97, with a description and plates that are reproduced in *Peintres primitifs: Collection de tableaux rapportée d'Italie et publiée par M. le Chevalier Artaud de Montor*, 1843, pp. 41–42, as Andrea Orcagna. An extract from the Artaud de Montor catalogue is attached to the back of the present panel; Artaud de Montor sale, Hôtel des Ventes Mobilières, Paris, January 16–17, 1851, nos. 98–100, as Andrea Orcagna, bt. Louvisille (according to Ebersman, this name appears in the margin of an annotated copy of the sale catalogue in the Bibliothèque Nationale); Comte Pourtalès-Gorgier, Paris; Pourtalès sale, Hôtel Drouot, Paris, February 21–22, 1867, no. 230, as Orcagna; Mlle. G. de V. sale, Hôtel Drouot, Paris, March 29, 1922, nos. 9, 10, as school of Benozzo Gozzoli, bt. Bacri (Fr. 25,100, see *Gazette de l'Hôtel Drouot*, March 29, 1922, p. 1); F. Kleinberger, Paris, by 1923 (Schubring, *Supplement*, 1923, pl. 197 caption). Acquired by Philip Lehman before 1928. The third panel, *The Suicide of Lucretia at the Table of Brutus*, was separated from its companion panels after the Pourtalès sale (1867) and reappeared at the sale of the estate of a Paris banker on April 10, 1962 (Paris, Palais Galliera, *Primitifs italiens et flamands . . . objets d'art de haute époque provenant pour partie de l'ancienne Collection Claude Lafontaine*, no. 9, as school of Gozzoli) and is now in a private collection, New York.

EXHIBITED: Cincinnati Art Museum, *The Lehman Collection*, 1959, no. 73 (as Jacopo del Sellajo).

83. The Funeral of Lucretia

1975.1.76

Tempera on panel. Overall: 39.8 × 70 cm. (15⅝ × 27½ in.); paint surface: 38 × 68.8 cm. (14¹⁵⁄₁₆ × 27¹⁄₁₆ in.). The panel, which has a horizontal grain, has been thinned to 10 mm. and cradled. The upper, lower, and left edges are original, but the panel has been cut on the right.

In the left half of the panel, before a loggia with red columns, Lucretia's body lies on a bier covered with a gilt pall inscribed with her name. Behind the bier stand Brutus, Collatinus, and other figures. A mourning woman with head covered by her cloak stands on the left, and another is seated on the ground before the corpse. In the distance to the right of center is a palace. On the right before a circular brick building with a loggia supported by four variegated marble columns are seven armed youths taking an oath to expel Tarquinius Superbus from Rome.

This panel is a companion to No. 82.

CONDITION: Though abraded, the paint surface is better preserved than in the companion panel. The gilding is mostly original in the entablature frieze in the center, and Brutus's breastplate retains its original glazes. The heads are rubbed but not repainted, save for the neck of a woman on the left and the face of a youth framed in the doorway on the right-hand side. The architecture in the center and on the left is well preserved. On the right, it has been reinforced, and the youth on the extreme right beneath the portico is totally repainted. The white shroud of Lucretia and the dresses of the mourning women in front of her bier are somewhat restored.

PROVENANCE: See No. 82.

EXHIBITED: Staten Island Art Museum, 1958; Cincinnati Art Museum, *The Lehman Collection*, 1959, no. 74 (as Jacopo del Sellajo).

UMBRIA AND ABRUZZI

Fifteenth Century

Niccolò Alunno

Born in Foligno about 1420 and trained locally, perhaps by his father-in-law Pietro di Giovanni Mazzaforte, Niccolò di Liberatore, known as Niccolò Alunno or Niccolò da Foligno, emerges as an independent artist about 1456–58 with frescoes in Santa Maria in Campis at Foligno, which reflect the influence of Benozzo Gozzoli's fresco cycle of ca. 1451–52 at Montefalco. Periods of employment in the Marches seem to have introduced him to the work of Venetian and local artists active there. The development of his early style can be traced in altarpieces painted for Cagli (1465, now in the Pinacoteca di Brera, Milan), for Montelparo (1466, now in the Pinacoteca Vaticana), and for Gualdo Tadino (1471). The panel discussed below is associable with these early works. The painter died in 1502.

84. Saint Anne and the Virgin and Child Enthroned with Angels

1975.1.107
Tempera on panel. 120.2 × 68.7 cm. (47⅜ × 27¹⁄₁₆ in.).

Saint Anne, wearing a yellowish cloak and a white veil, is seated at the left with her hands crossed on her breast; she gazes at the Child Christ standing on the knee of the Virgin, who is seated in a forward plane. To the left of the throne is a group of angels, one of whom plays a harp; their blue and gold wings extend vertically upward through the gold ground. A similar group of angels, one of whom plays a lute, is seen on the right. In the gable above the throne is a further group of angels represented in half-length. The throne is backed by a shell niche with a pink and blue cornice and a garland arch. At the sides are Corinthian pilasters with central strips of inlay, and across the lintel is a frieze with foliated garlands looped over four cherub heads. In the spandrels of the arch are two gold rosettes. In front of the throne is an oriental carpet.

The panel was once inscribed across the base in gold and red. Only a few letters in the center, partially obscured by the frame, are now legible: NT. ESSE[T]. Along the bottom edge of the Virgin's cloak runs an inscription in mordant gilding: AVE MARIA GRATIA PLENA DOM[INUS] TECVM BENEDICTA.

The panel formed one face of a double-sided altarpiece or processional standard of which the other face, showing Saint Michael adored by members of a confraternity (Fig. 70), is in the Princeton University Art Museum (no. 65.266, C. C. von Kienbusch, Jr., Memorial Collection). The two panels were first associated by Perkins ("Un dipinto sconosciuto di Niccolò da Foligno e un quadro di Fiorenzo di Lorenzo," *Rassegna d'arte umbra*, 3, 1921, p. 3). They correspond closely in size and shape, and the modern (early twentieth-century) framing around both is identical. The thinning and cradling of both panels has obscured any evidence of the manner in which they may have been joined. Double-sided panels of this type are encountered frequently in Umbria and the Marches, and appear generally to have been used as processional standards (see J. Gardner, "Fronts and Backs: Setting and Structure," *La pittura nel XIV e XV secolo: il contributo dell'analisi tecnica alla storia dell'arte*, eds. H. W. van Os and J. R. J. van Asperen de Boer, 1983, pp. 297–322). Five standards (*gonfaloni*) by Niccolò Alunno or his workshop painted on linen are known (see F. Santi, *Gonfaloni umbri del Rinascimento*, 1976, pp. 18–22), and a comparable wooden structure by Niccolò, showing on one side the Madonna and Child enthroned with Saints Francis and Eustace and on the other the Annunciation (Pinacoteca Nazionale, Bologna), is also likely to have been portative. Like the present panel, that in Bologna was commissioned by a confraternity; the Christ Child on the front face holds a scroll with an inscription that reads: IO BENEDICO QUISTI MIEI CONFRATI 1482.

One of Niccolò's linen *gonfaloni*, with the Crucifixion and Saint Gregory the Great Enthroned (Staatliche Kunsthalle, Karlsruhe), is dated 1468, and a second one, with Saint Anthony the Abbot and the Crucifixion on one side and Saints Francis and Bonaventure and the Flagellation on the other (Palazzo Comunale, Deruta), seems to date from approximately the same time. The present panel is evidently earlier than these two paintings. The pose of the Child (in reverse) and the architecture of the throne recall those in a dated polyptych of 1465 from Cagli (now in the Pinacoteca di Brera, Milan), but the style of the lateral angels is less mature and recalls that of the angels in the polyptych by Niccolò in the Duomo at Assisi (1460 or 1461). A plausible dating after the frescoes in Santa Maria in Campis at Foligno (1458) and before the Assisi altarpiece is proposed by Omelia (*Niccolò da Foligno and His Frescoes for S. Maria-in-Campis*, Ph.D. diss., Institute of Fine Arts, New York University, 1975, p. 31). The panel is accepted as an early work of Niccolò da Foligno by Perkins (loc. cit.), R. Lehman (1928, pl. 69), L. Venturi (*Pitture italiane in America*, 1931, no. 239), Berenson (1932, p. 393, and later editions), and Van Marle (*Development*, vol. 14, 1933, p. 39).

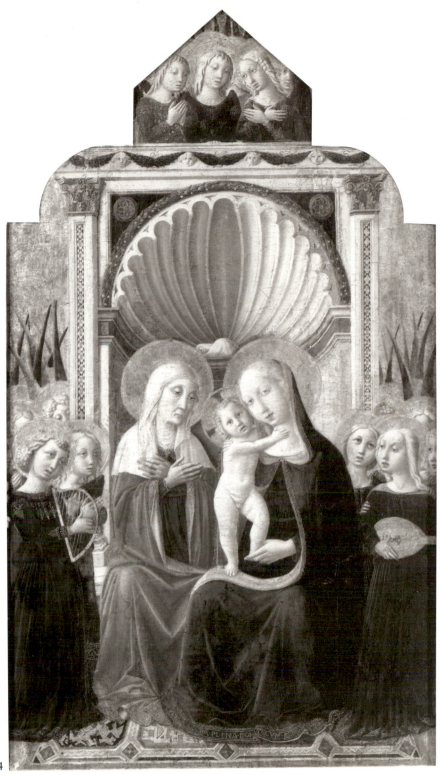

No. 84

CONDITION: The panel, which has a vertical grain, has been thinned to a depth of 5 mm. and cradled. A number of small vertical cracks in the wood have resulted in flaking losses in the paint surface. There are extensive repainted areas in the dresses of the angels. The blue of the Virgin's cloak is heavily reinforced, and her left shoulder, arm, and thigh are mainly modern, as are the right leg and right upper arm of Saint Anne. A hole in Saint Anne's jaw and veil has been inpainted. The flesh parts are otherwise well preserved.

PROVENANCE: Sir Kenneth Matheson, Gladfield House, Ardgay, Rosshire, Scotland; R. Langton Douglas, London. Acquired by Philip Lehman before 1921.

EXHIBITED: William Rockhill Nelson Gallery of Art, Kansas City, 1942–44; Metropolitan Museum of Art, New York, 1954; Cincinnati Art Museum, *The Lehman Collection*, 1959, no. 87.

Andrea Delitio

Also known as Andrea da Lecce, and apparently born either at Guardiagrele or Lecce de' Marsi, Delitio is survived by one dated work, a colossal fresco of Saint Christopher painted in 1473 on the façade of Santa Maria Maggiore at Guardiagrele. A fresco cycle of scenes from the life of the Virgin in the choir of the Duomo at Atri appears to date from the same time. The reconstruction of Delitio's early style is unsupported by any documented work. He has, however, been credited with some plausibility with a group of frescoes (at Aquila and Sulmona) and panel paintings, executed in the middle of the fifteenth century. At this time, in addition to contacts with Umbrian and Marchigian painting, and particularly with the work of Bartolomeo di Tommaso da Foligno, he seems to have been cognizant of the work of a number of progressive Florentine artists.

85. The Virgin Annunciate

1975.1.29

Tempera on panel. 49.4 × 30.5 cm. (19½ × 12 in.) with original engaged frame; 40.5 × 24.1 cm. (16⅛ × 9½ in.) painted surface. The panel has not been thinned and is painted on the back with a black on red design representing brocade. The molding at the base is modern and covers about 2.4 cm. of the original paint.

The Virgin is seated on a marble pavement, facing to the left. She wears a red robe covered by a blue, green-lined cloak. Her fair hair is covered by a transparent white veil. The dove of the Holy Ghost flies in toward her from the left.

The panel, which formed the pinnacle of the right wing of a small triptych, was published by Van Marle (*Development*, vol. 9, 1927, p. 324) as an early work of Sassetta. An attribution to Sassetta was accepted initially by Berenson (1932, p. 513), who later (1936, p. 300) listed it as a work of Masolino. It is ascribed to Masolino by Serra (*Aquila monumentale*, 1912, pp. 69–70), R. Lehman (1928, pl. 10: "The technique is not that of Sassetta, nor is the color that of the Sienese"), and Pope-Hennessy (*Sassetta*, 1939, p. 184); an attribution to Masolino or a Masolino follower seems to have been endorsed by De Nicola, Offner, and Perkins (see R. Lehman, loc. cit.). An attribution to Sassetta was supported by Longhi ("Fatti di Masolino e di Masaccio," *Critica d'arte*, 25–26, 1940, p. 182, n. 14). The plausible ascription to Andrea Delitio is due to Bologna ("Andrea Delitio," *Paragone*, vol. 5, 1950, p. 46) and Volpe ("Una ricerca su Antonio da Viterbo," *Paragone*, vol. 253,

1971, p. 46), and is endorsed by Zeri (*Italian Paintings in the Walters Art Gallery*, vol. 1, 1976, pp. 183–84), who associates it with a *Madonna and Child Enthroned with Saints* in the Walters Art Gallery in Baltimore (no. 37.715) and a predella panel in the Rhode Island School of Design in Providence as a work reflecting the styles of Masolino, Domenico Veneziano, and Uccello, with a conjectural dating in the second half of the 1440s.

CONDITION: A vertical crack runs through the panel to the left of the Virgin's knee, resulting in small losses in the gold ground. The paint surface is generally well preserved, save for minor flaking in the red of the Virgin's robe, in the green lining of her cloak, and at the edge of the marble pavement where it overlaps the gold ground.

PROVENANCE: Marchese Dragonetti de Torres, Aquila; Grassi, Florence. Acquired by Philip Lehman in 1916. Offered for sale on July 20, 1955, at Sotheby's, London (no. 42) and repurchased for the Lehman Collection.

EXHIBITED: Metropolitan Museum of Art, New York, 1944 (as Masolino); Cincinnati Art Museum, *The Lehman Collection*, 1959, no. 27 (as Sassetta).

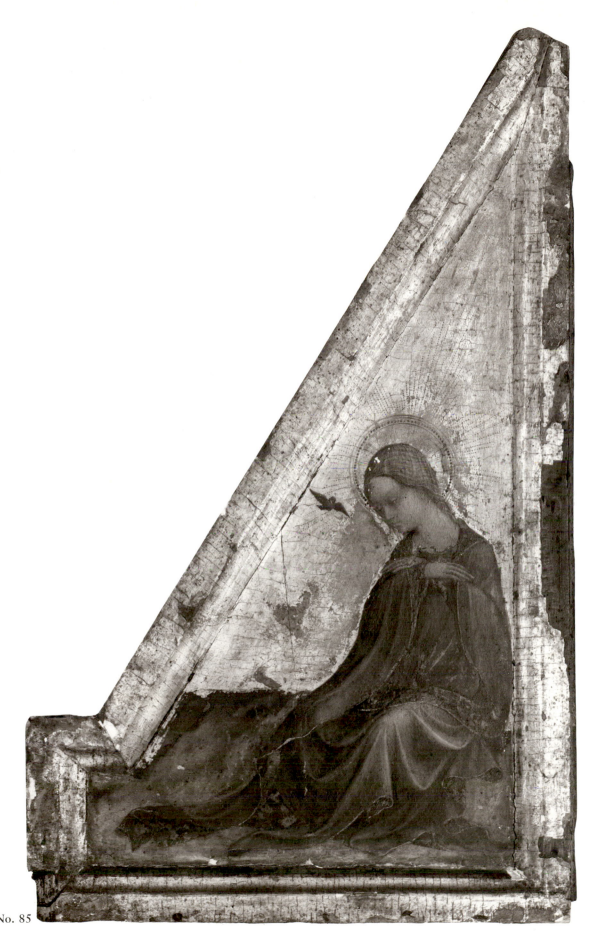

No. 85

ROME

Fifteenth Century

86. Santa Francesca Romana Clothed by the Virgin

1975.1.100

Tempera on panel. 55.3 × 37.5 cm. (21¾ × 14⅞ in.). The panel, with a vertical wood grain, has been thinned to 6 mm. and cradled. The cradling is cut away in two pieces to expose two illegible stamps on the back of the panel. At the back a vertical crack 12 cm. from the left edge is joined by butterfly wedges.

In the upper half of the panel Santa Francesca Romana in a white cloak kneels in right profile before the Virgin and Child. The Virgin and Child hold inscribed scrolls (see below). The Virgin wears a golden cloak, which Saint Paul, on the extreme left in right profile, wraps around the saint. Saint Paul holds an inscribed scroll in his right hand. The scene takes place on a platform of cloud, and the Virgin and Child are surrounded by scarlet seraphim. On the extreme right are three flying angels with blue and red wings. Beneath is Saint Mary Magdalene, holding one end of a protective cloak round twenty members of the Olivetan Oblate order. The near end of the cloak is held by Saint Benedict, standing in left profile in the foreground. On the left, in perspective, is a wall with two Gothic windows; beneath its projecting roof an angel, dressed in white and with white wings, is engaged in carding golden threads with a warp and loom. Playing round the warp are two dogs and two cats.

The present panel, No. 87, and a panel with the *Communion and Consecration of the Blessed Francesca Romana* (Fig. 80) in the Walters Art Gallery in Baltimore (acc. no. 37.742) formed part of a more extensive series of panels with scenes from the life of Santa Francesca Romana, presumed to have been painted for the church of Santa Maria Nuova in Rome. A fourth panel, a *Mystical Crucifixion* (Fig. 81) in the Národni Galerie, Prague, may originate from the same complex. It is published by Fiocco as Venetian ("Le pitture venete del Castello di Konopiste," *Arte veneta*, 2, 1948, pp. 13–16) and by Pujmanova as by a North Italian artist active in the Marches (*Italienische Tafelbilder des Trecento in der Nationalgalerie, Prag*, Berlin, 1984, no. 22). The possibility that the Prague panel (which measures 62.5 × 45.5 cm.) formed part of the same series as the present panels is noted by Pujmanova. The first three panels have been studied in an exemplary article by Kaftal ("Three Scenes from the Legend of Santa Francesca Romana," *Journal of the Walters Art Gallery*, 11, 1948, pp. 50–61, 86), and by Zeri (*Italian Paintings in the Walters Art Gallery*, vol. 1, 1976, pp. 154–58, no. 99);

the substance of the present entry is drawn from these two sources.

Santa Francesca Romana, the founder of the Olivetan Oblates, was born in 1384 and died in 1440. The case for her canonization was presented in the year of her death, and again in 1443 and 1445, and her cult as a *beata* was authorized in 1460. She was canonized in 1608. The complex of narrative scenes from which these panels come formed the basis, in 1468, of a fresco cycle by Antoniazzo Romano or from his workshop in the Oblate convent of Tor de' Specchi. They seem to have been commissioned in connection with the cause for canonization, and are generally thought to date from about 1445. Thirty-seven scenes are depicted in the Tor de' Specchi fresco cycle (for these see A. Rossi, *Bollettino d'arte*, 1, 1907, pp. 4–22; Lugano, *La Nobil Casa delle Oblate di Santa Francesca Romana in Tor de' Specchi*, 1933; and Kaftal, *Iconography of the Saints in Central and South Italian Schools of Painting*, 1965, pp. 447–67). It would be wrong, however, to infer that the cycle to which the present panels belong necessarily represented the same number of scenes since those frescoes that derive from the earlier panels can be differentiated, on the basis of style and structure, from those designed in the third quarter of the fifteenth century. The penultimate fresco, showing the saint on her deathbed with Christ fetching her soul, was evidently based on a lost panel in the present series whereas the final fresco, showing the funeral of the saint, has the character of an original composition by the author of the fresco cycle. A second cycle of monochrome frescoes at Tor de' Specchi, dating from 1485, illustrates scenes from the life of the saint omitted from the earlier fresco cycle. None of these appears to have been based on lost panels from the present series. If the present series of panels illustrated only the visions of the saint, as is tentatively suggested by Kaftal (1948, pp. 59–60), it would have contained three further scenes. The evidence from the frescoes is that the number of scenes may have been somewhat larger. Since the grain of the wood is vertical, they would have been

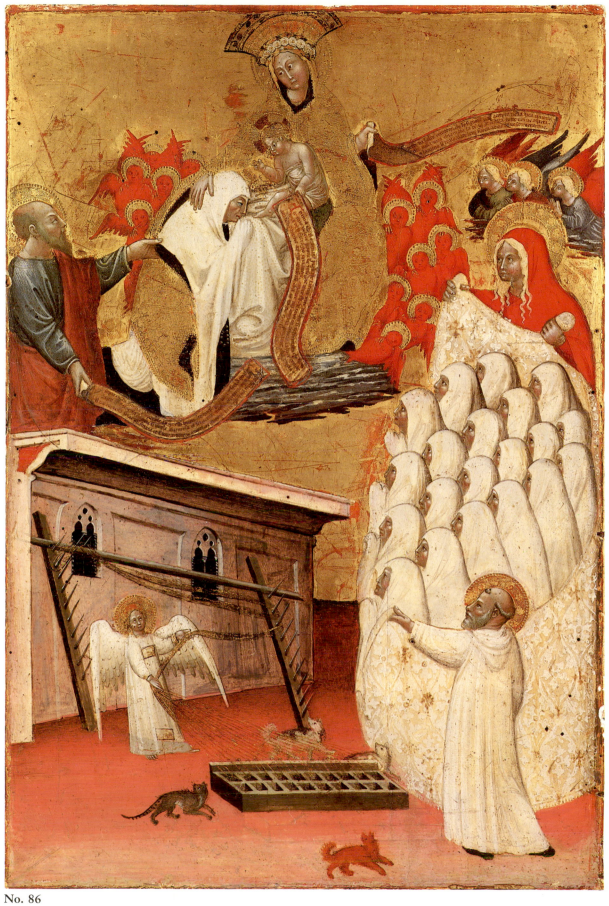

disposed one above the other, probably—as Kaftal deduced—on either side of a painted full-length figure of the saint. Zeri makes the convincing suggestion that the altarpiece stood over the saint's tomb in the church of Santa Maria Nuova.

When only one panel from this cycle, in the Walters Art Gallery, was known, it was ascribed in the catalogues of the gallery initially to the school of Fra Angelico (1909) and later (1922, 1929) tentatively to Giovanni di Paolo. The theory of a Sienese origin was adopted by Berenson (1932, p. 458; 1936, p. 393), who gave it (with a question mark) to Pietro di Giovanni d'Ambrogio, but was rejected by Pope-Hennessy (*Sassetta*, 1939, pp. 186, 204), who suggested that the panel might be a Veronese. A Roman origin for the panel was postulated by Kaftal (1948, p. 60) on the ground that no community of Olivetan Oblates existed outside Rome, and that the paintings must therefore have been commissioned locally. After the appearance of the two Lehman panels, all three scenes were ascribed by Zeri (*Bollettino d'arte*, 25, 1950, p. 41 and postscript) to a Lombard painter "di cui forse saranno di ricercare altre tracce non a Roma, ma a Napoli, nella cerchia di Leonardo da Besozzo, di Petrinetto e dell'ignorato Giovanni Sagittano." Salmi (letter of 1951 in the Walters Art Gallery) ascribed them to a Neapolitan artist familiar with the frescoes of Leonardo da Besozzo in San Giovanni a Carbonara. An attribution to the circle of Leonardo da Besozzo was supported by Mazzini (in *Arte lombarda dai Visconti agli Sforza*, exh. cat., Palazzo Reale, Milan, 1958, p. 64) and Puppi (*Arte lombarda*, vol. 4, 1959, p. 247). A direct ascription to Leonardo da Besozzo was advanced by Volpe (letter of 1960 in the Walters Art Gallery) and Longhi (*Saggi e ricerche*, 1967, pp. 248f.). The affinities of the panels with the work of Leonardo da Besozzo are superficial, and it was later concluded by Zeri (1976, p. 156), on the basis of extended study of Gothic painting in Rome, that "there are many passages in the three paintings which show a link with the painter Antonio da Viterbo I, who was active in Rome and who, moreover, was often patronized by the Benedictine Order. . . . Antonio da Viterbo's development is still obscure, but it may be that the series to which our painting belonged was executed in his immediate circle."

The inscriptions on the three scrolls in the present panel are drawn from accounts of the saint's visions in a manuscript life of the saint of 1469 in the Vatican Library (for which see G. Mattioti, *Vita di S. Francesca Romana*, ed. Armellini, 1882). That on the scroll held by the Child Christ reads: "Anima che si ordinate pigliate larme mee da mi si reformata che facci lo mio volere puorti le insegne mee fa che vivi in amore la luce con ardore in ti farragio remanere, amame mi anima amame che tagio riamata damme ad mi conforso cha io tagio conforsata." On the scroll held by the Virgin are the words " . . . ette da lalto creatore. che lo signore ve a accepte nella mea unione . . . este nella mea chiamata la dona anunita tutte voi ve aspetta . . . lanimo si reale. siate bene fuorti ad cio che ne intervenerano." The only words legible on the scroll held by Saint Paul are "Preparate tu anima preparate ad questi bieni ad (?) questi . . . li quali . . . fa chencie (?) si virile animosa et fervente . . . confiamata et . . . te ardere de amore. . . ." The sources of the three passages occur in Visions XCV and XLVII.

The fresco at Tor de' Specchi derived from the present panel is inscribed with the words "Como la beata Francesca fu acceptata sotto lo manto della matre de dio. Et le soe figliole in cristo furono ancora acceptate per offerte de essa gloriosa matre de dio." The scene represented in the foreground is identified by Kaftal as that described in Vision LXIX of August 15, 1439: "Almighty God, desiring to increase His favours towards this Saint, willed that this second Angel should change his former work, which he had been doing with skeins and balls; and he set up a warp-beam for the laying of a warp, and he spoke solemnly unto the aforesaid Saint, and said: 'I will begin, and will lay the warp for a web of a hundred ties [threads], and I will make another [of sixty, and another] of thirty ties.' . . . But in the warp which the said Angel had laid, certain dogs and cats did hinder the ordering of the threads of the cloth, by which thing was denoted contradiction." This vision is interpreted by Ponzileoni (*Vita di Santa Francesca Romana*, 1874, p. 255, cited by Kaftal) to signify that the Oblate congregation was woven by heavenly visions and was assailed by evil spirits in the form of cats and dogs, which were unable to break its threads. The extensive underdrawing revealed by infrared reflectography beneath the paint surface in this panel includes a cat and mouse, which were omitted from the painted version of the scene.

CONDITION: The paint surface is generally well preserved though somewhat overcleaned. The edges are original, though the beard has been pressed flat. Infrared reflectography reveals extensive underdrawing beneath the pigment layer. There is no comparable underdrawing in No. 87, where the figures are modeled in light pigment over gray underpainting, and the two panels may therefore have been executed by different workshop hands.

PROVENANCE: Santa Maria Nuova, Rome (see above, unconfirmed); Violet, Lady Melchett, London; Melchett sale, Sotheby's, London, March 6, 1946, lot 109A; Tómas Harris, London. Acquired by Robert Lehman after 1948.

87. Santa Francesca Romana Holding the Child Christ

1975.1.101

Tempera on panel. 55.3 × 37.5 cm. (21¾ × 14⅞ in.). The panel, with a vertical wood grain, has been thinned to 5 mm. and cradled. The cradling is cut away in two places to expose two illegible stamps on the back of the panel. A prominent lip with fragments of the original wood moldings is visible on all four sides.

In the center, raised above the earth (a symbolical representation of which fills the lower part of the panel), kneels the saint, in the habit of an Olivetan Oblate, holding the Child Christ in her arms. In his left hand the Child holds a scroll for an inscription, which has been effaced and replaced with blue paint. To the left stands an angel in a red dalmatic, with extended wings, holding a bunch of flowers in his left hand and a scroll with an inscription (see below) in his right. Behind the saint (*right*) is a vision of Saints Paul, Mary Magdalene, and Benedict, shown in half-length supported on clouds. Saint Paul holds a sword, Saint Benedict a book, and the Magdalene, dressed in red, holds a jar of ointment and an inscribed scroll. In the upper left corner is seated the Virgin, in a pale yellow dress and light gray cloak and with a triple crown, supported by seraphim. She holds a scroll in her left hand. Six more angels appear in the upper right part of the panel.

For the history of this and the related panels, see No. 86. Whereas in No. 86 and in the panel at Baltimore the inscriptions on the scrolls are original, containing transcriptions from an account of the saint's visions, in the present painting they appear to have become illegible and to have been replaced with inscriptions on parchment. The texts are drawn from Canto XXXIII of Dante's *Paradiso*. On the scroll held by the Virgin are the words:

> Donna, sei tanto grande e tanto vali,
> Che qual vuol grazia, ed ad te non ricorre,
> Sia distanza vuol volar senza ale.
> La tua benignità non pur socorre
> A chi demanda; ma molto fiate
> Leberalmante al dimandar precorre.

The scroll held by the angel contains the lines:

> In te misericordia, in te pietate,
> In te magnificenzia, in te saduna:
> Quantunque in creatura e di bontate.

The scroll held by Saint Mary Magdalene reads:

> Vergine Madre, figlia del tuo figlio:
> Umile ed alta più che creatura,

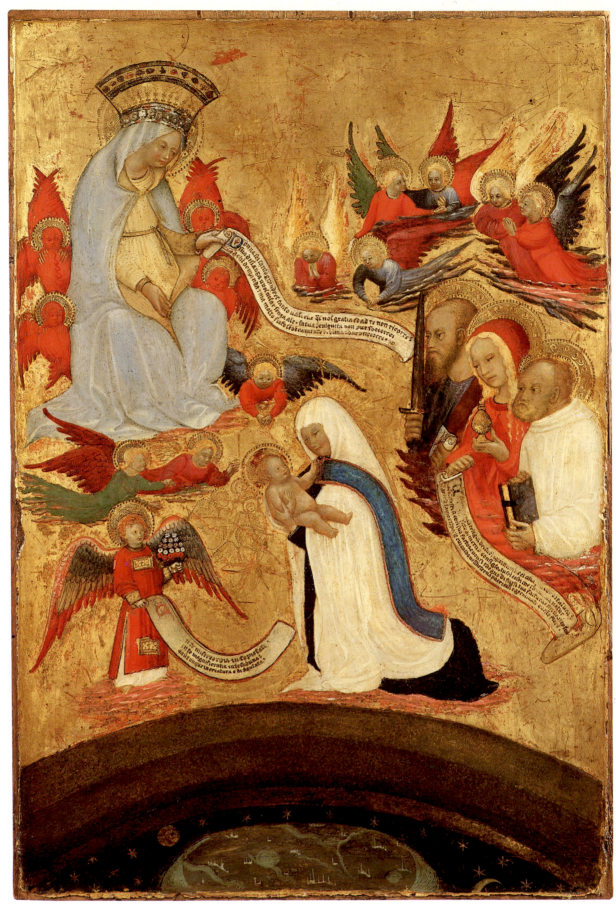

No. 87

Termine fisso d'eterno consiglo,
Tu se' colei che l'umana natura.
Nobilitasti si che'l suo Fattore
Non si sdegno di farsi tua factura
Nel ventre tuo si raccese l'amore,
Per lo cui caldo nell' eterna pace
Cosi è germinato questo fiore.

The scroll held by the Child Christ was presumably filled with a fourth inscription from the *Paradiso*, and the present blue paint must have been added when this became detached. The original scrolls were somewhat wider than those now visible.

The present panel, like No. 86 and the other surviving panels, was copied in a fresco by Antoniazzo Romano at Tor de' Specchi, the Olivetan Oblate convent in Rome, beneath which is an inscription describing the scene: "Come spesso fiate essendo la beata Francesca nella beatifica visione lo eterno dio apparendole nelle braccia della soa gloriosa vergine matre se degnava de venire nella braccia de essa beata" (How the blessed Francesca, being in a beatific vision as she so often was, saw the eternal God in the arms of the glorious Virgin His mother and how He deigned to come into her arms). This miracle occurred on five separate occasions during the saint's life, and is described in a manuscript life of 1469 in the Vatican Library (for which see G. Mattioti, *Vita di S. Francesca Romana*, ed. Armellini, 1882, and the Bollandist *Acta Sanctorum*, Martii II, 1865, pp. 89ff., Visions XII, XV, XLV, LVII and LXX). The angel in a red dalmatic is described in the same source (Vision I: "There was given to her an Angel, who [as the servant of God declared] was of the second choir of the holy Angels, and was not that attendant Angel who is given as a guardian to every man"), as is the bunch of flowers in his left hand (Vision LVII: "The said apostle in human shape presented to the saint a nosegay of very beautiful roses, in which there were twenty roses, five of them white, five red roses and five white and red musk roses; and below all these roses were five violets. Then the Apostle said to the saint: Give all these flowers to the Archangel, for he will deal with them as is fitting. And when this was done, the glorious Archangel held in his hand the fair gift, which gave forth a wondrous and fragrant odour; by which the handmaid of Christ was mightily rejoiced and strengthened"). The triple crown worn by the Virgin is explained in Vision XV of Christmas 1432, when the saint described to her confessor the crown worn by the Virgin ("in one and the same crown there were three crowns, one above another; by the first was denoted the humility of the Mother of Christ, and this crown was pure white and adorned with shining white roses. . . . The second crown signified her virginity. . . . And the third and uppermost crown was adorned all round with twelve precious stones").

CONDITION: The paint surface has been heavily abraded and has flaked extensively. The figures of the Child Christ and of the angel at the left are badly preserved. There is some retouching in the streaks of clouds above, in Saint Paul's sword, and in the saint's white robe. The globe and the celestial orbits at the base of the panel have been reinforced, and the gold ground is much scratched and repaired.

PROVENANCE: See No. 86.

EXHIBITED: Musée de l'Orangerie, Paris, *La collection Lehman*, 1957, no. 34 (as Maître Lombard XV siècle); Cincinnati Art Museum, *The Lehman Collection*, 1959, no. 91 (as Unknown Master of the Marches, fifteenth century); Metropolitan Museum of Art, New York, *Saints and Their Legends*, 1974 (as Unknown Master of the Marches).

EMILIA AND ROMAGNA

Fifteenth Century

Romagnole, Middle of the Fifteenth Century

88. Crucifix

1975.1.25

Tempera on panel. 39.8 × 35.3 cm. (15⅝ × 13⅞ in.) excluding the peg (8.2 cm.; 3¼ in.) at the base. The cross is constructed of two pieces of wood 25 mm. thick joined at the center. The sides are painted red.

The crucifix is double-sided. It is carved in two full pieces lap-joined at the center, so that one face is continuous at the crossbar and the other at the shaft. The top and bottom and the two arms end in quinquelobe terminals, with punching following the border. In the center is the crucified Christ, on one side as a living figure with eyes open and blood spurting from his wounds, and on the other as a dead figure with eyes closed and no stream of blood. Both figures have a cruciform halo. In the terminals of the two arms appear (*left*) the Virgin, in half-length with a red dress and blue cloak, with open hands gesticulating toward Christ, and (*right*) Saint John the Evangelist, in a green robe and red cloak, also gesturing toward Christ. At the bottom of the shaft is the Magdalene, in a green dress and scarlet cloak, with head turned up toward Christ, and at the top is a figure of God the Father, in a green robe and scarlet cloak, holding an open book and making a gesture of benediction with his right hand.

The crucifix was intended for display on the top of a processional pole, to which it would have been attached by the carved peg at its base. It was originally completed by wood or metal spikes and perhaps crystal beads, fitted into holes along its outer sides, one at each lobular protrusion and three along each side of the shaft beneath the arms of the cross, twenty-five in all. A larger and deeper hole at the top may have supported a carved titulus.

The crucifix appeared at auction in 1931 (see below) with an attribution to the Sienese school of the fourteenth century, and retained this identification when it entered the Metropolitan Museum of Art (see K. Baetjer, *European Paintings in the Metropolitan Museum of Art, a Summary Catalogue*, vol. 1, 1980, pp. 95–96). A comparable processional crucifix by Sano di Pietro is in the Staatliche Gemäldegalerie in Dresden (nos. 25, 26), and another by Pietro di Francesco degli Oriuoli is in the Metropolitan Museum (acc. no. 22.30.31), but no known painter or workshop in Siena can be associated with the crude figure style and freehand engraving on the gold ground of the present cross. It has been pointed out by Fahy (verbally) that the tooling in the haloes and the punching are closely similar to those in the quatrefoils of Christ and the twelve

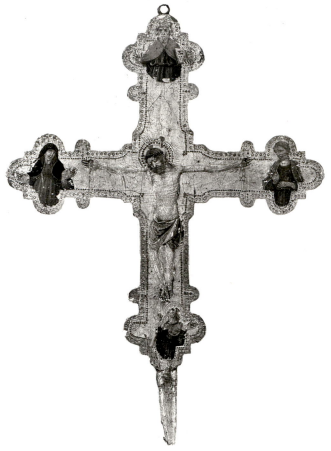

No. 88, reverse

apostles in a polyptych of 1433 by Giovanni da Rioli in San Domenico at Imola. The cross seems to have been produced in this area and perhaps in this shop.

CONDITION: The gold ground is well preserved, but the paint surface is badly broken up. There are some old retouches on the verso, but the recto is free of later inpainting save in the head of the Evangelist.

PROVENANCE: Achille de Clemente; sale, American Art Association–Anderson Galleries, New York, January 15, 1931, lot 189. Acquired at this sale by Robert Lehman.

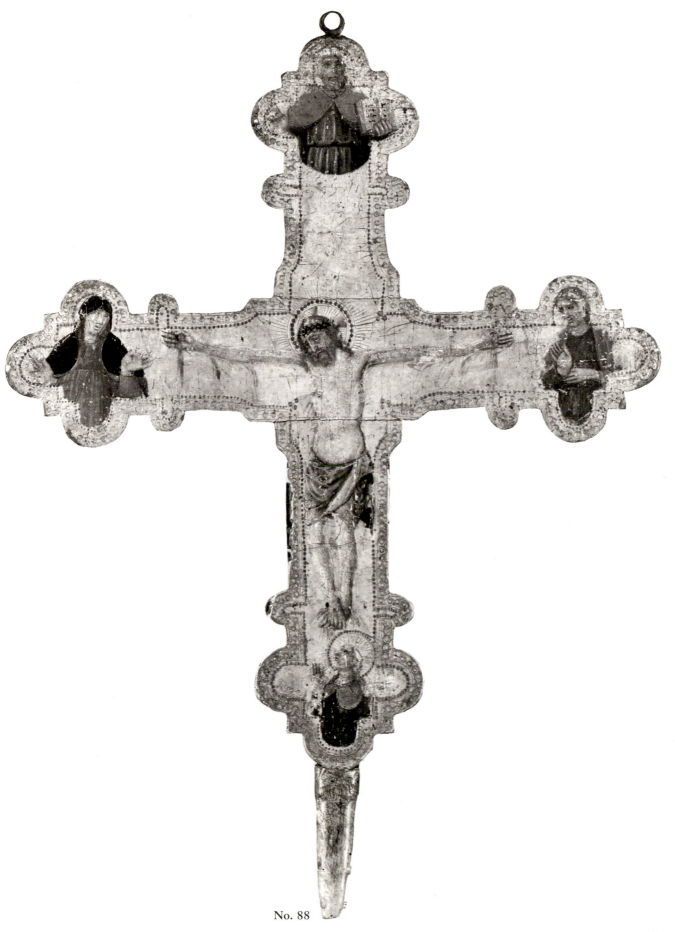

No. 88

89. Portrait of a Member of the Gozzadini Family

1975.1.95

Tempera on panel. Overall: 51 × 37.1 cm. (20¹¹/₁₆ × 14⅝ in.); paint surface: 49.3 × 35.6 cm. (19⅜ × 14 in.). The panel, of a vertical wood grain, has been thinned to 9 mm. and is cradled. The frame is antique but is not original to the panel. It has been cut to size at the corners and made up with false coats of arms to conceal the joints.

The sitter is portrayed in bust-length, in profile to the right. He holds a spray of pinks between the fingers of his right hand, and wears a pleated red doublet over a black tunic, the collar and sleeve of which are exposed. His cap is red. Behind him to the right is the receding face and part of the forward face of a stone building, across the entablature of which is inscribed VT SIT NOSTRA. From a spike beneath the cornice hangs a coat of arms (see below). On the left is an extensive landscape, in which the domes and towers of a city are seen above a line of hills. In the foreground of this scene, to the left, appear two halberdiers, a falconer on horseback with a hunting dog, a pelican feeding her young from her breast, and a phoenix consumed by flames on the stump of a felled tree.

This portrait and No. 90 represent a husband and wife of the Gozzadini family. Their commemorative function is indicated by an inscription running across the building in the background of both panels: VT SIT NOSTRA FORMA SVPERSTES (in order that our features may survive). There is no indication that the diptych was necessarily commissioned as a marriage portrait, and the age of the female sitter and the fact that only the Gozzadini arms are depicted in her portrait make this improbable.

While the arms on both portraits are those of Gozzadini, there is some doubt as to the identity of the sitters. In the Bardini sale catalogue of 1902 (see below) they are described as "portraits peints par Melozzo da Forli en commémoration du mariage de Comte Rodolphe de Gozzadini, comme on le voit par une inscription de l'époque sur le dos d'un tableau." The panels have since been thinned and cradled, and there is no trace of this inscription. A fragmentary label on the cradle behind the male portrait, however, probably reproducing an inscription originally on the panel, reads:

BERNARDINI DI GOT. . . .

. . . OS VIGINTI UNO.

There is no record in the Gozzadini archive in the Biblioteca Comunale at the Archiginnasio at Bologna of a Rodolfo Gozzadini, and this reference is likely to be incorrect. The sitters were later identified (R. Lehman, 1928,

pls. 78, 79) as Alessandro di Bernardina [sic] Gozzadini and Donna Canonici of Ferrara, and were presumed to have been painted to commemorate a marriage in 1477 when Alessandro, who was born in 1456 (Litta, *Famiglie celebri italiane*, 1839, vol. 6, table III), would have been aged twenty-one. A manuscript biography of members of the Gozzadini family (Bologna, Biblioteca Comunale Gozz. 415–22; G. Gozzadini, *Materiali per la storia di sua famiglia*, 1832, vol. 1) containing the *ricordi* of Alessandro Gozzadini's son, Alessandro, shows that the writer, who was born on March 20, 1480, was illegitimate and was legitimized only in 1492. His mother was a member of the Canonici family. The possibility that the diptych represents the elder Alessandro and his mistress can be ruled out, the more so as the background of the female portrait includes a unicorn and an ermine, symbols of chastity. Alessandro's brother, Sebastiano di Bernardino di Matteo Gozzadini, was appointed Podestà of Lucca in 1488 and married Pantasilea di Filippo Bargellini. His eldest son, Matteo, was born in 1473. If the male portrait represents Matteo, the inscription on its reverse could be reconstructed as MATTEUS SEBASTIANI BERNARDINI DE GOTSADINIIS / AETATIS SUAE ANNOS VIGINTI UNO, and the picture would have been painted in 1494 (see below). Nothing is known of Matteo's wife, Ginevra d'Antonio Lupari, save that she died in 1557 (Litta, loc. cit.). The male sitter is described by R. Lehman (loc. cit.) as "this great Lord of Ferrara." The Gozzadini were, however, a Bolognese family, who occupied a number of minor posts in Bologna in the last quarter of the fifteenth and the first half of the sixteenth centuries. One member of the family was knighted by Giovanni II Bentivoglio, and another, Annibale Gozzadini, was responsible for commissioning a stained-glass window by Cossa for San Giovanni in Monte, Bologna.

The portraits are noted by A. Venturi ("Le opere de' pittori ferraresi del '400," *L'arte*, II, 1908, p. 424: "niuno sa dove il quadro, venduto segretamente dalla contessa Gozzadini, sia andato a finire"), and are ascribed by him (*Storia*, vol. 7, iii, 1914, pp. 643–46) to Francesco del Cossa, who died in 1477. An attribution to Cossa is accepted by Gruyer (*L'art ferrarais à l'époque des Princes d'Este*, 1897, p. 121), Bode ("Old Art in the United States," *New York Times*, December 31, 1911, p. 4), Lafenestre ("Une exposition des tableaux italiens," *La re-*

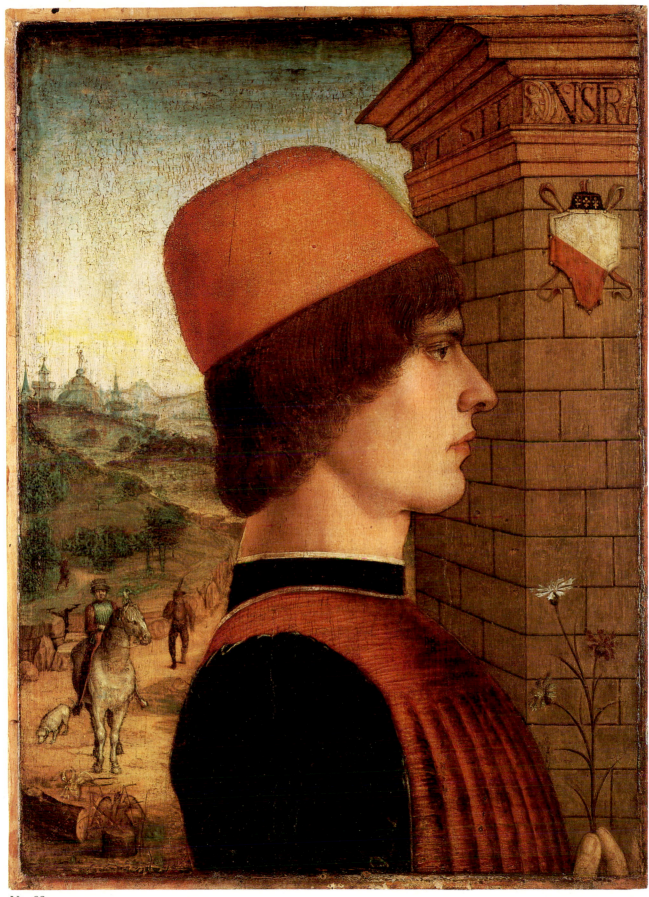

No. 89

vue de l'art ancien et moderne, 25, 1909, p. 6), L. Venturi (*Pitture italiane in America*, 1931, pls. 265, 266), R. Lehman (loc. cit.), and Szabo (1975, p. 59). The panels bear only a generic relationship to the style of Cossa, and their attribution to this artist is dismissed throughout the modern literature. The painter is classed by Berenson (*Essays in the Study of Sienese Painting*, 1918, p. 66) with "certain followers of Cossa and Tura," and was later categorized (idem, 1932, p. 186; 1936, p. 160) as "between Cossa and Ercole de' Roberti," and (idem, 1968, vol. 1, p. 132) as Ferrarese before 1510 without further qualification. The problem of the date of the two portraits was first confronted by Longhi (*Officina ferrarese*, 1934, pp. 172–73, n. 104), who concluded that they were a decade later than the paired portraits of Giovanni II Bentivoglio and Ginevra Bentivoglio by Ercole de' Roberti, now in the National Gallery of Art in Washington, "e perciò più vicino al '90 che all '80," and were possibly early works by Lorenzo Costa. The attribution to Costa, which was reaffirmed in more positive terms in 1940 (idem, *Ampliamenti nell'officina ferrarese*, p. 17, with a dating "verso l'85"), rests on analogies to the portraits of thirteen members of the Bentivoglio family in the Bentivoglio altarpiece of 1488 in San Giacomo Maggiore, Bologna. None of the Bentivoglio portraits is in profile, and their relationship to the present pair is insufficiently close to substantiate the attribution. Other factors militating against an ascription to Costa are the projection system employed in the architectural backgrounds of the present portraits, which is not compatible with that in the Bentivoglio altarpiece, and the fact that the two landscapes bear no resemblance to those in works by Costa of this date (e.g., the *Nativity* in the Musée de Lyon). The late dating proposed by Longhi is, on the other hand, likely to be correct, and the identification of the male sitter as Matteo di Sebastiano di Bernardino Gozzadini is plausible on chronological grounds.

The attribution to Costa is accepted with some reserve by Neppi (*Francesco del Cossa*, 1958, p. 33: "il non eccelso dittico ritrattistico . . . ora presso Lehman a New York") and is rejected by Clifford M. Brown (*Lorenzo Costa*, Ph.D. diss., Columbia University, 1966, p. 485), who adheres to the traditional dating of 1477 with a tentative attribution to Baldassare d'Este. Laclotte (1957, p. 7) lists the portraits under the rubric "Attribué à Lorenzo Costa" and relates them to two donor portraits in the Kestner-Museum, Hanover, where the profiles are likewise set off by a darker architectural background. The Hanover portraits have been inconclusively ascribed to Baldassare d'Este, with whom a number of fresco fragments from

the Oratorio della Concezione, now in the Pinacoteca Nazionale at Ferrara, have also been associated (for these see M. Calvesi, "Nuovi affreschi ferraresi dell'Oratorio della Concezione, I," *Bollettino d'arte*, 32, 1958, pp. 141–56). The present portraits have affinities with the portraits at Hanover, though these are too general for identity of authorship to be presumed. Sgarbi ("A Painter Restored," *FMR*, 12, 1985, p. 118) notes that the portraits are tentatively attributed by Zeri (written communication) to Antonio da Crevalcore. The style is inconsistent with that of other portraits ascribed to Crevalcore, notably the *Portrait of the Sacrati Family* in the Alte Pinakothek, Munich, and the *Portrait of a Youth*, signed A. F. P., in the Museo Correr, Venice. The quality of the diptych is less high than that of the Bentivoglio diptych by Ercole de' Roberti, and the two portraits appear to be the work of a secondary Emilian artist active in the last decade of the fifteenth century. Volpe ("Tre vetrate ferraresi e il Rinascimento a Bologna," *Arte antica e moderna*, 1, 1958, pp. 30–31) ascribes them to the anonymous author of a fresco cycle in the Castello dei Bentivoglio at Ponte Poledrano. This attribution, resting on convincing analogies between the landscapes in the present paintings and those in the frescoes, was later accepted by Sgarbi (*Antonio da Crevalcore e la pittura del Quattrocento a Bologna*, 1985, pp. 20–22) and is likely to be correct.

The male figure is shown holding a spray of pinks, and his wife holds a fruit which may be an apple or a peach. The pink occurs frequently in the context of marriage or engagement portraits (see F. Mercier, "La valeur symbolique de l'oeillet dans la peinture du Moyen-Age," *La Revue de l'art ancien et moderne*, 71, 1937, pp. 233–36), and the peach commonly symbolizes marriage. The conjunction in the lower left corner of the male portrait of a severed tree trunk with a pelican in her piety (a personification of charity) and a phoenix (symbolizing revival or resurrection), and in the lower right corner of the female portrait of two rabbits (representing fecundity) and a girl with a bridle confronting a unicorn (connoting chastity), provides evidence that the portraits were painted to a program deriving from specific circumstances which cannot now be reconstructed.

CONDITION: The paint surface has been evenly abraded throughout, but paint loss is largely confined to scratches in the lower left corner of the panel and across the sitter's mouth and nose. The sitter's hair and red doublet have been reinforced, with a false craquelure added across his shoulder. A pentiment around his cap has been painted out. The bearded edge of the paint is evident on all four sides.

PROVENANCE: Contessa Gozzadini, Bologna; Stefano Bardini, Florence; Bardini sale, Christie's, London, May 26–30, 1902, lot 600 (bt. Anderson); Trotti, Paris, 1909. Acquired by Philip Lehman from Trotti in October 1911.

EXHIBITED: Esposizione d'Arte Antica, Bologna, 1888 (omitted from catalogue); Galerie Trotti, Paris, January 1909; Nelson Art Gallery, Kansas City, 1942–44; Colorado Springs Fine Arts Center, *Paintings and Bronzes from the Collection of Robert Lehman*, 1951–52 (as Francesco del Cossa); Metropolitan Museum of Art, New York, 1954–61 (as Francesco del Cossa); Musée de l'Orangerie, Paris, *La collection Lehman*, 1957, nos. 7, 8 (as Lorenzo Costa); Cincinnati Art Museum, *The Lehman Collection*, 1959, nos. 81, 82 (as Francesco del Cossa); Metropolitan Museum of Art, New York, *Masterpieces of Fifty Centuries*, 1970–71, no. 198 (as Francesco del Cossa).

90. Portrait of a Lady of the Gozzadini Family

1975.1.96

Tempera on panel. Overall: 50.1 × 37.2 cm. (19¾ × 14⅝ in.); paint surface: 48.6 × 35.9 cm. (19⅛ × 14⅛ in.). The panel, with a vertical wood grain, has been thinned to 9 mm. and cradled. Its frame is old but not original to the panel.

The sitter is shown in bust-length, in profile to the left. She wears a blue-green dress with brocaded sleeves of red and brown on a white ground, and has a transparent veil over her shoulders. In her right hand, the fingers of which are visible at the lower left corner, she holds an apple or peach. Round her neck is a collar of four strands of black beads, and beneath it is a jeweled pendant hanging on her chest. Her soft brown hair is braided and tied into a knot at the back of her head. Her head is silhouetted against the dark window of a stone building, in the cornice of which are the words FORMA.SVPERSTES. The two words are separated by a roundel with a horseman, and a half roundel with a putto closes the frieze on the right. From a spike beneath the window hangs a coat of arms (see above). On the right is a distant view of a lake with a number of small boats, beyond which is a town. On the near side of the lake to the left is a castle or fortified town. A stream winds back round a rocky cliff in the middle distance, with a boatman steering his boat. In the foreground is a young woman extending a bridle toward a unicorn; in front are two rabbits, an ermine, a bird, and the stump of a withered tree with one new branch.

See No. 89.

CONDITION: The paint surface is heavily abraded, and the flesh tones have been reinforced. The bearded edge of the paint is visible on all four sides.

PROVENANCE: See No. 89.

EXHIBITED: See No. 89.

No. 90

Francia, who was born about 1450 and died in 1517, is the dominant figure in Bolognese painting in the late fifteenth and early sixteenth centuries. He was strongly influenced in his early work by Lorenzo Costa, and his development can be traced after 1492 in a succession of altarpieces painted for Santa Maria della Misericordia, Bologna (1494, Pinacoteca Nazionale, Bologna), the Bentivoglio Chapel in San Giacomo Maggiore, Bologna (1499), Santa Cecilia, Modena (1502, Berlin-Dahlem), and the Frati dell'Annunziata, Parma (1515, Pinacoteca Nazionale, Parma). An extremely prolific artist whose best work is of excellent quality, Francia, sometimes in collaboration with his sons Giacomo and Giulio, also produced a large number of half-length paintings of the Virgin and Child, a good example of which is the painting discussed below.

91. Madonna and Child with Saints Francis and Jerome

1975.1.97
Oil on panel. 74.8 × 56.3 cm. (29⁷⁄₁₆ × 22½ in.). The panel, which has a vertical grain, has been thinned and cradled.

The Virgin is shown behind a parapet. Seated on her right thigh, the Child leans outward to the spectator's left. On the left is a Franciscan saint (probably Saint Francis) and on the right is a bearded saint (probably Saint Jerome) with body in profile and head turned frontally. At the back is a tree-filled landscape with a distant town, framed at the sides by hills, which rise somewhat above the level of the saints' heads. To the right on the front face of the parapet is the artist's signature: FRANCIA AURIFABER P.

There is no record of the history of the picture prior to 1916, when it appeared in the Volpi sale in New York. According to the sale catalogue (*Illustrated Catalogue of the exceedingly rare and valuable Art Treasures and Antiquities formerly contained in the famous Davanzati Palace, Florence, Italy, which, together with the contents of his Villa Pia, were brought to America by their owner Professore Commendatore Elia Volpi, the recognized European expert and connoisseur*, 1916, no. 1018), it had been purchased by Volpi in Rome in the preceding year from the palace "of one of the oldest Patrician families of Rome." At this sale and subsequently, it was claimed to be identical with a painting executed by Francia for Cardinal Riario, which is referred to in a letter from Raphael to Francia variously assigned to 1508 and 1516 (see J. Calvi, *Memorie della vita, e delle opere di Francesco Raibolini,*

detto Il Francia, 1812, pp. 56–57). There is no corroboratory evidence of this. A point of reference for the panel is provided by a *Madonna and Child with Saints Francis and Jerome* in the Metropolitan Museum of Art (acc. no. 41.100.3). In the latter painting, the mark of the stigmata is shown on the exposed hand of Saint Francis, and traces of the same mark occur on the hand of the Franciscan saint in the Lehman panel. The landscape is closely related to that in the panel in the Metropolitan Museum, and the distant view of a city on the right recalls that in Francia's portrait of Evangelista Scappi in the Uffizi, Florence. The present painting is, however, of somewhat lower quality, and appears, on the analogy of the Buonvisi altarpiece in the National Gallery, London, to date from about 1512–15. A head on the right of a half-length Madonna in the Galleria Nazionale di Palazzo Barberini, Rome, commonly given to Giacomo Francia, depends from the same cartoon as the Saint Jerome in the present panel. The cartoon for the entire composition, less the figure of Saint Francis, was used once more in a panel in the Pinacoteca Vaticana (inv. 360).

CONDITION: The paint surface is well preserved but is disfigured by liberal inpainting over the broad craquelure. The hand and habit of the Franciscan saint have been damaged and inpainted, as have the Child's left ankle and the fingers of the Virgin's left hand. The signature at the base is restored but is evidently original. A black strip has been painted across the top over the sky.

PROVENANCE: Elia Volpi, Villa Pia, Florence (for alleged earlier pedigree, see above); Volpi sale, Plaza Hotel, New York, November 27, 1916, no. 1018, bt. Ehrich Galleries; Henry Goldman, New York; Duveen Bros., New York (by exchange from Henry Goldman); John R. Thompson, Chicago (Duveen Bros., *Six Pictures and a Gothic Tapestry in the Collection of Mr. John R. Thompson*, 1924, no. 3); Trustees of the late John R. Thompson sale, Parke-Bernet Galleries, New York, January 15, 1944. Acquired by Robert Lehman in 1944.

EXHIBITED: Cincinnati Art Museum, *Italian Pictures*, 1923; Duveen Bros., New York, 1924 (W. R. Valentiner, *Catalogue of Early Italian Pictures Exhibited at the Duveen Galleries*, 1924, no. 34); Art Institute of Chicago, September 1924 (see *Bulletin of The Art Institute of Chicago*, 1924, 18, no. 6, p. 81); Cincinnati Art Museum, *The Lehman Collection*, 1959, no. 93.

No. 91

MARCHES
Fifteenth Century

Carlo Crivelli

Born about 1430–35, Carlo Crivelli, and his brother Vittorio, were the sons of a painter who is documented in Venice between 1444 and 1449. Crivelli seems to have been trained in Venice, but at an early stage he came in close contact with Paduan painting—especially with the work of Squarcione and his pupils Mantegna, Zoppo, and Schiavone. In the middle of the 1460s he was working in Dalmatia, and thereafter he was active in the Marches at Fermo and Ascoli Piceno. No dated early works are known, but after 1468 (the date of an altarpiece in the Palazzo del Municipio at Massa Fermana) the development of Crivelli's sophisticated, archaizing style can be traced in a disassembled polyptych of 1472 (panels in the Metropolitan Museum of Art and elsewhere) and an altarpiece of 1473 in the Duomo at Ascoli Piceno. The Madonna discussed below must be judged in relation to these works. Crivelli died in 1495.

92. An Apostle

1975.1.84

Tempera on panel. 32 × 23 cm. (12⁹⁄₁₆ × 9¹⁄₁₆ in.). The panel, which is warped along its horizontal wood grain, is neither thinned nor cradled, and is approximately 3 cm. thick.

The figure, shown in half-length on an arched panel, holds a scroll in the left hand. His right hand is raised and his index finger extended, and he gazes upward to the left. He wears a yellow cloak, lined in gray, over a pale blue robe.

The figure of an apostle is one of a series of panels of Christ and seven apostles which remained till 1926 in the Cornwall Legh collection, Cheshire. They were earlier owned by Pietro Vallati in Rome (see below), and were stated at that time to have formed part of an altarpiece by Crivelli in the Franciscan Observant Church at Montefiore dell'Aso, near Fermo. The panel of Christ is now in the Clark Art Institute at Williamstown (Fig. 83), two apostles are in the Detroit Institute of Arts, two apostles are in the Honolulu Academy of Arts (Fig. 84, Kress collection), and two apostles are in the Bearstead collection (National Trust), Upton House, Banbury, Oxfordshire. The panels at Detroit represent Saints Peter and John the Evangelist (Fig. 82), one of the panels in Hawaii represents Saint Andrew, and one of the panels in the Bearstead collection represents Saint Luke. The apostles shown in the second Bearstead panel, in the second Honolulu panel, and in the present panel cannot be identified.

That the panels come from Montefiore dell'Aso is accepted by Rushforth (*Carlo Crivelli*, 1900, p. 96), Drey

(*Carlo Crivelli*, 1927, p. 53), Zampetti (*Carlo Crivelli*, 1961, pp. 81–82), and all other students of Crivelli. The central panel of the main register of the Montefiore altarpiece is a *Madonna and Child Enthroned* (Fig. 85) in the Musées Royaux des Beaux-Arts, Brussels, purchased, with a contiguous figure of Saint Francis (Fig. 86), from Vallati in Rome. Three further lateral panels, with Saints Catherine of Alexandria, Peter, and Mary Magdalene (Fig. 87), are in the church of Santa Lucia at Montefiore. The pinnacles of the altarpiece comprised a *Pietà* in the National Gallery, London (no. 602, for which see Davies, *National Gallery Catalogues: The Earlier Italian Schools*, 1951, pp. 119–20), three Franciscan saints (Louis of Toulouse, Clare, and another unidentified saint) at Montefiore, and a fifth panel, which is untraced. Two further panels with Saints Bartholomew and John the Evangelist in the Museo Civico del Castello Sforzesco, Milan, have the same provenance as the eight predella panels (Vallati, Rome) and were regarded by Drey (op. cit., pl. 17) and Van Marle (*Development*, vol. 18, 1936, p. 13) as parts of the same predella. They have since been correctly associated by Zeri ("Cinque schede per Carlo Crivelli," *Arte antica e moderna*, 13–16, 1961, pp. 158–62) with a second predella, further panels of which are at El Paso and in the Yale University Art Gallery.

A reconstruction of the Montefiore dell'Aso altarpiece by Bovero (*L'opera completa del Crivelli*, 1974, pp. 87–88) shows the predella with Christ and ten apostles. In this form, the width of the predella would have been approximately coterminous with that of the main register of the altarpiece, as in the predella of the altarpiece by Crivelli in the Duomo at Ascoli Piceno, where ten apostles are also shown. An altarpiece by Carlo and Vittorio Crivelli in San Martino di Montesammartino (see Zampetti, "Un polittico poco noto di Carlo e Vittore Crivelli," *Bollettino d'arte*, 36, 1951, pp. 130–38), however, has a predella in which the panel of Christ is set forward from the main plane with two figures of apostles at angles beside it, comprising in all twelve apostles. At least three, and perhaps five, panels of the present predella are thus untraced.

CONDITION: The paint surface and gilding are very well preserved, except for a strip 4 cm. deep at the base of the panel that is modern. Damage to the gold surface on both sides, about 10 cm. from the top, may have resulted from the removal of framing pilasters.

PROVENANCE: Probably church of the Observant Franciscans at Montefiore dell'Aso near Fermo; purchased by Pietro Vallati, Rome, shortly before 1858 (diary of Otto Mündler and note-

No. 92

books of Sir Charles Eastlake in the National Gallery, London, cited by Davies, loc. cit.); Cornwall Legh collection, High Legh Hall, Knutsford, Cheshire, till 1926; Hadeln, Florence. Acquired by Robert Lehman in 1926.

EXHIBITED: Smith College Museum of Art, Northampton (Mass.), 1942–43; Cincinnati Art Museum, *The Lehman Collection*, 1959, no. 97.

Carlo Crivelli (attributed to)

93. Madonna and Child Enthroned

1975.1.83

Tempera on panel. 141 × 59.4 cm. (55½ × 23⅜ in.). The panel, which has a vertical grain, has been cut out of its engaged frame, thinned, and cradled. It is composed of three vertical strips of wood approximately 5.5 cm., 48.5 cm., and 5.5 cm. wide.

The Virgin is seated on a marble throne. At either side of the throne is a panel of foliated decoration, and at the back is an arched tabernacle structure enriched with decorative carving and swags of fruit. The throne rests on a polygonal platform which projects to the front of the pavement painted across the bottom of the panel and comprises, in the front plane, two concave sections meeting in a point. The surface of the platform is inlaid in white and black. The Virgin's head is crowned and covered with a veil, and she wears a blue and gold brocaded cloak over a brocaded dress. She supports the Child in the crook of her right arm and holds his left foot in her right hand.

Since it was first published by Fry ("*Madonna and Child* by Carlo Crivelli," *Burlington Magazine*, 22, 1913, p. 309) and Mather ("A Madonna by Carlo Crivelli," *Art in America*, 1, 1913, pp. 48–53), this panel, which is exceptional in that it is unsigned, has been unanimously accepted as a work of Carlo Crivelli. The dating about 1482, proposed by Fry and Mather, was advanced to ca. 1476 by A. Venturi (*Storia*, vol. 7, *iii*, 1914, p. 370) and to ca. 1474 by Testi (*La storia della pittura veneziana*, vol. 2, 1915, p. 624). A still earlier dating, in the vicinity of the Macerata *Madonna* of 1470, was proposed by Berenson ("Venetian Paintings in the United States, II," *Art in America*, 3, 1915, pp. 113–14, and *Venetian Paintings in America*, 1916, p. 19), and in the Berenson lists (1932, p. 102; 1936, p. 141; 1957, vol. 1, p. 70) the painting is described as an early work. Berenson's dating has since been generally endorsed, e.g., by L. Venturi (*Pitture italiane in America*, 1931, pl. 272) and Zampetti (*Carlo Crivelli*, 1961, pp. 98–99, "opera giovanile, attorno al '70–'71, non lontana da quella di Macerata"), though Bovero (*Tutta la pittura del Crivelli*, 1961, pp. 16–17, 59–60, and *L'opera completa del Crivelli*, 1974, p. 85) believes it to have been painted in Venice at a still earlier date. Drey (*Carlo Crivelli und seine Schule*, 1927, p. 62) observes that the *Madonna* is "chronologisch schwer einzureihen" but was possibly painted about 1473–76. He notes that the form of the throne is unusual for Crivelli and has a parallel in the *Stonyhurst Madonna* of Nicola di Maestro Antonio da Ancona, now at Minneapolis. Bovero (loc. cit.,

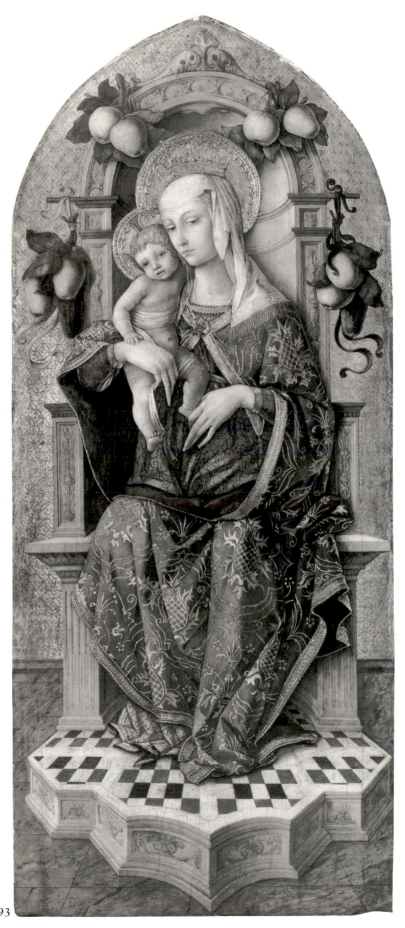

No. 93

1961) wrongly relates the structure and decoration of the throne to that in an altarpiece of 1465 by Bartolomeo Vivarini in the Pinacoteca Nazionale di Capodimonte, Naples.

These discussions are vitiated by inadequate attention to the deplorable condition of the painting, which accounts for the anomalous position it occupies in the sequence of Crivelli's signed and dated altarpieces. A detailed account of its physical state, based on microscopic examination, is given below. The only areas that remain in their original state are the platform of the throne and the areas of pavement to right and left behind it, the pilasters beneath the seat and parts of the pilasters above them, the border of the Virgin's cloak and the base of her skirt, the Virgin's left hand, the Child's right leg, his forehead over the right eye, and a small part of the veil over the Virgin's forehead. The gold ground is in part original below the two arms of the throne. The upper part of the throne retains its original form, but the fruit and ribbons have been much modified. The gold in this part of the painting is modern, with a stamp that differs slightly from the stamp employed beneath. The shape of the upper part of the panel has been changed, and there is evidence that the panel at the top originally had a quinquefoil molding. On the basis of these areas alone, it may be noted that the form and projection of the lower part of the throne recall that of the Madonna by Nicola di Maestro Antonio at Minneapolis, as do the folds of the Virgin's skirt which fall on the platform. The architectural elements in the upper half have a counterpart in an altarpiece by the same artist in the Carnegie Institute in Pittsburgh, and the form of the quinquefoil molding recalls that in the Pietà by him at Jesi. There is no parallel for these features in the work of Carlo Crivelli, and the parts of the painting that relate to Crivelli—the head of the Virgin and the Child—date from a restoration undertaken before 1913. It may be noted that a number of altarpieces or panels by Crivelli (e.g., a Virgin and Child with two saints in the Pinacoteca Civica at Ascoli Piceno) and by Nicola di Maestro Antonio (e.g., an altarpiece in the Pinacoteca Vaticana) are gravely damaged, in the case of the Ascoli Piceno panel in somewhat the same manner and somewhat the same areas as the present painting. We have therefore the alternative (i) of regarding the present Madonna (as has been suggested verbally by Zeri) as a ruined work by Nicola di Maestro Antonio, which was repainted before 1913 to resemble the work of Crivelli in the 1470s, or (ii) of considering it a ruined early work by Crivelli, painted under the influence of Schiavone, not of the Vivarini, which was repainted in the style of

Crivelli's mature paintings. The first of these explanations is likely to be correct.

CONDITION: Save for the parts noted above, the figures of the Virgin and Child are in all essentials false. The pavement in the foreground (*right* and *left*) is largely modern, and the forward point of the platform beneath the throne has been made up. Though the gold edging of the Virgin's cloak appears to be original, the bluish paint and much of the pastiglia decoration over it is of comparatively recent date. The lining of the cloak has been rubbed down to its priming and repainted green. The two haloes and the Virgin's pastiglia crown are modern. The Child's head is in large part false, and the figure is extensively restored across the chest and belly, on the left leg, and on the right arm. The Virgin's veil and face have been built up with thin pigment over the original ground, and a fine painted craquelure has been applied to the surface. Her right hand has been treated in the same way, but her left hand is relatively well preserved. With the exception of one area noted above, the veil is modern, and the fringe on the left shoulder is also wholly new.

PROVENANCE: Baron Lazzaroni, Paris; Duveen Bros., New York. Acquired by Philip Lehman in 1912 (a letter of November 21, 1912, from Duveen to Berenson announces the sale of the painting to "Mr. Philip Lehman here in New York, who is a new collector and who apparently has a great ambition to add to his collection the finest pictures he can buy"). Bovero (op. cit., p. 85) incorrectly gives the date of acquisition as 1928.

EXHIBITED: Nelson Art Gallery, Kansas City, 1942–44; Colorado Springs Fine Arts Center, *Paintings and Bronzes from the Collection of Robert Lehman*, 1951–52; Metropolitan Museum of Art, New York, 1954–61; Musée de l'Orangerie, *La collection Lehman*, 1957, no. 11; Cincinnati Art Museum, *The Lehman Collection*, 1959, no. 98.

VENICE
Fifteenth Century

A member of a family of artists active in Murano, Bartolomeo Vivarini was born about 1432, and was apparently trained by his elder brother, Antonio, with whom he collaborated during the 1450s. At the outset of that decade, he was active, with Antonio, at Padua, where the works of Mantegna and his imitators had a formative influence on his style. A long succession of dated or documented paintings extends from Bartolomeo Vivarini's first signed and dated work (a panel of Saint Giovanni Capistrano, of 1459, in the Musée du Louvre) to 1491, the date of a triptych in the Accademia Carrara at Bergamo.

94. Madonna of Humility with Two Angels and a Kneeling Nun, Between *(left)* the Annunciatory Angel and the Nativity and *(right)* the Virgin Annunciate and the Pietà

1975.1.82

The triptych consists of three panels with a vertical grain, each of which has been thinned to approximately 6 mm. and cradled. Central panel, overall: 58.4 × 45.8 cm. (23 × 18 in.); picture surface: 53.8 × 44.1 cm. (21³/₁₆ × 17⁵/₁₆ in.). Left panel, overall: 56.8 × 24.1 cm. (22³/₈ × 9½ in.); picture surface, above: 24.9 × 21.6 cm. (9¹³/₁₆ × 8½ in.), below: 24.8 × 21.7 cm. (9¾ × 8½ in.). Right panel, overall: 56.6 × 23.7 cm. (22¼ × 9⁵/₁₆ in.); picture surface, above: 24.8 × 21.3 cm. (9¾ × 8³/₈ in.), below: 24.9 × 21.6 cm. (9¹³/₁₆ × 8½ in.).

The Virgin is seated on a red and gold cushion in a meadow backed by distant trees. She wears a pink dress covered with a gold-embroidered cloak. Two white-clad angels support the crown on her head. The Child, in a pale violet tunic, seated on her thigh, extends his right hand to a kneeling nun in a Dominican habit at the left. The left wing shows *(above)* the Annunciatory Angel in a pink cloak and white tunic, with blue and yellow wings, kneeling with outstretched arm. To the side is a receding building and at the back a garden. A vase of lilies stands on the pavement at the right. In the lower register is the Nativity. The kneeling Virgin, turned to the right, is shown beside a tree trunk that supports the stable roof, with hands clasped in prayer adoring the Child, who lies on her cloak in the center foreground. To the right, in a middle plane, is the sleeping figure of Saint Joseph leaning against the manger. In the right wing is the Virgin Annunciate *(above)*, in a blue cloak and pink dress, kneeling before a wooden prie-dieu. Behind is her bed with a dark green coverlet and red curtain. The scene below shows the Virgin in a blue cloak over a pink dress and a white head-dress, seated on the ground in a barren landscape in

which the three crosses are visible on a distant hill. With her left hand she supports the head of Christ, whose body is disposed diagonally across her knees.

The present frame of this beautiful triptych is modern, but it preserves the original relationship among the five scenes. The two scenes in each wing are painted on a single panel, and the three panels are reproduced, without framing, by Berenson (1957, fig. 112A–C). At Gosford (see below), the two wings and the central panel were framed as rectangles. The regular ogival form imposed upon the lateral panels by the present framing is incorrect, and the condition of the paint surface leaves no doubt that they were originally framed more freely with irregular spandrels. The central panel culminates in a depressed arch similar in form to those of the main panels of the altarpiece by Antonio Vivarini and Giovanni d'Allemagna, of 1443, in the Cappella di San Tarasio in San Zaccaria, Venice, and may, on a reduced scale, have been framed in somewhat the same way.

The panel is listed by Berenson (1911, p. 149; 1932, p. 602; 1936, p. 518; 1957, vol. 1, p. 202) as a work of Bartolomeo Vivarini, and is discussed by him in *Venetian Painting in America* (1916, p. 18, n. 2): "As this is going to the press I hear that Mr. Philip Lehman of New York has acquired Lord Wemys' [*sic*] Madonna with the 'Annunciation,' 'Nativity,' and 'Pietà.' It is a welcome addition to our Vivarinis although it does not come up to either Mr. Platt's 'Madonna,' or Mr. Morgan's 'Epiphany.' It must have been painted toward the end of Bartolomeo's early period." The picture is listed by Crowe and Cavalcaselle (*A History of Painting in North Italy*, vol. 1, 1912, p. 49, n. 2) and Testi (*La storia della pittura veneziana*, vol. 2, 1915, p. 487), and is accepted as a work of Bartolomeo Vivarini by Sirén and Brockwell (*Catalogue of a Loan Exhibition of Italian Primitives in Aid of the American War Relief*, Kleinberger Galleries, New York, 1917, no. 89, as a "very important work from the finest period of Bartolomeo's artistic activity"); R. Lehman (1928, pl. 76); L. Venturi (*Pitture italiane in America*, 1931, pl. 269: "Molto affine per lo stile è il quadro del museo di Napoli. La data del politico va posta circa il 1470"); Van Marle (*Development*, vol. 18, 1936, p. 110, as "in a manner close to the picture of 1471" in the Galleria Colonna, Rome); Laclotte (1957, p. 49, no. 59, "oeuvre caractéristique de la maturité de Bartolommeo Vivarini, vers 1465–70"); and Pallucchini (*I Vivarini*, n.d., p. 119, no. 154, fig. 54). The iconography of the *Madonna of Humility* in the central panel recalls that of a *Madonna of Humility* by

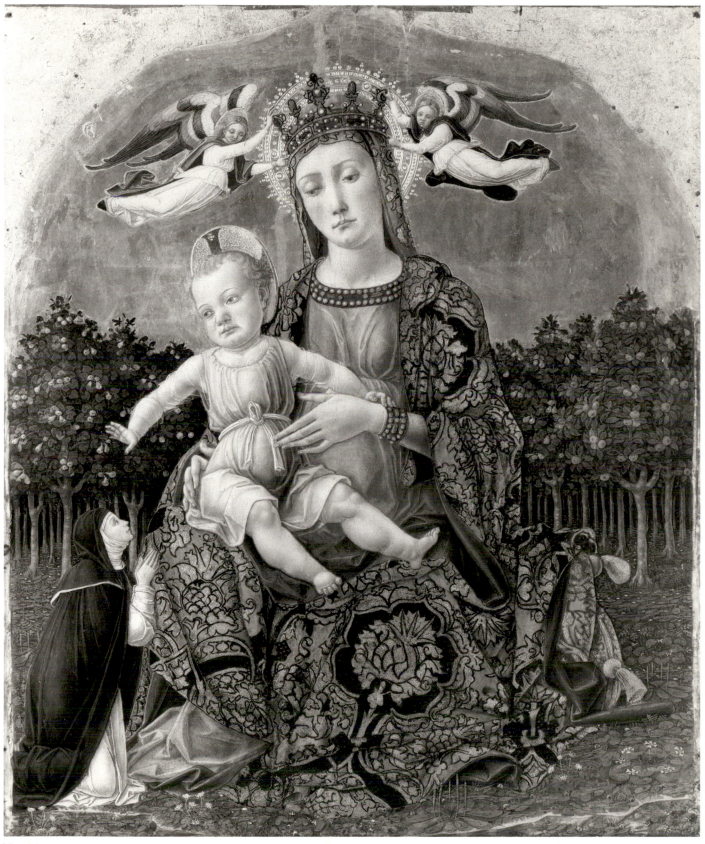

No. 94

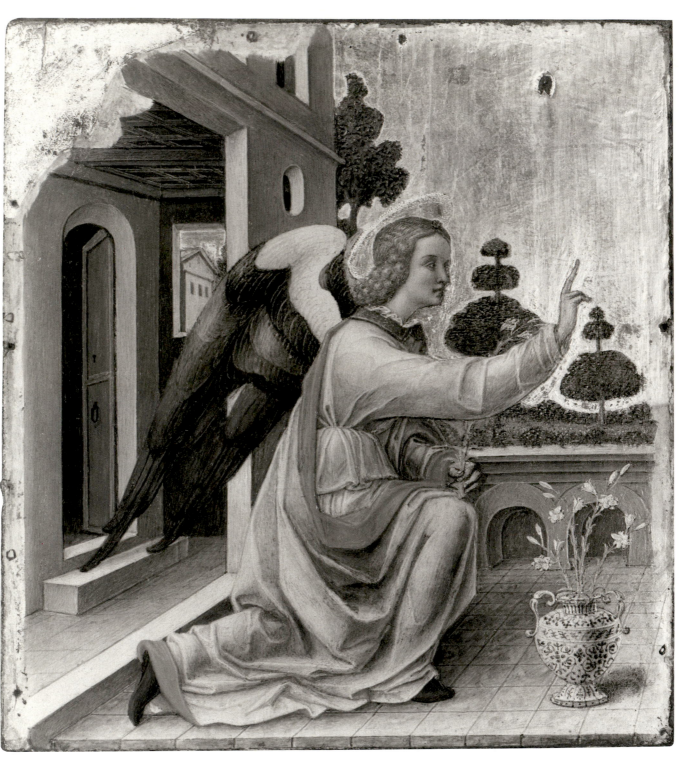

No. 94

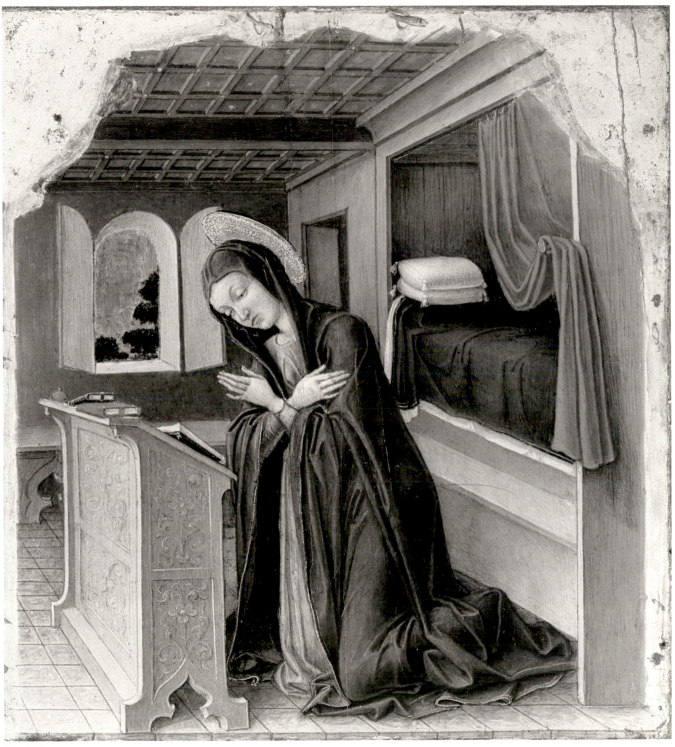

No. 94

No. 94

No. 94

Antonio Vivarini in the Museo Davia Bargellini, Bologna, where the Virgin is also shown in a woodland setting. The line of trees behind the Virgin recurs in the altarpiece by Bartolomeo Vivarini, of 1465, in the Pinacoteca Nazionale di Capodimonte, Naples, where the gold brocade of the Virgin's cloak follows the same pattern as in the present painting. Pallucchini regards the Virgin as "sorella di quella di Napoli," and his dating soon after 1465 is likely to be correct.

CONDITION: In the central panel, a vertical split running the whole height of the panel to the left of center has been repaired, and the resultant paint losses have been made good. The principal areas of damage are the Virgin's left hand and the face of the nun. The lapis surface of the Virgin's robe seems to have undergone two restorations, and the gilt ornament has been partially renewed. The upper scene in the left-hand panel, though regilt, is generally well preserved. In the lower scene, the faces and hands, other than those of Christ, have been slightly reinforced and the gold ground has been renewed. In the upper scene on the right panel, the face and hands of the Virgin have been slightly reinforced and scratches on the Virgin's cloak have been touched in. The paint surface is otherwise extremely well preserved. In the lower scene, the figures are abraded and have been extensively retouched, especially in the areas of shadow on Christ's body and face and in his left arm, which is largely reconstructed. The landscape, however, is well preserved, as is the gold ground.

PROVENANCE: Earl of Wemyss, Gosford House, Longniddry, Scotland; bt. on commission by R. Langton Douglas, May 1916. Acquired by Philip Lehman in 1916.

EXHIBITED: F. Kleinberger Galleries, New York, *Loan Exhibition of Italian Primitives in Aid of the American War Relief*, 1917, no. 89; Metropolitan Museum of Art, New York, 1944, 1954–61; Musée de l'Orangerie, Paris, *La collection Lehman*, 1957, no. 59; Cincinnati Art Museum, *The Lehman Collection*, 1959, no. 96.

Giovanni Bellini

Son of the best-known Venetian painter of the first half of the fifteenth century, Jacopo Bellini, and brother of Gentile Bellini (1429–1507), Giovanni Bellini was born about 1430. His development can be followed in dated or datable works from the 1470s to the penultimate year of his life (1515). There is some doubt as to the exact chronology and sequence of his earlier paintings. This affects judgments especially on the early half-length paintings of the Madonna and Child, one of which is discussed below.

95. Madonna and Child

1975.1.81

Tempera and oil on panel. 53.9 × 39.9 cm. (21¼ × 15¾ in.) excluding added strips, save for one 7 mm. deep at the top, not extending the full width of the panel, incorporated into the paint surface.

The Virgin is shown in half-length behind a narrow ledge covered with cambric that runs across the base of the panel. Her left hand rests on the ledge, the middle finger touching its front edge. Her head is turned slightly to her left, and she supports the standing Child with her right hand. Her auburn hair is parted in the center and is covered by a white veil. She wears a dark mauve dress edged with white at the throat, beneath a dark blue cloak. The cloak over the forearms and the neck of the dress are bordered with a geometrical pattern in gold thread. The Child, whose right hand is raised in benediction and whose left hand grips the fingers of the Virgin's right hand, wears a red cap tied under the chin, a red tunic with white sleeves, and a wide belt round his body. The figures have translucent foreshortened haloes. On the ledge are (right) a single reddish gold fruit and (left) a gourd with a dark green stem. Behind the Virgin's head is a garland suspended by red ribbons from points beyond the edges of the painting. The foliage in the garland, apparently acanthus, is interspersed with orange-red globular fruit. The landscape background shows (left) two curved paths leading to a town or village, the roofs of whose houses are visible among the trees. Further back are three tall buildings, the towers of which rise against a distant mountain. The tree-filled middle distance (right) gives way to a lake, on the further side of which are two hills seen against the blue of a more distant mountain range. The sky shades from a saturated blue at the top of the panel to white at the horizon, broken at the left by a bank of white clouds.

The painting was first identified and published by Gnoli (*Rassegna d'arte*, 11, 1911, p. 177) as an early work by Giovanni Bellini associable with the Davis *Madonna* (Metropolitan Museum of Art, New York), the Frizzoni *Madonna* (Museo Correr, Venice), and a *Madonna* in Berlin (no. 1177). The attribution to Giovanni Bellini is contested only by Dussler (*Giovanni Bellini*, 1935, pp. 149–50), who later withdrew his objections and accepted the panel as an autograph work (*Giovanni Bellini*, 1949, p. 87: "Die von mir früher erhobenen Bedenken gegen die Eigenhändigkeit teile ich heute nicht mehr"). A number of widely differing views have been expressed on the date of the painting. A dating ca. 1455–60 is advanced by Pallucchini (*Giovanni Bellini, catalogo illustrato della mostra*, 1949, no. 5; *Giovanni Bellini*, 1959, pp. 28, 131) and Bottari (*Tutta la pittura di Giovanni Bellini*, vol. 1, 1963, p. 23; *Encyclopaedia of World Art*, vol. 2, 1960, p. 452), and a dating ca. 1460 by Longhi ("The Giovanni Bellini Exhibition," *Burlington Magazine*, 91, 1949, p. 278), Laclotte (1957, p. 2), Pignatti (*L'opera completa di Giovanni Bellini*, 1969, no. 19), and Huse (*Studien zu Giovanni Bellini*, 1972, pp. 3, 13). A somewhat later dating, between 1460 and 1465, is proposed by Dussler (op. cit., 1949, p. 14) and Moschini (*Giambellino*, 1943, p. 12), and by implication by Van Marle (*Development*, vol. 18, 1935, pp. 220–21), Gronau (*Giovanni Bellini*, Klassiker der Kunst, 1930, p. 17), and Robertson (*Giovanni Bellini*, 1968, p. 37). Berenson ("A Madonna by Giovanni Bellini Recently Acquired by Mr. Philip Lehman," *Art in America*, 5, 1916, pp. 3–5) relates the panel to the *Lamentation over the Dead Christ*, of 1472, in the Palazzo Ducale, Venice, and postulates a dating ca. 1470.

The closest parallel in Giovanni Bellini for the type of the Virgin, with her long face divided into contrasting areas of light and shadow, occurs in the Frizzoni *Madonna* in the Museo Correr, Venice, and a *Madonna* in the Isabella Stewart Gardner Museum, Boston. Though both paintings are much abraded, it is likely that the three works were produced in close proximity. The present painting is, however, distinguished from them by its stronger coloring, by the type of the Child, and by the garland hanging behind the Virgin's head. These three features reflect the style of Mantegna, and the early dating proposed for it by Longhi and other students is based upon this fact. The head of the Child recalls that in Mantegna's altarpiece in San Zeno, Verona (1457–60), and an analogy for the belt worn round the Child's waist occurs in the figure of a child in the *Circumcision* in the right wing of Mantegna's Uffizi triptych (undated, perhaps 1464).

The relationship of the painting to Mantegna is not,

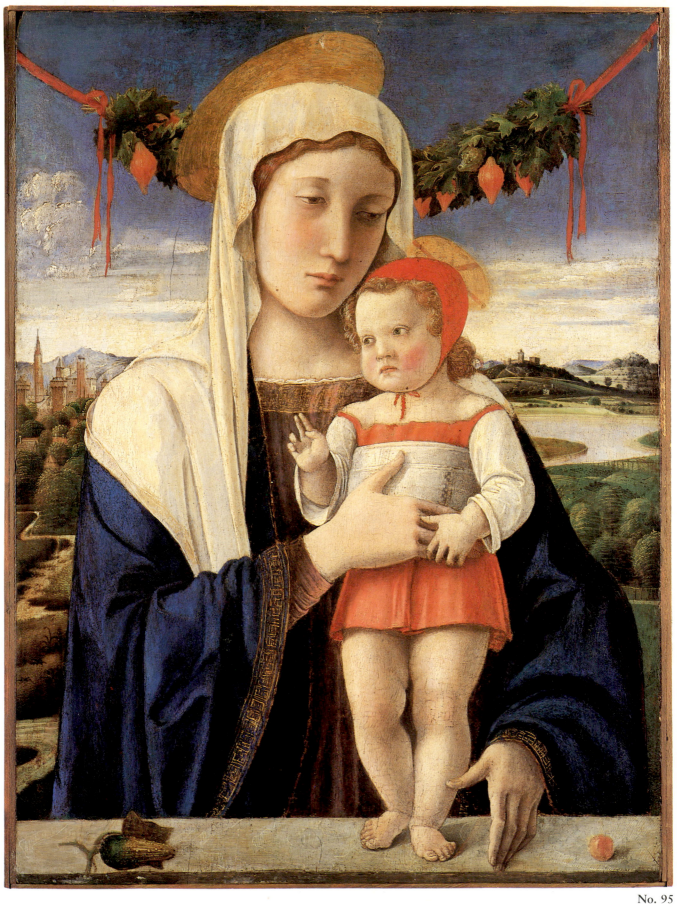

however, a matter of generic influence (which might support a dating ca. 1460), but suggests rather, as Berenson (loc. cit.) supposed, that it was adapted from a lost Madonna by Mantegna of the class of a Mantegnesque Madonna at Tresto. A Child similarly clothed and wearing a body belt occurs in a *Madonna and Child with Saints Jerome and Louis of Toulouse* in the Musée Jacquemart-André, Paris, variously ascribed to Mantegna and to Mantegna in collaboration with Gentile or Giovanni Bellini, and in Bellinesque Madonnas in the Ca' d'Oro, Venice, and in the Pinacoteca Querini-Stampalia, Venice. The landscape, with its strongly defined horizontal lines of cloud and its slow movement into depth, differs markedly from that of the early Davis *Madonna* in the Metropolitan Museum of Art, and would be consistent with a dating shortly before 1470. Berenson, writing in 1916, observes that "the reappearance of this work was more of a delight than a surprise, for I had long been acquainted with a crude but nearly contemporary copy. It is in the collection of the Bavarian Minister at Vienna, Baron Tucher." This painting is recorded in an Anderson photograph (6185) as Bono da Ferrara.

The gourd on the left of the ledge is identified by Levi d'Ancona (*The Garden of the Renaissance*, 1977, p. 157) as a balsam pear (*Momordica charantia*). The fruit on the right is either a cherry or a small apple. The cherry carries a eucharistic significance. The association of an apple, as symbol of the Fall, with a gourd, as symbol of the Resurrection, occurs in Madonnas by Carlo Crivelli in the National Gallery, London, and in the Metropolitan Museum of Art, New York. The orange-red globular fruits and the one greenish-brown fruit of the same type in the garland seem also to represent a type of gourd.

CONDITION: The paint surface in the figures is much abraded. A photograph of the painting in a stripped state made during cleaning in 1945 shows that the right side of the Virgin's face and neck has suffered extensively and has been liberally overpainted, as have the whole surface of her dress between the neckband and the parapet, the lining of her cloak above and below her right wrist, and the surface of her cloak over her left and beneath her right arms. Her veil and her left hand are, however, almost perfectly preserved. The head of the Child is better preserved, with some abrasion and consequent inpainting on the near cheek and shoulder. The shaded areas in the Child's legs are extensively damaged. The landscape background at both sides is well preserved, as is the right side of the garland behind the Virgin's head. The blue sky above the garland is much abraded and has been extensively retouched. The panel was recradled after cleaning in 1945. The account of its condition given by Heinemann (*Giovanni Bellini e i Belliniani*, 1962, p. 3, no. 11) is incorrect.

PROVENANCE: Principe Potenziani, Villa San Mauro, Rieti (1911); Luigi Grassi, Florence. Acquired by Philip Lehman in Italy in or before June 1916.

EXHIBITED: Duveen Galleries, New York, *A Loan Exhibition of Early Italian Paintings*, 1924, no. 41; Colorado Springs Fine Arts Center, *Paintings and Bronzes from the Collection of Robert Lehman*, 1951–52; Metropolitan Museum of Art, New York, 1954–61; Musée de l'Orangerie, Paris, *La collection Lehman*, 1957, no. 3; Cincinnati Art Museum, *The Lehman Collection*, 1959, no. 99; Metropolitan Museum of Art, New York, *Masterpieces of Fifty Centuries*, 1970–71, no. 195.

The present paintings are fundamental for a reintegration of the work of this mysterious painter, who was active in Venice about 1472 and died in or before 1497. A number of portraits by Jacometto in Venetian collections were listed in the sixteenth century by the Anonimo Morelliano (Marcantonio Michiel). Two of these are discussed below. The same artist was responsible for a portrait of a boy and a male portrait in the National Gallery, London, and for a male portrait in the Metropolitan Museum of Art. All these works are of conspicuously high quality. Jacometto also practiced as a miniaturist. Criteria for the style of his illuminations (none of which have been conclusively identified) are supplied by the paintings on the backs of the present panels.

96. Alvise Contarini (?)

1975.1.86

Oil on panel. Overall: 11.7 × 8.4 cm. (4⅝ × 3⁵⁄₁₆ in.); paint surface recto: 10.5 × 7.7 cm. (4⅛ × 3¹⁄₁₆ in.); paint surface verso: 11.1 × 7.7 cm. (4⅜ × 3¹⁄₁₆ in.). The wood edges of the panel are beveled and painted in white from the outer edge to the paint surface, all four sides of which are original.

The sitter is shown in half-length, facing three-quarters to the right. He wears a black robe, trimmed in black, and a black cap. The line of a white chemise is visible over his collar. His brown hair is thick and carefully waved, framing his face over the eyebrows and falling down at the side over his ear. The landscape background is continuous and shows a meadow and, beyond it, the sea. On the right a bay or inlet gives way on the horizon to a strip of land with two domestic buildings and a tree. On the horizon on the left, somewhat below the level of the sitter's shoulder, is a galleon. The blue sky shades to pink at the horizon and is broken up on the right by a cluster of clouds.

On the verso, on a rocky ledge, is a seated hart with velvet antlers; its red collar is attached by a chain to a gold roundel. Above the boss to which the chain is linked are the letters AI EI. The roundel is set in a porphyry slab which fills the upper four-fifths of the panel.

This and the companion panel (see No. 97 below) bore a tentative attribution to Memling until 1866, when they were reattributed by Waagen (*Die vornehmsten Kunstdenkmäler in Wien*, 1866, p. 280) to Antonello da Messina. This ascription was accepted by Falke (*Katalog der Fürstlich Liechtensteinischen Bildergalerie im Gartenpalais der Rossau zu Wien*, 1873, p. 125, no. 1081), Bode (*Die*

Liechtenstein Galerie, 1896, p. 70), Kronfeld (*Führer durch die Fürstlich Liechtensteinische Gemäldegalerie in Wien*, 1931, p. 147, no. 734), L. Venturi (in Thieme-Becker, *Künstler-Lexikon*, vol. 1, 1907, pp. 570–71, and *Le origini della pittura veneziana*, 1907, pp. 226–27), A. Venturi (*Storia*, vol. 7, IV, 1915, pp. 43–46), Longhi ("Piero dei Franceschi e lo sviluppo della pittura veneziana," *L'arte*, 17, 1914, pp. 241–56), and Berenson (*John G. Johnson, Catalogue of a Collection of Paintings and Some Art Objects*, 1913, p. 155, comparing a portrait by Jacometto in the Johnson collection to "the marvellous little double portrait by Antonello da Messina in the Liechtenstein Gallery at Vienna"; "Una santa di Antonello da Messina e la pala di San Cassiano," *Dedalo*, 6, 1925–26, pp. 642–43; 1932, p. 25, as Antonello da Messina ?; 1936, p. 22, as Antonello da Messina ?). An alternative attribution to Giovanni Bellini, proposed by Ravà ("Antonello da Messina o Giovanni Bellini?" *L'arte*, 23, 1920, pp. 279–81) on the strength of an inventory reference of 1565 (see below), was accepted by Gamba (*Giovanni Bellini*, 1937, pp. 82–84) and, at a later stage, by Berenson (1957, vol. 1, p. 30).

In 1887 Frimmel proposed (*Der Anonimo Morelliano*, vol. 1, 1888, p. 15; note in *Wiener Zeitung*, October 5, 1889; "Bemerkungen zu Marc-Anton Michiels notizia d'opere di disegno," *Beilage der Blätter für Gemäldekunde*, 2, 1907, pp. 76–77; "Bemerkungen zu Jacometto Veneziano," *Studien und Skizzen zur Gemäldekunde*, 2, 1915–16, pp. 16–18) that the Liechtenstein panels were identical with two portraits noted in 1543 by Marcantonio Michiel in the house of Michele Contarini at the Misericordia in Venice. In the form in which it is transcribed by Frimmel this passage reads: "Vi è vno ritratto picolo di M[isser] Aluixe Contarini con M[isser] . . . che morse già anni, et nelinstesso quadretto v'è al incontro ritratto d'una monacha da San Segondo, e sopra la coperta de detti ritratti vna carretta in un paese, e nella coperta de cuoro de detto quadretto fogliami di oro maxenato, di mano di Jacometto, opera perfettissima." This text differs from those printed by Morelli (*Notizia d'opere di disegno nella prima meta del secolo XVI . . . scritta da un anonimo di quel tempo*, ed. Jacopo Morelli, 1800, p. 84) and Frizzoni (*Notizia d'opere di disegno pubblicata e illustrata da D. Jacopo Morelli*, 1884, p. 226) in that in the latter the words "con M[isser]" appear as "q.M." and the words "al incontro" and "carretta in un" are omitted. In this case some importance attaches to exact textual analysis since (i) if Alvise Contarini was shown with a second male

No. 96

No. 97

figure, and (ii) if the reverse of one or the other panel showed a two-wheeled chariot in a landscape, the present paintings cannot be identical with the Contarini panels. It has been suggested (Frimmel) that "con M." should be read as an abbreviation for "Commissario" and that the word transcribed "carretta" should read "cervetto."

Frimmel's identification was later adopted by Gronau ("Zu Jacometto Veneziano," *Studien und Skizzen zur Gemäldekunde*, 2, 1915–16, pp. 48–50, and in Thieme-Becker, *Künstler-Lexikon*, vol. 18, 1925, p. 264), Lauts ("Antonello da Messina," *Jahrbuch des Kunsthistorischen Institutes in Wien*, n.f. 7, 1933, pp. 78–79), Wilde ("Über einige venezianische Frauenbildnisse der Renaissance," *Petrovics Elek Emlekkönyv*, 1934, pp. 206–12), Van Marle (*Development*, vol. 17, 1935, pp. 389–91), Stix and von Strohmer (*Die Fürstlich Liechtensteinische Gemäldegalerie in Wien*, 1938, p. 89), Servolini (*Jacopo de' Barbari*, 1944, pp. 21–41, where Jacometto is mistakenly identified with Jacopo de' Barbari), Davies (*National Gallery Catalogues: The Earlier Italian Schools*, 1951, p. 201), Heinemann (*Giovanni Bellini e i Belliniani*, 1962, p. 239), and Pope-Hennessy (*The Portrait in the Renaissance*, 1966, pp. 211–12, 321–22). A double portrait recorded in 1565 in the Vendramin collection ("Un quadreto de man de Zuan Belin con una figura de dritto et de roverso una cerva. Un altro quadreto con una munega de man de Zuan Belin," for which see Ravà, "Il 'Camerino delle Antigaglie' di Gabriele Vendramin," *Nuovo archivio veneto*, n.s. 39, 1920, p. 170) has been cited as evidence that the panels were later in the Vendramin collection. The present portraits are almost certainly identical with those in the Vendramin collection.

Whether or not the panels are also identical with the two panels described by the Anonimo Morelliano, there can be no reasonable doubt that they are the work of an independent artist who was also responsible for a *Portrait of a Youth* in the Metropolitan Museum (acc. no. 49.7.3) and for a second *Portrait of a Youth* and a male portrait in the National Gallery, London. The extreme delicacy of the obverses of the Lehman panels suggests that the artist is likely to have been trained and to have practiced as a miniaturist. Since Jacometto (to judge from the numerous references to his work in the Anonimo Morelliano) was the best-known miniaturist and small-scale portrait painter active in Venice in the second half of the fifteenth century, he is likely to have been the painter of these panels, and their reverses offer the sole basis for the identification of his miniatures. Unsuccessful attempts have been made to associate the Lehman panels with an illuminated breviary in the Bodleian Library, Oxford (*Italian Illuminated*

Manuscripts from 1400 to 1550, 1948, exh. cat., no. 69), with an illuminated Pliny of 1476 in the library of the Earl of Leicester at Holkham Hall (M. Canova, *La miniatura veneta del Rinascimento*, 1969, pp. 42–44, 111–12), and with the Master of the London Pliny (Armstrong, *Renaissance Miniature Painters and Classical Imagery*, 1981, pp. 48–49). In all these cases the graphic style is incompatible with that of the reverses of the present portraits. Two pages in a manuscript of Petrarch's *Rime e trionfi* in the Victoria and Albert Museum (L.101–1947, f. 106, 149v., for which see J. J. G. Alexander, "A Manuscript of Petrarch's Rime and Trionfi," *Victoria and Albert Museum Yearbook*, 2, 1970, pp. 27–40) are more closely related to the reverses of the Lehman paintings, but in the absence of other manuscripts by the same hand it cannot be claimed that these illuminations are necessarily by Jacometto.

The letters on the reverse of the male portrait are commonly interpreted as a Latin transcription of the Greek 'ΑΕΙ (forever), and the hart as a symbol of fidelity. The scene on the reverse of the second panel is too greatly abraded to be identified.

A second version of the male portrait exists in the collection of the Duke of Buccleuch. Somewhat smaller than the present portrait (9.5 × 7.2 cm.), it shows on the right a variant of the same landscape, with two trees on a hill on the horizon, and it omits the seascape on the left. The reverse corresponds with that of the present panel. A larger variant of the female portrait (23.4 × 17 cm.), from the collection of Lord Rochdale, appeared at Sotheby's, London, on February 25, 1948 (lot 133), was later in the collection of Lord Clark, and is now in the Cleveland Museum of Art. Though the pose is identical and the sitter wears the same coif as the sitter in the Lehman female portrait, she is dressed differently, in a pleated smock, and it is likely that here another sitter is shown.

The Buccleuch painting is evidently by the same hand as No. 96, and has been mistakenly claimed (*Italian Art and Britain*, exh. cat., Royal Academy of Arts, London, 1960, pp. 129–30, no. 351) to be "perhaps of superior quality." The Cleveland portrait has been tentatively ascribed by Longhi (*Paragone*, vol. 125, 1960, p. 61) and Pallucchini (*Eberhard Hanfstaengl zum 75. Geburtstag*, 1961, p. 74) to Lazzaro Bastiani.

CONDITION: The paint surface of the recto is immaculate, save for a few pinpoint discolorations in the sky. On the verso there is some paint loss along a vertical strip close to the left edge, as well as on the left side of the medallion and the muzzle of the hart. The shadow round the hart has been slightly reinforced.

No. 96, reverse

97. A Lady, Possibly a Nun of San Secondo

1975.1.85

Oil on panel. Overall: 10.2 × 7.2 cm. (4 × 2¹³⁄₁₆ in.); paint surfaces recto and verso: 9.6 × 6.5 cm. (3¾ × 2⁹⁄₁₆ in.). Remnants of a bearded edge and gilt border are evident on all four sides, and the paint surface, though smaller than that of No. 96, cannot therefore have been cut down.

The sitter is shown in half-length, facing to the left. She wears a black scapular or dress over a white smock, with black sleeves hanging loosely from her bare shoulders. Her head is wrapped in a white coif, which falls over her ears and across her throat. Behind her is a landscape with an inlet or lagoon like that on the right of the companion painting, backed by green and blue hills with a number of small fortified villages, and in the distance is a line of blue mountains. The blue sky is dotted with large white cirrocumulus clouds.

The verso shows a grisaille scene drawn in gold on olive green. In the right foreground is an island with a cliff crowned by trees, at the foot of which sits a female figure, averting her head and raising her arm. There are indistinct traces of a second figure. In front and to the left is water with an empty boat tossing on the waves. On the further shore is another hill.

The panel and No. 96 are a pair. The identification of the sitter as a nun of San Secondo (a Benedictine community established till 1534 on the island of San Secondo between Venice and Mestre) is based on Michiel's description of the Contarini diptych (see No. 96 above). The meaning of the grisaille allegory on the back has not been established.

PROVENANCE: Possibly Michele Contarini (1543); probably Gabriele Vendramin (1565); Fürstlich Liechtensteinische Gemäldegalerie, Vienna, 1863 (cat. 1873, no. 1081 [as Antonello da Messina]; cat. 1885, no. 734 [as Antonello da Messina]); Wildenstein, New York, from 1961. Acquired by Robert Lehman in November 1967.

EXHIBITED: Kunstmuseum, Lucerne, *Meisterwerke aus den Sammlungen des Fürsten von Liechtenstein*, June–October 1948, nos. 16, 17; National Gallery, London, 1951.

CONDITION: The paint surface of the recto is almost perfectly preserved, only a small hole at the tip of the nose and minor damage along the bottom edge being inpainted. The verso is much rubbed and in its present state is imperfectly legible. No attempt has been made to compensate the losses in this part of the painting.

PROVENANCE: See No. 96.

EXHIBITED: See No. 96.

LOMBARDY
Fifteenth Century

Lombard School, Third Quarter of the Fifteenth Century

98. Madonna and Child with Saint Catherine of Siena and a Carthusian Donor

1975.1.98

Tempera on panel. Overall: 57.6 × 33.2 cm. (22⅝ × 13 1/16 in.); picture surface: 55.5 × 31.2 cm. (21⅞ × 12¼ in.). The panel, which has a vertical grain, has been thinned to 6 mm. and cradled. There is a pronounced lip on all four sides of the paint surface, but the original engaged frame has been cut away and the edges of the panel are filled in with gesso.

The Virgin, represented as a Madonna of Humility with a gilt gesso crown and surrounded by gold rays, is seated on a tiled pavement with her right knee raised and her body turned above the waist. She presents the Child (*right*) to a kneeling Carthusian monk, who is shown on a reduced scale, kneeling with hands clasped in prayer. Behind him, with hands pressed against his shoulders, stands a Dominican nun with the halo of a *beata*, holding a sheaf of lilies.

At the Crespi sale in Paris in 1914, the panel was ascribed to the Cremonese painter Cristoforo Moretti (M. Nicolle, *Catalogue des tableaux anciens...composant la Galerie Crespi de Milan*, Galerie Georges Petit, Paris, June 4, 1914, no. 41). This attribution was retained after its purchase for the Lehman Collection (R. Lehman, 1928, pl. 81). The only authenticated work by Cristoforo Moretti is a signed Madonna formerly in the collection of Commendatore Bassano Gabba, Milan, now in the Museo Poldi-Pezzoli, identified by Longhi ("Me Pinxit: I resti del politico di Cristoforo Moretti già in Sant'Aquilino di Milano," *Pinacoteca*, 2, 1928, pp. 75–79; *Opere complete di Roberto Longhi*, vol. 4, 1968, pp. 53–66) as the central panel of an altarpiece recorded in Sant'Aquilino, Milan, of which two further panels, with Saints Lawrence and Genasius, now in the Museo Poldi-Pezzoli, also formed part. The style of the present panel is incompatible with that of the Poldi-Pezzoli *Madonna*, and the attribution to Cristoforo Moretti was for that reason doubted by Frizzoni ("Rassegna d'insigni artisti italiani," *L'arte*, 3, 1900, p. 326), and rejected by A. Venturi (*La Galleria Crespi in Milano*, 1900, p. 220), Malaguzzi-Valeri (*Pittori lombardi del Quattrocento*, 1902, p. 92), and Toesca (*La pittura e la miniatura nella Lombardia*, 1912, p. 555), and implicitly by Longhi. It is ignored by Natale in a detailed discussion of the Poldi-Pezzoli Madonna (Mottola Molfino and Natale, *Museo Poldi-Pezzoli, dipinti*, 1982, pp. 67–70, nos. 2–4). The discrepancy between the present panel and the Poldi-Pezzoli Madonna is wrongly ascribed by Lehman to the damaged state of the painting in Milan. There is no possibility that the two works are by a single hand, and no other painting or miniature by the author of the present panel has been identified. Inconclusive affinities with the work of the Maestro dei Giuochi Borromeo are noted by Bollati ("Gli Zavattari e la pittura lombarda: Osservazioni in margine a una mostra," *Arte cristiana*, 73, 1985, pp. 418–21).

The presence of a Carthusian donor makes it possible, though far from certain, that we have here to do with a votive panel commissioned for the Certosa at Pavia. The saint standing behind the kneeling monk is Saint Catherine of Siena (see G. Kaftal, *Iconography of the Saints in the Painting of North-West Italy*, Florence, 1985, no. 264), not Saint Anne (as suggested by Reinach, *Répertoire des peintures*, vol. 4, 1918, pp. 391–92). As noted by Todini (*Il polittico degli Zavattari in Castel Sant'Angelo*, 1984, p. 62), the panel is datable before 1461, since Saint Catherine is represented with the rays of a *beata*, and may have been produced as early as 1440. A diptych by a follower of Michelino di Besozzo, divided between the Alte Pinakothek, Munich, and the Národni Galerie, Prague, tentatively associated with the present panel in this essay, is markedly different in style.

CONDITION: The paint surface is heavily abraded, exposing bole and *terra verde* underpaint. The blue on the Virgin's cloak has darkened and the green lining has turned brown, but her red dress is well preserved. There is minor flaking on the face and cowl of the female saint, and the monk's habit has been strengthened with a thin white glaze.

PROVENANCE: Professor Magenta, Milan; Cristoforo Benigno Crespi, Milan (see above); Crespi sale, Galerie Georges Petit, Paris, June 4, 1914, no. 41 (bt. Kleinberger). Acquired by Philip Lehman before 1928.

EXHIBITED: Cincinnati Art Museum, *The Lehman Collection*, 1959, no. 94.

No. 98

VENICE
Eighteenth Century

Luca Carlevaris

Born at Udine in 1663, Carlevaris settled in Venice in 1679. Little is known of his work before the first decade of the eighteenth century, when he was already an accomplished *veduta* painter. Though his reputation depends on the fact that he was the first highly productive, fully professional Venetian *vedutista*, the interest of his paintings derives not from their competent, rather prosaic, depiction of Venetian topography but from the animation of the figures with which they are populated. A figure painter of genius, Carlevaris recorded his vision of Venetian life in pen drawings and oil sketches which were then incorporated in his paintings. At its freest and best, the figure content of his canvases is comparable to that of Canaletto. Carlevaris died in 1730.

99. The Bacino, Venice, with the Dogana and a Distant View of the Isola di San Giorgio

1975.1.88
Oil on canvas. 50.7 × 119.6 cm. (19^{15}/$_{16}$ × 47^{1}/$_{16}$ in.).

The view shows, on the right, the quay on the north side of the Dogana, with the halls of the Dogana surmounted by Bernardino Falcone's statue of Fortune on a globe. In the distance, to the left of center, is the facade of San Giorgio Maggiore. The right half of the foreground is filled with boats, and more boats are seen on the left, where the scene terminates in a boat with a high sail.

When at Stoneleigh Abbey (see below), this and the following three pictures were described as "Four views of Venice in the style of Canaletto," though "some experts think they are by Guardi" (A. Leigh, *Stoneleigh Abbey Pictures*, n.d., p. 11; see also S. C. K. Smith, *Stoneleigh Abbey: An Illustrated Survey*, n.d., no. 18). The four paintings are reproduced with their correct attribution by Rizzi (*Luca Carlevarijs*, 1967, figs. 86–89). It was a common practice of Carlevaris to produce paired views of Venice or sets of four interrelated views. Thus a pair of paintings in the Fano collection, Milan, shows *The Molo from the Bacino di San Marco* and *The Molo Looking West*, while a group of four paintings formerly in the Talbot collection, Kiplin Hall, Scorton, shows *The Piazza San Marco*, *The Molo with the Palazzo Ducale*, *The Molo Seen from the Bacino di San Marco*, and *The Piazzetta and the Riva degli Schiavoni*. The first three subjects in the latter group correspond with the subjects of three of the present paintings. Many of Carlevaris's versions of his own paintings

are not in the strict sense replicas, since (i) the viewing point is commonly changed from one painting to another, and (ii) the figures and boats in the foreground vary from scene to scene.

The staffage in the foreground of Carlevaris's paintings is in great part based on oil studies, seemingly made from life, of which the largest collection is a group of fifty-three oil sketches in the Victoria and Albert Museum, London (for these see Pope-Hennessy, "A Group of Studies by Luca Carlevaris," *Burlington Magazine*, 73, 1938, pp. 126–31). A large number of figure drawings by Carlevaris also survives; the most important of these are contained in volumes in the British Museum, London (acc. no. C. 197.NC.5), the Victoria and Albert Museum, London (acc. no. D. 1352A-1887), and the Museo Correr, Venice (acc. no. III/6956–84). A volume of studies of boats is also in the Museo Correr (acc. no. A.II/44). The oil sketches and drawings related to the present paintings are noted below.

The Molo, Venice, Looking West (No. 102). The panoramic content of this painting was repeated by Carlevaris on many occasions, notably in *The Entry of the British Ambassador, the Earl of Manchester* (Birmingham City Art Gallery), drawn from a point east of the balcony of the Palazzo Ducale; in views in the Levi collection, Milan, drawn from a similar position nearer the lagoon; in the Fano collection, Milan, drawn from a point east of the first window to the east of the balcony of the Palazzo Ducale; and in the Talbot collection, Kiplin Hall, centered on the two columns and drawn from a point to the east of the balcony. (For these paintings see Rizzi, op. cit., figs. 28, 47, 54, 121.) Two of the figures in the present painting derive from oil sketches in the Victoria and Albert Museum (acc. no. P. 59–1938, a boatman and male figure, Fig. 88; acc. no. P. 66–1938, a sailor turned to the right; acc. no. P. 42–1938, a man with back turned, wearing a cloak, Fig. 90).

The Molo, Venice, from the Bacino di San Marco (No. 100). The panoramic content of this painting recurs in a number of pictures by Carlevaris, notably in the Fano collection, Milan (Rizzi, op. cit., fig. 51), which is severed on the left before the last window of the Zecca, and in the Talbot collection at Kiplin Hall (Rizzi, op. cit., fig. 123), which is centered on the left half of the Palazzo Ducale. A drawing of a *brigantino* in the Museo Correr (Rizzi, op. cit., fig. 15) may be associable with the boat in front of the Zecca. A number of drawings in the British Museum sketchbook recall the boatmen in the foreground, but the

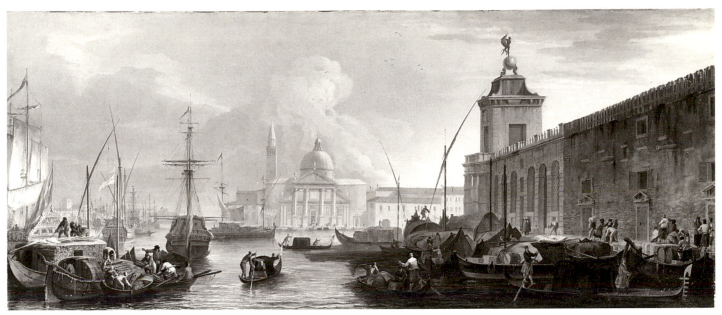

No. 99

relationship is insufficiently explicit for a direct connection to be assumed.

The Piazza San Marco, Venice (No. 101). Views of the Piazza San Marco formed a regular component of Carlevaris's *veduta* cycles and are subject to the same variations as the other paintings. The Campanile, for example, is sometimes severed beneath the upper gallery (Talbot collection, Kiplin Hall; Rizzi, op. cit., fig. 119) and sometimes represented complete (Christie's, London, February 22, 1924, lot 77; Rizzi, op. cit., fig. 136). The latter painting is, however, lit from the south, whereas the present painting and those in the Talbot collection and elsewhere (Rizzi, op. cit., fig. 156) are lit from the west. Eight of the figures in the foreground depend on oil sketches in the Victoria and Albert Museum (acc. no. P. 71–1938, woman with back turned, Fig. 91; acc. no. P. 78–1938, woman in frontal pose with fan, Fig. 92; acc. no. P. 37–1938, male figure with back turned, Fig. 97; acc. no. P. 38–1938, male figure in domino, Fig. 89; acc. no. P. 65–1938, two males facing left, Fig. 93; acc. no. P. 64–1938, woman with shawl, Fig. 94; acc. no. P. 72–1938, masked woman, Fig. 95; acc. no. P. 61–1938, magistrate, Fig. 96).

The Bacino, Venice, with the Dogana and a Distant View of the Isola di San Giorgio (No. 99). A narrower version of this subject is in the Emo Capodilista collection, Rome (Rizzi, op. cit., fig. 113). The small boats on the right and the galleons on the left are presumably based on drawings like those in the Museo Correr, though no study for them can be identified. There are no studies among the London oil sketches for the figures on the right.

In addition to a number of dated paintings, the chronology of Carlevaris is based upon his representation of historical scenes: *The Entry of the British Ambassador, the Earl of Manchester*, of 1707 (Birmingham City Art Gallery), *The Regatta in Honour of King Frederick IV of Denmark*, of 1709 (Frederiksborg), *The Regatta in Honour of the Elector of Saxony*, of 1716 (Hermitage, Leningrad), and *The Entrance of the Imperial Ambassador, Count Colloredo*, of 1726 (Gemäldegalerie, Dresden). The present paintings are dated by Rizzi (op. cit., p. 55) to the years 1710–20. The inscription on No. 101 consists of an L (for Luca), a void, and the numbers DCC/IX, and would be consistent with a dating either in 1709 or in 1719. Some of the London oil sketches were made in connection with the Birmingham painting and are therefore datable to 1707; others were made in connection with the Dresden painting and are therefore datable to 1726. The studies associable with the present paintings are related to those for the earlier, not the later, work. They do not pro-

vide firm criteria for the dating of the paintings, since it was Carlevaris's practice to reuse his figure studies; a number of studies employed here were also utilized in the Talbot pictures, which were bought in Leghorn by Christopher Crowe, British consul in Genoa in 1720–30, as well as in a view of the Molo in the Seattle Art Museum. The present paintings may have been purchased in 1711, when their putative first owner, Edward Leigh, third Baron Leigh of Stoneleigh, made the Grand Tour to Italy, and a dating for them in the year 1709 is likely to be correct.

CONDITION: Some damage in the boats in the right foreground and along the right edge. The paint surface has been flattened by relining, and a tear through the crenellation of the Dogana has been repaired.

PROVENANCE: Lord Leigh, Stoneleigh Abbey, Kenilworth, Warwickshire; Bruscoli, Florence. Acquired by Robert Lehman in 1954.

EXHIBITED: Cincinnati Art Museum, *The Lehman Collection*, 1959, no. 102.

100. The Molo, Venice, from the Bacino di San Marco

1975.1.87
Oil on canvas. 50.7 × 119 cm. (19^{15}/$_{16}$ × 46^{13}/$_{16}$ in.).

The view, taken from the Bacino, is centered on a point midway between the columns of the Piazzetta. On the left are the Library and the Zecca and, behind them, the Campanile. On the right is the Palazzo Ducale to a point east of the first window to the right of the balcony. In the center, between the columns, are the Torre dell'Orologio and the basilica of San Marco. The foreground is filled with small craft and, to the left, a large boat with sails.

See No. 99.

CONDITION: Abrasion losses along marks from a vertical stretcher bar in the center and a diagonal bar across each corner have been touched in. A heavy craquelure has been pressed flat in relining, and losses in it and in the sky have been inpainted. Damage is otherwise minimal.

PROVENANCE: See No. 99.

EXHIBITED: Cincinnati Art Museum, *The Lehman Collection*, 1959, no. 104.

No. 100

101. The Piazza San Marco, Venice

1975.1.89
Oil on canvas. 50.5 × 119.9 cm. (19⅞ × 47³⁄₁₆ in.).

The view is taken from the west end of the Piazza San Marco. On the left are the Procuratie Vecchie with, in the distance, the Torre dell'Orologio, and on the right are the Procuratie Nuove with, beyond them, part of the Palazzo Ducale and the Campanile, to the level of its open gallery. Behind, in the center, is the basilica of San Marco. The scene is lit from the west, with the Campanile casting a shadow on the Procuratie Nuove, and the Procuratie Vecchie casting a wide shadow across the Piazza.

See No. 99.

CONDITION: The paint surface is generally well preserved. Scattered flaking losses along the bottom and diagonally across the upper left corner follow the marks of stretcher bars, and small losses in the sky follow the heavy craquelure.

PROVENANCE: See No. 99.

EXHIBITED: Cincinnati Art Museum, *The Lehman Collection*, 1959, no. 103.

No. 101, detail

No. 101

No. 102

102. The Molo, Venice, Looking West

1975.1.90
Oil on canvas. 50.5 × 119.6 cm. (19⅞ × 47¹⁄₁₆ in.).

The view is taken from a point west of the balcony of the
Palazzo Ducale, the side of which is seen in the upper right
corner. To the right of center are the two columns of the
Piazzetta and the Library, and to the left of center is a
distant view of Santa Maria della Salute and the Dogana.
The foreground is broken up by three main groups of fig-
ures. To the left, on the quay, are small craft filled with
boatmen, further back is a masted galleon, and on the
extreme left, in the distance, is a boat under sail. On a
pillar of the Palazzo Ducale on the extreme right is the
inscription L/DCC/IX.

See No. 99.

CONDITION: The paint surface is very well preserved.

PROVENANCE: See No. 99.

EXHIBITED: Cincinnati Art Museum, *The Lehman Collection*,
1959, no. 101.

No. 102, detail

Giambattista Cimaroli

Born about 1687 and a pupil or follower of Zuccarelli, Cimaroli is known to have collaborated with Canaletto, Piazzetta, and Pittoni in the background of two of a celebrated series of fantastic paintings of English Whig tombs. He also provided fluent and attractive records of scenes in Venice, the Veneto, and the region of Verona. Cimaroli died after 1757.

103. View on the Brenta Near Dolo

1975.1.91
Oil on canvas. 82.3 × 113.2 cm. (32⅜ × 44⁹⁄₁₆ in.).

In the center is a house facing, at the left, onto a river or canal and, on the right, onto a street. In the distance on the left are a boat and a number of small houses. On the right, the street leads to a church with a cupola and campanile. The entrance to a further house, with a balcony covered by an awning, is in the foreground on the right. In front of it are three horsemen, two carriages, and a number of standing figures.

The scene has been identified (verbal communication) by Dr. Glauco Benito Tiozzo of the Accademia di Belle Arti in Venice as a view on the Brenta between Dolo and Sambruson, at a point at which the river bifurcates. The large house on the right was demolished recently.

Ascribed at auction and subsequently to Francesco Zuccarelli, this painting does not resemble any securely attributable work by that artist. A related painting, *A View on the Brenta*, sold at Sotheby's, London, on November 28, 1962, lot 150, is attributed to Cimaroli by Morassi ("Saggio su Giambattista Cimaroli, collaboratore del Caneletto," *Arte veneta*, 26, 1972, pp. 167–76), and there can be little doubt that Cimaroli (for whom see Donzelli, *I pittori veneti del Settecento*, 1957, pp. 68–69) was also responsible for the present painting. The distinctive foliage of the trees and the thickly impastoed, stiffly posed figures are found again in other paintings by Cimaroli, e.g., *A View on the Brenta at Strà with the Villa Negrelli* in the Musées Royaux des Beaux-Arts, Brussels (repr. Pallucchini, *La pittura veneziana del Settecento*, 1960, fig. 453), and a pair of landscapes formerly with the Hallsborough Gallery, London (repr. *Connoisseur*, September 1955, p. 39). A related painting by Cimaroli, *A Lagoon Scene: Capriccio*, in a private collection, is reproduced by Watson ("G. B. Cimaroli: A collaborator with Canaletto," *Burlington Magazine*, 95, 1953, pp. 205–207).

CONDITION: The paint surface is flattened by relining, and paint losses have been made good along the left and bottom edges. Losses in the facade of the building and in the ground in front of it, as well as in the left half of the sky, have been inpainted. Pentiments show that the roof on the central building was originally to have been 30 mm. lower than it is now.

PROVENANCE: M. Knoedler & Co., London; Mrs. Edward Shearson, New York (sale of the estate of the late Mrs. Edward Shearson, Parke-Bernet, New York, November 26, 1955, lot 50, as Francesco Zuccarelli, bt. Lock). Acquired by Robert Lehman in 1955.

No. 103

104. Capriccio with a Circular Tower, Two Houses and a Bridge

1975.1.92

105. Capriccio with a Square Tower and Two Houses

1975.1.93

106. Capriccio with an Island, a Tower and Houses

1975.1.94

Oil on paper mounted on masonite. No. 104: 5.4 × 8.9 cm. (2⅛ × 3½ in.); No. 105: 5.7 × 8.7 cm. (2¼ × 3⅜ in.); No. 106: 5.5 × 8.9 cm. (2⅛ × 3½ in.).

These three paintings were originally part of a group of four *capricci* sold at Sotheby's, London, on May 7, 1952, under a generic attribution to Guardi. There is no indication of the present whereabouts of the fourth scene. The clumsiness with which the three scenes are executed precludes an attribution to either Francesco or Giacomo Guardi. A related set of four small *capricci* on the New York art market is reproduced by Morassi (*Guardi*, n.d. [1973?], no. 1012, figs. 900–903) with an attribution to Francesco Guardi. The composition of the fourth of these paintings is related to that of No. 105. Features of its design occur in a number of other putative autograph paintings (Morassi, op. cit., figs. 826–29).

CONDITION: The paint surface of all three scenes is covered by a dense discolored varnish but in two cases is well preserved. In No. 105 there are extensive damage from pinpoint flaking, and larger losses in the sky and in the lagoon beneath the sailing boat.

PROVENANCE: Sotheby's, London, May 7, 1952, lot 68, bt. Koetser. Acquired by Robert Lehman in March 1953.

EXHIBITED: Cincinnati Art Museum, *The Lehman Collection*, 1959, nos. 105, 106, 107.

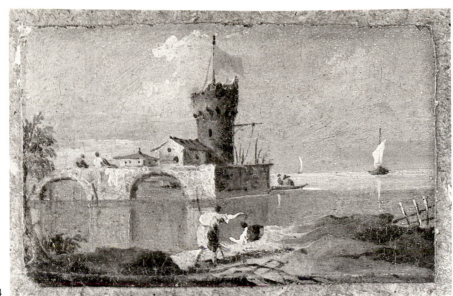

No. 104

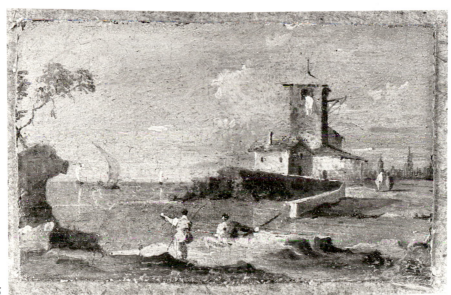

No. 105

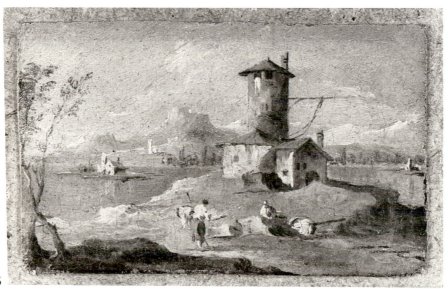

No. 106

PAINTINGS OF
RECENT ORIGIN

Icilio Federico Ioni

Born in 1866, Ioni was trained in Florence and practiced in Siena, where he was in contact with Perkins, Hutton, Langton Douglas, and other early students of Sienese fourteenth- and fifteenth-century painting. A number of his paintings are reproduced in a volume of memoirs (*Le memorie di un pittore di quadri antichi*, San Casciano Val di Pesa, n.d., published in English as *Affairs of a Painter*, 1936). Though archaizing in style, these pictures are original works. Ioni's métier, however, was the forging of Sienese paintings, and a number of his fabrications escaped detection even by the scholars with whom he was associated. While his memoirs refer to the copying of well-known Sienese paintings (e.g., the altarpiece by Benvenuto di Giovanni at Montepertuso), they are careful to conceal, under a veneer of frankness, the essential information about this aspect of his work. He was for many years employed to restore paintings in the Pinacoteca at Siena, where he copied the three panels by Sano di Pietro noted below. An attempt has been made by Frinta ("The Quest for a Restorer's Workshop of Beguiling Invention: Restorations and Forgeries in Italian Panel Painting," *Art Bulletin*, 60, 1978, pp. 7–23, and "Drawing the Net Closer: The Case of Ilicio [*sic*] Federico Ioni, Painter of Antique Pictures," *Pantheon*, 40, 1982, pp. 217–24) to isolate a number of panels in whose gilding modern punches are employed. These include one certain work by Ioni—a polyptych from Agnano now in the Museo Nazionale di San Matteo at Pisa—and a number of pictures that can reasonably be ascribed to him, but other forgers appear to have been active in this field as well, and inadequate attention has been given to Ioni's activity in other areas than the forging of Sienese primitives. For other works by Ioni see H. W. van Os, "Ophet spoor van een verwalser," *Spiegel Historiael*, 6, 1971, pp. 80–87.

107. Saints Cosmas and Damian and Their Brothers Before the Proconsul Lycias

1975.1.47

108. Saints Cosmas and Damian and Their Brothers Saved by an Angel After They Have Been Condemned to Death by Drowning

1975.1.48

109. The Stoning of Saints Cosmas and Damian

1975.1.49

Tempera on panel. No. 107, overall: 27.1 × 39.9 cm. (10⅝ × 15¾ in.); picture surface: 26.5 × 30.5 cm. (10⅜ × 12 in.); No. 108, overall: 27.1 × 40.8 cm. (10⅝ × 16¹⁄₁₆ in.); picture surface: 26.4 × 30.8 cm. (10⅜ × 12⅛ in.); No. 109, overall: 27 × 40.6 cm. (10⅝ × 16 in.); picture surface: 26.5 × 30.7 cm. (10⅜ × 12¹⁄₁₆ in.). All three scenes are on panels with a horizontal grain, 2.5 mm. thick, not warped, but artificially made to appear worm-eaten.

The three panels reproduce the first three scenes in the predella of an altarpiece by Sano di Pietro in the Pinacoteca Nazionale at Siena (no. 233). The altarpiece was painted for the convent of the Gesuati at San Girolamo in Siena, and its main panel shows the Virgin and Child enthroned with ten angels and Saint Jerome and the Beato Colombini between lateral panels with Saints Cosmas and Damian (Torriti, *La Pinacoteca Nazionale di Siena: I dipinti dal XII al XV secolo*, 1977, no. 233, pp. 284–86). The polyptych is dated by Trübner (*Die Stilistische Entwicklung der Tafelbilder des Sano di Pietro*, 1925, pp. 65–68) and Torriti (loc. cit.) to the 1460s. The present panels are reproduced by Gaillard (*Sano di Pietro*, 1923, pp. 108–109, nos. 10, 11, 12), who wrongly states that the man throwing stones in the center of No. 109 differs from the corresponding figure in the Siena predella. The authenticity of the panels was apparently accepted by Perkins, by whom they were at one time owned, as well as by Gaillard and by R. Lehman (1928, pls. 43, 44, 45), who comments: "These panels are practically identical with three of the six predella pieces of no. 233 in the Siena Gallery. They are later works and were probably executed from the design of the Siena predella. In the Munich gallery there is a similar predella by Sano. The other panels, which evidently went to complete these here illustrated are unidentified." The panels are ignored in Berenson's lists of

No. 107

No. 108

No. 109

1932, but are included in those of 1968 (vol. 1, p. 377). According to the Bayerische Staatsgemäldesammlungen, there was at no time a related predella by or ascribed to Sano di Pietro in the Alte Pinakothek in Munich.

Technical examination (see below) shows that the paintings are modern forgeries, and they have been correctly ascribed by Frinta (op. cit., 1978, pp. 19, 22, and op. cit., 1982, pp. 217–18), on the strength of a leaf punch appearing in the gilded interstices, to Icilio Federico Ioni.

It is clear that Ioni was not responsible for all the paintings ascribed to him by Frinta, but some may be traced to Ioni's ownership, such as the *Madonna* at Oberlin (R. Lehman, 1928, pl. 43) and a forged Neroccio *Madonna* reproduced by Frinta (op. cit., 1982, fig. 17). There is no confirmation of Frinta's theory that the present panels were intended to be substituted for the corresponding sections of Sano's predella in Siena. Ioni relates (*Affairs of a Painter*, 1936, p. 312): "From the time when I began painting in tempera I often used to go to the Picture Gallery [in Siena], to study the technique of the early Sienese masters. One day, when the superintendent was doing his rounds of the rooms, and saw me copying a picture, he said to the attendant: 'Keep your eye on that man, he might substitute one of his copies for an original.' The attendant told me this and I was much amused at his stupidity; for if I had been able to make copies so exact as that, I could have sold my own pictures without disturbing the originals; and on the other hand, if I had once tried a substitution and been found out (as sooner or later I should have been), it would have been a case of hard labour for me, which did not attract me at all."

CONDITION: A lip of raised gesso with traces of gilding is visible on all four sides of the three panels; it ought to appear only at the top and bottom. In all three cases the gilt interstices are full- and not half-width. The verdaccio underpaint appears to be chromium oxide green, a modern pigment. The craquelure is artificially induced by painting on a very fine canvas, which is then rolled and applied to the panel, with dry pigment rubbed in to produce an effect of antiquity. The heaviest craquelure has been inpainted in a later restoration. Frinta establishes that the leaf punch in the gilt interstices also appears in a triptych at New Haven (Yale University Art Gallery, acc. no. F.1970.117) and in a second triptych in the possession of the Courtauld Institute, London, both attributed to Ioni.

PROVENANCE: F. Mason Perkins, Lastra a Signa; Vicomte Bernard d'Hendecourt, Paris. Acquired by Philip Lehman in 1917.

EXHIBITED: Cincinnati Art Museum, *The Lehman Collection*, 1959, no. 49 (as Sano di Pietro); Metropolitan Museum of Art, New York, *Saints and Their Legends*, 1974 (No. 109 only).

110. Madonna and Child with Saints Mary Magdalene and Sebastian

1975.1.57

Tempera on panel. Overall: 109.5 × 72.3 cm. (43⅛ × 28½ in.); picture surface: 99.7 × 62.6 cm. (39¼ × 24⅝ in.). The panel, which has a vertical grain, is 29 mm. thick. The gold frame is constructed in five sections, broken at the bottom corners, at the springs of the arch, and at the top, and is fastened to the panel with spikes.

The Virgin, wearing a blue mantle over an orange dress with blue and gold collar and cuffs, and a gold belt, is shown frontally on a seat of which one end is seen on the left. The Child, dressed in a gold tunic, is seated in her lap with head turned to the right, right hand raised in benediction, and legs apart, the right foot resting on the seat end. The Magdalene (*left*), in a mauve dress, holds a jar of ointment, and Saint Sebastian (*right*) holds an arrow in his left hand.

The panel is published as by Neroccio di Bartolommeo by Perkins ("Some Sienese Paintings in American Collections," *Art in America*, 9, 1921, pp. 59–60) with a careful and generally unfavorable analysis, of which the relevant passages read:

Despite the splendid design of the central figure of the Madonna, with its nobly spreading silhouette, and notwithstanding its extraordinary attractiveness of colour and tone, the Madonna and Child with St. Mary Magdalene and Sebastian by Neroccio di Bartolommeo in the Lehman Collection falls short, in many respects, of the usual high standard of Neroccio's work. This is particularly noticeable in the two Saints. There is a heaviness and vulgarity in the features and a structural inconsequence, not to say faultiness, in the figure of the Magdalene, and a fleshy coarseness and lack of spirituality in the face and expression of the Child, awkwardness of drawing and of modelling in the Saint Sebastian, which are in such distinct contrast with the usual grace and accomplishment of Neroccio's style as to awaken, and even to encourage, the suspicion that we have here a work designed by the master, but, in part at least, carried out, and marred in the process, by the less sensitive hands of an assistant.

Perkins adds, "There is, in fact, nothing in the actual technique of the painting that justifies us in definitely denying it to Neroccio, nor does the handling reveal any visible signs of the cooperation of a second painter." The picture is regarded by Van Marle (*Development*, vol. 16, 1937, pp. 296–300) as a work by Neroccio of about 1476, and is dated by R. Lehman (1928, pl. 53) and L. Venturi (*Pit-*

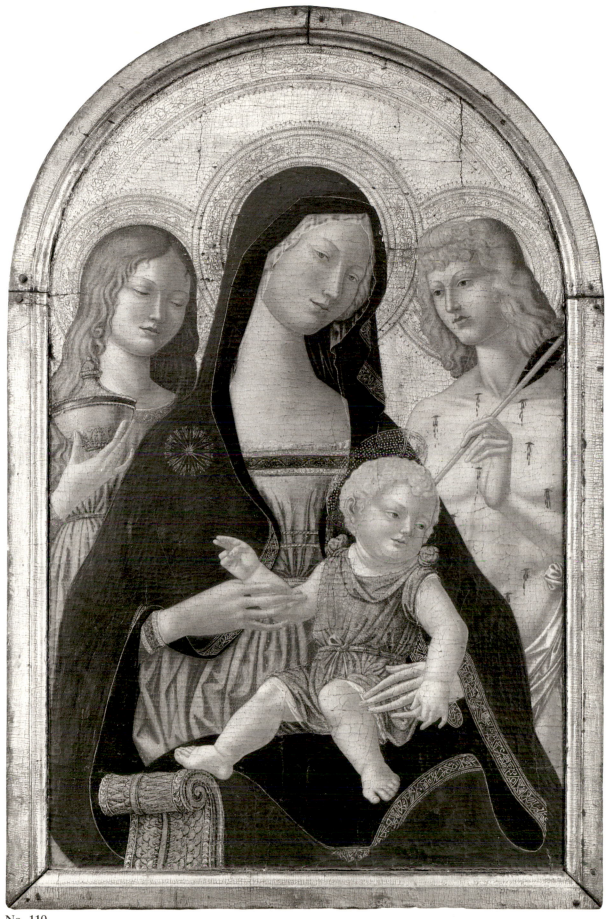

No. 110

ture italiane in America, 1931, no. 235) ca. 1492 on the strength of an altarpiece painted in this year in the Pinacoteca Nazionale at Siena. It is omitted from all editions of the Berenson lists and from Coor's monograph on Neroccio (*Neroccio de' Landi*, 1961).

There can be no reasonable doubt (see below) that the picture is a modern forgery, and its omission from the lists of Berenson and the catalogue of Coor may be construed as implying that both authorities regarded it as such. In form and handling it has much in common with a heavily restored autograph *Madonna with Saints John the Baptist and Mary Magdalene* in the Pinacoteca Nazionale at Siena (no. 295), the condition of which is accurately described by Coor (ibid., no. 56, pp. 187–88). That the present panel is the work of Icilio Federico Ioni is attested (i) by its provenance (see below), and (ii) by its identity of handling with other works correctly attributed to Ioni by Frinta ("Drawing the Net Closer: The Case of Ilicio [*sic*] Federico Ioni, Painter of Antique Pictures," *Pantheon*, 40, 1982, pp. 217–24). These include a *Madonna* in the style of Matteo di Giovanni in the Walters Art Gallery, Baltimore (ibid., fig. 13), an untraced *Madonna* in the style of Benvenuto di Giovanni (ibid., fig. 15), and a *Madonna* signed OPVS NEROCII DE SENIS MCCCCLXXIII formerly in the Lehman Collection (ibid., fig. 17). Of this last picture Perkins wrote to Philip Lehman on January 4, 1921 (letter in Lehman Collection Archives): ". . . it is wholly incredible that this picture could have been painted at the early date which it now bears. . . . I am therefore convinced that the whole inscription is modern, and that it was in all likelihood added to the picture by our friend Ioni. This is precisely the sort of silly thing that he would be most apt to do—and which I am sure he has done in connection with other pictures. Otherwise there is only one possible other explanation—i.e., that the whole picture is false."

CONDITION: The heavy, even craquelure was produced by applying the paint and gold leaf to canvas and rolling it before laying it down on panel, a technique described by Ioni (*Affairs of a Painter*, 1936, p. 297). Dirt has been rubbed into the resultant craquelure. No underdrawing or modeling appears beneath the paint layer, and infrared reflectography shows that gray was mixed with the green underpaint to simulate the effects of aging. There is no abrasion damage to the paint surface to justify either the dirt in the craquelure or the exposed verdaccio. The Madonna's robe is painted green to simulate oxidized blue.

PROVENANCE: I. F. Ioni, Siena, 1913 (ms. note by F. M. Perkins in the Lehman Collection files); Carlo Angeli, Florence, 1914; Duveen. Acquired by Philip Lehman in January 1915.

EXHIBITED: Duveen Galleries, New York, *Loan Exhibition of Important Early Italian Paintings*, April 17–May 3, 1924, no. 32.

Uncertain Authorship

111. Judith with the Head of Holofernes

1975.1.109

Tempera on panel. 21.6 × 14.5 cm. (8½ × 5¹¹⁄₁₆ in.). The panel, which has a vertical grain, has been trimmed to its present size and thinned to a depth of 6 mm. but not cradled.

Judith, in a light blue dress and red cloak, with a broad flat sword in her right hand, stands before the opening of Holofernes's tent. With her left hand she drops the head of Holofernes, in left profile, into a sack held by a female attendant at the right. In the right background is a barren tree.

The composition is based on a number of compositions by or attributed to Andrea Mantegna. The foreground reproduces, in a simplified form, the irregular pavement of the painting of the subject by Mantegna in the National Gallery of Art, Washington (Widener collection); the baluster supporting the bed to the left derives either from a painting in the National Gallery of Ireland, Dublin, or from a related engraving by Zuan Andrea; and the attendant and the neck of the sack in which the head is placed depend from a painting now in Montreal. The date of the present panel cannot be determined.

CONDITION: The paint surface, which is lightly but evenly abraded, is covered by a thick, uneven, badly discolored varnish.

PROVENANCE: No record. On September 26, 1930, I. F. Ioni offered a Mantegna of unspecified subject for sale to Robert Lehman. On November 2, 1934, he wrote again to protest the authenticity of a small Mantegna he had restored. One of these two pictures may be identical with the present panel. Date of acquisition not recorded.

EXHIBITED: Cincinnati Art Museum, *The Lehman Collection*, 1959, no. 92 (as Veronese Master, fifteenth century [?]. After Mantegna).

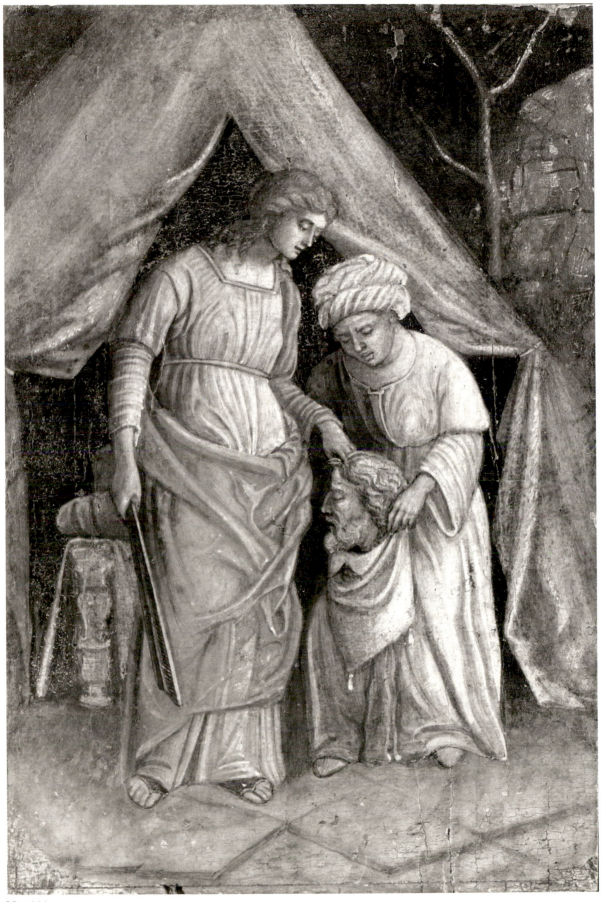

No. 111

112. Christ on the Cross with the Virgin, Saint John the Evangelist, Saint Mary Magdalene, and Two Male Saints

1975.1.108

Tempera on panel. Overall: 49.3 × 43.4 cm. (19⅜ × 17 in.); picture surface: 43.2 × 36.8 cm. (17 × 14½ in.). The panel, which has a vertical grain and is 19 mm. deep, has been cradled, but seems not to have been thinned.

The cross is silhouetted against the gold ground, its two arms covered with a dark hanging. At its foot kneels Saint Mary Magdalene, wearing a red dress. At the sides, set off against two groups of trees that curve down to the level of the Magdalene's head, are (*left*) a male saint in a red tunic, carrying the model of a town or castle, and the Virgin, with arms extended, in a blue, green-lined cloak over a red dress, and (*right*) a male saint in a green tunic, carrying a sword and arrow, and Saint John the Evangelist in a reddish pink cloak over a dark blue robe. Three angels stippled into the gold ground collect the blood which flows from Christ's wounds.

While the panel is old, the paint surface is revealed by technical examination to be almost entirely modern, and the painting in its present state must be considered a forgery made for purposes of deception. According to R. Lehman (1928, pl. 70), it successfully deceived De Nicola (verbal opinion as school of Camerino), Gnoli (verbal opinion as school of Camerino, identifying the two male saints as Venantius and Sebastian), Perkins (verbal opinion as an anonymous Umbro-Marchigian painter), Van Marle (verbal opinion as School of Modena), R. Lehman (loc. cit., as Umbrian, probably Giovanni Boccati), L. Venturi (*Pitture italiane in America*, 1931, pl. 244, as Girolamo di Giovanni, on the strength of analogies with a Madonna della Misericordia at Camerino), Berenson (1932, p. 126, and subsequent editions, as a questionable Caporali), Laclotte (1957, p. 3, no. 4, as Boccati, perhaps reflecting a lost work by Domenico Veneziano), and G. Vitalini Sacconi (*La pittura marchigiana, la scuola camerinese*, 1968, pp. 166, 245, n. 354, as Giovanni Boccati, assisted). The Christ seems to depend from that in the central predella panel of Boccati's *Madonna del Pergolato* in the Pinacoteca Nazionale at Perugia.

CONDITION: See above.

PROVENANCE: Duchessa Altemps di Galese, Fermo and Stresa; Eugène Moyse, Paris; acquired by Philip Lehman in 1913 (?); Pauline Ickelheimer. Acquired by Robert Lehman in 1946.

EXHIBITED: Metropolitan Museum of Art, New York, 1944, 1954–61 (as Giovanni Boccati); Musée de l'Orangerie, Paris, *La collection Lehman*, 1957, no. 4 (as Giovanni Boccati); Cincinnati Art Museum, *The Lehman Collection*, 1959, no. 86 (as Giovanni Boccati).

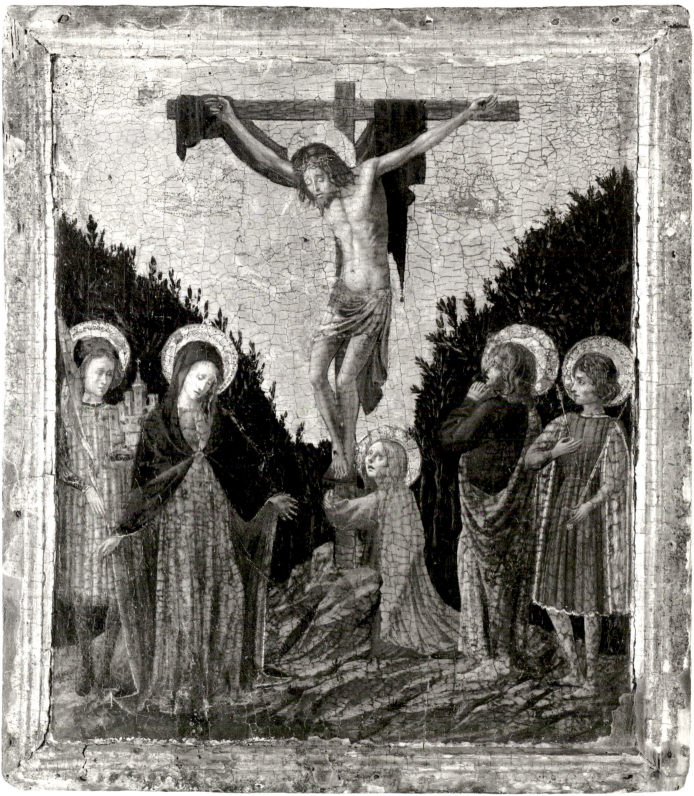

No. 112

COMPARATIVE ILLUSTRATIONS

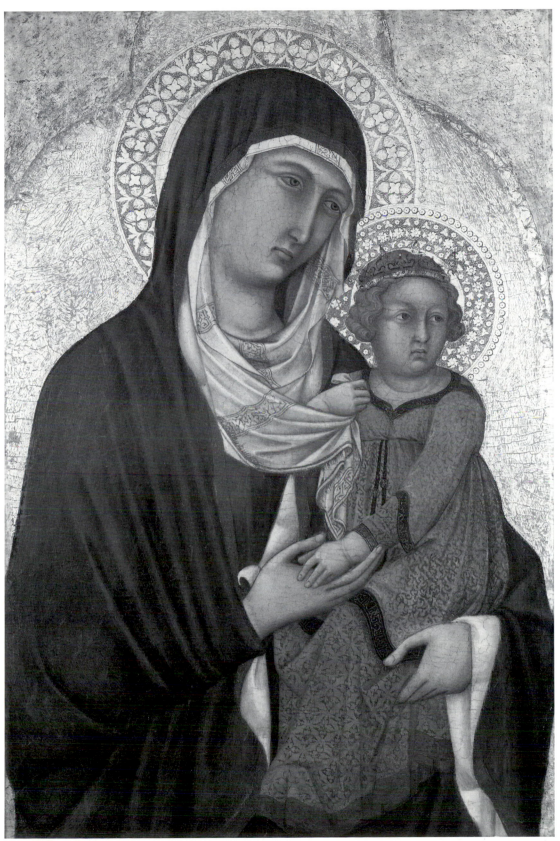

1. Ugolino di Nerio, *Saint Anne with the Infant Virgin* (National Gallery of Canada, Ottawa)

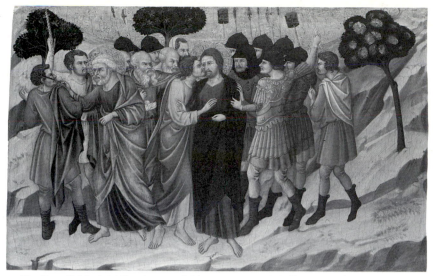

2. Ugolino di Nerio, *The Arrest of Christ* (National Gallery, London)

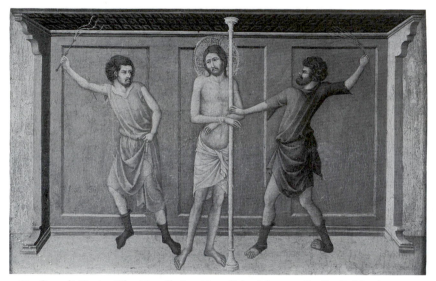

3. Ugolino di Nerio, *The Flagellation* (Staatliche Museen, Berlin-Dahlem)

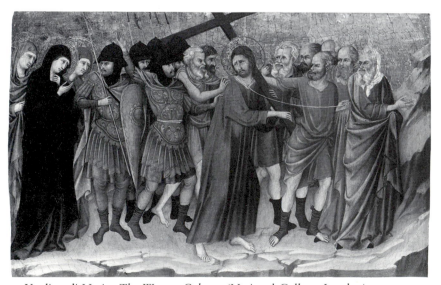

4. Ugolino di Nerio, *The Way to Calvary* (National Gallery, London)

5. Ugolino di Nerio, *The Deposition* (National Gallery, London)

6. Ugolino di Nerio, *The Entombment* (Staatliche Museen, Berlin-Dahlem)

7. Ugolino di Nerio, *The Resurrection* (National Gallery, London)

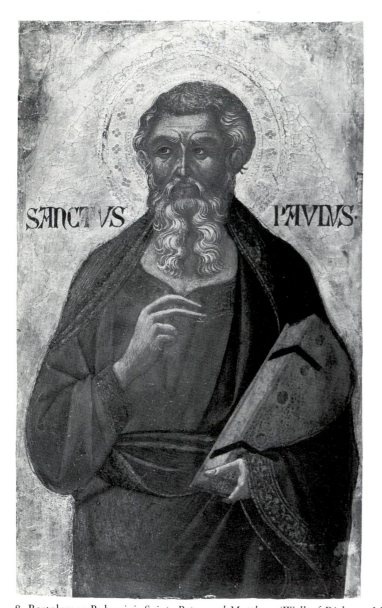

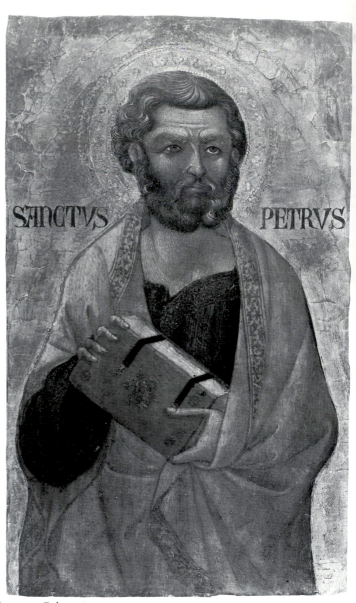

8. Bartolomeo Bulgarini, *Saints Peter and Matthew* (Wallraf-Richartz-Museum, Cologne)

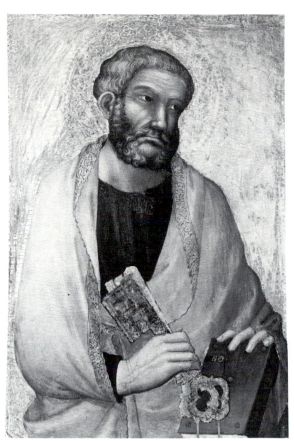

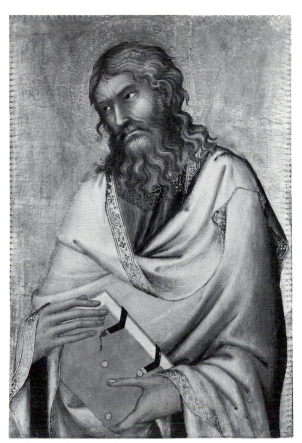

9. Simone Martini, *Saint Peter* (Private Collection, New York)

10. Simone Martini, *Saint Andrew* (Metropolitan Museum of Art, New York)

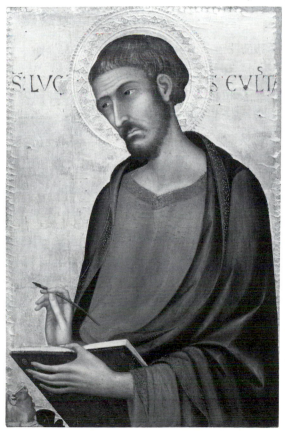

11. Simone Martini, *Saint Luke* (J. Paul Getty Museum, Malibu)

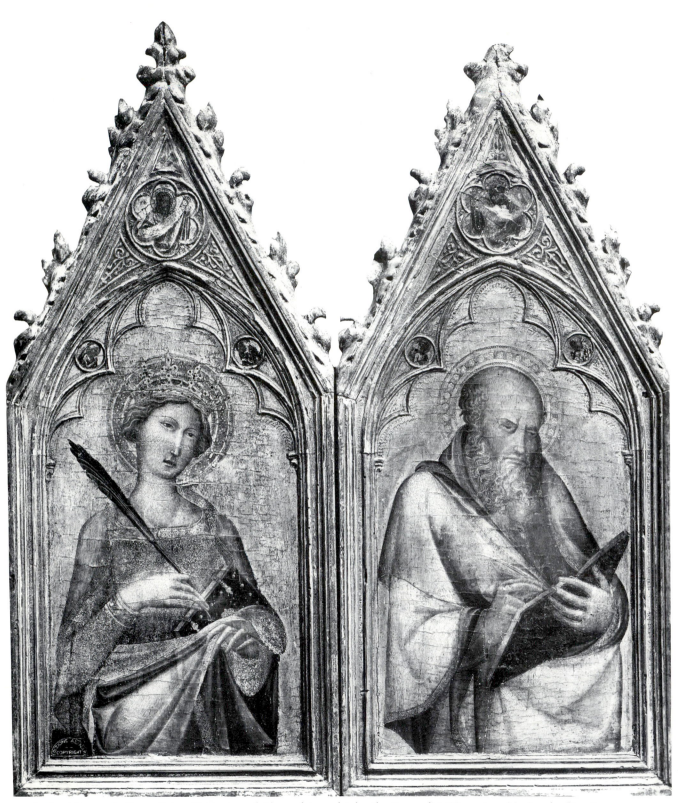

12. Style of Barna da Siena, *Saints Catherine of Alexandria and John the Evangelist* (Pinacoteca Nazionale, Siena)

278

13. Style of Barna da Siena, *Saints John the Baptist and Paul* (Pinacoteca Nazionale, Siena)

14. Niccolò di Buonaccorso, *The Presentation of the Virgin in the Temple* (Uffizi, Florence)

15. Niccolò di Buonaccorso, *The Marriage of the Virgin* (National Gallery, London)

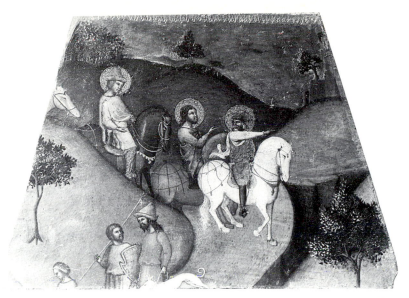

16. Bartolo di Fredi, *The Journey of the Magi* (Musée des Beaux-Arts, Dijon)

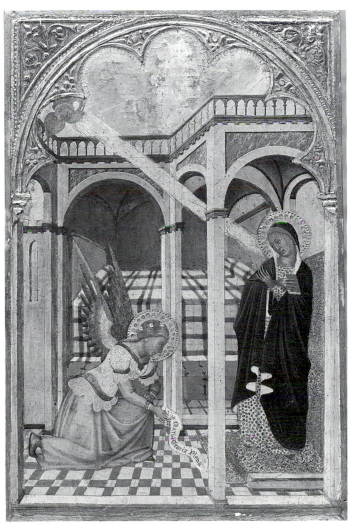

17. Workshop of Niccolò di Buonaccorso, *The Annunciation*
(Wadsworth Atheneum, Hartford, The Ella Gallup Sumner and
Mary Catlin Sumner Collection)

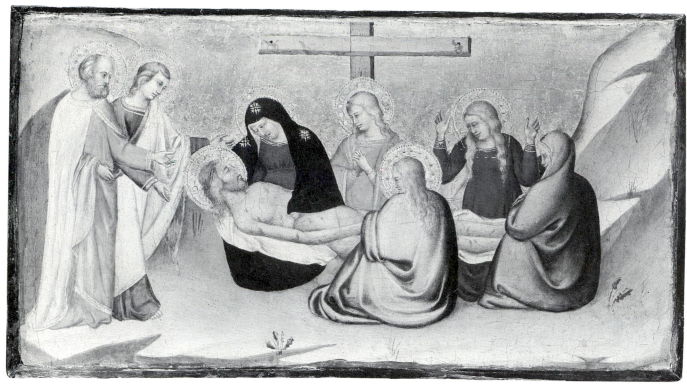

18. Puccio di Simone, *Pietà* (Staatliche Museen, Berlin-Dahlem)

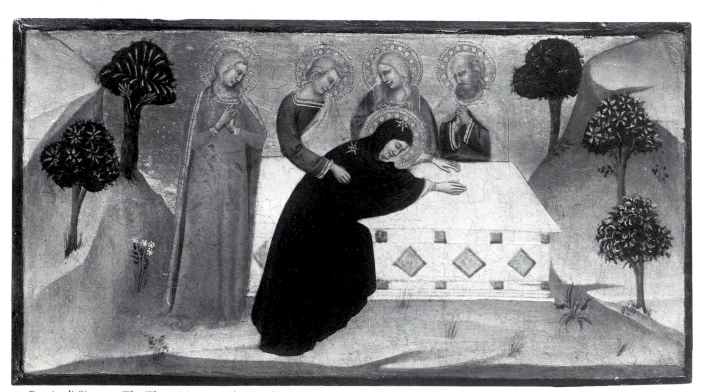

19. Puccio di Simone, *The Three Marys at the Tomb* (Statens Museum for Kunst, Copenhagen)

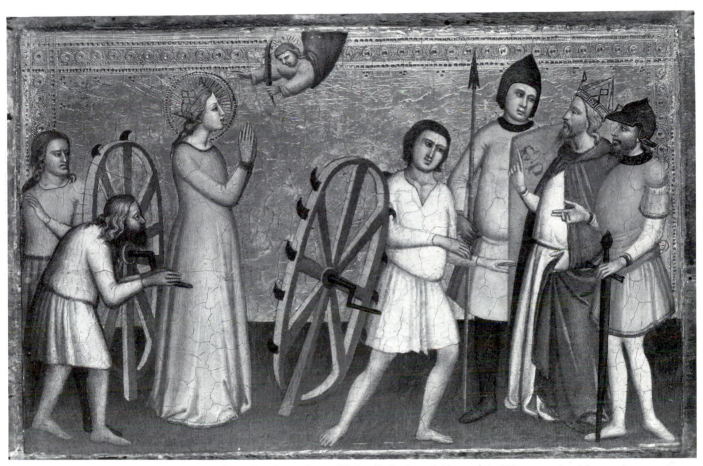

20. Master of the Orcagnesque Misericordia, *The Martyrdom of Saint Catherine of Alexandria* (Worcester Art Museum)

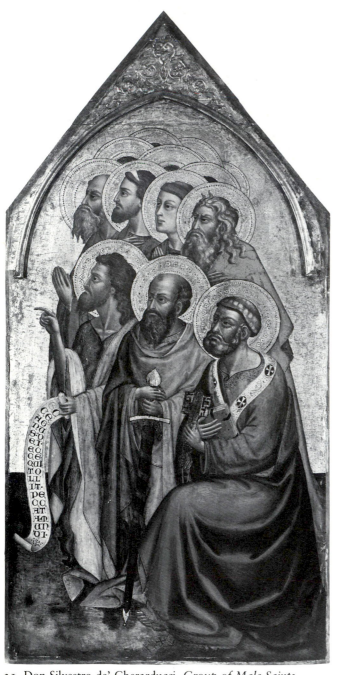

21. Don Silvestro de' Gherarducci, *Group of Male Saints*
(Musée d'Histoire et d'Art, Luxembourg)

22. Don Silvestro de' Gherarducci, *Group of Female Saints*
(Private Collection, Rome)

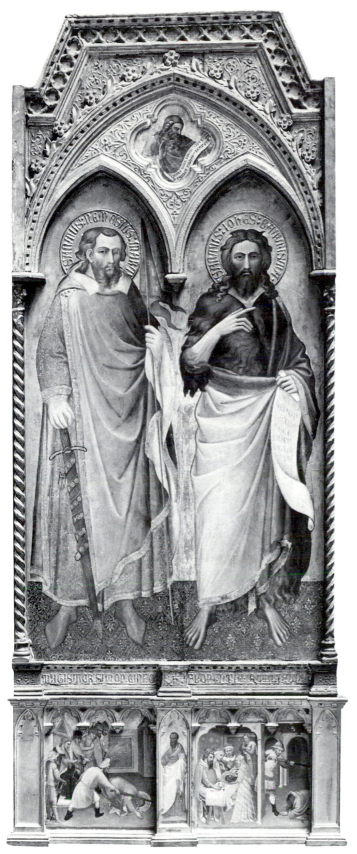

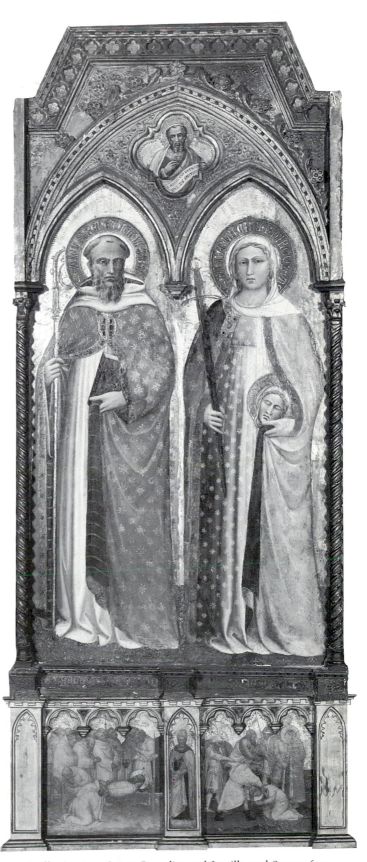

23. Spinello Aretino, *Saints Nemesius and John the Baptist and Scenes from Their Lives* (Szépművészeti Múzeum, Budapest)

24. Spinello Aretino, *Saints Benedict and Lucilla and Scenes from Their Lives* (Fogg Art Museum, Harvard University, Purchase Friends of the Fogg Fund, Cambridge)

25. The Master of Saint Francis, Reconstruction of the left side of the reverse of the Altarpiece from San Francesco al Prato, Perugia, from left to right: *Saint Francis* (Galleria Nazionale, Perugia); *Saints Simon and Bartholomew* (Robert Lehman Collection); *Saint James Major, Saint John the Evangelist* (National Gallery of Art, Washington, Samuel H. Kress Collection); *Saint Matthew* (Galleria Nazionale, Perugia); *Saint Peter* (Cleveland Museum of Art)

26. The Master of the Life of Saint John the Baptist, Reconstruction of the Altarpiece, from left to right, top row: *Annunciation to Zaccharias* (Private Collection); *Birth of Saint John, Madonna and Child, Baptism of Christ* (National Gallery of Art, Washington, Samuel H. Kress Collection); *Saint John in Prison* (Private Collection); lower row: *Saint John in the Wilderness* (Pinacoteca Vaticana); *Saint John and the Pharisees* (Seattle Museum of Art, Samuel H. Kress Collection); *The Feast of Herod* (Robert Lehman Collection); *Saint John in Limbo* (Private Collection)

27. The Master of Forlì, *The Deposition* (Thyssen-Bornemisza Collection, Lugano)

29. Neapolitan or Avignonese, *The Nativity* (Musée Granet, Aix-en-Provence)

28. Neapolitan or Avignonese, *The Annunciation* (Musée Granet, Aix-en-Provence)

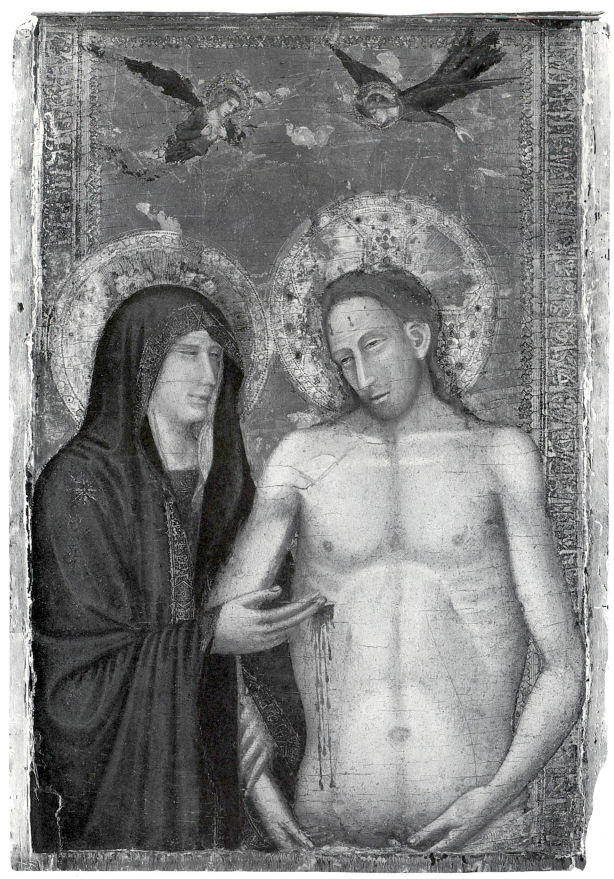

30. Roberto d'Oderisio, *The Virgin with the Dead Christ* (National Gallery, London)

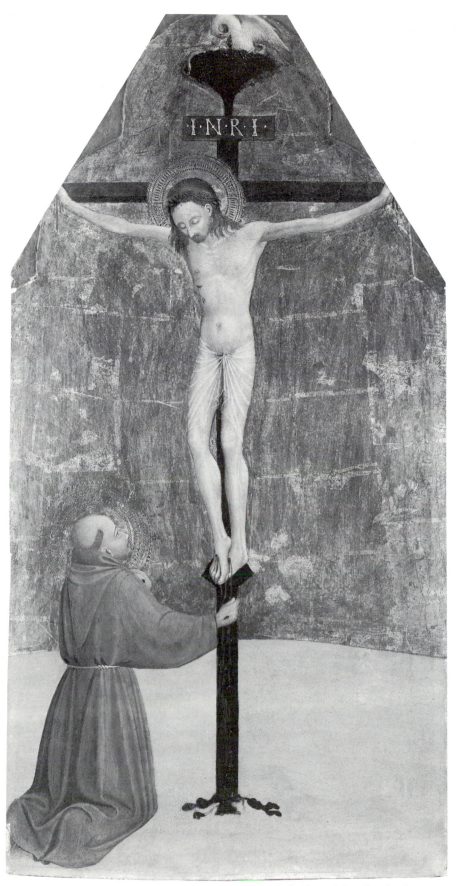

31. Sassetta, *Saint Francis Kneeling Before the Crucified Christ* (The Cleveland Museum of Art)

32. The Osservanza Master, *Saint Anthony at Mass Dedicates His Life to God* (Staatliche Museen, Berlin-Dahlem)

33. The Osservanza Master, *Saint Anthony Distributes His Fortune in Alms* (National Gallery of Art, Washington, Samuel H. Kress Collection)

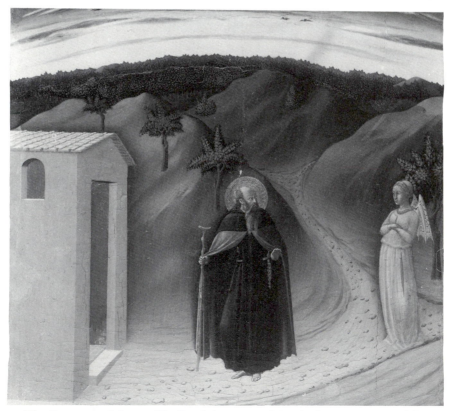

34. The Osservanza Master, *The Devil Appears to Saint Anthony as a Beautiful Woman* (Yale University Art Gallery, New Haven, University Purchase from James Jackson Jarves)

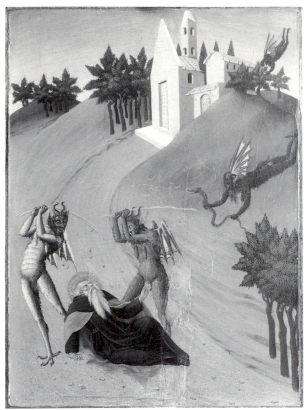

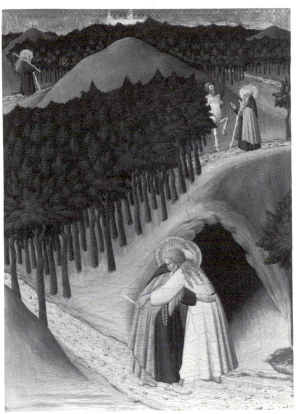

35. The Osservanza Master, *Saint Anthony is Beaten by Devils* (Yale University Art Gallery, New Haven)

36. The Osservanza Master, *Saint Anthony Visits Saint Paul the Hermit* (National Gallery of Art, Washington, Samuel H. Kress Collection)

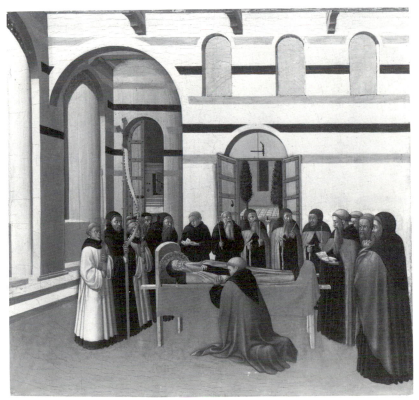

37. The Osservanza Master, *The Funeral of Saint Anthony* (National Gallery of Art, Washington, Samuel H. Kress Collection)

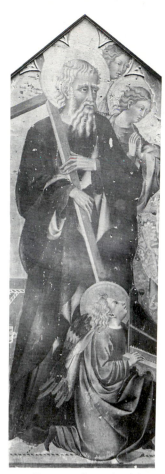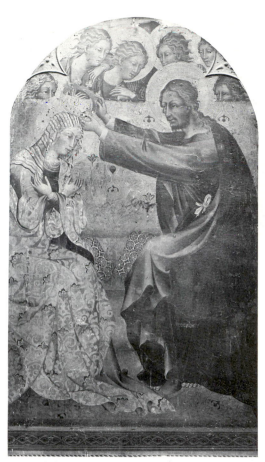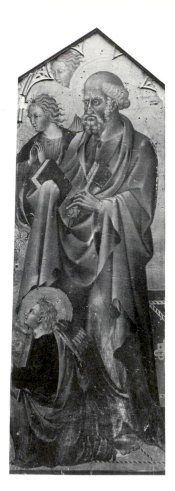

38. Giovanni di Paolo, *The Coronation of the Virgin* (Sant' Andrea, Siena)

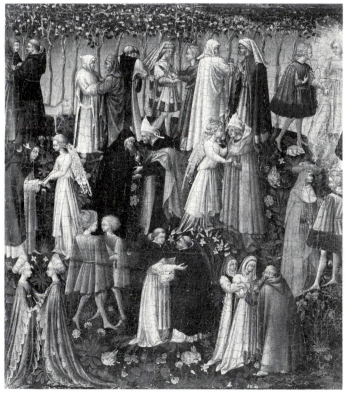

39. Giovanni di Paolo, *Paradise* (Metropolitan Museum of Art, New York)

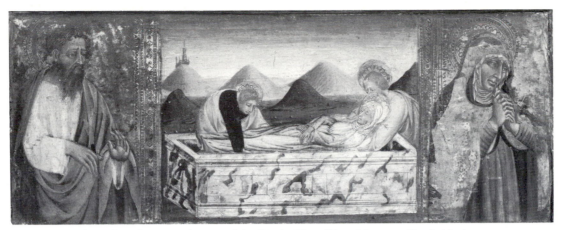

40. Giovanni di Paolo, *The Entombment of the Virgin* (Fitzwilliam Museum, Cambridge)

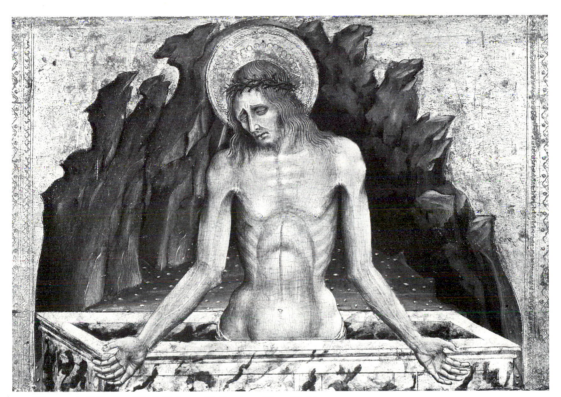

41. Giovanni di Paolo, *Pietà* (Private Collection, New York)

42. Giovanni di Paolo, *The Assumption of the Virgin* (El Paso Museum of Art, Samuel H. Kress Collection)

43. Giovanni di Paolo, *Angel*
(reverse of No. 50)

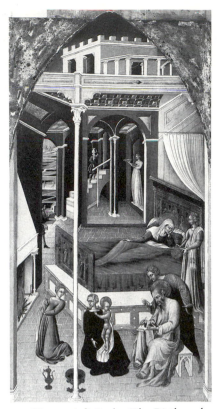

44. Giovanni di Paolo, *The Birth and
Naming of the Baptist* (Westfälisches
Landesmuseum, Münster)

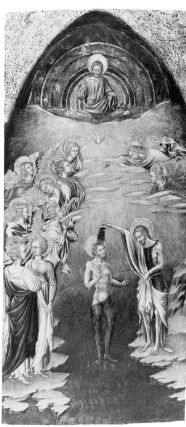

45. Giovanni di Paolo, *The Baptism
of Christ* (The Norton Simon
Foundation, Pasadena)

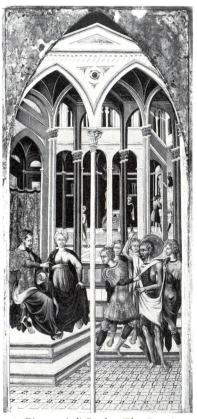

46. Giovanni di Paolo, *The Baptist
Preaching Before Herod* (Westfälisches
Landesmuseum, Münster)

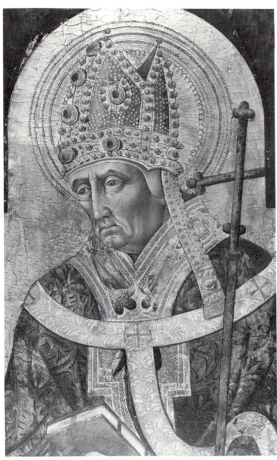

47. Giovanni di Paolo, *Saint Augustine* (Fogg Art Museum, Harvard University, Gift Arthur Sachs, Cambridge)

48. Giovanni di Paolo, *Saint Gregory the Great* (untraced)

49. Giovanni di Paolo, *Saint Jerome Appearing to Saint Augustine* (Staatliche Museen, Berlin-Dahlem)

50. Giovanni di Paolo, *St. Gregory the Great Staying the Plague at the Castel Sant'Angelo* (Louvre, Paris)

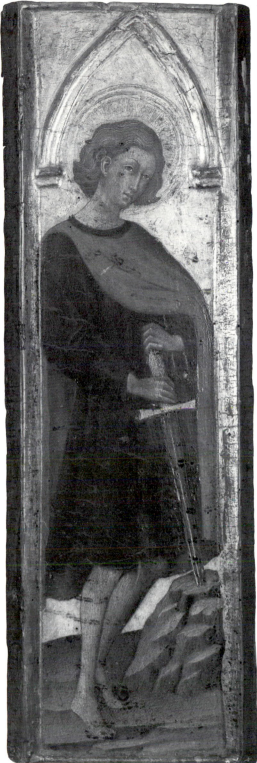

51. Giovanni di Paolo, *San Galgano and a Franciscan Saint* (Aartsbisschoppelijk Museum, Utrecht)

52. Giovanni di Paolo,
Painted edge of No. 52

53. Giovanni di Paolo, *Saint Catherine Invested with the Dominican Habit* (The Cleveland Museum of Art)

54. Giovanni di Paolo, *Saint Catherine and the Beggar* (The Cleveland Museum of Art)

55. Giovanni di Paolo, *The Miraculous Communion of Saint Catherine of Siena* (Metropolitan Museum of Art, New York)

56. Giovanni di Paolo, *The Mystic Marriage of Saint Catherine of Siena* (Heinemann Collection, New York)

57. Giovanni di Paolo, *Saint Catherine Exchanging Her Heart with Christ* (Heinemann Collection, New York)

58. Giovanni di Paolo, *Saint Catherine Dictating Her Dialogues to Raymond of Capua* (Detroit Institute of Arts)

59. Giovanni di Paolo, *Saint Catherine Before the Pope* (Thyssen-Bornemisza Collection, Lugano)

60. Giovanni di Paolo, *The Death of Saint Catherine of Siena* (untraced)

61. Benvenuto di Giovanni, *Christ in Benediction* (Nelson-Atkins Museum of Art, Kansas City)

62. Benvenuto di Giovanni, *Saint Dominic* (Nelson-Atkins Museum of Art, Kansas City)

63. Benvenuto di Giovanni, *Saint Francis* (Museum of Fine Arts, Houston)

64. Sano di Pietro, *The Stigmatization of Saint Francis* (untraced)

65. Lorenzo Monaco, *Virgin and Child* (Pinacoteca della Collegiata, Empoli)

66. Lorenzo Monaco, *The Visitation* (Courtauld Institute of Art, London)

67. Lorenzo Monaco, *The Adoration of the Magi* (Courtauld Institute of Art, London)

68. Lorenzo Monaco, *The Flight into Egypt* (Lindenau Museum, Altenburg)

69. Bicci di Lorenzo, *Virgin and Child Enthroned with Four Angels*
(Pinacoteca Nazionale, Parma)

70. Niccolò Alunno, *Saint Michael Adored by Members of a Confraternity*
(Art Museum, Princeton University)

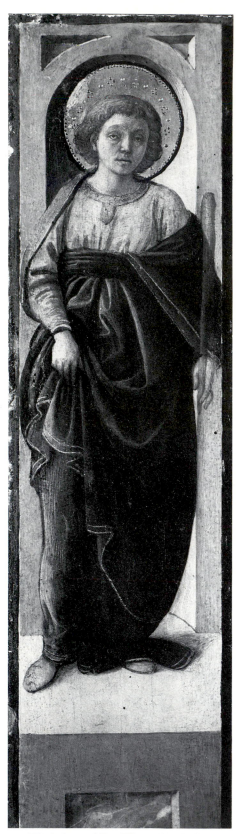

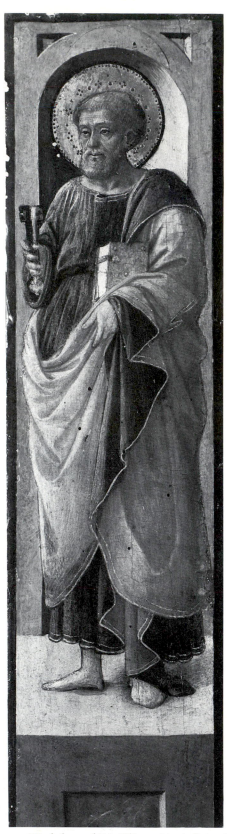

71. Workshop of Fra Filippo Lippi, *Saint James the Less* (Courtauld Institute of Art, London)

72. Workshop of Fra Filippo Lippi, *Saint Peter* (Courtauld Institute of Art, London)

73. Workshop of Fra Filippo Lippi, *Saint Dominic* (Courtauld Institute of Art, London)

74. Workshop of Fra Filippo Lippi, *Saint Barbara* (Courtauld Institute of Art, London)

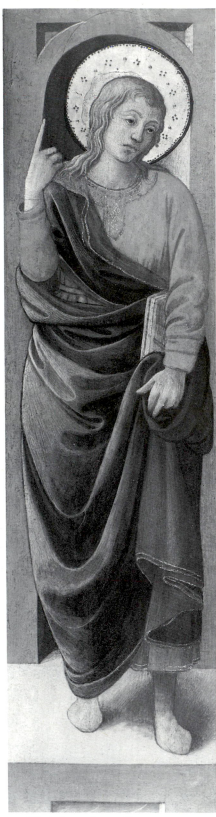

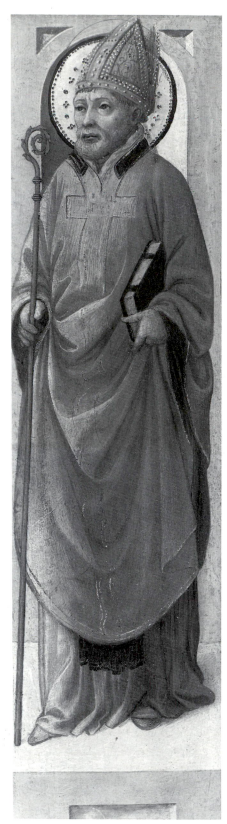

75. Workshop of Fra Filippo Lippi, *Saint John the Evangelist* (Fogg Art Museum, Harvard University, Bequest Adele L. and Arthur Lehman, Cambridge)

76. Workshop of Fra Filippo Lippi, *Saint Nicholas* (Fogg Art Museum, Harvard University, Cambridge)

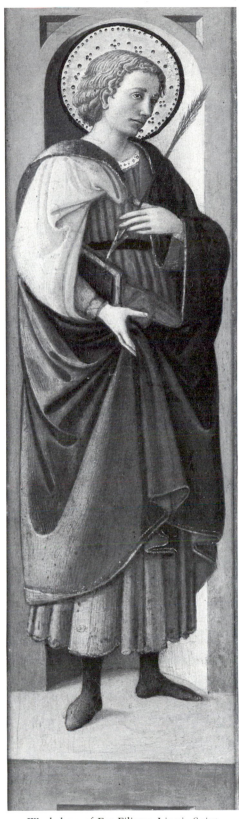

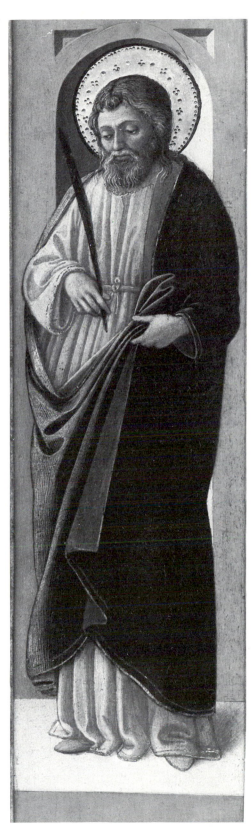

77. Workshop of Fra Filippo Lippi, *Saint Sebastian* (Honolulu Academy of Arts)

78. Workshop of Fra Filippo Lippi, *Unidentified Male Saint* (Honolulu Academy of Arts, Gift of Samuel H. Kress Collection)

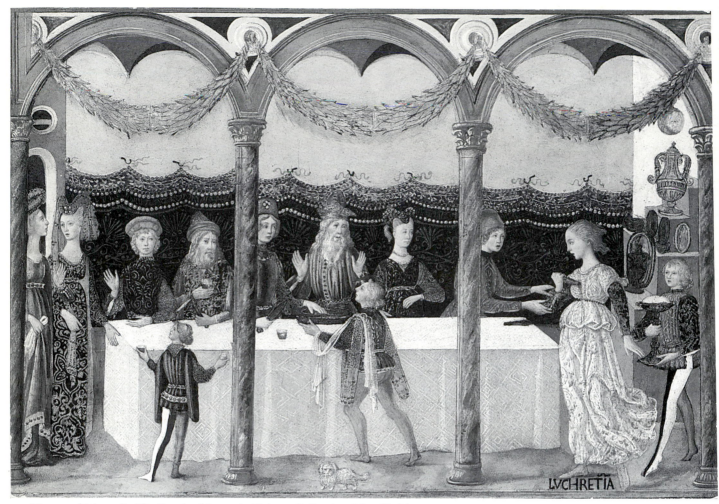

79. Master of Marradi, *The Death of Lucretia* (Private Collection, New York)

81. Roman, Middle of the Fifteenth Century, *The Mystical Crucifixion* (Národni Galerie, Prague)

80. Roman, Middle of the Fifteenth Century, *Scene from the Legend of Santa Francesca Romana* (Walter Art Gallery, Baltimore)

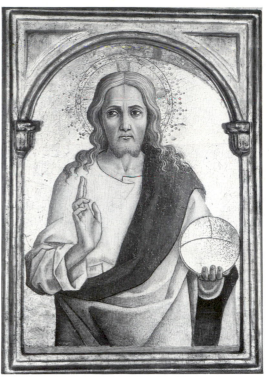

82. Carlo Crivelli, *Saint John the Evangelist* (Detroit Institute of Arts, Gift of Mr. F. Kleinberger)

83. Carlo Crivelli, *Salvator Mundi* (Clark Art Institute, Williamstown)

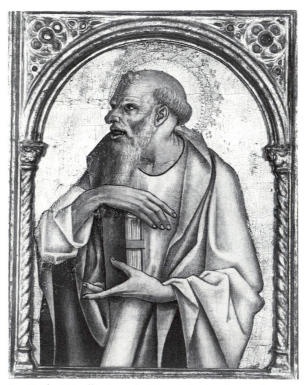

84. Carlo Crivelli, *Apostle* (Honolulu Academy of Arts, Gift of Samuel H. Kress Collection)

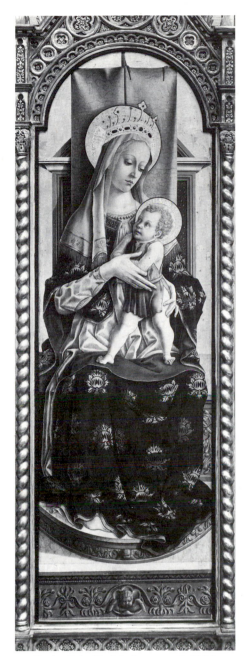

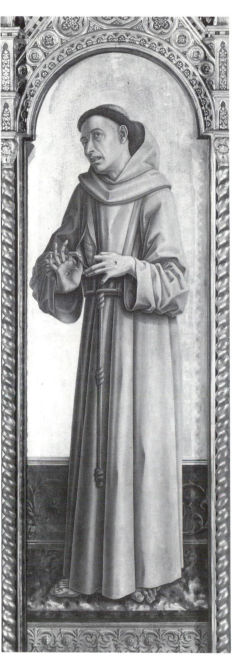

85. Carlo Crivelli, *Madonna and Child Enthroned* (Musées Royaux des Beaux-Arts, Brussels)

86. Carlo Crivelli, *Saint Francis* (Musées Royaux des Beaux-Arts, Brussels)

87. Carlo Crivelli, *Saint Mary Magdalene* (Santa Lucia, Montefiore dell'Aso)

88. Luca Carlevaris, *Boatman and Male Figure Facing Left* (Victoria and Albert Museum, London)

89. Luca Carlevaris, *Male Figure in Domino* (Victoria and Albert Museum, London)

90. Luca Carlevaris, *Cloaked Man Seen from the Back* (Victoria and Albert Museum, London)

91. Luca Carlevaris, *Woman with Back Turned* (Victoria and Albert Museum, London)

92. Luca Carlevaris, *Woman in Frontal Pose with Fan* (Victoria and Albert Museum, London)

93. Luca Carlevaris, *Two Male Figures Turned to the Left* (Victoria and Albert Museum, London)

94. Luca Carlevaris, *Woman with Shawl*
(Victoria and Albert Museum, London)

95. Luca Carlevaris, *Masked Woman*
(Victoria and Albert Museum, London)

96. Luca Carlevaris, *Magistrate* (Victoria and
Albert Museum, London)

97. Luca Carlevaris, *Male Figure with Back
Turned* (Victoria and Albert Museum, London)

Index

Page numbers are in roman type. Paintings in the Lehman Collection are indicated by Nos. and are preceded by an asterisk (*) when in color. Comparative illustrations are indicated at the end of the entries and are noted as Figs.

PHOTOGRAPH CREDITS

The publisher thanks the museums, galleries, and private collectors for permitting the reproduction of works of art in their collections and for supplying the necessary photographs. Additional photography sources are acknowledged below.

All photographs of the Lehman Collection by Malcolm Varon Associates, New York.

Comparative illustrations: Figs. 3 and 6 Jörg P. Anders, Berlin; Fig. 8 Rheinisches Bildarchiv, Cologne; Fig. 17 E. Irving Blomstrann; Fig. 18 Jörg P. Anders, Berlin; Fig. 25 Saint Peter, Denis Feron; Figs. 28 and 29 Jean-Pierre Sudre; Fig. 32 Jörg P. Anders, Berlin; Fig. 38 Institute of Fine Arts, New York University; Fig. 49 Jörg P. Anders, Berlin; Fig. 57 Bullaty-Lomeo Photographers, New York.